ROOKWOOD AND

THE INDUSTRY OF ART

WOMEN, CULTURE, AND COMMERCE, 1880–1913

Ohio University Press / *Athens*

ROOKWOOD

AND THE

INDUSTRY

OF ART

NANCY E. OWEN

Ohio University Press, Athens, Ohio 45701
© 2001 by Nancy E. Owen
Printed in the United States of America
All rights reserved

Ohio University Press books are printed on acid-free paper ⊗ ™

09 08 07 06 05 04 03 02 01 00 5 4 3 2 1

Library of Congress Cataloging-in-Publication Data
Owen, Nancy Elizabeth.
 Rookwood and the industry of art : women, culture, and commerce, 1880–1913 /
Nancy E. Owen.
 p. cm.
 Includes bibliographical references and index.
 ISBN 0-8214-1337-6 — ISBN 0-8214-1338-4 (pbk.)
 1. Rookwood Pottery Company—History. 2. Rookwood pottery. 3. Art pottery,
American—Ohio—Cincinnati—Marketing. 4. Women artists—United States—Social
conditions—19th century. 5. Women artists—United States—Social conditions—
20th century. I. Title.

NK4340.R7 O95 2000
338.7'617383'0977178—dc21

 00-040631

7.09
we

CONTENTS

ILLUSTRATIONS

FIGURES

Color Plates (Following page 144)

ACKNOWLEDGMENTS

This work has been undertaken with funding from the Henry Francis du Pont Winterthur Museum and Library, the Hagley Museum and Library, and the James Renwick Gallery of the National Museum of American Art, Smithsonian Institution, and I thank these institutions for their assistance.

The project was helped at several critical stages by the advice and counsel of Rookwood scholars Anita J. Ellis, chief curator and curator of decorative arts of the Cincinnati Art Museum, and Kenneth R. Trapp, chief curator of the Renwick Gallery of the National Museum of American Art. Both were generous with their time, knowledge, and support of my work. Thanks also to Dr. Art and Rita Townley, owners of the Rookwood Pottery Company and to Bonnie Lilienfeld of the Ceramics and Glass division of the National Museum of American History. Gratitude must also be extended to colleagues Karen Kettering, Amelia Rauser, Michael Clapper, Margo Thompson, Elizabeth Hutchinson, Joan Hansen, and Richard Mohr who read, commented upon, and helped me clarify my ideas about major issues in the book. Michelle and Randy Sandler of Cincinnati Art Galleries were wonderfully patient and helpful in providing images for this publication. I particularly appreciate the opportunity given me by Gerald and Virginia Gordon and James J. Gardner to view and study their superb Rookwood collections.

Librarians at several institutions have provided invaluable assistance. Special thanks to Eleanor McD. Thompson and Bert Denker at the Winterthur Library; to Cecilia Chin, Pat Lynagh, Jill Lundin, and Tessa

Veazey at the National Museum of American Art Library; to Arthur Breton at the Archives of American Art; to Paula Fleming at the National Anthropological Archives; to Mary Alice Cicerale at the Philadelphia Museum of Art Library; to Laura Chase at the Cincinnati Historical Society Library; to Mattie Sink of the Mitchell Memorial Library, Mississippi State University; to Russell Koonts of the John W. Hartman Center for Sales, Advertising, and Marketing History, Duke University; and to the staffs of Interlibrary Loan, Government Publications, and Special Collections at Northwestern University Library.

To my dissertation advisor, Hollis Clayson, I offer deep thanks and appreciation for her support, patience, wisdom, and guidance. I am also grateful to David Van Zanten and Diane Dillon for serving as members of my dissertation committee; and to Nancy J. Troy and Michael Leja for their involvement in the early stages of this work. Sandra Hindman, Maria Makela, and Thomas Sloan, although not directly involved with this project, have played key roles in shaping my approach to art history and I am pleased to have had the opportunity to have worked with each of them. In the women's studies department, Frances Freeman Paden has been a wonderful mentor and friend.

Nancy Basmajian, Gillian Berchowitz, Mary Gillis, and David Sanders at Ohio University Press have been generous with their time, energy, and perseverance. They deserve a lot of credit.

Special thanks to and for my friends and family, including Susan Friedes, Diane Locandro, Martha O'Donnell, David Orlinsky, and Kathryn Owen; and to my husband, Bill James, to whom this work is dedicated.

ROOKWOOD AND

THE INDUSTRY OF ART

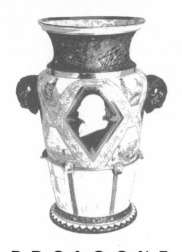

CHAPTER ONE

PROLOGUE

Rookwood Pottery of Cincinnati (1880–1967) was the largest, longest lasting, and arguably most important of the more than 150 art pottery operations in the United States during the late nineteenth and early twentieth centuries. The American Art Pottery movement came about largely in reaction to the perceived inferiority of American ceramic ware exhibited at the 1876 Centennial Exhibition in Philadelphia.[1]

> Great foreign Art Galleries are complete without the work of American painters or sculptors. The Americans . . . may be given place, but their work by no means represents the requisite part of a complete whole. Not so with Rookwood Pottery. No great national collection representative of the Keramic Art of the world would be considered complete without its group of Rookwood.[2]

At this exposition the ceramics displays from more than four hundred foreign exhibitors—including important displays from England, France, and Japan—stimulated an interest in improving the quality of America's production on the part both of established ceramists (primarily men) and of amateur china painters (primarily women). The key cultural issues

1

of the period—women's roles outside the home; anxiety about industrialization, immigration, and urbanization; distinctions between fine art and craft; tensions between national identity and international competition; and technological advances in communication and transportation —are enmeshed in the American Art Pottery movement. Because of this, it presents an especially revealing set of practices and rhetorics about the culture and history of the Gilded Age and Progressive Era. This book explores the ways in which the production, marketing, and consumption of Rookwood pottery reflect and inflect the commercial and cultural milieu in the United States from 1880 to 1913.[3]

THE CENTENNIAL

Just as the Crystal Palace exhibition had galvanized British design reform in 1851, so the 1876 Philadelphia Centennial Exhibition initiated calls for the integration of culture and commerce in the United States. Dalton Dorr, first director of the Pennsylvania Museum and School of Industrial Art, wrote: "With the opening of the Centennial Exhibition were unfolded possibilities of culture and refinement for the people never before thought of. We learned then the lesson that previous expositions had taught Europe: that art as a branch of mental training had value as an economic factor and importance as an educational aid." Significantly, Dorr concluded that "The era of national culture in the United States may be dated from the Centennial."[4] The manifest aims of the exposition were reformist and educational: to apprize manufacturers of their "friendly competition," to improve middle-class taste, and to morally instruct the working classes. Despite these lofty goals, issues of commerce tended to envelop the Centennial's didactic strategies because America was still experiencing effects of the 1873 depression.[5]

It was at the Centennial Exhibition that most American producers and consumers first were exposed to the cultural production of other countries, most notably English Aesthetic theory and practice. Although heralded as a "school for the nation," the Centennial instructed the

American public in an "object lesson" of moral and material progress stressing the value of "comparison" in assessing national accomplishments.[6] Thus, notwithstanding its function as a historical celebration aimed to enlighten and entertain, the fair was first and foremost a commercial enterprise that explicitly linked notions of reform and consumption. The Centennial's competing foreign exhibits provided models for emulation. It was generally held that this ability to shape and improve national taste would be the most significant result of the exposition, for a public demand for excellence would help American manufacturers to compete successfully in the international marketplace.[7]

In addition to providing Americans with their first glimpses of foreign cultures, the Centennial, which was attended by nearly ten million people—more than one-fifth of the American population—demonstrated that women had an important role to play in the administration of public affairs. It was widely held that without women's help, the Centennial celebration would never have been realized. Local and national committees organized teas, balls, concerts, bazaars, and art exhibitions to sell Centennial stock. In the midst of an economic depression, the women raised over $100,000. Women also lobbied for the participation of foreign nations, suggesting a desire on their part to widen America's intellectual and aesthetic horizons. Ironically, it was this effort that cost them their exhibition space in the Main Building. When notified by Director-general Alfred Goshorn that there would be no room for the women's display because of the unexpectedly large number of exhibitors, the Women's Centennial Executive Committee decided to build its own structure on the fairgrounds. The Women's Pavilion at the Centennial, a public female sphere, was the first example of the institutionalization of a space for women at a world's fair. The pavilion contained approximately six hundred exhibits intended to illustrate women's progressive influence in many fields, from the industrial and fine arts to science and education.[8] According to the New Century for Women, a weekly paper published by women in the Pavilion, the purpose was "to show what woman has been able to do, with all the limitations that social prejudices, and the laws of the Medes and Persians have set to her working at all."[9] This journal,

which included many features on household art at the fair and the Centennial's artistic mission, as well as a consideration of the amateur-professional debate and the power of women consumers, anticipated the shape and tone of much post-Centennial discourse about women, culture, and commerce.

American Aesthetic Movement

The Centennial also served as a catalyst for the American Aesthetic movement, which Roger Stein has contended was in many ways a "women's movement" that had a marked influence on the so-called woman question.[10] Because they were both producers and consumers of artistic goods, women viewed Aestheticism as a vehicle for personal expression and independence.[11] This late-nineteenth-century art craze was concerned with introducing art into all domestic manufactures—furniture, metalwork, ceramics, stained glass, textiles, wallpapers, and books. The preoccupation with uniting art and industry was found in the proliferation of art magazines, books, societies, and clubs that counseled women how to decorate their houses and how to make their own objects in the aesthetic taste.[12] Although it was primarily upper-class and middle-class women who engaged in a self-conscious pursuit of beauty during this period, Aestheticism in fact was a far-reaching phenomenon that permeated the lives of a wide array of Americans. Working-class men and women who used personalized shaving mugs, Moss Rose teapots, and china bric-a-brac were as active in the pursuit of beauty as upper- and middle-class consumers who bought goods embellished with sunflowers, lilies, storks, and frogs.[13]

American Ceramics at the Centennial

The reform impulse of the Aesthetic movement was fueled by a widespread sense of crisis due to the perceived impoverishment of national

taste, a struggling and depressed class of artists, and a debased and vul-
gar stock of consumer goods. Whereas America's technical exhibits, such
as the Corliss Steam Engine, drew enthusiastic praise, her decorative arts
and handicrafts were reportedly tasteless, imitative, and even shoddy.
Looking back, ceramics educator Charles Fergus Binns noted: "The exhi-
bition was educational almost to a fault. America was hopelessly beaten.
There was nothing to do but rear the rampart of a prohibitive tariff
around her infant industries and to trust to luck."[14] In particular, Ameri-
can ceramic wares seemed to pale by comparison with foreign wares.
A leading critic noted the American display of porcelain was "so poor
as not to be noticeable artistically." Another discoursed at length about
the "thorough lack of artistic pottery of American make at the Philadel-
phia Exhibition."[15] Charles Elliott wondered, "Have we Americans noth-
ing in the great Exhibition to show our skill in the ceramic arts? Let
us see. Some twenty firms, mostly from Trenton, are collected in the
southeast corner of the Main Building, where they make a creditable
display of what is known as the 'white granite' ware, so useful, and so
detestable."[16]

The lack of recognition was not for want of effort on the part of
American factory managers, who viewed the Centennial as an opportu-
nity to elevate the general quality of domestic wares and to abandon the
mimicry of imported goods that plagued the industry. In order to maxi-
mize their chances for success, potters from around the country joined
together in January of 1875 to form the National Potters' Association
(later the United States Potters' Association). Their first meeting, imbued
with an overwhelming spirit of optimism, was primarily concerned with
encouraging original designs, created specifically for their countrymen,
that would unmistakably proclaim the "stamp of national character."[17]
The association further resolved that "the American potters shall make
a fine display at the United States Centennial Exhibition, to exhibit to
the world at large the extent to which the ceramic art has been carried
by American manufacturers."[18] President of the organization John Moses
urged his colleagues to "make great exertions to bring such displays of
ware to the Centennial Exhibition as would convince Americans that

foreign articles should no longer be regarded as superior to those of American manufacture."[19]

All of the major ceramic centers (New York, Trenton, Philadelphia, and East Liverpool, Ohio) were represented at the Centennial; most of the displays focused on the improved quality noted in the manufacture of hotelwares, which received praise for technical, but not artistic, excellence, as was noted by critic Charles Elliott. Several of the larger firms, such as the Union Porcelain Works of Greenpoint in Brooklyn and the Ott and Brewer company of Trenton—whose proprietors had been instrumental in forming the Potters' Association—had gone so far as to hire professional sculptors to design their exhibition pieces.

The display of the Union Porcelain Works included a pair of Centennial pedestals (fig. 1.1) supporting large Century vases (fig. 1.2) covered with a profusion of historical scenes and novel combinations of patriotic motifs in relief. At the top of each pedestal were masks of Greek drama, under which were depicted four vignettes, divided by Ionic pilasters, possibly representing the story of Electra.[20] These three-and-one-half-foot-tall pedestals and the nearly two-foot-tall vases they supported were designed by Karl L. H. Müller, a German-born sculptor who had studied at the Ecole des Beaux-Arts in Paris and later at the National Academy of Design in New York. The design of the vases was intended to illustrate the progress of the United States during its first century. North American bison heads serve as handles. Smaller animal heads in full relief are arranged around the body. Adorning either side is a bisque profile portrait in relief of George Washington within a diamond-shaped reserve. On the neck a gold eagle is surmounted by gold stars and lightning bolts. Each of six biscuit relief panels around the base depicts a different event in American history. Flanking the Washington portraits above and below are eight slightly truncated triangular reserves painted around the vases, which contain vignettes of American progress. These vases became the virtual emblem of the factory's work throughout the nineteenth and early twentieth centuries, and numerous smaller versions were produced. They provided a striking contrast to the white tablewares that were the firm's staple production.

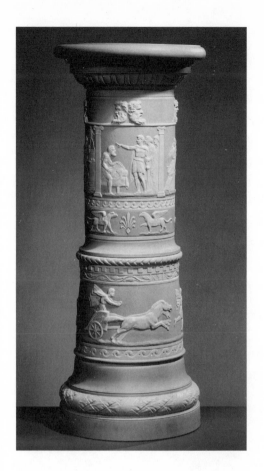

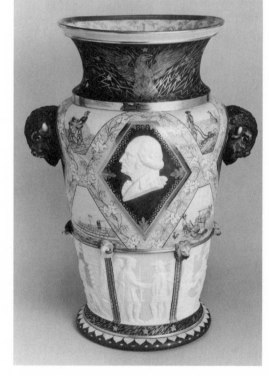

FIGURE 1.1. Greenpoint Union Porcelain
Works, Karl L. H. Müller, designer, *Centennial
Pedestal*, 1876, porcelain. *The Metropolitan Museum of
Art, purchase, anonymous gift, 1968 (68.99.1).*

FIGURE 1.2. Greenpoint Union Porcelain
Works, Karl L. H. Müller, designer, *Century
Vase*, 1876, porcelain, gilt decoration. *Collection
High Museum of Art, Virginia Carroll Crawford Collection
(1986.163).*

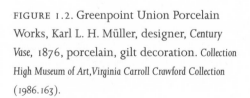

The only works that were consistently admired at the Centennial were parian statues, designed for Ott and Brewer by sculptor Isaac Broome. They were viewed as "the work of a genuine artist, who has surrounded a general design of great merit with many finely executed and suggestive details."[21] The most popular objects Broome designed and modeled for the fair were a pair of covered vases, on pedestals of creamy white parian, in celebration of baseball, America's national sport (fig. 1.3). In early June, one of the vases was moved from the Ott and Brewer display in the ceramics exhibition area to the Art Gallery in Memorial Hall, thus elevating the status of the vase from a mere ceramic figural piece to a sculptural work of art.[22] At the American Institute's exhibition in New York City in 1876, many potteries sent duplicates of their Centennial objects. The following year, another exhibition at the

FIGURE 1.3. Ott and Brewer Co., Isaac Broome, *Baseball Vase*, 1876, parian porcelain, bisque. *New Jersey State Museum, The Brewer Collection* (354.22).

American Institute in New York provided a setting for the wares that had not been sold in Philadelphia. There Ott and Brewer displayed Broome's parian bust of Cleopatra among a group of objects that included many parians the firm had also displayed at the Centennial.

The commercial potteries that bore the brunt of the criticism at the Centennial resolved to stimulate a "desire for artistic excellence in the articles of everyday utility such as potters are called upon to produce."[23] In a petition requesting the U.S. Potters' Association to form a permanent Art and Design committee, members cited a report by Col. J. E. Clark, chief of the U.S. Bureau of Education: "Industrial art is the application of the principles of art to the objects of daily use. The place of art is not only in public galleries; it is above all in the homes and at the firesides of the people."[24] For the U.S. Potters' Association, the merger of art and industry would provide employment for skilled designers who would in turn improve the quality of United States ceramic ware, which would then benefit the industry financially. Although culture and commerce were held apart by the frankly commercial aims of the latter and the supposedly "pure" motives of the former, more often than not the application of art to industry was intended to provide financial benefits to both.[25] Despite this, many factories were discouraged from pursuing a national character in their production, and in the years following the Centennial followed their foreign counterparts even more closely.[26]

AMERICAN ART POTTERY MOVEMENT

Although the elaborate *pièces de résistance* produced by Union Porcelain Works and Ott and Brewer for the Centennial were decided attempts to make art pottery, the designs by Müller and Broome largely relied upon a mid-nineteenth-century concept that advocated the integration of symbolic associations and narrative messages into decoration. This did not satisfy the growing demand for decoration that could be spontaneously enjoyed from the art-for-art's-sake viewpoint of the Aesthetic movement. It was not the manufacturers who were to build an Art Pottery

movement; rather, it was the amateurs who came to the Centennial and went home inspired. The Centennial unleashed a flood of enthusiasm and new ideas. Two years afterward, George Ward Nichols, a judge at the Centennial and the husband of Rookwood's founder, Maria Longworth Nichols, wrote, "In decorated wares there is scarcely any competition with foreign countries. We know but little in the United States, of the science and art of decoration, either by hand or by printing."[27] The Centennial inspired a response to this lament: the Art Pottery movement.

American Art Pottery is the generic name used to designate ceramics made with a consciously artistic intent during the period roughly from the time of the Centennial until the beginning of World War I.[28] The label is problematic in that it encompasses ceramics varying widely in methods of fabrication and decoration. Art Pottery includes both ceramics made in a single-potter setting and those fabricated in a highly organized factory. In many cases women decorated the pottery and even founded successful potteries, while other potteries were male-dominated enterprises. Moreover, there is an extraordinary variety in the types of objects designated by this rubric. Some feature painted decoration, carefully executed in a naturalistic manner. Others rely on form and colored glazes for aesthetic effect. Some are hand thrown or hand built. Others are cast or molded into shapes. A remarkable range of different glazes was also produced during this era, resulting in vessels with highly varied and distinct appearances.

The makers of American Art Pottery took great care with the vessel design, fabrication, and decoration. Often the wares, like works of fine art, were signed by the pottery and the decorator, and sometimes by the modelers or potter as well. Such wares were exhibited at special showings at decorative arts societies in cities all over the United States and were sold in some of the finest china and department stores. Examples of American Art Pottery were virtually the first American ceramics to receive international acclaim when exhibited at the great international exhibitions, where they were awarded high commendation from the juries and garnered significant attention from the press.[29]

Among Centennial visitors who were to play a significant role in the

American Art Pottery movement was the founder of Rookwood Pottery, Maria Longworth Nichols of Cincinnati, who had displayed her china painting in the Women's Pavilion. Reportedly, Nichols was so impressed by the ceramics of Japan at the Centennial that she persuaded her wealthy father to provide the funds so that she could have her own pottery, which she named after the Longworth country estate.[30] The mission statement of Rookwood Pottery, which drew its first kiln in November of 1880, was brief and to the point: "While my principal object is my own gratification, I hope to make the Pottery pay expenses."[31] Three years later, in 1883, William Watts Taylor, an able administrator with no experience in the ceramics business, was hired to manage the Pottery. Nichols, widowed in 1885, devoted less time to her decorating interests following her 1886 marriage to Bellamy Storer, a politician in Theodore Roosevelt's circle. She signed the pottery over to Taylor in 1890 when she retired, giving it to him as a present. Rookwood was subsequently incorporated, with Taylor, the majority shareholder, as president and treasurer—positions he held until his death in 1913. Throughout his tenure at Rookwood, Taylor maintained a tight control over production, marketing, and consumption of the ware, overseeing the growth of the firm from a local entity to one earning international acclaim.

Overview

While Rookwood's production, marketing, and consumption are the topic of what follows, the theme is the nexus of women, culture, and commerce, and the approach is topical and thematic rather than strictly chronological. Chapters 2 and 3 assess the labor practices and production of Rookwood ceramic ware as a way to explore anxiety about women's roles outside the home, as well as about industrialization, immigration, and urbanization. By situating Rookwood's production within the "wild ceramic orgy" that overtook the United States in the years following the Centennial, its utilization of and apprehension about women's labor is linked to the taint of amateurism. In chapter 3 Rookwood's

place within the American Arts and Crafts movement is examined. Although labor practices seemingly followed the goal of reuniting art and labor, Rookwood's aesthetic is not found to mesh with Arts and Crafts precepts about good design. Chapter 4 takes up the marketing of Rookwood products as fine art and the connections with museums both locally and nationally. The thesis is advanced that conceptions of fine art and culture are closely linked to the debate about machinery and industrialization. It is argued that management positioned the firm's production and working methods as "an artist's studio, not a factory," in order to appropriate the aura and cachet of fine art for its wares. Rookwood's presence at international expositions is examined in chapter 5, in order to map issues of national identity and competition. The meaning of Americanness is parsed in order to move beyond the focus on "native clay," American-born workers, and local flora and fauna as decoration. Rookwood's Native American portrait pieces are examined within the discourse about Native Americans and the closing of the frontier. Chapter 6 hypothesizes Rookwood's consumers by exploring the vehicles through which Rookwood was sold: magazine advertising, mail-order catalogues, and department stores, all of which are imbricated in technological advances in communication and transportation. By assessing the demographics of subscribers and the clientele of retail venues, it is concluded that Rookwood's targeted consumers were primarily urban, upper- and middle-class women. It is further demonstrated that Rookwood's basic aesthetic of traditional shapes with floral decoration was formulated to appeal to this sought-after audience for the ware. Finally, chapter 7 extends the narrative past 1913 and looks at efforts to modify production and marketing to attract new consumers. It is concluded that the continuation of Taylor's policies and philosophy—the backbone of Rookwood's self-identity as producers of one-of-a-kind art objects—eventually led to financial ruin.

CHAPTER TWO

DOMESTICITY AND WOMEN'S LABOR

There are scores of women in Cincinnati belonging to the "idle rich" class who spend most of their time in the potteries. It is to be feared that this occupation is often at the expense of what are called "social duties," but there can be no doubt of the fact that they are by it much healthier in mind and body. . . . [H]andling dear old mother earth, whether it be digging potatoes or making pots and plaques, does not leave much room for hysteria.

Harper's Weekly Magazine, 1880

THIS CHAPTER EXAMINES Rookwood AS A SITE OF WOMEN'S LABOR THAT inspired two very different views. On the one hand a sizable percentage of the populace saw and praised the pottery as a feminine endeavor. On the other hand William Taylor, who ran the company for thirty years, emphatically denied this association. These different vantage points can be understood within the nexus of domesticity and women's labor. The doctrine of separate spheres, also known as the "cult of domesticity,"

provided both a limitation and a springboard to women's art production in the United States in the late nineteenth and early twentieth centuries. That is, this ideology insisted that woman's place was in the home and viewed women as natural guardians of the arts. This made available several opportunities for women to be involved in art production but particularly favored arts accomplished in and for the home, such as china painting. In the last quarter of the nineteenth century, "china mania" and a "wild ceramic orgy" swept the United States. Rookwood's founder, Maria Longworth Nichols, and a number of other socially prominent Cincinnati women were avid participants. Nichols was the granddaughter of art patron Nicholas Longworth, sponsor of Hiram Powers and Robert Duncanson; Longworth was listed in the 1850 census as paying the largest sum in real estate taxes of any individual in the United States except for William B. Astor. She was the daughter of Joseph Longworth, who became wealthy in his own right after Nicholas's death in 1863.[1] Although Nichols and the other Cincinnati ceramists gained national recognition for art pottery efforts, they never escaped the association of their work with the amateur endeavors of the "idle rich." When Nichols founded Rookwood, this association followed her into the public sphere. It was this appellation that William Taylor sought to avoid when he took over the firm as manager in order to make it a viable commercial enterprise. As we will see, women might be associated with culture, but they were not to be associated with commerce.

Shortly after the pottery was founded in 1880, Maria Nichols and Rookwood began to receive a great deal of positive publicity seemingly because of her sex. Writing in 1895, Nichols acknowledged this, saying, "I don't suppose any undertaking ever had so much gratuitous advertising as the Rookwood Pottery, because it was a woman's."[2] Rookwood decorator Clara Newton wrote in 1901 that "The trying of such a project by a woman, was not only new in our country, it had in it also an element of the picturesque that fascinated the imagination."[3] An article in the Ladies' Home Journal of October 1892 suggests that "in having been founded by a woman, it is a witness to the important and active share taken by women in the work of this country, a privilege peculiarly American,

and not paralleled except in comparatively rare instances in the nations of the Old World."[4] Moreover, Rookwood was often invited to exhibit wares in the women's section of national and international expositions.

This recognition of Rookwood as a feminine endeavor persisted long after Maria Nichols had dissociated herself from the pottery. As early as 1883 she had turned over management of the concern to family friend William Watts Taylor. After her husband died in 1885, Nichols married Bellamy Storer and made a present of Rookwood to Taylor in 1890.[5] Taylor, who ran the pottery for thirty years, until his death in 1913, did not welcome the links between Rookwood and femininity. Although the decorating department, established in 1881, initially included only women (most of whom worked part-time), when Taylor took over as manager he immediately began to hire male decorators, a practice that led some of the women to resign. Maria Nichols supported Taylor's policy and echoed evolutionary sentiments about women's lack of endurance, telling the remaining female workers that "there were simply not enough women with the proper artistic ability and sufficient energy to come day after day and do a day's work."[6] Despite Taylor's efforts at gender segregation, during the golden age of the pottery (1883–1913), women decorators usually outnumbered men. This point is discussed in detail in the next chapter.

Taylor may have felt some personal antipathy to women as well as to his subordinate role, for in 1887 he wrote that, "while she remains the proprietor of Rookwood, the writer, who is an adult male conducts the business."[7] Moreover, when invited to display ware in the Women's Industrial Section of the 1888 Glasgow International Exhibition, Taylor responded, "On looking into the matter closely we find that practically all the high class work we now have on hand is done by men and could not well be classified in the department of women's work."[8] When asked about participation in a local industrial fair, Taylor again replied that "so large a part of our higher class work is done by men that we do not think we could made a proper exhibit in the woman's department."[9] On another occasion he tried to hedge his bets, remarking that "most of our work is done by men, but of course the Pottery as an institution

is 'woman's work.' "[10] In a letter to a Chicago patron he wrote, "You please us greatly in calling Rookwood Pottery 'virile.' We do our best to get that quality into it at least."[11] Indeed by 1904, the role of women at Rookwood was being discounted altogether. Taylor peevishly wrote to his friend and fellow art pottery expert, Charles Fergus Binns, that "The Pottery has been written about to a rather tiresome degree from the 'woman's standpoint' and . . . you can imagine how this has been rather written to death. . . . Of course you know Rookwood so well that you appreciate how its characteristic development has been the work of the other sex to at least a controlling extent."[12]

Cult of Domesticity

The late Victorian "cult of domesticity" was rooted in the traditionalist notion of separate spheres for middle- and upper-class men and women. This powerful ideology posited a rigorous division between a masculine public realm dedicated to production, competition, and material gain and a feminine private or domestic realm consecrated to ideal virtues, beauty, and consumption.[13] Nineteenth-century advice books, women's magazines, evangelical sermons, and social criticism provided a prescriptive image of virtuous femininity that is sometimes dubbed the "cult of true womanhood."[14] This way of thinking reinforced Darwinian notions of the innate difference between the sexes, which held that women's nature was all but fixed in the sphere of their responsibilities for reproduction and mothering.[15] Dr. Edward H. Clark, a Harvard professor who provided a physiological perspective on women's education in his 1873 book *Sex in Education; or, A Fair Chance for the Girls*, went so far as to suggest that too much energy devoted to thought actually undermined women's childbearing powers.[16] Clark's theories of a brain-uterus competition along with other sex-based assumptions of Victorian society provided social sanctions as well as scientific justification for overt discrimination toward women seeking to enter the public sphere.

Critics and pundits typically held domesticity and artistic accom-

plishment in opposition, concluding that because the womb was the center of woman's energy, women were simply incapable of the genius required to be great artists.[17] E. A. Randall writing in *The Arena* in 1890 noted that "the history of art is closely associated with the fact of sex. . . . Since woman is by nature or cultivation passive, she possesses to a less degree than man the creative art. In regard to the inability of woman to create there seems to be no difference of opinion."[18] Molly Elliot Seawell echoed this sentiment, noting that "genius . . . has been totally denied the feminine sex," and pointing out that the lack of great women artists was not due to their dearth of opportunities but because "women are naturally, radically, and mentally inferior to men intellectually."[19]

Although these models of Victorian womanhood are vulnerable to criticism, they are useful as a framework within which to examine how women shaped their lives within a patriarchal culture. There were many progressive thinkers who forcefully challenged the essential male-dominated structures of Victorian thought and culture and formulated a philosophy of women's intellectual capacity and equality. Some, like novelist and theorist Charlotte Perkins Gilman, bore witness to their personal and social anguish. In *The Yellow Wallpaper*, a novella published in 1892, Gilman described her nervous breakdown following the birth of her daughter.[20] The breakdown was due in large part to her fear that motherhood and domestic responsibilities would confound her ability to write. The prescription for her to regain her health was that she devote herself to domestic work and to her child and "never touch pen, brush or pencil" for the rest of her life.[21] Gilman's vividly recounted experience makes it impossible to deny either the existence of rigid role prescriptions (whether or not they were descriptive) or that domestic responsibilities and the consequent lack of physical and psychic space often had a negative effect on women's art production.[22] However, many sentient, talented women were capable of politicizing domesticity for their own purposes. Domestic ideology can be conceptualized as a tense and unstable network of oppositions and resistances instead of an opposition of dominance and subordination.[23] It is overly simplistic to view the cult of domesticity as *merely* an impediment to women's achievement

as artists. Indeed, the separation of spheres was constantly and multiply produced and counteracted in a variety of sites, especially in women's art production.[24]

Women as Moral Guardians of the Arts

The socially sanctioned model of true womanhood, the "angel in the house," actually provided a springboard for a number of women to enter into art production.[25] The first step in this process was the claim that women and not men were the natural guardians of the arts. Domestic theorists argued that by presiding over cultural matters in the home, women could preserve and foster morality and spirituality in an increasingly base and materialistic world.[26] Elaborating on this conceptual framework in their best-selling 1869 treatise *The American Women's Home*, Catherine Beecher and Harriet Beecher Stowe note that "the aesthetic element . . . holds a place of great significance among the influences which make home happy and attractive, which give it a constant and wholesome power over the young, and contributes much to the education of the entire household in refinement, intellectual development, and moral sensibility."[27] Writing in 1878, Harriet Spofford explained that "the study of furnishing is as important, in some respects as the study of politics; for the private home is at the foundation of the public state, subtle and unimagined influences molding the men who mold the state."[28] Another author warned that the interior design of the home refined the inhabitants when done well but vulgarized them when done poorly.[29] In his cautionary treatise *Sesame and Lilies*, John Ruskin urged women readers to adorn their homes in ways that would safeguard their families from the corrosive influences of urban life.[30]

Most writers agreed with Ruskin that the enormous task of child rearing—woman's highest calling—would be aided by the proper physical surroundings. In 1884 *Godey's* editor stated that "the home influence that is daily exerted will be the main arbiter of the extent of what that light [of intelligence] in the family and its children shall be."[31] Mary

Tillinghast reinforced the idea in her comment that the "human mind is more sensitive to surroundings than we are in the habit of believing." Tillinghast's "Talks on Home Decoration," published in the *Art Interchange* in 1896, began with the assumption that "our homes express the strongest influence upon our characters and our lives, and that it is due to our moral and aesthetic education, and the development of ourselves and our children that the home should show the highest standard of art that our means and condition will permit." She went on to note that children brought up in such an environment would obtain an "unconscious education," of "the best and most lasting" type, by being always surrounded by the beauty chosen by their mother.[32]

WOMEN'S ART EDUCATION

In the name of pursuing the legitimately feminine task of promoting moral and spiritual uplift, the American women who read these texts not only collected art objects to adorn their parlors, but formed arts clubs to foster the production of such objects.[33] Educators championed the arts wholeheartedly. One survey of higher education of women in the antebellum South documents hundreds of parochial and secular seminaries and academies that included painting instruction as a regular part of the curriculum.[34] Schools of design, founded in the 1850s, offered women instruction and employment in the decorative and industrial arts. By the early 1860s, women also began to enter traditional art academies for academic training in painting and drawing.[35] Yet these institutions taught not only sculpture and drawing from the antique, but also provided instruction in needlework and china painting.[36] According to the 1890 census, nearly eleven thousand women self-identified as artists, a stunning increase from the four hundred women counted in the same category just twenty years earlier.[37] The most important explanatory factor for the large number of women artists in the late nineteenth century was women's ability to draw on the association of refinement, femininity, and culture to justify their pursuit of art. This opened a

rationale for public lives that stressed women's roles as guardians of culture and exemplars of taste and refinement.[38] By 1897, artist Candace Wheeler enthusiastically noted that "Girls are being educated for much arduous and responsible work in life and for many varieties of it; but most of all perhaps, they are studying art. There are to-day thousands upon thousands of girl art students and women artists, where only a few years ago there was scarcely one."[39]

Although women's traditional domestic association with art and culture provided them with ready access to fine art academies and schools of design, this same association worked against their critical and financial success.[40] Bracketed as "women artists," they were often steered toward genres supposedly suitable to feminine sensibilities but typically having less prestige. Critics called for greater individuality and virility in art, rejecting refinement as too "feminine."[41]

WOMEN IN THE DECORATIVE ARTS

The hierarchy of artistic subjects, forms, and media that was applied to women's art production in the late nineteenth century stretched back several centuries. The French Academy had determined the preeminence of history painting over landscape, genre, portraiture, and still life. By the late nineteenth and early twentieth centuries in the United States, male artists typically undertook historical subjects—figures and landscapes—rather than portraits or flower painting.[42] It became an axiom of American art that men created fine art and most women artists either worked in lesser genres or worked in the decorative arts.[43] Men painted on canvas; women painted portrait miniatures and flowers or decorated wooden screens, paper fans, and ceramic vases.[44] Contemporary observers argued that women were particularly well suited to the "lower" levels and subjects of art and that decorative arts were "peculiarly adapted to the female mind and hand." Women were specifically advised against ambitious painting: "let women occupy themselves with those types of art they have always preferred, such as pastels . . . or the painting of

flowers."[45] It was taken for granted that "lady artists" who excelled at flower painting were perfectly suited for the decoration of china.[46] This opinion was expressed clearly in an 1872 article entitled, "Art-Work for Women": "But there is perhaps no branch of Art-work more perfectly womanly and in every way desirable than painting on china. The character of the designs brings them within the reach of even moderate powers and it must be admitted that painting flowers and birds and pretty landscapes, or children's heads, is work in itself more suitable for women than men."[47] E. A. Randall, writing in 1900, noted condescendingly, "China painting and decorative art in general are the specialty of woman, who excels in the minor, personal artistic impulses, and in this way gives vent to her restricted life."[48]

Thus, the discourse of domesticity that provided a springboard for women's entry into art academies and schools of design was also used to relegate women's art to second-class status. However, in 1877 Candace Wheeler used these discriminatory distinctions between the "types" of art and of artists as a basis to stimulate opportunities for female art exhibition and gainful employment. Wheeler, founder of the New York Society of Decorative Arts (hereafter NYSDA), which constituted the first major artistic crusade created, managed, and promoted by women in the United States, was careful to point out that decorative arts were minor rather than major arts, suggesting her reluctance to enter into the more "elevated" bastions of male artistic endeavor. As Wheeler explained, "Where architecture leads, decorative art follows. Its first principle is subordination. To be itself it must acknowledge its dependence, and be not only content but proud to be secondary." She concluded that it "was easily within the compass of almost every woman," requiring "far less ability than painting pictures."[49] According to Wheeler, the applied or decorative arts were suitable occupations for women because they involved similar (often identical) skills to those women employed in their own homes. One writer found added suitability for women in the anonymity of the decorative arts, which allowed "women to remain in the shadow of retirement, overlooked, never publicly advertised, and never summoned to appear before the curious and heartless world."[50] Whereas

this point of view reflected and condoned enduring societal biases about women's inferior role in the arts, it nonetheless provided a safe, non-threatening way for men to endorse the women's art ambitions.

It was believed that talented, ambitious, or impoverished women could convert their skills into a profession and that these women would go into new businesses and would thus be given new occupations which would not cause them to compete with men.[51] Kathleen McCarthy points out that the decorative arts "steeped its appeal in the interests of women and the imperatives of the domestic sphere in an ingenious reiteration of women's traditional roles—with the added advantage of avoiding the supposedly unfeminine traits of personal ambition or the egotism of the fine arts."[52]

While many professionals (male and female) celebrated the household arts as a "natural" vocation for women, offering both psychological and economic remuneration, this endorsement broke down along class lines.[53] In an 1879 editorial in Lippincott's Monthly, Joshua Lippincott railed against women who chose to work by selling their decorative arts production to manufacturers. Claiming that such activities interfered with a woman's natural profession of housekeeping, the journal betrayed a class bias. The idea of artistically motivated middle- and upper-class women seeking "pin" money was found morally distasteful, because their handiwork competed with the production of less fortunate women for whom work was not a matter of choice but of necessity.[54] Another author criticized upper- and middle-class women "who live luxuriously and who are willing to sell their manufactures at any price thereby reducing the asking price of 'honest workers.'" It was deemed necessary to save "deserving poor women workers . . . from the rapacity of their heartless well-to-do-sister-women."[55]

Societies of Decorative Arts and Women's Exchanges

Founded in 1877, Wheeler's NYSDA sought "to encourage profitable industries among women who possess artistic talent, and to furnish a

standard of excellence and a market for their work." It catered to both deserving poor women workers as well as the above-mentioned "well-to-do-sister-women." In order to raise women's arts from the level of amateurism to new professional standards of quality and design, the NYSDA hired teachers, distributed information on foreign art industries, and maintained exhibition halls and salesrooms. With its cross-class emphasis, this organization attempted to meld artistic results and philanthropy. There was a committee of design which included Louis Comfort Tiffany; the painter Samuel Colman; the architect Richard Morris Hunt; Lockwood de Forest, a noted authority on South Asian crafts; and John La Farge.[56] These men were responsible for the approval of all work submitted for exhibition and sale and actually supplied many of the designs executed by society members. Charter members of the NYSDA included society leaders as well as artists, artisans, collectors, and connoisseurs. Within three years of its founding, the New York chapter listed five hundred subscribers, and by the end of 1877 auxiliaries were operating in Chicago, St. Louis, Hartford, Detroit, Charleston, and Green Bay. By 1880 over thirty chapters were in operation throughout the United States and Canada.[57] Ultimately the mixed motives of the organization —philanthropy and art—caused problems because the neediest women did not always submit works considered to be aesthetically acceptable by the committee. Wheeler later wrote about these difficulties, explaining, "Philanthropy and art are not natural sisters, and in the minds of the majority of the members of our board the art motive predominated; indeed, our constitution clearly committed us to art. So we wrangled and continued to wrangle over this point of art versus utility."[58]

These inherent difficulties eventually led Wheeler to organize a separate Women's Exchange which was primarily a charitable organization intended to help needy women sell their home-produced wares with little or no concern for aesthetic standards.[59] Women's exchanges, which began to appear in the late 1870s, were designed to broker the sale of "any marketable object which a woman can make."[60] By 1892, there were nearly one hundred chapters nationwide, some of which were highly profitable. According to estimates published in 1894, the New

York Exchange for Women's Work distributed revenues of $51,000 to its clients; the Boston chapter, $35,000; Cincinnati, $27,000; and San Francisco, $23,000.[61]

Aside from ventures like the NYSDA and the women's exchanges, there were almost no viable employment alternatives for middle-class women who had been widowed or deprived of suitable means of making a living. Nursing schools were just beginning to be founded in the 1870s, and social settlements would not appear for another decade. Traditional needle trades had become increasingly sporadic, offering only minimal, irregular gains.[62] For some women who were thrown on their own resources, prostitution offered a solution, albeit a brutal one.[63] Because the Civil War and western migration had markedly thinned the ranks of available men, young widows could not count on remarrying to support themselves or their children. Candace Wheeler noted that the type of employment undertaken by middle-class women was critical to avoiding "losing caste" and presumably damaging hopes for a suitable marriage.[64] It was thought that schools of design could "furnish [middle-class] women with a means of supporting themselves suited to their taste, requiring no exertion of bodily strength unsuitable to their sex, capable of being exercised at their own homes and calling for no sacrifice of their delicacy."[65] Underlying these assumptions was a desire to protect middle-class women from direct association with their working-class peers. The young women who labored in factories and department stores often enjoyed far more personal autonomy than middle-class behavioral codes normally would allow. Working girls had their own money; they went where they pleased. Working in unregulated settings beyond the control of their families, they were free to act on their whims. As a result, middle-class women who ventured into these settings risked a loss of status via both the nature of the work and the working-class camaraderie it implied. By shielding the "ladies" from the need to work outside their own homes, the decorative arts movement sought to protect them from the taint of moral contagion that many believed such work implied. The discursive category of the "distressed gentlewoman"

managed the contradictions between a strengthening of domestic ideology and coincident economic pressures for middle-class women to earn money. "Needy ladies" worked not out of choice but out of necessity.[66]

Rather than join in the rites and rituals of men, women were encouraged to claim an artistic sphere of their own, rooted in domestic imperatives and the "minor" arts. The decorative arts movement catered to female constituencies and need by linking household decoration to the creation of new career opportunities, producing a cultural agenda scaled to the contours of the home. To quote Candace Wheeler, "it opened the door to honest effort among women . . . and if it was narrow, it was still a door."[67]

Amateurism versus Professionalism

In the late nineteenth and early twentieth centuries, bourgeois masculinity was hegemonically defined in relation to paid professional work, whereas bourgeois femininity was organized in the family around marriage, domesticity, motherhood, and child care. The "masculine" professional took his meaning by inflection with its opposite, the amateur, who stayed comfortably at home within the realm of "lady amateur," dabbling at art study and more often at decorative art production. In the Gilded Age, "amateur" lost all vestiges of its association with upper-class refinement and virtuous gentlemanly achievement. Instead, as one writer suggested, "amateur collided with professional."[68] During this period another author noted, "It is not easy, again, for women to escape the influence of the common notions of 'amateur,' as contrasted with 'professional' work, by which, in a strange confusion of meaning, we have come to understand that to do a thing 'for love of it' is really equivalent to doing it imperfectly."[69] Because the work of amateurs was almost always understood to be the work of women, "amateur accomplishment" came to be associated with the tradition of female parlor training, and amateurism came to be a cultural conceit that distinguished a popular and

frequently feminine art from "serious" elite and often masculine art.[70] Lewis Day wrote in 1881, "Assuming that lady amateurs do not, as a class, think of materially altering their mode of life, but simply desire to occupy their leisure pleasurably in the pursuit of art, it would be better for them . . . that they should realize at the outset that . . . it is improbable that their paintings will have any great value as art. The conditions of their life are against it."[71] In the late nineteenth and early twentieth centuries, "amateur" had the connotation of feminine, the opposite of professional. The caricature of the lady amateur not only created severe problems for professional women artists, it was also problematic for professional craftswomen trying to establish the sincerity of their involvement.

Amateurism was also threatening from an economic perspective. Charles Ashbee, writing in 1908, acknowledged that amateurs were not exclusively female yet at the same time he criticized the lady amateur: "Our fellows are rightly nervous of this competition of the amateur, especially the lady amateur. . . . She is perpetually tingling to sell her work . . . and her name is legion and because, being supported by her parents she is prepared to sell her labour for 2d. an hour, where the skilled workman has to sell his for 1s. in order to keep up standard and support family."[72] Similar sentiments were expressed by a critic of "well-to-do society ladies who are using their knowledge of the arts, especially that of china painting to increase their allowance of pin money, so that they may indulge themselves or rather their passion for more elaborate apparel." The author did not take issue with women's painting for their "own satisfaction" or "for sweet charity's sake," but considered it selfish for women of wealth and fashion to try to sell their work and possibly drive down the prices for commercial wares produced by male professionals.[73] Thus, the constellation of attributes associated with amateurism were: female, dilettante, upper-class, self-taught, and noncommercial. Features ascribed to professionalism were: male, serious or intellectual, middle-class, educated, and commercial.

One way for women to bridge the gap between womanliness and pro-
fessionalism was to undertake typical amateur activities for pay that could
be accomplished at home. China painting and needlework were ideal
professions for middle-class women not only because they had aristo-
cratic associations but because they were performed at home. "Ladies"
were shielded from the working class.[74] Figure 2.1, taken from an article
on "Working Women in New York," shows a nicely dressed china painter
plying her trade in a clean, comfortable domestic environment. There is
even evidence of her handiwork decorating the wall behind her. China
painting and needlework were especially valued because they contributed
to creating a soothing environment distinctly separate from the materi-
alistic world in which husbands and fathers worked.[75] Estimates of the
total number of china painters in the United States during the 1890s
range from forty-five hundred to twenty-five thousand.[76] Interestingly,
china painting was often equated with an affliction: American women
had supposedly succumbed to the "china craze" or to "china mania."
With these pejoratives the amateur status of the work was neatly rein-
forced. Figure 2.2 also makes fun of the products of the lady china
painter, suggesting a sartorial use for the handpainted china plates which
already clot the interior of this home.

Most decoration of china was floral and was done by the overglaze
process, which involved applying mineral colors to the surface of a pre-
viously fired hard-china blank and then refiring it to a temperature that
caused the enamel to fuse with the blank, making the painted design a
permanent decoration. Painters could purchase white blanks, colors, and
other supplies from a large number of vendors (fig. 2.3). They could
take or send their work by mail to be fired at a commercial kiln or could
purchase a portable kiln for home use. Many larger cities featured china
painting classes either with individual teachers or at schools of design.[77]
The china painting class shown in figure 2.4 illustrates the variety of
equipment used: arm rest, banding wheel, brushes, blanks, glass palettes,

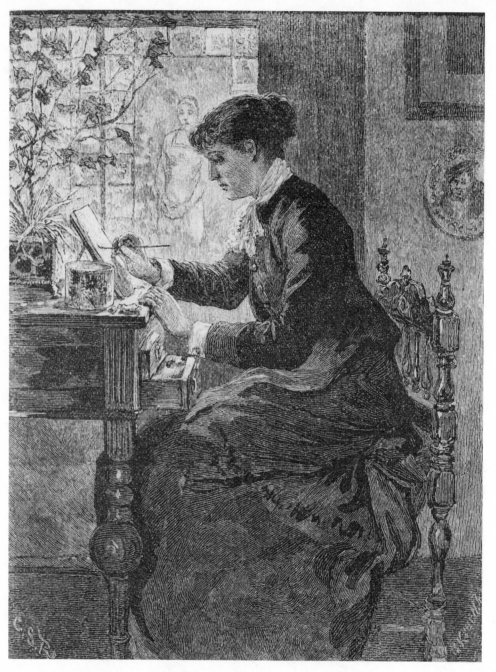

FIGURE 2.1. "Painting Tiles," 1880. From William H. Rideing, "Working Women in New York," *Harper's New Monthly Magazine* 61, 361 (June 1880): 33.

Courtesy, The Winterthur Library: Printed Book and Periodical Collection.

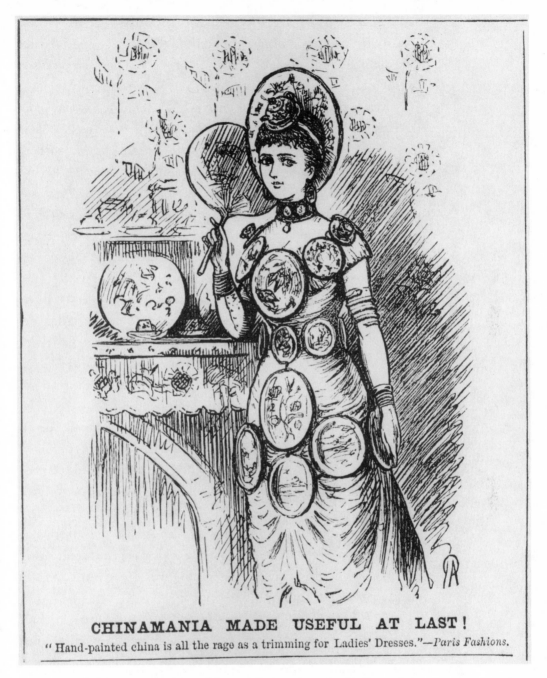

CHINAMANIA MADE USEFUL AT LAST!

" Hand-painted china is all the rage as a trimming for Ladies' Dresses."—*Paris Fashions.*

FIGURE 2.2. "Chinamania Made Useful at Last!" 1879. From *Punch's Almanac* for 1880 (December 12, 1879): 11. *Courtesy, The Winterthur Library: Printed Book and Periodical Collection.*

and tube and powder colors. In addition to such classes, there were also at least fifty instruction manuals published between 1870 and 1920 that disseminated information on china-painting techniques and processes to enthusiasts. One of the most popular was Mary Louise McLaughlin's *China Painting*, first published in 1877, which sold more than twenty thousand copies. Another popular manual was *Tried by Fire*, written by Susan Stuart Frackelton, which includes pithy and direct comments such as: "Never buy a cheap brush," "Always accomplish as much with one stroke as possible," and "It is generally best to give two fires." These two manuals are instructive because they point out the debate among china painters about the appropriate style and arrangement of china decoration. Some china painters (e.g., Frackelton) favored the naturalistic rendering of subjects in order to create an illusion of reality (fig. 2.5); others (e.g., McLaughlin) believed that naturalistic subjects should be conventionalized, that is, abstracted as ornament (fig. 2.6).[78] These debates and others were also taken up by special interest periodicals such as the *China Decorator* (1887–1901), *Keramic Studio* (1899–1924), and *Ceramic Monthly* (1895–1900). In addition, these journals provided instructions, color studies for copying at home, and hints on firing.[79]

China painting was not entirely segregated from the broader developing interest in art during the period. Magazines like *Art Amateur, International Studio, Brush and Pencil, Magazine of Art*, and *Arts & Decoration* also carried news and sometimes reviewed exhibitions held by china painting organizations or other arts and crafts exhibitions that included china painting.[80] Thus home decoration and art endeavors such as china painting, while practiced in the private sphere, gave women some personal control over their homes and played a role in liberating women's creative spirit in the late nineteenth century.

This is not to say that the creative efforts of many women china painters were always taken seriously. Although both men and women painted china, it was usually the men who were the European-trained leaders of the movement and the women who were most often labeled "amateurs."[81] Indeed, McLaughlin's exceedingly popular manual was subtitled: *A Practical Manual for the Use of Amateurs in the Decoration of Hard Porcelain*. McLaughlin alludes to the fact that the book was written for women

FIGURE 2.3. Advertisement for Thayer and Chandler, Chicago. From *Keramic Studio* 6, 12 (April 1905): 6. Courtesy, The Winterthur Library: Printed Book and Periodical Collection.

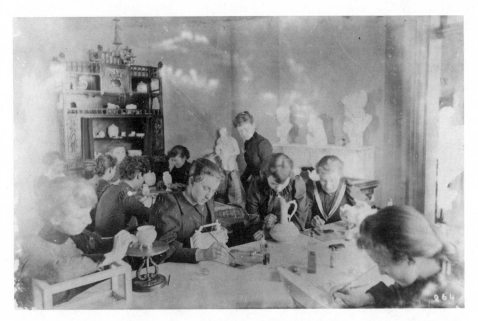

FIGURE 2.4. China painting class, unidentified technical school, c. 1900. From *Jean King Glass Negative Collection*, Archives Center, National Museum of American History, Smithsonian Institution.

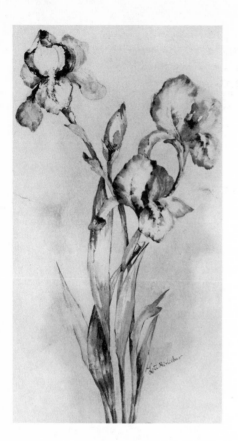

FIGURE 2.5. Naturalistic fleur-de-lis. From *Keramic Studio* 2, 7 (November 1900): 141. *Courtesy, The Winterthur Library: Printed Book and Periodical Collection.*

FIGURE 2.6. Conventionalized fleur-de-lis. From *Keramic Studio* 2, 7 (November 1900): 140. *Courtesy, The Winterthur Library: Printed Book and Periodical Collection.*

in its preface: "Having been repeatedly urged to give the results of my experience in china painting to my fellow art-students, I take this method of doing so." McLaughlin's "fellow art-students" were, of course, women who were becoming increasingly attracted to china painting.[82] To be sure, there were many women for whom china painting was little more than a way to fill the leisure time made possible by household servants.[83] However, there were other women who sought and achieved financial success and recognition, but all were consumers buying materials and taking lessons. Regardless of their purpose, the great majority of women who participated in this popular art rarely if ever received the labels of "artist" or "professional." Although a few women china painters, such as Mary Louise McLaughlin, Susan Stuart Frackelton, and Adelaide Alsop Robineau, achieved national and international professional recognition, the efforts of the majority of the women participants were trivialized as amateurish.[84] Frackelton attempted to remedy this situation by establishing the National League of Mineral Painters in 1892. This organization, founded "for the purpose of bringing into closer relations the mineral artists of this country and aiding in the development of a national school of ceramic art," held annual exhibitions and numbered about five hundred members.[85] The distinction between amateur and professional china painters in this era was blurred by imprecision. Labels changed as contexts changed. However on those rare occasions when women were considered to be professionals they usually had some fine art training, painted from designs of their own making, and worked for pay.[86]

Although one china painting manual, written by a man, claimed to "know scores of ladies with a little talent for painting who . . . have secured to themselves a material increase of their comforts by painting pottery for sale amongst their friends," it seems doubtful that most independent china painters earned a living wage.[87] Despite the poor income prospects, many self-supporting women continued to labor as independent china painters because it was considered to be a genteel profession which did not disrupt class status and marriage possibilities.[88]

Thus, during the American china painting craze, the doctrine of separate spheres and the discourse on domesticity, by assigning women

the role of guardians of the arts, cleared a path for women's artistic endeavors (such as china painting) which could be practiced in and make objects for the home. Moreover, although women's art production in and for the home was often relegated to second-class status, this very inferiority provided a non-threatening "window of opportunity" for proponents of women's art education and led to professionalization and employment opportunities for china painters as well as other types of decorative arts producers.

The woman who founded Rookwood Pottery, Maria Longworth Nichols, and the women who labored there were imbricated in these various issues surrounding women's labor and domesticity: the separation of spheres, women as moral guardians of the arts, women's art education, women in the decorative arts, and amateurism versus professionalism. Maria Nichols, an upper-class amateur china painter, founded the pottery primarily for her own satisfaction but succeeded in providing consistent, respectable employment for a large number of professional women artists. However, in order to fully grasp what was at stake in the founding and promulgation of Rookwood Pottery, it is necessary to examine the cultural climate in the city of Cincinnati in the late nineteenth century and to discuss Rookwood's amateur antecedents.

Art and Culture in Nineteenth-Century Cincinnati

Cincinnati, founded in 1788, was a mature and prosperous city by the mid-nineteenth century. A boom town in the years before the Civil War, the city's population grew from 750 persons in 1800 to 26,515 in 1830 and to 161,044 in 1860.[89] The city's position on the Ohio River, the major transportation link between the East Coast and the opening West, brought trade and an impetus to manufacturing. Beginning in 1870, Cincinnati annually staged the largest Industrial Expositions held in the United States prior to the Centennial Exhibition of 1876, held in Philadelphia.[90] With the wealth of industry came cultural refinement. Known variously as the "Queen City," and the "Athens of the West," Cincinnati developed

into a major regional art center by 1865.[91] A number of artists lived and worked there. Patrons promoted the artists by direct support and by purchasing their paintings. Several organizations were formed to provide training and criticism.

One such organization, the Ladies' Academy of the Fine Arts (LAFA) was founded in 1854 by Sarah Worthington King Peter, who had earlier founded the Philadelphia School of Design. The purpose of the Ladies' Academy was "To aid in the cultivation of public taste—to afford encouragement to artists, and to furnish a source of intellectual recreation and enjoyment to the people by the establishment of Galleries of copies executed in the best manner from master pieces of paintings and sculpture."[92] In the first sixty days of its existence, the LAFA managed to sponsor four events, including a loan exhibition, a Shakespeare reading, a gala party, and a lecture. The standard price of admission to LAFA events was fifty cents, which probably excluded all but the "best sort."[93] Within three months, the LAFA had raised enough money to send Mrs. Peter to Europe to secure the aforementioned copies. Although she eventually had to advance the majority of the funds herself (a money panic hit Cincinnati during her absence and the association's funds evaporated), she did succeed in obtaining copies of Raphael's *School of Athens* and numerous casts of classical sculpture. These works were exhibited in the LAFA gallery until 1864, when the Association disbanded. The collection then passed to McMicken University and sparked the McMicken School of Design, which eventually became the Cincinnati Art Academy. At least one person later gave the LAFA considerable credit on a larger scale, noting that its members, "appear to have been the first body of women in America to appreciate the art-needs of the country, and to set about supplying those of their own city."[94]

McMicken University, chartered in 1859, had been funded by a bequest from Charles McMicken's extensive land holdings and railroad investments to the city of Cincinnati for the establishment of a college where students could obtain a practical English education and sound moral instruction. The McMicken School of Design opened its doors in 1868 as the first functioning department of a reorganized University of

Cincinnati. The new school admitted students of both sexes, charged no tuition to city residents, and forbade loud talking and the use of tobacco. From the beginning, the curriculum was similar, but not identical to, the traditional European academies. First-year students worked on shading and perspective, spending long hours copying from engraved prints of acknowledged masterpieces. Second-year students drew from casts with a focus on composition and design. Third-year students were allowed to draw from nature and work with color, sometimes drawing from models dressed in costumes.[95] Classes were offered during the day and in the evening. Day classes attracted genteel women searching for respectable careers. Evening classes were attended primarily by working-class men.[96]

In 1873, in addition to drawing, the school offered applied art classes in sculpture, wood carving, and engraving. At the center of this application of design to local manufacturing was wood-carver Benn Pitman, who had come to the United States from England in 1853. Because furniture manufacture was a major industry in Cincinnati, wood carving was readily accepted into the curriculum at the School of Design. The writing desk shown in figure 2.7, carved by Catherine Peachy, is a splendid demonstration of American romantic naturalism. The desk also embodies Pitman's ambivalent attitude toward women's work. While training, guiding, and cooperatively working with them in the decorative arts, he was also to some degree supervising the segregation of specific tasks by gender. A work like this desk was usually made by a male joiner from Pitman's designs, then "deconstructed" into its separate parts for decoration by the women artists, before being reassembled by the male joiner. Pitman instituted a virtual one-man revival of handicrafts in Cincinnati always stressing the fundamentals of good design.[97] A local influence in Pitman's wood carving came from the similar work of Henry and William Fry, father and son, who had come to Cincinnati at midcentury where they decorated the homes of several prominent citizens including John Shillito and Henry Probasco. Subsequently, they received two commissions from Joseph Longworth: first to decorate Rookwood, his Cincinnati estate; and second to design the interior of a

home built for his daughter Maria on the occasion of her marriage to George Ward Nichols in 1868. The Frys, also English, along with Pitman played particularly influential roles in teaching artistic wood carving to a generation of Cincinnati women, many of whom came from the most refined families in the city.[98] The school's exclusiveness brought criticism from one of the university trustees. He found that "instead of helping people who needed art education to make a living, it was run for the accommodation of ladies, mostly the wives and daughters of our wealthy citizens, who go into rhapsodies over the 'Antique.' "[99] The Frys and Pitman agreed that decoration, especially in the home, not only fit the proper domestic sphere of women, but that women "possessed more refined sentiment" and worked "for less sordid ends," than men. "Let men construct and women decorate," suggested Pitman in his influential A Plea for American Decorative Art.[100]

Pitman was also a major force in introducing the art of china painting to Cincinnati. Reportedly, he obtained a set of colors for china painting in 1874 during a trip to Philadelphia. He subsequently invited a number of students from his wood carving class to try some experiments in mineral painting. The class met in his business office at the Phonographic Institute, which was in the Carlisle Building, diagonally across from the School of Design. Because china painting was not yet included in the school's curriculum, such classes could not be offered there. Pitman hired Marie Eggers, a young German woman, to give instruction to this small class of interested women that included Mary Louise McLaughlin, Clara Chipman Newton, and Jane Porter Dodd, among others.[101] Independent of Pitman's efforts, a year earlier Maria Longworth Nichols had discovered china painting when a neighbor, Karl Langenbeck, received a set of mineral colors from an uncle in Germany.[102] Whatever the genesis of the movement, at least one local observer noted that "the decorated china fever broke out in this city in almost epidemic form."[103]

The interest of these socially prominent and artistically inclined women in china decorating came to the attention of the local organization established "to secure a creditable representation of women's work

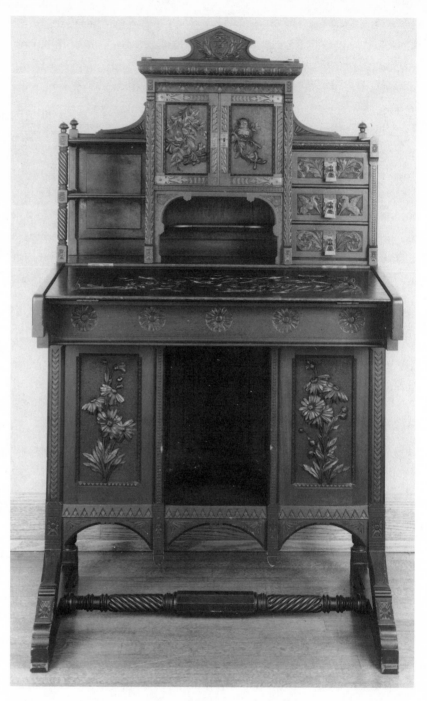

FIGURE 2.7. Catherine Peachy, *Writing Desk*, c. 1870s, black cherry and mahogany. *Cincinnati Art Museum, gift of Miss Irene Edwards* (1979.4).

at the approaching 'Centennial,'" the Women's Centennial Committee. The committee, which included virtually every woman of prominence in Cincinnati, sponsored several events designed to arouse public interest and, more importantly, to raise funds for participation in the national celebration.[104] The most lavish, the "Martha Washington Tea Party," featured dancing as well as food and beverages served in china decorated with flags and facsimile signatures of George and Martha Washington.[105]

As a result of this fund raising, the Women's Centennial Committee had $7,000 in its treasury when it recessed for the summer. Eventually $5,000 of this was donated to help raise the $30,000 needed to construct the Women's Pavilion in Philadelphia. As a consequence of this generosity, the northwest corner of the Women's Pavilion was reserved for an exhibit from the Cincinnati School of Design, under the sponsorship of the Women's Centennial Committee. The school's clientele in 1876 was largely of the same class as the women who sponsored the centennial activities, and some of the students were also members of the centennial committee. Benn Pitman, who cooperated closely with the Women's Centennial Committee, accompanied the exhibit of carved furniture, painted china, and other art work to Philadelphia and set up the display. The installation, which included wares by Maria Longworth Nichols, was "unquestionably the most extensive and satisfactory exhibit of amateur overglaze decoration made up to that time in the United States."[106] Indeed, the event marked a significant step in the development of ceramic art in Cincinnati and "can well be designated as an event in the history of pottery in the West. . . . It was a remarkable exhibit, prepared by a few society ladies, and attracted universal comment, so much so that it was deemed worthy of a prominent place in the Centennial."[107] The Cincinnati exhibition received a great deal of attention and praise, "as its features of wood carving and china painting were novel and in advance of women's work shown by other cities."[108] This exhibition was particularly important for these Cincinnati women in that their work, seen outside the city for the first time, was subjected to professional scrutiny and criticism.[109]

An even greater impact than national recognition came from the

displays of other nations at the centennial. Several Cincinnati crafts-women visited the exhibition, and both Mary Louise McLaughlin and Maria Nichols returned inspired by the work of foreign artists. McLaughlin was impressed by the distinctive underglaze faience pottery produced by Haviland and Company of Limoges, France, and began to direct her own efforts in this direction.[110] Their technique, known as *procès barbotine*, involved painting under a clear glaze with a liquid mixture of clay and oxides. As will be discussed in chapter 5, Nichols's attention was claimed by the Japanese display of pottery and lacquer ware. Both she and her husband came to believe that Japanese design promised "to exert a wide and positive influence upon American art industries."[111]

In the year following the centennial McLaughlin published her first book on ceramic decoration, *China Painting: A Practical Manual for the Use of Amateurs in the Decoration of Hard Porcelain*. She also began working at the Coultry Pottery to try to duplicate the Limoges *procès barbotine* of underglaze decoration. It is important to realize the differences between china painting and art pottery making. Critically, china painting most often was accomplished at home, whereas art pottery production was of necessity carried out in the public sphere. China painting involved painting designs with mineral colors on glazed blanks, which could then be fired in a small, low-temperature kiln. Making art pottery involved many steps: mixing clay, shaping the ware, painting the design, first firing, glazing, and second firing. In order to make art pottery, one had to have access to facilities, equipment, and a staff of workers. McLaughlin succeeded in producing "Limoges" style decoration the next year, but her technique differed from that of the French in using natural slip on a damp, unfired ground rather than slip prepared from fired clay on a thoroughly dried ground.[112] Figure 2.8 shows McLaughlin's *Ali Baba* vase: a virtuoso example of her mastery of the new technique, the vase is over three feet tall. Once she accomplished this goal, McLaughlin then joined her socially prominent friends to organize the Pottery Club.[113] The minutes of the first meeting record that "The purpose of the Club shall be the development of the art interests of Cincinnati in the direction of underglaze work in pottery, carving in clay, and in such other directions as

may suggest themselves as practicable."[114] It is likely that Maria Nichols was also asked to join, but her invitation was somehow mislaid. Nichols interpreted the undelivered invitation as a slight and decided to work independently, renting space from Frederick Dallas, owner of the Hamilton Road Pottery.

While McLaughlin and Nichols traveled their separate paths, the city had awakened to the fact that it was in the midst of "a wild ceramic orgy."[115] The Women's Centennial Committee reorganized to become the Women's Art Museum Association of Cincinnati (WAMA). In concert with their male advisors, they decided that Cincinnati should have both a museum and an art school modeled on the South Kensington Museum in London. As had been the case for the Ladies Academy of Fine Art, WAMA was interested in the decorative arts at least as much as

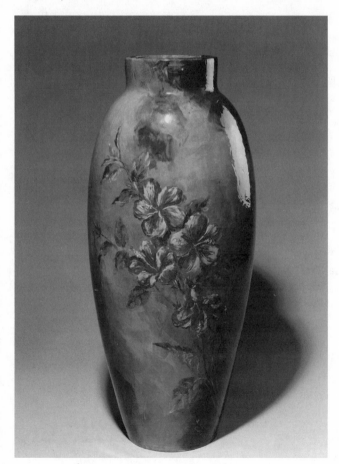

FIGURE 2.8. Mary Louise McLaughlin, *Ali Baba Vase,* 1880, earthenware. Cincinnati Art Museum, gift of the Women's Art Museum Association (1881.239).

they were in painting and sculpture. Copies rather than originals were still considered to be the main goal of the collection. The newly formed WAMA organized several classes, including one on china painting. Contending that they had used "good judgment in providing new art classes," Benn Pitman urged WAMA to take over the operation of the School of Design.[116] They also initiated a Decorative Art Society, similar to the one in New York and for the same purpose.[117] Separately, John Rettig, a local artist and scene painter, and Albert Valentine opened a class in the Limoges style of pottery decoration, which numbered about "fifty ladies" by the summer of 1880. After three months of instruction it was noted that "A number of the pupils have been learning with the hope of adding to their income by their products. Others have entered the class for amusement."[118] Mary Gay Humphreys commented that "A whirlwind of petticoats had invaded the potteries. . . . Every woman who could find a corner in a pottery installed herself there."[119] Frederick Dallas alone was firing the work of more than two hundred amateurs, all but two of whom were women.[120]

Among these hundreds of amateur pottery decorators there may well have been some women who engaged in the activity in order to add to their income. However, most of the national attention which focused on Cincinnati faience concerned the "idle rich" who were neglecting their social duties (but avoiding hysteria, as mentioned in the opening quotation from Harper's Weekly Magazine).[121] Given that women were urged to eschew intellectual stimulation in order to avoid nervous ailments, it is striking that pottery decoration was viewed as a way to prevent hysteria. Presumably this judgment stemmed from the idea that pottery decoration was not serious enough to be dangerous. This is borne out by another author who asserted that the Art Pottery movement was "Begun by a few thoughtful women of taste and social influence," noting that there was much to be said in favor of pottery making and decorating as a "purely social and domestic entertainment" which was also "an educating and refining influence." This author goes on to point out, "It is an interesting commentary upon the occupations of our women that the dusty quarters of the manufacture of iron-stone and

Rockingham should be the point of attraction for so many of the refined, and cultivated women of the city." Nonetheless, praise is meted out for "the introduction of a new industry in the United States, in which the feeble instrumentality of women's hands are quietly doing the initial work."[122] In *Potter's American Monthly*, Alice Hall noted, "Still another lady who does not seem to consider that abundant wealth and family prestige imposes upon her a life of idleness or social vacuity, devotes herself to the construction of dragon vases to such an extent that her work may also be regarded as distinctive." The person referred to is almost certainly Maria Longworth Nichols.[123] Finally, Lilian Whiting observed that "The Cincinnati ceramic ware is almost exclusively the product of the leisure of ladies whom a love of art, and not necessity has inspired to exertion."[124] The attribution of amateur was most often deployed to suggest inferior work, but it could also be used to demonstrate social standing and financial independence.[125]

Contemporary commentators went to some length to emphasize not only the class and refinement of the participants in the pottery movement but also their amateur status and difference from the professional (male) potters and decorators. The male employees of the potteries are often referred to as "patient," "gallant," or as "having a soft place in their hearts" for the lady amateurs.[126] It was observed that "It must have been with grim humor and some condescension that the potters saw this eruption into the Dallas and Coulter [sic] establishments, the ringed fingers in the clay, and the fashionable toilettes mud-besmeared."[127] Tellingly, an article in *Crockery and Glass Journal*, a publication geared toward commercial ceramic and glass manufacturers, praised the work of the Cincinnati lady potters with the caveat, "Of course these pieces are done by our amateurs and not by the professional decorators. For the regular trade Mr. Dallas has employed a gentleman well versed in his art, and is turning out a large quantity of decorated ware, and of a superiority that promises to make a good name for Cincinnati and a specially good name for the Hamilton Road Pottery in this particular line."[128]

Thus, in Cincinnati as elsewhere, there were decided gender- and class-based distinctions within the potteries. The commercial potteries

were the province of male professionals who were serious, busy, and often members of the lower or lower middle classes. Yet women were permitted in (for a fee) with the understanding that they were beholden to the men who made the pots and did everything but the decoration. Their upper-class status was preserved, even within the confines of a manufactory, because they were amateurs. Once again, women could be associated with culture, but not yet with commerce.

The Early Years at Rookwood

This constellation of attributes—upper-class lady, amateur, and artistic —was approvingly applied when Maria Longworth Nichols founded Rookwood in 1880. Nichols, shown in figure 2.9, was described as a "pleasant little lady with twinkling eyes." Yet in painting garb, posed in her studio, she presents the visage of a serious artist. Elizabeth Perry (herself an upper-class lady with artistic aspirations) wrote about Nichols that "These are pleasant times and places, when women give their leisure and means to the founding of an artistic industry."[129] Other articles about the founding do not mention Maria Nichols. *Crockery and Glass Journal* noted that "The new pottery which is shortly to be completed on Eastern Avenue . . . will be devoted to the work of our lady decorators. Mr. Joseph Longworth is the chief financial supporter of it."[130] The next week this same publication opined, "That a lady of Mrs. Nichols' wealth, culture and social standing should wish to embark in so singular a business venture is remarkable." The author continues, "She has associated Mr. Cranch, Esq." who "will aid her in making designs and will also conduct the business transactions of the firm."[131] These comments suggest that Nichols's movement into the public sphere was acceptable because she did so as an amateur with the financial backing and management skills of men.

There are several possible explanations as to why Nichols founded the pottery when she did—among them the long distance she had to travel from her home to the Dallas Pottery and her estrangement from

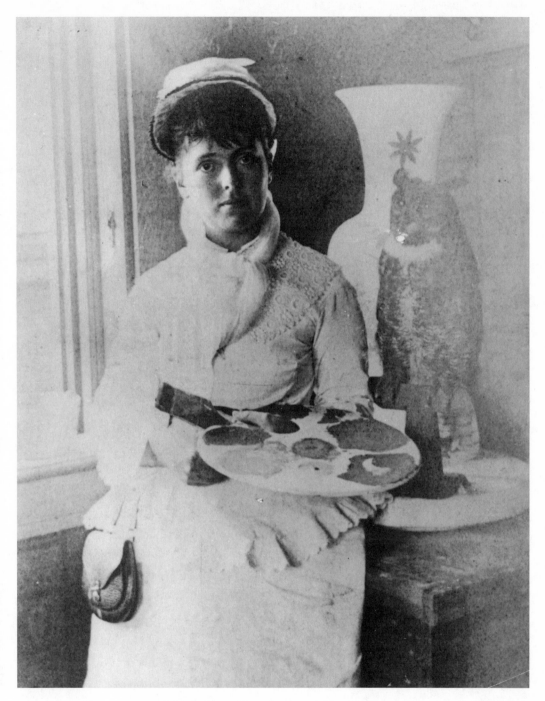

FIGURE 2.9. Maria Longworth Nichols, c. 1880, photograph. *Cincinnati Historical Society Library.*

her husband. Indeed, the founding of Rookwood, which propelled Nichols into the public sphere, was closely linked to her own domestic situation. Reportedly, her father agreed to finance her pottery endeavor in order to dissuade her from seeking a divorce.[132] Another motivating factor may have been her frustration with the hard fire of the commercial kilns at the Dallas Pottery.[133] She wrote that she "was continually discouraged by the fact that the hard fire of the granite ware kilns destroyed nearly every color I used except cobalt blue and black."[134] This explanation is cast into doubt though, because Nichols and Mary Louise McLaughlin had paid to build two lower fire kilns at the Dallas Pottery, one for underglaze, the other for overglaze work.[135] Nichols remained determined to have her own pottery, and her father agreed to give her an old schoolhouse, which she then outfitted as a pottery with the advice of Joseph Bailey, Sr., a friend and employee from the Dallas Pottery. The name of the pottery came from her father's estate, "Rookwood," and because the last syllable reminded her of "Wedgwood." The pottery was on the banks of the Ohio River, a location thought to be advantageous for delivery of clay by barge (but instead left the fledgling operation subject to devastating floods).[136]

Whereas Joseph Bailey provided advice and support, his employer, Frederick Dallas, went to some lengths to discourage Nichols's endeavor by pointing out the difficulties involved and suggesting that it would fail as a business.[137] Thomas Wheatley, a decorator who had worked at the Coultry Pottery, then threatened to enjoin Rookwood from using the underglaze slip painting technique. Wheatley had somehow obtained a patent in 1880 on the technique, which had been developed by Mary Louise McLaughlin in 1877.[138] Wheatley's work featured underglaze slip painting as well as modeled ware. When a reporter for the Daily Gazette asked Nichols if she feared Mr. Wheatley instituting proceedings against her she replied, "I don't care if he does, I shall go on building my pottery and I hope to have the first fire in the kiln in a month's time. While my principal object is my own gratification, I hope to make the pottery pay expenses."[139] The second clause of this statement suggests that whereas Nichols was aware of the need to separate women's art accom-

plishments from commerce, she was ambitious enough to want professional status.

Reportedly, Joseph Longworth was fond of saying that he financed the pottery "to give employment to 'the idle rich.'"[140] Although this humorous remark undoubtedly contained a grain of truth, several efforts made in the first few years of the pottery's existence were ostensibly intended to help make it pay expenses. In 1881, Nichols started a pottery school which was intended to provide training and experience for future artists. Clara Chipman Newton taught two classes a week in overglaze painting and Laura Fry gave instruction in underglaze work. The school charged $3.00 weekly tuition or $1.00 per hour for private instruction. Students came from as far away as Chicago, Pittsburgh, and Cleveland.[141] Given the tuition charged, it is likely that the students were largely upperclass. Nichols also began renting space to the Pottery Club, firing their wares and providing them with specimens to paint.[142] Nichols also instituted the production of commercial ware for table and household use such as breakfast and dinner services, pitchers, plaques, wine coolers, ice tubs, water buckets, and the like.

However, it was the art pottery, produced by Maria Nichols and other decorators, that received the approbation of the press. One highly acclaimed piece, shown in figure 2.10, was Nichols's *Aladdin Vase*, decorated with fish (instead of the floral decoration more commonly used then in Cincinnati) which in size (thirty inches tall) rivaled McLaughlin's *Ali Baba*. Remarking on the first year's production, *Crockery and Glass Journal* noted that "This pottery has finished its first year's work with results that bear the highest testimony to the genius and courage of a woman who is laudably seeking to impress upon a great industry—whose creations enter more largely into domestic life than any other—the principles of pure art."[143] The pottery also received awards at the Tenth and Eleventh Cincinnati Industrial Expositions.[144] This early success was in no small measure due to the training and experience of the decorators hired by Nichols. In 1881, she hired Albert Valentine (later Valentien) as the first full-time decorator. Valentien, who along with John Rettig taught underglaze decoration classes, had studied under Thomas Wheatley at

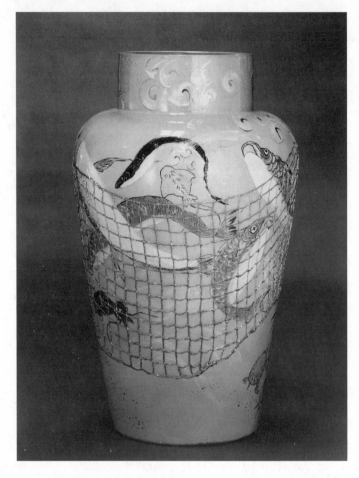

FIGURE 2.10. Maria Longworth Nichols, *Aladdin Vase*, 1880–84, earthenware. *The Metropolitan Museum of Art, gift of William and Marcia Goodman, 1981 (1981.443).*

the Coultry Pottery and was a graduate of the School of Design.[145] Valentien's work demonstrates the Japanese influence. His vase, shown in plate 1, was influenced by Hokusai's *Manga*, a multivolume set of random drawings. The banded relief decoration on this piece was created by scoring a nailhead and impressing it into the clay. The gilt, applied after the glaze firing, was probably meant to resemble Japanese brocade.

Unfortunately, the encomia earned by Rookwood at exhibitions didn't translate into financial success. Haphazard accounts make it difficult to determine the extent of the pottery's indebtedness, but it is clear that without Joseph Longworth's continued support, Rookwood would not have survived. The financial difficulties were compounded by Maria Nichols's poor management. She was careless with the Pottery's funds,

often confusing her personal and business accounts. As mentioned, in 1883, in an effort to put the Pottery on a more businesslike footing, Nichols hired William Watts Taylor to be manager. Although he had no experience in the pottery business he did possess a keen mind, sound administrative skills, and a flair for public relations.[146]

Taylor was determined to make Rookwood a thriving commercial concern. One way this could be done was to move the perception of its production into the male realm of fine art and out of the female realm of amateur production. As a first step, Taylor closed the pottery school, pointing out that people who could afford to pay $3.00 per week tuition would not be likely to go to work for the salaries currently paid by Rookwood. Fearing that an "amateur taint" (gendered feminine) would damage Rookwood's reputation, he banished nonemployees from the premises—taking away space from the Pottery Club and discontinuing the practice of selling ware to amateurs for decoration. This was remarked upon in *Crockery and Glass Journal* when it was announced that "The ladies [of the Pottery Club] have been informed that they can no longer make their ware at the Rookwood Pottery." The reasons given were quite pointed: "Their products have brought the fame of the place into disrepute." It further claimed that it hurt the trade that the managers of the pottery themselves might get, although this reason was not given publicly.[147] These statements are self-contradictory, suggesting on the one hand that the amateurs' work brought Rookwood's fame into disrepute and on the other hand that it was good enough to impinge on Rookwood's markets. At any rate there was confusion because these pieces decorated by the Pottery Club were stamped with the Rookwood symbol, making it difficult to distinguish ware made by amateurs from that made entirely by the Pottery. Taylor went so far as to tell an aspiring Rookwood decorator that work by amateurs was "generally embarrassing."[148] It is noteworthy that Edward Cranch, a lawyer with no art training, was neither fired nor referred to as an amateur; rather he was to "do anything he pleased."[149] His rather idiosyncratic etched designs, which often related to American folktales, were said to be "quaint" and to "possess uncommon merit" (fig. 2.11).[150] Many years later, Taylor wrote of this

FIGURE 2.11. Rookwood Pottery
Co., Edward Pope Cranch,
Temperance Jug, 1886, Dull Finish
glaze line. *Private Collection.*

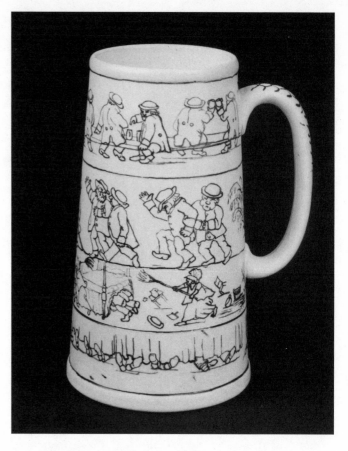

early period that "the difficulties of the art were too great to tempt the
amateur after the first outburst of enthusiasm."[151]

Nichols agreed with Taylor in her analysis of this sort of amateur
occupation: "The women decorators are generally working for some
specified purpose, to accumulate a certain sum of money for a given
purpose, or to acquire skill enough to open a class in decoration, but
very rarely with the intention of permanent employment or with the
expectation of making a reputation in their art."[152] A few days later she
added, "It was without doubt one of the objects of the Rookwood
Pottery to give needy women of the refined and educated classes the
opportunity to obtain profitable employment and the 'idle rich' a new
and pleasant accomplishment."[153]

This first generation of women decorators was not interested in full-

time employment, for this would have undermined Victorian sensibilities of what constituted a lady. What the women decorators, including Maria Nichols, wanted was a recognized outlet for their creative energy which, at the same time, would not damage their social positions. This required a more casual approach to work than a successful business could tolerate. As the next chapter details, after Taylor took over, Rookwood employed many female decorators, but these women came from a different social class, with far less restricted views on the role of women in art industries.[154] By the mid-eighties the last of the "lady amateurs" departed and, except for Maria Nichols and Edward Cranch, the individuals who had shaped Rookwood's early years were gone.

CHAPTER THREE

"AN IDEAL WORKSHOP"

Whatever of artistic satisfaction there lies in Rookwood is
due first to the individuality of its artists, to their freedom of
expression. Rookwood cannot be understood without an appre-
ciation of its radical difference from commercial industries. Its
whole history and development centers upon the one idea of
individualism.

William Watts Taylor

In the years since the Civil War, industrialization had propelled the
United States into the forefront of the world's major powers, lowered
the cost of goods through mass production, generated many thousands
of jobs, and made available a wide range of new consumer products. As
is well known, these advantages carried with them a number of disad-
vantages. The rise of giant corporations had been achieved through sav-
age competition, exploited labor, unethical business practices, polluted
factory sites, and the collapse of an economic order built on craft skills
and a traditional apprenticeship system that had forged bonds between
skilled and unskilled labor. In addition, there were outbursts of labor

violence, urban slums, and extreme poverty.[1] In the 1880s and 1890s, Americans sought strategies that would preserve the benefits of industrialization while alleviating some of its undesirable by-products. There were efforts to regulate the railroads, as well as national measures such as the Interstate Commerce Act and the Sherman Antitrust Act.

Although many Americans welcomed the possibilities of wealth and power inherent in the new industrial order and celebrated these accomplishments as progress in Machinery Halls at national and international expositions, others suspected shifts of authority from individuals and small social units to impersonal entities and felt that mechanization was beyond—indeed out of—control. These later naysayers, who personally suffered feelings of isolation and anxiety, viewed the factory system and the mechanization of labor as antithetical to the republican ideology— fierce individualism and practical inventiveness—that had once seemed to epitomize the United States. Their experience of self-crisis or fragmentation led them to question whether industrialization was "an unmixed good," and to warn that factories with their greater division of labor and greater employment of machinery were likely to degrade workers into mere feeders of machines, with cramped minds and enervated bodies.[2]

According to Jackson Lears, those in America opposed to or at least ambivalent about industrialization and the factory system were primarily educated middle-class persons such as journalists (e.g., Richard Watson Gilder, editor of *Century*, and E. L. Godkin, editor of *The Nation*), academics (e.g., Charles Eliot Norton, art history professor at Harvard, and Oscar Lovell Triggs, literature professor at the University of Chicago), as well as ministers and literati whose circumstances ranged from wealthy to moderately comfortable.[3] Such ambivalence was exemplified in the work of John Ruskin and William Morris, leaders of the Arts and Crafts movement, a reform effort begun in England with both aesthetic and social aims that had rapidly spread to the United States.[4] In 1884, Morris published a series of essays titled "A Factory as It Might Be," wherein he envisioned factories as learning and living centers which would reunite art and labor. According to Morris, these new factories would reaffirm

the craftsman's identity as an artist and an independent worker. Released from the confines of traditional factory production, the worker "would be able to impress individuality onto his work because he combined the talents of the designer with the practical knowledge of the trades," and "because it expressed his own personality, work would cease to be mechanical."[5]

The Rookwood Pottery company, in theory if not in practice, agreed with William Morris's goal of reuniting art and labor. Though operating on an industrial scale throughout the golden age of the Pottery (1883–1913), management emphatically refuted the factory nature of their production. William Watts Taylor, first manager and then president of Rookwood during this period, wrote about his labor policy in *The Forensic Quarterly* in 1910 (quoted above) in terms that emphasize individuality and freedom of expression, and absolutely deny any notion of regularized production and division of labor. He also disavowed commercial aspirations, suggesting that Rookwood did not value profit over worker satisfaction or product quality.[6] Taylor's denials won the support of several authors writing independently for contemporary publications, such as Oscar Lovell Triggs, who devoted an entire chapter to Rookwood in his 1902 book *Chapters in the History of the Arts and Crafts Movement.*[7]

Although management and contemporary observers agreed that Rookwood was not operated according to the prevailing factory system of regularized production and division of labor, when the circumstances of production are probed they do not always match the claims. In spite of the fact that the firm produced objects which closely conformed to the traditional Arts and Crafts aesthetic, they continued to produce and favor wares whose style Arts and Crafts advocates referred to as an "irritating iteration of glitter and shallow sparkle."[8] This chapter argues that these inconsistencies are enmeshed in the nexus of values comprising the American Arts and Crafts movement, philosophically opposed to the factory system but practically reliant upon commercial methods and markets.

Although the Arts and Crafts movement was well established in England in the 1880s, and in the United States a decade later, the philosophical roots of the movement lie in the early nineteenth century.[9] One early reformer, A. W. N. Pugin (1812–52) expressed his anxiety about mechanization in the 1830s, believing that it had contributed to the corruption of Victorian society. Pugin rejected the Victorian vogue for Classical architecture and saw in the simple functional design of Gothic structures evidence of a purer world. For him, the Gothic cathedrals evinced an order and stability, a sense of community and joy in labor missing from nineteenth-century life. Pugin's goal of reuniting art and labor, designer and craftsman, and the spiritual with the everyday provided the ideological foundations of the Arts and Crafts movement. His thoughts ignited a chain reaction: Peter Stansky, for example, cites the intellectual pedigree that runs from Pugin to Ruskin and then to William Morris.[10]

John Ruskin (1819–1900), the first professor of art history at Oxford University, shared Pugin's dislike of the classical world. For Ruskin, Gothic architecture was superior because its asymmetry, irregularity, and roughness permitted the craftsman freedom of expression. One of the only Arts and Crafts reformers to totally reject the use of machinery, Ruskin believed that factory work had disturbed the natural rhythms of life, turning once creative craftsman into mere cogs in the wheel of machinery. He felt that the industrial revolution had converted designers into anonymous laborers. Individuality and quality could only be restored by a return to handwork.[11]

Ruskin was fervent about both style and work process. Of particular interest for the Arts and Crafts movement was his dictum that ornament had to be derived from nature and could not violate the qualities inherent in the material from which it was made. Like his contemporary Karl Marx, Ruskin believed that division of labor within the workplace alienated the workers from their own nature and destroyed the pleasure to be had in honest labor. He sought to recast the work ethic along lines that distinguished "work" from "toil." Although he accepted

the conventional division of fine from decorative art, he elevated the stature of the decorative or "applied" arts because they combined mental and manual labor.

Although Ruskin was one of the most widely read English authors, William Morris's (1834–1896) ideas exerted the most durable influence. He had encountered Ruskin's ideas as an undergraduate at Oxford in 1853 and committed his life to reforming society through craftsmanship. His goal was to challenge manufacturers to simplify design not only in order to raise standards and keep unit costs at an affordable level, but also to draw together the designer and the craftsman. Unlike Ruskin, who for most of his life stood clear of politics and the work processes he advocated, Morris became not only an active socialist but a craftsman and well-respected designer. His own company, which went through several transformations, was a collaborative venture, housed after 1882 at Merton Abbey, a workshop about an hour by train outside London. Writing in 1899, Morris's biographer, J. W. Mackail, remembered it as an ideal factory set within a garden, "the low long buildings with the clear rushing little stream running between them, and the wooden outside staircases leading to their upper storey, have nothing about them to suggest the modern factory." Even the business manager recalled Merton Abbey as "altogether delightful."[12] In its working conditions and physical setting, Merton Abbey would serve as a model for other art manufacturers.

Arts and Crafts in the United States

The English Arts and Crafts movement, which emphasized both aesthetic and labor reform, came to the United States via magazine articles, exhibitions, and lecture tours by leading English proponents such as C. R. Ashbee, Christopher Dresser, Walter Crane, and May Morris. Some Americans, such as Charles Eliot Norton, established direct relationships with English members of the movement or visited England to see things firsthand.[13] Yet the tenets of the English movement did not translate

exactly in the United States, where the Arts and Crafts movement was more concerned with the appearance of objects than the conditions under which they were produced. Which is to say, some Americans were interested in labor reform, but the mainstream of the movement in the United States was more interested in deriving inspiration from English styles and had little interest in espousing English issues. American craftsmen and manufacturers cultivated the myths of the Arts and Crafts movement, but its realities provided some ironic contrasts with those myths. The success of the movement in the United States rested on compromises that adapted it to American capitalism. Using English philosophies and rhetoric, American proponents successfully promoted the decorative arts as fine art handmade by single craftsmen, despite the fact that most products were actually hybrids made by various hands and machines.[14]

Most American Arts and Crafts organizations, such as Arts and Crafts Societies, William Morris Societies, and the like, drew many more members from amateurs and dues-paying associates or patrons than they did from the alienated laborers in whose interest the groups were ostensibly founded. Also, the majority focused on reforming taste and aesthetics, a determination which encouraged a concentration on unique, precious, often purely decorative objects and inhibited plans to uplift industrial design. The primary model for these groups was the extremely well-organized Society of Arts and Crafts, Boston (SACB), founded in 1897. The SACB had an active salesroom and jury system which developed a market and standards for craftsmen, as well as publishing the journal *Handicraft*. The group, founded by representatives of the Museum of Fine Arts (including General Charles G. Loring, chairman of the trustees of the museum), architects, journalists, Harvard professors, and members of prominent families, selected Charles Eliot Norton to be their first president.[15] During the early years, the organization expressed some concern with labor conditions but for the most part they were very dismissive of such matters, choosing to emphasize reform of taste and aesthetic values.[16] As secretary Frederick Whiting explained, "Much as we deplore the conditions under which many

people must work with the modern system of exploiting labor, it must nevertheless be stated frankly that our fight with the machine and the factory system begins when they encroach upon the province of art."[17] H. Langford Warren, a Harvard architect who became the third president of the SACB in 1903, claimed, "The art and crafts movement has suffered very much from being associated, as it has come to be in the eyes of a great many, with socialism."[18] Warren never accepted industrial democracy or social equality as worthwhile goals. Although he condemned the modern world for destroying art through commercialism, subdivision of labor, and the machine, he refused to admit that the impact of these forces on the arts might be symptomatic of their influence on society as a whole. Rather, he contended that "commercialism has its place, the subdivision of labor has its place, the machine has its right and proper place"—which meant a place next to ordinary labor and well below that of art in the hierarchy of human work. Thus for SACB, good taste became an end in and for itself rather than the handmaiden of a higher spirituality or the guide to a more humane workplace.

In Chicago, there were several interrelated organizations—the Chicago Society of Art and Crafts (CSAC), the Industrial Art League, and the Morris Society—all of which, unlike the SACB, were seemingly interested in labor reform in addition to reforming taste. Most Chicago Arts and Crafts proponents did not focus their attention on the purely aesthetic merits of the craft object. They usually emphasized the object's relationship to the life of the individual creator or consumer (leaving open the possibility for a more humane workplace), to society at large, or to its assumed utilitarian purpose.[19] Although none of these groups quite fulfilled their promise, their ideas about "the association of art and labor" were well publicized thanks to the proselytizing efforts of Oscar Lovell Triggs. Triggs, a faculty member at the University of Chicago, was a Whitman scholar, Morris enthusiast, and one of the initiators of the Intercollegiate Socialist Society. In 1902 he wrote *Chapters in the History of the Arts and Crafts Movement*, which singled out Rookwood Pottery as an "Ideal Workshop," and also devoted segments to Carlyle, Ruskin,

Morris, Ashbee, and the "Development of Industrial Consciousness," calling for universal labor reform. In this text, Triggs proposed transforming the factory into a workshop that combined studio and school, forming an integral production unit capable of shaping men as well as goods. He argued that, with the craftsman as artist, educator, and workman, the new industrialism had the capacity to turn the handicraft revival into a progressive evolutionary force, using machinery when possible but not at the cost of human dignity.[20] Frank Lloyd Wright, another charter member of the CSAC, agreed with Triggs about the use of machinery. In 1901, he argued for the machine as the harbinger of a new democratic art, capable of bringing joy to its maker and fulfilling "the gospel of simplicity" enunciated by Morris.[21] Chicago's groups were exceptional in the American Arts and Crafts movement in their dual interest in labor and aesthetic reform.

As prominent as Arts and Crafts societies were, they addressed only a small segment of the public and were mostly comprised of thinkers and consumers, not producers. Gustav Stickley, however, presumed, through his *Craftsman* magazine (1901–16) and his United Crafts workshop (1899–1916), to speak both to and for the American people.[22] The initial issue of the magazine, dedicated to William Morris (fig. 3.1) affirmed his moral commitment: "The United Crafts endeavor to promote and extend the principles established by Morris, in both the artistic and the socialistic sense and in the interests of art, they seek to substitute the luxury of taste for the luxury of costliness; to teach that beauty does not imply elaboration or ornament; to employ only those forms and materials which make for simplicity, individuality and dignity of effort."[23] His furniture-making enterprise, initially located near Syracuse, New York, was modeled on Morris and Company. Stickley assembled wood workers, metal smiths, and leather workers to "produce . . . articles which shall justify their own creation . . . as a reciprocal joy for the artist and the layman."[24] Exemplifying this deference to Morris, the United Crafts (changed to Craftsman Workshops in 1904) was a profit-sharing company where employees received stock options and were given lectures, music, and other cultural benefits.[25]

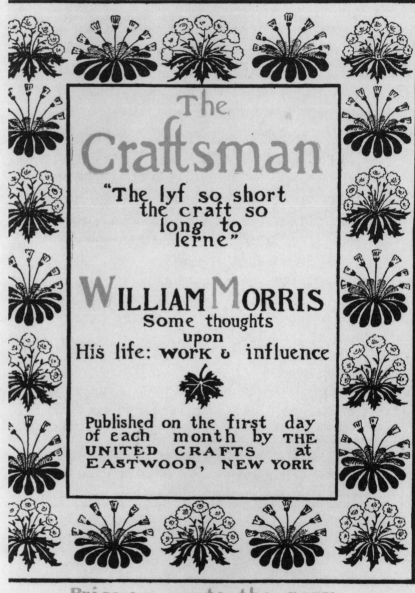

VOL. I October, MDCCCCI NO. 1

The
Craftsman

"The lyf so short
the craft so
long to
lerne"

WILLIAM MORRIS
Some thoughts
upon
His life: work & influence

Published on the first day
of each month by THE
UNITED CRAFTS at
EASTWOOD, NEW YORK

Price 20 cents the copy

FIGURE 3.1. *The Craftsman* 1, 1 (October 1901): front cover. *Courtesy, The Winterthur Library: Printed Book and Periodical Collection.*

Stickley, like Frank Lloyd Wright, acknowledged the valuable role of machinery. In a 1906 article, "The Use and Abuse of Machinery, and Its Relation to the Arts and Crafts," he noted, "Given the real need for production and the fundamental desire for honest self-expression, the machine can be put to all its legitimate uses as an aid to, and a preparation for, the work of the hand, and the result be quite as vital and satisfying as the best work of the hand alone." To Stickley the trouble lay "not with the use of machinery, but with the abuse of it, and the hope of reform would seem to be in the direction of a return to the spirit which animated the workers of a more primitive age, and not merely to an imitation of their method of working."[26]

Although design reform had been ongoing in the United States since the 1876 Centennial, during the Arts and Crafts movement (in the United States c. 1890s to World War I), a focus on form and structure replaced the emphasis on surface decoration. Hand craftsmanship (or the appearance thereof), quality construction, solid straightforward materials, design dedicated to function and environmental harmony, ornament derived from nature and subordinated to form and function now took precedence over machine-crafted, sumptuously decorated, exotic objects. The typically Arts and Crafts Stickley sideboard (fig. 3.2; design introduced in 1901) relies upon the bold framework, quarter-sawn grain pattern, batten-board galley, and iron hardware for decorative effect. This is in stark contrast to the earlier, 1871 Herter Brothers cabinet (fig. 3.3) which depends upon splendid materials (silk, velvet, rosewood), gilding, paint, and marquetry for its aesthetic. This new emphasis carried over into ceramics, glass, and metalwork as well as furniture. In contrast to the earlier goal of "art for art's sake," the aim of the Arts and Crafts reformers was to incorporate art into everyday activity—espousing "art for life's sake"—and thus to democratize it.[27] Although he made pragmatic choices and was at times inconsistent and not a systematic thinker, Stickley kept the ideals of Morris and Ruskin before the public more clearly than any other follower in the United States.[28]

The Arts and Crafts movement, as embodied in the teachings of Ruskin and Morris, called for reform of both labor conditions and

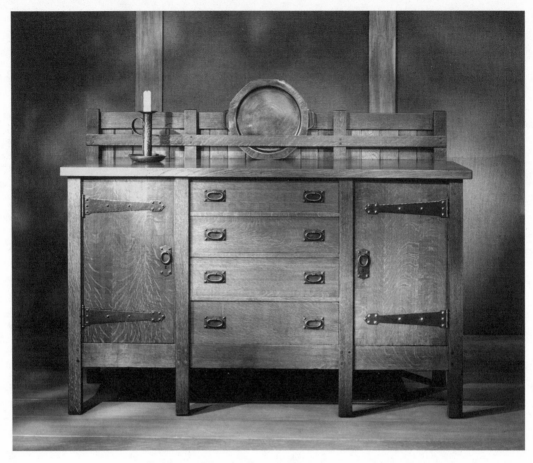

FIGURE 3.2. Craftsman Workshop, Gustav Stickley, *Sideboard*, 1912–16, oak and mahogany with iron hardware. *Los Angeles County Museum of Art, gift of Ellen and Max Palevsky* (1993.176.18).

aesthetics. The solution to both was thought to be a return to preindustrial hand craftsmanship. However, as Morris recognized early on, this way of thinking meant that only the wealthy would be able to afford good design, a recognition that eventually led him to spearhead social reform in the political arena. Some scholars have argued that the American Arts and Crafts, while ostensibly concerned with the character of industrial labor and of the physical environment created by modern production, was actually little more than an extension of the crusade for good taste in art inspired by the poor quality of American-made

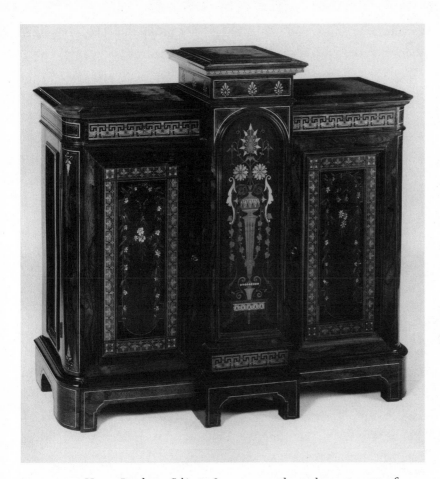

FIGURE 3.3. Herter Brothers, *Cabinet*, 1871, rosewood, maple, marquetry of various woods, gilding, paint, silk velvet. *The Currier Gallery of Art, Museum Purchase, gift of the Friends* (1989.9).

goods at the Centennial of 1876. They claim that the movement possessed certain social ideals but ultimately failed to challenge industrialism in any effective fashion because most of its advocates were strongly interested in either reviving the pleasures of the traditional handicrafts in craft communes, which were at odds with profit, or because they compromised the reform impulse and made the Arts and Crafts a style and not an ideology. Thus the image they present of the Arts and Crafts is either that of a group of middle-class aesthetes who indulged in a short-lived enthusiasm for making and buying exquisite but expensive

furniture, ceramics, and bookbindings or a group of profit-mongering manufactories who adapted factory production technology to produce objects that fit the handicraft aesthetic.[29] These exclusive pronouncements, both of which presume a simplistic definition of the American Arts and Crafts movement, have led other scholars to establish new boundaries or to give up the idea of boundaries altogether.[30] What follows examines the ways in which the Rookwood Pottery Company's labor conditions and aesthetics are imbricated in the contradictory strands that comprised the contemporary understanding of the Arts and Crafts movement in the United States.

"A Factory as It Might Be"

The building that first housed Rookwood Pottery, a converted schoolhouse on the banks of the Ohio River, was a two-story "double house" (fig. 3.4). On the right of the entrance hall were two rooms, one of which served as the ware room and the other as the decoration room. The second-floor rooms were occupied by Maria Longworth Nichols and her secretary, Clara Chipman Newton, and Mr. Cranch. The pottery foreman also had living quarters on the second floor. The kiln sheds and the engines were housed at the rear of the building. It had flooded in 1884, and was apparently quite noisy and dirty, since it was near the railroad crossing and the electric streetcar line (as evidenced by the electric pole shown squarely in front of the building). During the summer of 1881 the pottery was enlarged and the new rooms were described by Newton as having "a house-like look" that had not been possible when quarters were more crowded.[31] The new rooms provided space for a showroom and for the Rookwood School of pottery decoration. Showroom wares were displayed in a domestic setting, presumably to help customers visualize them in their own homes.

The pottery began to be profitable in 1889, and the decorating staff alone had grown from two to eighteen during the 1880s.[32] Because the facilities on Eastern Avenue were insufficient and overcrowded and

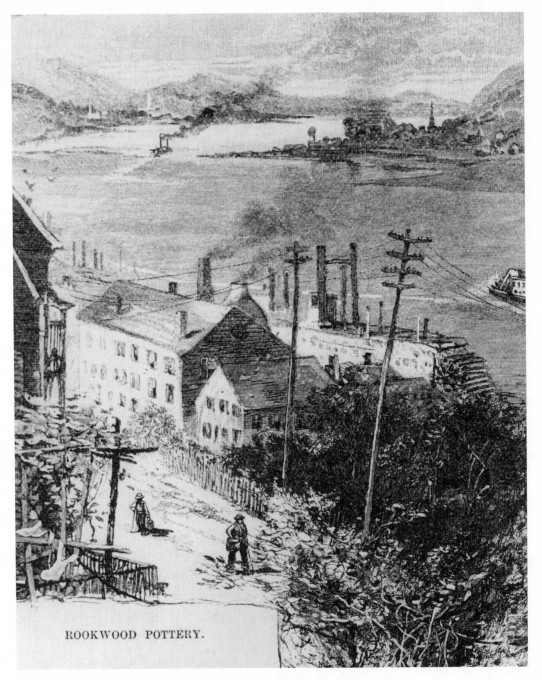

ROOKWOOD POTTERY.

FIGURE 3.4. Rookwood Pottery Company on Eastern Avenue, c. 1880, engraving.
From *Harper's New Monthly Magazine* 68, 398 (July 1883): 259. *Courtesy, The Winterthur
Library: Printed Book and Periodical Collection.*

funds were finally available, at the director's meeting on November 22, 1890, it was decided "to secure for the purposes of a new plant, the property owned by the Mt. Adams and Eden Park Inclined Railway Company on Mt. Adams."[33] When a representative of the Moses King Guidebook contacted the pottery about a photograph to illustrate the Rookwood entry, Taylor asked, "How long can you wait for the picture of our works? We have just bought a lot on one of the city hill tops and expect to build there as soon as possible. We think it within bounds to say that no factory in the world will have a situation so striking and picturesque."[34] The site on top of Mount Adams directly overlooked the downtown business district and offered many advantages: it was convenient for shipping to any of the more than a dozen railroad freight offices in the city; it was near the incline railway, already established as a tourist attraction; and, perhaps most important, it was adjacent to the Cincinnati Art Academy and Art Museum. Figure 3.5 is a postcard that shows the railway climbing Mount Adams with Rookwood at the top on the left.

Taylor drew plans for the new building that would include all necessary pottery facilities. H. Neill Wilson, an architect from Pittsfield, Massachusetts, formerly of Cincinnati, was engaged to refine the plans, make drawings, and supervise construction.[35] Wilson, who had earlier designed a home in Cincinnati for industrialist W. C. Procter, was a somewhat controversial choice since many board members felt that they should use a local architect such as James McLaughlin, who had designed the Cincinnati Art Museum and Art Academy as well as many other local commercial and domestic structures.[36] However, Taylor reassured Wilson that "they are well satisfied with the design from an artistic standpoint."[37] Taylor was very involved in the process. He wrote Wilson repeatedly with queries such as "Do you feel sure than an 8 or 8-½ foot ceiling in the designers' room (30–58 feet) will admit ample light?"[38] As the building neared completion he was anxious to show it off to ceramics scholar Edwin AtLee Barber. On one occasion he apologized for his zeal, "I wish I had not troubled you with the trip to our new building. You have no doubt however suffered before from proud

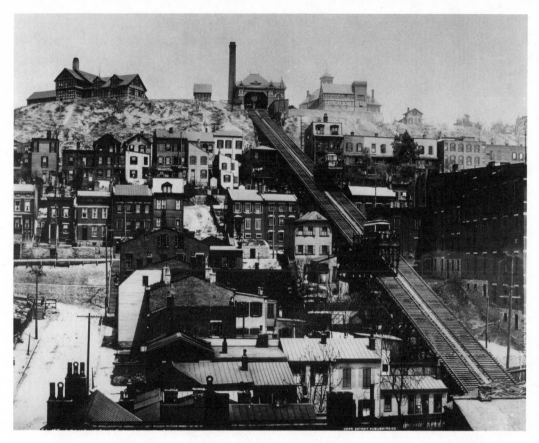

FIGURE 3.5. Mount Adams Elevated Railway, c. 1910, photograph. *Cincinnati Historical Society Library.*

fathers of very undeveloped infants. Being a bachelor myself I suppose the pottery stands in *loco filii*."[39] Instead of a steam whistle to announce the hours, Taylor looked into purchase of a Japanese Temple Bell like one Mrs. Storer owned that had a "sweet and penetrating tone."[40] Although the interest in Japanese aesthetics was a widespread Victorian phenomenon, Arts and Crafts proponents also admired Japanese craft workers, whom they compared to medieval guild members.[41]

Three kilns were installed that were designed to burn oil instead of the coal-burning kilns at the old location. Taylor, who was quite particular about the odor of the fuel, admonished the manager of the fuel oil department of Standard Oil of Chicago, "Ours is a 'show' place and

attracts visitors from all over the world. This will be still more the case in our new works and to greet these visitors in an artistic workshop smelling like an oil refinery we must only do as a last resort."[42] The basement of the building was intended for clay storage and preparation by specially designed machinery. Also in the basement were the throwing and casting room, the engine room, the boiler room, and the "damp room," where green shapes were held at the correct degree of moisture while awaiting decoration. On the ground floor were the salesrooms, served by the main entrance. Next to them was the "dry room," where decorated wares were kept before being fired. The second floor housed Taylor's office, the accounts payable office, and a "showroom" where key buyers and prospects were entertained. The remainder of the second floor was assigned to the decorating department, except for space taken up by the kilns, which extended from the basement through the roof. Although the newer members of the decorating department, the "juniors," shared a communal studio (fig. 3.6), the long-time decorators or "seniors" were provided with individual studios. Taylor reported to shareholders that the employees were well satisfied with the facility: "The working force is unanimous in praise of the convenience and comfort of the new plant and I think it fair to expect a steady improvement in quality and to some extent in quantity of work per hand during the coming year."[43] In 1899 the building was extended to the west, which permitted the addition of eleven individual studios for senior decorators, a new color room, a new ladies toilet room, lockers, and a library. Once again, Taylor reported to shareholders that the changes had been excellent morale boosters, noting that "Such an esprit de corps as seems to be developing is of very great value to the interests of the pottery and should be encouraged in every way."[44]

The main building, a half-timbered Tudor structure (fig. 3.7), was very similar to "Shadow-Brook" (fig. 3.8), a slightly earlier home designed by Wilson in Lenox, Massachusetts.[45] Certainly, the Rookwood plant looked more like an overgrown family dwelling in a garden setting than a pottery shed (fig. 3.9).[46] This was remarked upon by a critic in *House and Garden*, who observed that "because a building is used for

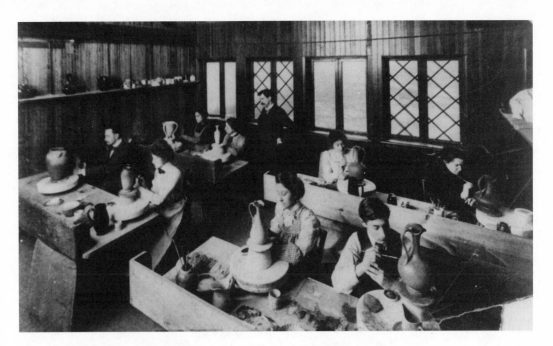

FIGURE 3.6. Decorating Department of the Rookwood Pottery Company, 1892, photograph. *Cincinnati Historical Society Library.*

manufacturing purposes it need not be otherwise than artistic. The [pottery] is interesting in the extreme and conveys the impression of a large country house rather than a factory."[47] The Tudor style of the architecture, with its old English antecedents, was very much in vogue during the 1890s and was certainly considered acceptable by Arts and Crafts proponents ranging from Edward Ould, who designed Wightwick Manor in Staffordshire in this style in 1887–93, to Gustav Stickley, who designed his own house in this style (fig. 3.10) and often advocated it in the *Craftsman.*[48] All three of these buildings have scratch work decorations in the spaces between the timbers. Taylor's concern about adequate light apparently bore fruit, as shown in the view overlooking the city (fig. 3.11). Even the engine room had great semicircular windows, a fact noted by contemporary observers such as Susan Stuart Frackelton, who wrote that "there is no thought or idea of 'factory' in the plant; even the engine room . . . looking down into the beautiful valley, is free from this influence."[49]

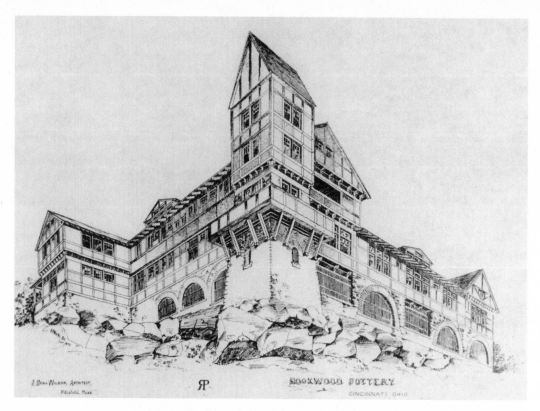

FIGURE 3.7. Rookwood Pottery Company, 1893. *American Architect and Building News* 41 (1 July 1893): 15. *Wilmington Institute Library.*

When one compares the architecture of the Rookwood factory to commercial pottery establishments, it looks even more like a domestic dwelling (compare to fig. 3.12). In the first place, commercial potteries, being much larger and with many more kilns, made no effort to hide their kilns or to disguise them as chimneys. Taylor had explicitly instructed H. Neill Wilson to put the kilns in "back" of the building (considered to be the side facing the river and not the view seen from the city; see fig. 3.13).[50] In addition, commercial pottery factories tended to be no-nonsense structures without pretensions to being architectural showplaces. The Tudor style employed by Rookwood is also strikingly different from the Beaux Arts style of architecture used for the Court of Honor at the 1893 World's Columbian Exposition, which went on to be the accepted mode for public buildings throughout the American

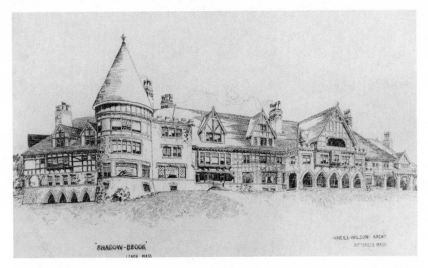

FIGURE 3.8. Shadow-Brook, Lenox, Massachusetts, 1893. *American Architect and Building News* 40 (April 1, 1893): 14. *Wilmington Institute Library.*

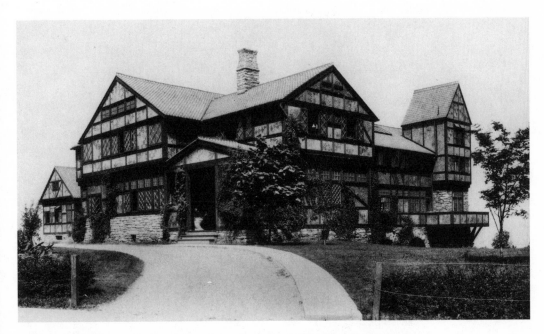

FIGURE 3.9. Rookwood Pottery Company, 1892, photograph. *Cincinnati Historical Society Library.*

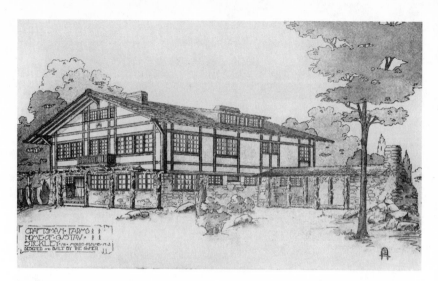

FIGURE 3.10. Front view of the house at Craftsman Farms, Morris Plains, New Jersey, 1908. *Craftsman* 15, 1 (October 1908): 81. *Courtesy, The Winterthur Library: Printed Book and Periodical Collection.*

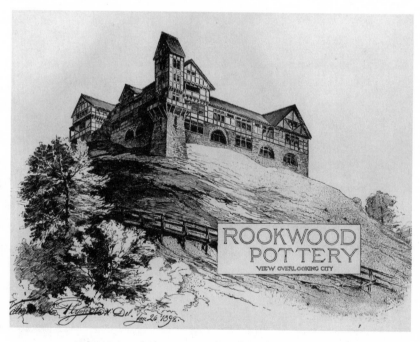

FIGURE 3.11. Valentien and Plimpton, *Rookwood Pottery: View Overlooking City*, 1892, drawing. *Cincinnati Historical Society Library.*

Renaissance. Whereas Beaux Arts classicism invokes the cultural authority of Renaissance Europe, the Tudor style summons the medieval associations sought by proponents of the Arts and Crafts movement.[51]

Perhaps unsurprisingly, the physical plants of a number of other art potteries also resembled domestic structures far more than they did factory buildings. The Pewabic Pottery built in Detroit in 1907 even employed the same Tudor-style, half-timbered architecture as Rookwood. Mary Chase Stratton, founder of Pewabic, wrote that the building was intended to be "a cross between a studio and laboratory with little of the factory idea."[52] The Newcomb College Pottery building, which opened in 1902 in New Orleans, "was designed to suggest a late eighteenth-century New Orleans house with fan lights over the broad leaded windows, 'a reproduction of the old Creole style of residence.'"[53] Susan Stuart Frackelton commented, "A more ideally charming building could hardly be devised, and quite unlike any other pottery that ever existed, the large airy rooms with their beautiful fenestrations, the cleanliness, the completely individual work tables and the freshly costumed workers are no where else as here."[54] The Robineau Art Pottery actually combined living and working quarters. This pottery, built in 1903–4 in Syracuse, exemplified the English cottage style typical of the Arts and Crafts movement and was repeatedly illustrated in the *Craftsman*. It consisted of three stories, with the kiln area taking up the whole first floor and the pottery the second. The third floor was used as a playroom for the three Robineau children while mother worked, an innovation considered drastically "modern" when the building was reviewed in *American Homes and Gardens* in 1910.[55] The Paul Revere Pottery, also in the English cottage style, was designed by co-founders Edith Brown and Edith Guerrier and built in 1915 in Brighton, Massachusetts.[56]

In addition to conforming to an Arts and Crafts style of domestic architecture, these potteries—Rookwood, Pewabic, Newcomb, Robineau, and Paul Revere—had another factor in common: they were all founded by and continued to employ a large number of women.[57] In the case of the Pewabic, Robineau, and Paul Revere potteries, we know the founders either designed the buildings or played an active role in deciding how

FIGURE 3.12. Homer Laughlin China Company's factory at East Liverpool, Ohio, 1912. From Choice Selections in Decorated Table and Toilet Wares, *Homer Laughlin China Co. Trade Catalogue, 2. Hagley Museum and Library.*

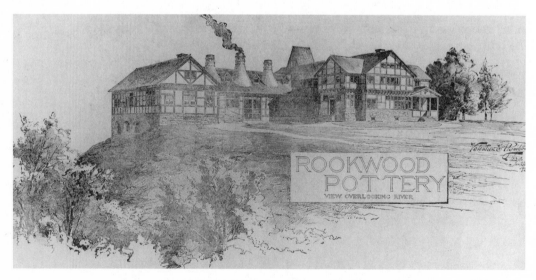

FIGURE 3.13. Valentien and Plimpton, *Rookwood Pottery: View Overlooking River,* 1892, drawing. *Cincinnati Historical Society Library.*

they would look. It is likely that this was also the case for Newcomb. For the most part, potteries such as Gates, near Chicago, and Grueby of Boston that either did not employ women (Gates) or were not recognized as doing so (Grueby) were utilitarian structures that made no apparent effort to conform to a domestic model.[58]

It is possible that these designs were linked to uneasiness about women's presence in the public spheres of labor and consumption, which is to say that women "belonged" to the private, not the public, sphere. In accordance with this belief, the more their workplace resembled home, the better. Cynthia Brandimarte has pointed out that women involved in the tea room movement fashioned a type of netherworld between work and home—in part-home, part-work spaces called "tea rooms." Tea rooms created a liminal space where women could earn money while still engaging in the domestic activities of cooking, serving, and caregiving.[59] Rookwood and the other art potteries, in common with many public spaces of the late nineteenth century (e.g., sales rooms, art galleries, department stores, theater lobbies), may have also acquired a domestic patina in part to make the firm and its products more agreeable and accessible to women consumers.[60]

Labor Conditions

Rookwood's suburban location, domestic-looking physical plant, and landscaped grounds seem to conform closely to William Morris's notions of the ideal factory. However, the labor conditions, while for the most part superior to those found in commercial potteries, proved to be vulnerable to the demands of the marketplace and differed little from the labor practices of enlightened capitalists.

When Taylor took over the management of Rookwood in 1883, he closed the pottery school and banished amateurs from the premises. He also instituted a series of steps intended to rationalize production, beginning with an in-depth sales analysis. He assigned Clara Chipman Newton the task of compiling a detailed record of past sales and listing

current ones as they were made. These entries were made in what became the official Shape Record Book kept at the pottery for the next twenty years. As shown in figure 3.14, each piece was numbered and described on the correspondingly numbered page, often with sales figures. Thumbnail size photographs were used to illustrate some of the shapes but most were shown by a small pen-and-ink sketch.[61] According to this analysis, shapes that did not sell well or could not be produced successfully were dropped from the line.

Taylor used these shape numbers to develop an elaborate accounting system whereby he tracked what was sent and sold by each retail agent. In almost all cases, wares were sold on consignment, necessitating periodic reports and payments by retailers who were instructed to arrange pieces consecutively according to shape numbers, giving prices and descriptions. Taylor, exasperated with retailers who didn't closely follow his instructions, wrote, "Your account sales came in such form that we have had half the time to guess what piece you meant. . . . [We] do not write to wound your feelings and should be sorry to do so but we must have the accounts straightened and at once and we are a little weary of explaining the necessity of it so often."[62] Taylor kept records of each decorator's production, noting how many pieces were decorated and what each sold for.[63] These records were considered to be so important that any worker responsible for a mistake in numbering a vessel was fined—a rule in effect until the 1930s.[64] Taylor also conducted price/labor studies, which led him to base prices on the cost of the decoration (which factored in the hourly pay rate of the decorator and the time it took to execute the design) rather than the size of the vessel. This rationale was supported by his comment that "No real work of art is valued according to its size, but by its quality."[65] In addition, Taylor was constantly probing various segments of the market for feedback on Rookwood.

Comparisons to domestic space or to medieval guilds argue against the Rookwood Pottery's industrial nature. While it is difficult to draw precise distinctions between sound business practice and commercial aspirations, it can be assumed that "commercial" enterprises valued profit

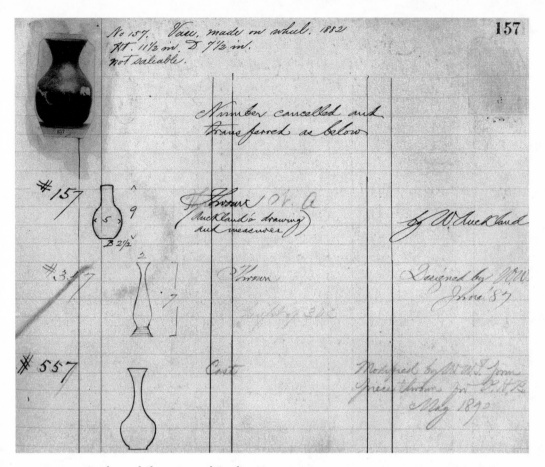

FIGURE 3.14. Rookwood Shape Record Book, 1883–c. 1900, 157. Cincinnati *Historical Society Library*.

to the exclusion of worker satisfaction or aesthetics. Yet most Rookwood decorators, particularly the women, worked the same hours and earned about the same income as employees in the commercial potteries who performed repetitive, unskilled labor.[66] Hiring practices involved a trial period of six weeks to two months.[67] Whereas days in the commercial potteries ranged from seven to ten hours, Rookwood potters worked ten and one-half hours and decorators worked nine hours with thirty minutes for lunch and two ten minute breaks. In the 1880s pay ranged from $3.00 to $6.00 per week; women earned the lower wages. By 1894, junior decorators still earned $3.00 per week while decorators with ten

years of experience or more, most of whom were men, took home up to $35.00 per week. It seems that the "artistic" nature of the enterprise was in some measure intended to be a balm for the low pay the decorators received. In her memoirs, decorator Patti Conant remarked that "The prestige of being a Rookwood decorator and the 'love of art for art's sake' was supposed to compensate for the very low pay, which is just unbelievable today."[68] It may have been that working at Rookwood carried with it a feeling of social superiority that made it more desirable than higher paying, less genteel jobs—especially for female employees.[69] Although Taylor wished to downplay the role of women in the workforce, a year by year comparison of decorators (fig. 3.15) demonstrates that women usually outnumbered men.[70] Despite the fact that in 1894 most of the decorators with ten years experience had been men, over the time period covered here (1880–1913), of the thirty-three decorators employed more than ten years, nineteen were women and only fourteen were men. Although there were married female decorators (e.g., Anna Marie Valentien, whose husband Albert was the head of the decorating department), for the most part, the "career" female decorators were unmarried. In addition, of the thirty-nine decorators who were employed less than five years, twenty-four were women, many of whom left when they got married.[71] It is difficult to draw rigid conclusions from this information but it seems that there was no explicit company policy against married women working as decorators nor does it seem that there was a "glass ceiling" for female decorators.[72] Although there are no objective criteria as to the quality of their work, current collecting patterns suggest from 1880 through 1913 work decorated by women was as well received as that done by male decorators.[73]

Taylor, as president and treasurer of the pottery, received $3,000 per annum initially (1890), with an increase to $3,600 in 1895. He did not receive a salary increase again until 1905, when he received a raise of $1,460, bringing his salary up to $4,060. Executives Stanley G. Burt (superintendent) and J. H. Gest (vice president) received raises in the form of stock grants, a comparatively rare practice in 1904.[74] It appears that Taylor's management skills drew attention within the larger business

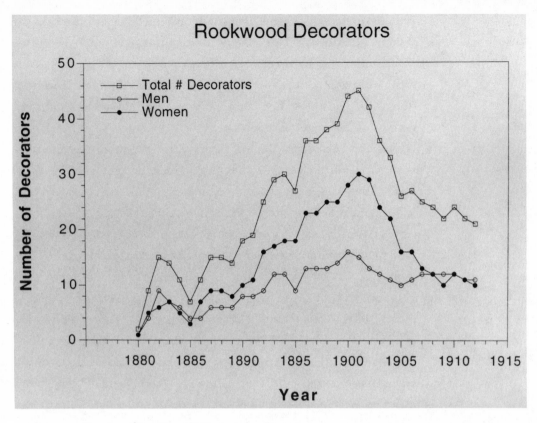

FIGURE 3.15. Gender of Rookwood Decorators, 1880–1913.

community as he corresponded with a professor from the Wharton Business School of the University of Pennsylvania about the Pottery and his practices.[75]

Following incorporation in 1890, the Pottery had been divided into various departments: clay, kiln, potter and crating, office and sales, and decorating each having a supervisor who reported to Taylor. Despite this division of labor, there was little doubt that all major decisions were made by Taylor, who applied some of the techniques of the "other Taylor"—Frederick Winslow Taylor—to increase artistic efficiency, causing speed-ups to occur during which junior decorators were encouraged to perfect their work (i.e., do multiple versions of the same motif) so that senior decorators were available for new designs.[76]

Although management-generated publicity tended to focus on the decorators, Rookwood art pottery passed through at least twenty-one hands before leaving the factory, a division of labor that seems to conform fairly closely to the prevailing factory system. From its inception, Rookwood had always divided labor between artisan potters and artist decorators but required cooperation between the two and had both throwers and decorators sign the pieces.[77] The decorators were nonetheless responsible for complete designs, whereas decorators in the commercial potteries rarely worked on an entire piece. They lined, gilded, laid ground, filled in, or applied decalcomania.[78]

Management encouraged domestic or familial associations by staging (and photographing) activities for employees such as picnics, boat rides, corn roast parties, dinner parties, and the like.[79] Archival materials suggest that the Pottery sponsored a baseball team in the Cincinnati commercial league and there is some suggestion that Pottery employees maintained a camp called "Valley of the Moon" down the river at California, Ohio.[80] At least once a year, an elaborate costume ball was staged where intricate decorations transformed a room at the pottery into a ballroom and fanciful costumes were worn. These balls grew in size and culminated in an Arabian Nights costume party in 1913. Apparently this was literally the party to end all parties, for it was the last such affair held at Rookwood.[81] Reportedly "discipline was unnecessary" because Taylor made workers aware of his presence, making rounds of the Pottery, chatting with the decorators and inquiring about work.[82] Management closed the works so that employees might attend lectures on such topics as the "Fertilization of Flowers" or "Japanese Art," held at the nearby Cincinnati Art Museum.[83] In some cases the Pottery sponsored foreign travel and study for decorators (see chapter 4). Decorators were also permitted to use facilities and materials to make holiday presents. All workers were given a week off, without deduction of pay, to visit the 1893 World's Columbian Exposition.[84] Beginning in 1900, the firm closed for two weeks each August for vacation.[85] This paternalistic treatment of workers was hardly unique to Rookwood; indeed Elbert Hubbard, founder of the Roycroft community, reportedly thought of himself as exemplify-

ing Ruskin's "just businessman," who serves his employees like a father. According to one of his business associates, Hubbard saw "most people as children who needed a Little Father to tell them when to go to bed and when to get up; when to work and how much and what! How much to spend and how much to save!" Accordingly, Hubbard regulated workers' spending habits by giving them less to spend; he paid even skilled workers a minimum but supplemented money with gifts—coal, flour, clothing, and hams.[86] Moreover, there were many other paternalistically organized industries that were frankly profit-driven, such as Pullman Railroad Car Co. near Chicago, Kohler Plumbing Co. in Kohler, Wisconsin, or the New England textile mills (e.g., the Boston Manufacturing Co. in Waltham, or the Merrimack Manufacturing Co. in Lowell, Massachusetts) which have been well documented.[87]

Friendly relations at Rookwood frayed during depositions taken from various senior decorators (who had worked there ten years or more) when the Pottery was involved in litigation brought by Laura A. Fry, a former employee, for patent infringement. Sometime between June and October of 1884, Fry had begun experimenting with the use of a mouth atomizer to apply a smooth blending of background color to Rookwood's ware. She had received fine art training and was familiar with the atomizer because it was used by artists to spray fixative onto their charcoal drawings. The atomizer, a simple bent metal tube that worked as a lung-powered spray gun, was apparently quite unpleasant to use and reportedly caused a wide range of physical symptoms ranging from sore, bloody throats to testicular swelling. In 1888, Fry had received a patent for her technique involving a newly invented airbrush.[88] She left Rookwood in 1891, eventually going to work for a competitor in 1893, at which time she sued to enjoin Rookwood from using the process that she had perfected while working there. The suit was not settled until five years later—during which time Rookwood continued to use the technique—in an 1898 Cincinnati federal court trial by Judge William Howard Taft, a close friend of Taylor's and of the Storers, who ruled that Fry's patent was invalid since it was simply a new use for an existing tool.[89] Two years after that, Fry's appeal of the decision was

denied and the airbrush was legally available to anyone in the pottery business.[90] At the time of the federal court trial, in an effort to establish when the technique was developed, Rookwood's legal representative deposed several senior decorators including Albert Valentien, head of the decorating department. Valentien testified that as a consequence of using this apparatus, "I frequently complained of headache. I do not think there was hardly a day but what I had a severe headache, and not only that, my throat got so sore that I found it necessary to get a physician." The consulting physician reportedly told Valentien that it was use of the mouth atomizer that was causing his difficulties. Valentien continued, testifying:

> I then went to Mr. Taylor and spoke to him about the effect it had on my throat, and there had at that time been a number of very large vases made, and I positively refused to do the blowing for them. They stood around for a long time—these vases and the complaints I made were so frequent that Mr. Taylor volunteered to call myself a chronic kicker. I remember the term very well. Well, as I did not like to be kicking all the time on that score, I said I would rather be a chronic kicker than have the chronic throat disease, which the doctor thought I was in danger of.[91]

Valentien and his coworkers could do little about their perceived mistreatment by Taylor other than resign from their positions, because Rookwood workers had no collective bargaining leverage. They were not members of the National Brotherhood of Operative Potters (NBOP).[92] This organization, formed in 1890, was controlled by key workmen within the commercial potteries of East Liverpool, Ohio. During the 1890s the union significantly changed existing labor-management relations. The Brotherhood survived an industry-wide strike, gained organizational consolidation with the other major pottery centers, and attained a uniform wage contract with the United States Potters' Association (USPA). The USPA, the management counterpart of NBOP, had been founded in 1875 to stimulate greater interest in domestic pottery, while lobbying for a protective tariff and fostering the development of the domestic clay industry.[93] This all-male organization grew from forty-one member firms in 1875 to a high in 1890–92 of seventy-eight mem-

bers.[94] Although Rookwood's employees were not members of NBOP, the firm itself was on the membership roll of the USPA throughout most of the 1890s.[95]

It is not known why Rookwood's employees were not union members. However, many American Arts and Crafts proponents were opposed to organized labor. For example, Gustav Stickley contrasted the guild stamp with the union label, claiming that although unions fixed wages like the old guilds, they ignored the standards of workmanship and efficiency for which the guilds had earned the right to regulate economic life. Guilds demanded of members "efficient workmanship through honesty, the perfection of system and personal pride in the reputation of the organization." Unions set "a premium upon inefficiency by demanding good pay for poor work and by defending incompetent and malingering workmen." Equality of wages killed "enthusiasm for good work, talent, inventive quality and individuality." Union membership prohibited "higher payment for the production of superior goods."[96] Eileen Boris has pointed out that "working-class collectives such as unions threatened Stickley's sense of individualism."[97] For Stickley, and possibly for Rookwood management, the guild, not the union, was the model for industrial relations.

AESTHETICS

Just as he had prescribed the ideal factory and optimal working conditions, so William Morris set down his views about the aesthetics and production of pottery. In his 1883 lecture on "The Lesser Arts of Life," Morris took a decidedly pessimistic view. Referring to wares of Sèvres as "the most repulsively hideous," those of Meissen as "the most barbarous," and those made in England "the stupidest, though it may be the least ugly," Morris outlined five points for the improvement of the aesthetics of pottery. He began by insisting that "no vessel should be fashioned by being pressed into a mould that can be made by throwing on the wheel or otherwise by hand." He also dictated that vessels should

be finished on the wheel and not turned in a lathe. As a corollary to these first two points, Morris observed that "we must not demand excessive neatness in pottery . . . [as] workmanlike finish is necessary." About decoration, Morris observed that it must never be printed and urged, "Don't paint anything on pottery save what can be painted only on pottery." Finally he admonished would-be buyers, "You will of course be prepared to pay a great deal more for your pottery than you do now, even for the rough work you may have to take. I'm sure that won't hurt you; we shall only have less and break less and our incomes will still be the same."[98]

Both aesthetically and in terms of production methods, Rookwood pottery was in basic, if not total, agreement with four of Morris's five points. The artist-signed wares were almost exclusively thrown on the wheel and not molded.[99] However, ware was often finished by turning with a lathe and the use of an atomizer or airbrush for the creation of soft transitions in color was an important part of Rookwood's aesthetic.[100] Certainly the notions that consumers should disdain machine-like finish and should be willing to pay more for handwork are borne out by many examples in the corporate correspondence. For example, to differentiate Rookwood from the very wares William Morris castigated (Sèvres, Meissen, or Royal Worcester) Taylor wrote a dealer that "All our ware is not perfect in a technical sense nor is it possible to make it so. . . . We are not making 'Worcester' with its requisite elaboration of overglaze work nor the bad copies of it with which the market is filled."[101] About the cost of Rookwood versus other wares he snapped, "We must take exception to your remark about prices. The largest importer of fine foreign wares in New York told the writer a short time ago that there was no ware in the world to compare with Rookwood for cheapness."[102] Taylor explained the "much higher cost of clay decorated ware" compared to commercial pottery as being due to the methods of production (i.e., handicraft versus machine and underglaze versus overglaze decoration).[103]

The point at which Rookwood's aesthetic and William Morris's differ greatly is regarding decoration. Morris and other design reformers be-

lieved that the type of decoration (e.g., painted, metalwork, etc.) and iconography must be subordinated and expressively adapted to the material, shape, and use of the functional article it is destined to embellish. It was considered deceptive for decoration to aspire to the pictorial illusionism proper to painting.[104] Consequently, relatively subdued and schematic formal treatments of discreet and thoroughly conventionalized imagery were preferred.[105] For a variety of reasons (most to be taken up in the next chapter) Rookwood's decorative aesthetic was quite different from this, incorporating pictorial illusionism and even imitating or copying famous oil paintings. Their emphasis was not so much on the vessel forms (which were often copies of well-known ancient and contemporary European and English forms) as it was on surface decoration. This decision led the firm to hire decorators who were trained as easel painters as opposed to having been schooled in ceramic arts.[106] Rookwood's naturalistic decoration had more in common with easel painting than it did with traditional ceramic decoration, which was usually conventional. Taylor was somewhat defensive about this, writing that "When Rookwood is told by the constituted authorities that all pottery decorations must be conventional in design, it is not convinced. We know that this theory has the sanction of many printed pages . . . nevertheless we know by practical experience that it is false, or only true with many limitations and exceptions."[107] The pottery's myriad awards for naturalistic decoration probably gave Taylor the confidence to refute the rightness of conventional designs.

Although Morris apparently didn't reveal his thoughts on glazes, until the early twentieth century the ware for which Rookwood was best known and received the most acclaim was covered with a highly refractive, sometimes glittering, glassy skin. In most cases, though, the glaze was subordinated to the decoration. As shown in the vases depicted in plate 2, the glaze is clear, emphasizing the flowers painted underneath. Around 1900, however, the Pottery shifted the ware's aesthetic from high gloss to mat finishes (figs. 3.16 and 3.17).[108] Although Taylor credited superintendent Stanley Gano Burt with the creation of the mat glazes, others claimed that the recipe for this glaze was discovered by Artus Van

Briggle during his years at Rookwood.[109] While no explanation was given for this shift, it was probably due in some measure to the "dead" glazes exhibited by the avant-garde French potters Auguste Delacherch and Ernest Chaplet at the 1893 World's Columbian Exposition.[110] Taylor reported to shareholders that "it is so decided and beautiful a novelty that it can hardly fail to meet a ready sale."[111] However, this "novelty" involved rather more than the replacement of one glaze type with another, for mat glazes marked a fundamental change wherein decoration was now subordinated to glaze.[112] The mat glazes (except Vellum, discussed in chapter 4) were colored and opaque. When there is decoration in the mat glaze line it usually involves the vessel itself, which is either incised as in figure 3.16 or modeled as in figure 3.17, because the opaque mat glazes do not allow for the necessary translucency to see a painted decoration underneath.[113] This shift in production followed the Arts and Crafts aesthetic, which favored modest forms, clean planes and lines, subdued flat colors, and unassuming finishes. Some of these mat wares did not pass through the decorating department but were incised by the clay workmen.[114] Taylor continued to favor underglaze decoration with an emphasis on three-dimensional representation, and he regarded these incised mat wares as a way to keep busy the "surplus labor in both the clay and kiln departments."[115]

Arts and Crafts at the Louisiana Purchase Exhibition

Most scholars give the general impression that the American Arts and Crafts movement was an apolitical consumer movement.[116] Although it is true that Americans were less interested in the social aims of the Arts and Crafts movement and more interested in aesthetic issues, there were exceptions to this rule. Rookwood's adherence to William Morris's goal of reuniting art and labor was more evident in theory than in practice, and its claims about its radical difference from commercial industries were largely illusory. Yet contemporary observers viewed both

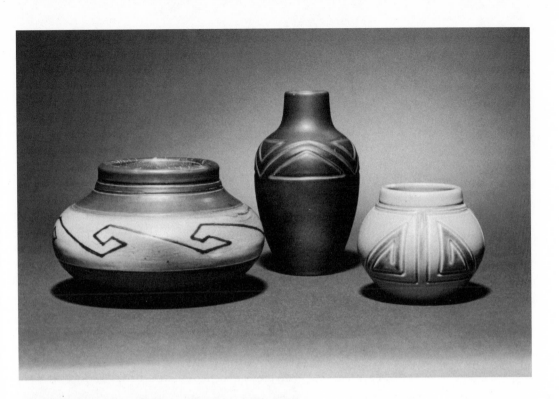

FIGURE 3.16. Left to right: Rookwood Pottery Co., William MacDonald, *Vase*, 1901; Rookwood Pottery Co., Harriet Wilcox, *Vase*, 1904; Rookwood Pottery Co., Olga Geneva Reed, *Vase*, 1904, Incised Mat glaze line. *Private Collection.*

FIGURE 3.17. Rookwood Pottery Co., Sara Alice Toohey, *Vase*, 1908, Modeled Mat glaze line. *Cincinnati Art Museum, gift of Mr. and Mrs. James J. Gardner (1992.99).*

Rookwood's production and products as part of the Arts and Crafts movement. Oscar Lovell Triggs visited the plant and almost certainly communicated with William Watts Taylor, identifying Rookwood as "an ideal workshop." Triggs, in common with other Chicago Arts and Crafts supporters, was far more interested in labor conditions than in the reform of aesthetics, writing, "The question of art is altogether a question of social reform. Art must grow out of the life." He was convinced that Rookwood was an example of these principles in the United States. Acknowledging that the "management of the business is centered in a board of directors," he went on to emphasize that "the fullest possible freedom is given to the workmen; they are encouraged to experiment, to express their own individuality, and to increase their culture by study and travel." After visiting the works he remarked that "the spirit of the factory is that of co-operation and good fellowship." Triggs also cited pottery-sponsored lectures and other entertainments that allowed the public to participate in the enterprise. The chapter concludes, "Its motive, its management, its principles of work, its fine artistic production—all distinguish it from contemporary factories." However, he qualified his remarks, noting, "With only slight changes, by the development of forces already implicit, such a workshop as the reformers have dreamed of could be here and now created."[117]

Unlike the labor reform emphasis of Triggs and the Chicago contingent of Arts and Crafts supporters, Frederick Whiting, the influential secretary of the Society of Arts and Crafts, Boston, was concerned exclusively with aesthetics. When asked by chief of the art department, Halsey Ives, to assemble a representative selection of Arts and Crafts from around the country for the Louisiana Purchase Exposition in 1904, Whiting wrote to Taylor that he wished the Pottery to submit "some undecorated pieces with your very lovely colors and textures [in the hope that] your collection [will be] largely made up with such as these."[118] Although the pottery made primarily mat glazed objects in 1904, both the Standard glaze line and the Iris glaze line (high gloss wares) were still in production. Taylor, who favored high gloss ware, ignored Whiting's request, sending instead a varied collection of sixty-

three pieces (many of them high gloss) that he regarded as representative of the best work of the firm. Whiting retaliated by rejecting all but fifteen of the submitted wares, of which ten were mat glaze. Although Taylor threatened to withdraw entirely, he recanted because "it might in some way become public that Rookwood was rejected from the Fine Arts Department and other potteries accepted." He went on to explain that "The selection of pieces was made in accordance with the following expression in Mr. Ives' letter of March 21st: 'I shall be very glad indeed to have a comprehensive collection showing the acme of perfection reached in the work produced in Rookwood Pottery. Indeed this Division of the Department of Art would not be complete without it.'" Whiting wished to have objects listed in the catalogue according to individual producers. Although each Rookwood object was the product of many hands, the decorator was given sole credit—here incorrectly listed as "designer."[119] Because objects in the Mat glaze line often did not pass through the decorating department, Taylor felt "It would be difficult if not impossible to enter them in the name of any individual artist. For this reason we threw out a number which we might otherwise have sent."[120] In Taylor's opinion the Mat glaze wares not only failed to represent the best work of the firm, but because many of them did not pass through the decorating department they lacked the individuality that was key to Rookwood's self-identity.

Although not specifically about pottery, the Society of Arts and Crafts, Boston, had a clearly articulated design credo steeped in William Morris's ideas. Form, function, material, and decoration were in harmony with one another. The visual appearance of the Pottery was inextricably linked with its production methods.[121] Whiting not only subscribed to this credo, he used it as a rigid guideline to impose his aesthetic ideas on exhibitors. Among the "other potteries accepted" were Grueby of Boston with forty objects (fig. 3.18), Van Briggle of Colorado Springs (lately from Rookwood) with fourteen objects, and Teco made by Gates Potteries from near Chicago with ten objects (fig. 3.19). All of these potteries produced wares that subscribed closely to Whiting's conception of the Arts and Crafts aesthetic.[122]

FIGURE 3.18. Grueby Pottery, *Vase*, 1897–1902, earthenware. *Los Angeles County Museum of Art, gift of Ellen and Max Palevsky (1993.176.10).*

Yet another author, writing for the less doctrinaire *Craftsman* magazine in 1903, praised both Rookwood's products and production, implicitly linking them to the Arts and Crafts movement. This author, like Triggs, seemed unperturbed by Rookwood's business practices because "It protects the interests of art; being practically an enterprise for the production and sale of the work of forty or more individual decorators,

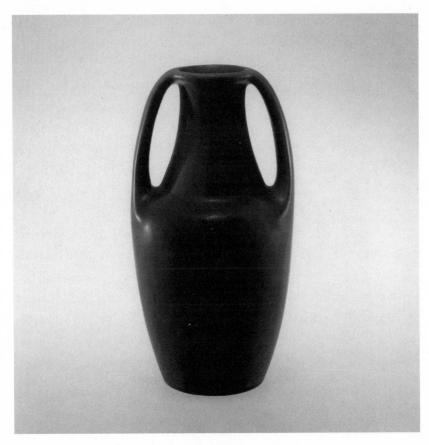

FIGURE 3.19. Teco Pottery, *Vase*, n.d. *Chicago Historical Society, Prints and Photographs Department.*

who, in obedience to the rules of the pottery constantly vary their shapes and never repeat their decoration." The Rookwood decorators were believed to form "a community resembling in constitution the workshop schools of the master artists and craftsmen of the Middle Ages." Although the mat glazes were praised, the author also awarded encomia to high gloss pieces.[123]

In the final analysis, it is clear that Rookwood's products and production are embedded in the contradictory strands that comprised the contemporary understanding of the American Arts and Crafts movement. Although management did not explicitly identify with the movement, it would have been impossible for them not to be aware of European

and American Arts and Crafts developments from books, magazines, and international expositions. This suggests that there is need for a more nuanced understanding of the movement. On the one hand, the physical and social structures of the Pottery were more familial (or feudal) than industrial, and most of the decorators, instead of being unskilled laborers, were highly skilled artisans. On the other hand, these same decorators were employees subject to supervision and low wages, while the Pottery had a rigid division of labor and operated according to the rules of cost accounting with production quotas and top-down management. In addition, management claims about individuality, liberality, and freedom of expression markedly disagree with the decorators' experience of rationalized production. That is, workers faced a decorating hierarchy where seniority, work space, design assignments, and pay levels differentiated them. Stylistically, a portion of the ware was neatly aligned with traditional Arts and Crafts principles, yet management did not consider this their best work, and continued emphasis on three-dimensional representation defined the Pottery's aesthetic.

CHAPTER FOUR

"AN ARTIST'S STUDIO, NOT A FACTORY"

The conditions under which objects of art can be made are
necessarily different from those governing manufacturers.
Where artistic expression is the first consideration financial
return must be secondary. While the Rookwood Pottery Com-
pany is a business organization it is deliberately operated at a
minimum profit in order that its staff of artists may have the
utmost latitude in the creation of new and ever-varying objects
of art. Any one familiar with art knows what it means to put
new thought, new life, new expression into each piece of
work, day after day and year after year. That Rookwood has
done this without wavering for a quarter of a century is its
greatest distinction.

The Rookwood Book

From its inception, Rookwood had insisted on its difference from com-
mercial enterprises. Though operating on an industrial scale, throughout
the Pottery's golden age (1883–1913) management unabashedly posi-
tioned the company as "an artist's studio, not a factory." Promotional

materials noted that "a vase made at Rookwood . . . is as much an object of art as a painted canvas or sculpture in marble or bronze. And the artist's signature upon the vase is as genuine a guarantee of originality."[1] Advertisements were accompanied by carefully posed photographs of Rookwood decorators sitting before their pots, brush in hand, reminiscent of a long tradition of representations of male painters in their studios (fig. 4.1). This chapter will begin by exploring the ways the Rookwood Pottery company adhered to and diverged from management rhetoric about "an artist's studio." Management instituted a series of steps to insure necessary public exposure for the ware, among them donating pieces to museums, lending pieces to regional and national expositions, and advertising in magazines with national circulation. Equally important from a marketing perspective was the decision to make the physical plant a showplace and to cooperate with serious writers for national publications. They also decorated wares with copies of Old Master portraits and imitations of Tonalist landscape paintings. The unifying theme in all of these strategies was the insistent positioning of Rookwood as fine art. Yet the actual circumstances of production suggest that Rookwood decorators and other workers were far from free to follow their inspiration and that the manufactory was run by strict cost accounting principles.

Establishing Rookwood as Fine Art

Taylor felt strongly that Rookwood pottery should be marketed as fine art and not "buried with the painted cuspidors."[2] This interest is made clear from his criticism of sales agents: "I am more and more impressed that our real difficulty is to get the right sort of agent. . . . They nearly all treat Rookwood as though it were so many spoons or pocket knives. The conception of it as a work of art . . . never enters their little heads."[3] In the Annual Report for 1902 Taylor noted that dealers often have "no artistic appreciation of the ware," and that the salesmen "have even less."[4]

Rookwood's presence in the precincts of fine art had begun as early

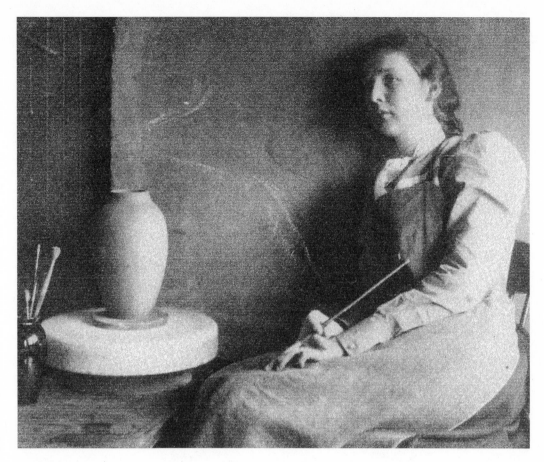

FIGURE 4.1. Marian Frances Hastings Smalley, c. 1900, photograph. *Cincinnati Historical Society Library.*

as 1883, when Maria Nichols donated fourteen pieces of Rookwood ware to the Museum of Fine Arts in Boston. The following year the civic-minded Women's Art Museum Association donated six pieces of Rookwood to the United States National Museum (now the National Museum of American History of the Smithsonian Institution) in exchange for thirty-one pieces of Pueblo pottery (fig. 4.2).[5] Over the next few years, beginning in 1886, Nichols and Taylor sent over twenty pieces to Edwin AtLee Barber, director of the Pennsylvania Museum and School of Industrial Arts in Philadelphia (forerunner to the Philadelphia Museum of Art). This later donation was intended to ensure Rookwood's

inclusion in Barber's monumental treatise, *The Pottery and Porcelain of the United States*. At the time of the Cotton States Exposition in Atlanta in 1895, Rookwood donated an additional five pieces to the United States National Museum. This strategy was continued by Taylor after Nichols left the Pottery—by 1906 Rookwood had placed on loan over two thousand pieces with the Cincinnati Art Museum. This collection of objects, locally well known, was referred to by the contemporary press as "The Rookwood Museum."[6] Links between Rookwood and the Cincinnati Art Museum were so close that the two institutions had executives in common. Taylor served as treasurer and as a member of the museum's acquisitions committee until his death in 1913. Joseph Henry Gest, director of the Cincinnati Art Museum, was vice president of the Pottery and succeeded Taylor as president.[7] This identification with fine art was reinforced when Rookwood was displayed at international expositions, such as the 1893 World's Columbian Exposition, where Taylor made sure that Rookwood was included in the fine arts displays in addition to industrial displays. At the Chicago fair, Rookwood was reportedly the only art pottery company whose wares were displayed in the Art Palace.[8] Rookwood ware was also included in the prestigious Pedestal Fund Art Loan exhibition intended to raise funds to build a base for the newly acquired Statue of Liberty.[9]

Rookwood Decorators as Artists

These fine art aspirations were reinforced by the Pottery's physical proximity to both the Cincinnati Art Museum and the Art Academy where nearly all of the decorators had trained as easel painters.[10] Management judged this training to be essential for employment since Rookwood art pottery featured underglaze painted decoration, which was often quite demanding to execute.[11] In addition, management hired Professor O. W. Beck of the Art Academy to visit the Pottery once a week to provide criticism and suggestions to the decorators.[12] In an effort to maintain and enhance the skills of senior decorators, it was viewed "in the Pottery's

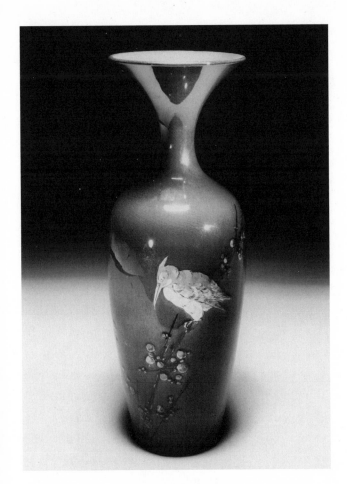

FIGURE 4.2. Albert R. Valentien, *Vase*, 1885, Standard glaze line. *National Museum of American History, Smithsonian Institution.*

artistic interest" to send some of them to Europe, often Paris, for additional training.[13] In this, they joined the ranks of nearly three thousand other ambitious American artists who sought European training during the last quarter of the nineteenth century.[14]

Many of the Rookwood decorators continued to produce easel paintings and sculpture and to exhibit in the Annual Exhibition of American Art at the Cincinnati Art Museum as well as in the annual exhibitions of the Society of Western Artists.[15] Indeed, these exhibitions often included Rookwood pottery, and on occasion decorators' work was represented in both pottery and easel painting.[16] Several Rookwood decorators eventually left the pottery to pursue fine art interests. For example, Bruce Horsfall (decorator, 1893–96) became well known as an easel painter

and an illustrator of nature books.[17] Grace Young (decorator, 1885–91 and 1896–1903) joined the faculty of the Cincinnati Art Academy as an instructor in painting.[18] Albert Valentien (decorator, 1881–1905) eventually left the pottery to pursue his interest in flower painting. His wife, Anna Bookprinter Valentien (decorator, 1884–1905), had exhibited a life-size sculpture of *Ariadne* in the Women's Building at the World's Columbian Exposition in 1893, and both Valentiens had work accepted by the Paris Salon.[19] Edward T. Hurley, who decorated at Rookwood for fifty-two years (1896–1948), was as well known for his work in other media as for his ceramic decoration. He produced oil paintings, watercolors, bronze sculpture, pen and ink drawings, photographs, and etchings. During his lifetime, his pen and ink drawings and etchings were published in *Brush and Pencil*. The text that accompanies his drawings notes that Hurley "is one of the ablest decorators at the Rookwood pottery, where his specialty is the painting of animals on the pottery's well-known artistic product." The author goes on to suggest that many of Hurley's drawings are afterward elaborated on Rookwood vases.[20] In cases of artists with enough examples of oil paintings or sculpture to make a comparison, it seems that similar concerns were taken up in ceramic decoration and other media. Anna Valentien executed carved wares at Rookwood that are visually similar to her free-standing sculpture (fig. 4.3), and Hurley's drawings and etchings are similar to his pottery decoration. In Hurley's case there is direct evidence that he had common aesthetic goals for etching and ceramic decoration. On the back of a signed landscape plaque is written, "At last! A dry point effect in pottery—after fifteen years of trying." It is signed E. T. Hurley, December 27, 1915 (plate 3).[21]

Old Master Portraits and "Scenic Vellums"

One of the most compelling bids to treat Rookwood pottery as fine art was the decision in the late 1890s to produce portrait vases and plaques decorated with copies of Old Master paintings that were labeled "after

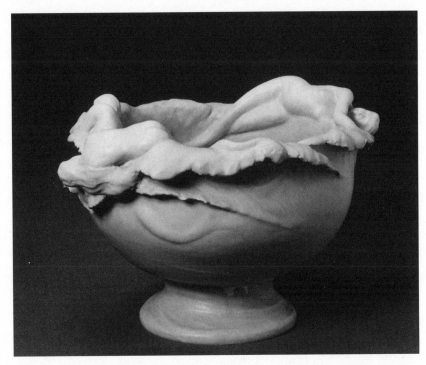

FIGURE 4.3. Anna Bookprinter Valentien, *Punch Bowl*, 1900, Modeled Mat glaze line. *Courtesy of Cincinnati Art Galleries.*

Rembrandt," "after Velásquez," or "after Frans Hals" (figs. 4.4 and 4.5). The portrait heads, in the Rookwood Standard glaze line, were highlighted on a dark background, recalling not only their seventeenth-century predecessors but also Munich school works then popular in Cincinnati.[22] The fact that nearly all of the decorators had been trained as easel painters in art academies in the U.S. and abroad makes it likely that they had copied Old Master paintings previously as part of their studio training.[23] Typical nineteenth-century academic methods required the student to systematically copy Old Master paintings so that "their positive qualities would be absorbed by him and reflected in his own work."[24] In Europe, among the most admired Old Masters were Rembrandt, Velásquez, and Hals. Thus it is probable that Rookwood's decision to produce Old Master copies was facilitated by academic training methods in use in Europe and at the Cincinnati Art Academy, where

after 1896 classes were reorganized to resemble Parisian ateliers.[25] The sources that were copied are not precisely known, but were almost certainly not original paintings because the Cincinnati Art Museum's collections did not include Old Master originals until the twentieth century. However, they did have many copies of Old Masters after 1881.[26] Indeed, firms such as Elkington, Mason and Co. existed solely to produce exact replicas of superior objects for collectors and the many newly built museums that did not have access to the originals.[27] In addition, the Pottery had an extensive art library, and there were many available publications about, and reproductions of, Old Master paintings. For example, the earliest biography of Rembrandt had appeared in German in 1675, with publications in Italian, French, and Dutch following soon thereafter.[28] English language publications lagged somewhat behind, but many were available by the 1890s and were reviewed in general circulation periodicals, which would have been readily accessible to a wide audience.[29] Photographs of Old Master paintings were also widely distributed through such firms as Berlin Photographic Company (which had a branch in New York) specializing in photographic reproductions of modern and Old Master paintings, engravings, and sculpture,[30] or through the Autotype Fine Art Catalogue which reproduced Old Masters from the Louvre, Uffizi, Pitti, Dresden, Frankfurt, and Amsterdam museums.[31] For example, two of the portraits which appear on several different Rookwood vases and plaques were copies of Rembrandt's *Man with a Fur Bonnet* (at that time in the collection of the Hermitage, but known to have been sold by Autotype Fine Art) and Velásquez's *Admiral Don Adrian Pulido Pareja* (known to have been sold by Berlin Photographic Co.).[32]

The Old Master copies were made at the Pottery from 1895 to 1903. The primary reason for the cessation of this venture was probably the declining popularity of the Standard glaze line in favor of lighter wares, but was in some measure also due to the departure from the decorating department of the key practitioners: Grace Young, who went to Europe for further study in 1903, and Sturgis Laurence, who moved to New York to run the Pottery's architectural faience division in 1904. Beginning in 1905, Rookwood decorators began imitating another type of

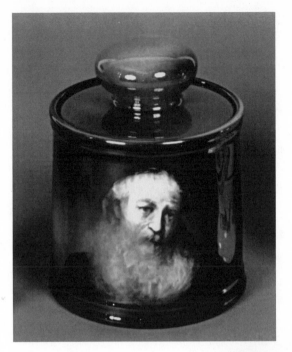

FIGURE 4.4. Sara Alice Toohey, *Tobacco Jar: Portrait of an Old Man,* 1895, Standard glaze line. *Courtesy of Cincinnati Art Galleries.*

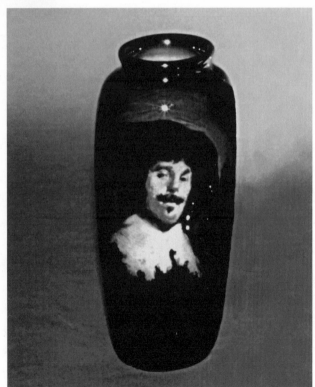

FIGURE 4.5. Grace Young, *Vase: After Frans Hals,* 1903, Standard glaze line. Collection of Mr. James J. Gardner.

fine art currently popular in the United States: Tonalist landscape painting.[33] These landscapes on both vases and plaques, known as "Scenic Vellums," were made possible by the development of a translucent mat glaze known as Vellum that "partakes both to the touch and to the eye of the qualities of old parchment." It was quite novel because while other mats were opaque, Vellum was translucent, making it possible for an underglaze slip decoration to be seen through it. Importantly, the glaze was devoid of luster and exhibited a slight haze, providing a gauzelike veil over the composition. Anita Ellis has noted that at this time all other translucent glazes were of the high-gloss variety which would obscure the evocative, quiet Tonalist mood because of their glossy surface.[34] Because the rounded surface of a vase made it difficult to impose a vanishing point, landscapes were reduced to a formula based upon horizontal bands and vertical lines. Most examples of Scenic Vellum have an irregular band, usually in a dark color around the base to suggest grass or undergrowth and trees, also in dark colors growing up from the base to establish the foreground. Behind the trees is a course of water, more trees or hills which define a mid-ground, with distance suggested by small forms painted in cool colors. The scheme is completed by colorful skies suffused with light. Spatial depth is implied via diminution of decorative forms and/or by tonal variations which suggest atmospheric space (plate 4). The Scenic Vellum plaques, even more firmly embedded in the oil-on-canvas convention, were framed in oak and given titles such as "Edge of the Forest," "Early Blossoms in the Spring Sun," "Winter Enchantment," and "The Drooping Pine"[35] (plate 5). The plaques and vases employ three main categories of subject matter: landscapes of the Ohio River valley, snow-capped mountains from the western United States, and scenes of the Venetian lagoon.[36]

Unlike the Old Master paintings, which would have been known through books, magazines, catalogues, and copies, Rookwood decorators would have had firsthand knowledge of Tonalist landscape paintings through their connections with the Art Academy, local exhibitions, and the painters themselves.[37] Between 1895 and 1922 there were at least ten exhibitions at the Cincinnati Art Museum in which Tonalist works

by George Inness, James McNeill Whistler, and others could be seen. Exhibitions also included Tonalist photography by Edward Steichen, Alfred Stieglitz, and Clarence H. White.[38]

In addition to donating ware to art museums and decorating vases and plaques with copies of Old Masters or imitations of popular Tonalist oil paintings, Rookwood management also situated the manufactory itself as a sort of museum, offering guided tours on a daily basis (except Sunday, when the Pottery was closed). Company publicity brochures boasted ten thousand visitors per year.[39] Rookwood was included in the 1896 edition of *King's Handbook of the United States*, which lists attractions by state and by categories such as government, education, culture, newspapers, manufactures, railroads, and canals. Rookwood was situated not in the manufactures section but in the culture section (with the Cincinnati Art Museum and Art Academy) where it was described as "one of the most successful and most creditable of these [pottery] efforts." Later in the entry it is noted that "the financial side of the enterprise remains . . . subordinate to the artistic."[40]

Differentiating Rookwood from Other Ceramics

The artistic nature of Rookwood pottery was also emphasized in advertisements. For example, in an advertisement (fig. 4.6) titled "The Twelfth Annual Exhibition (London 1887) of Paintings of China," the copy alludes to Rookwood's artistic qualities by quoting the judges' remarks verbatim: "The judges wish to call particular attention to the ornamental works from the Rookwood Pottery of Cincinnati. They desire to express their highest admiration of these exceedingly beautiful works of art, and to state that their inability to classify it with the other exhibits alone prevented its receiving one of the very highest awards." The exhibition referred to was the yearly china painting competition organized by the firm of Howell and James, who were fine china and glass dealers. These competitions were patronized by members of the royal family, who provided prizes, and judged by distinguished Royal Academicians

(in this case Frederick Goodall and H. Stacey Marks). Howell and James, as Rookwood's London agent, invited them to participate even though their ware could not compete as it was neither porcelain nor china painting in the traditional sense.

The "inability to classify" Rookwood noted by the judges bears remarking because it points to the central concern of the Pottery in the 1880s and 1890s: product differentiation. During this period the market for ceramics in the United States was dominated by porcelain such as Royal Worcester from England, Sèvres from France, and Meissen from Germany. In additional there were several American porcelain manufactories that copied contemporary European ceramics in both shape and decoration. Although porcelain could be hand painted, it was often decorated with transfer-printed patterns.[41] Rookwood was not porcelain but hand-painted faience or pottery—comprising a combination of clay types somewhere between earthenware (which will not hold water unless it has a glassy skin or glaze applied) and true porcelain. Typically, faience or pottery had utilitarian associations whereas porcelain had "artistic" or aristocratic associations. Taylor repeatedly answered critics that "we are not making porcelain and those to whom the exquisite finish and somewhat mechanical decoration of Royal Worcester or similar wares appeals exclusively will not want ours."[42] He goes on to say, "The great majority of people know nothing at all about the difference in quality of work and even those who do are apt to have their ideas of artistic ware centered upon such work as the Royal Worcester etc."[43]

During the 1880s and 1890s Rookwood was primarily known for its Standard glaze line (cf. plate 2, figs. 4.2, 4.4, and 4.5). In fact, at the 1900 Paris World's Fair, company-generated publicity referred to Standard ware as "Le Type Rookwood."[44] In addition to the dark glazed ware that characterized the Standard glaze line, beginning in 1893 Rookwood also produced light high gloss ware known as Sea Green and Iris (cf. plates 6 and 7).[45] Production of all of these richly glazed lines entailed many technical problems such as crazing or cracking, pinholes, peeling, blistering, or cratering. Such problems were a constant source of

THE TWELFTH ANNUAL EXHIBITION (LONDON, 1887) OF PAINTINGS ON CHINA.

Judges — FREDERICK GOODALL, R. A., H. STACY MARKS, R. A.

The most notable and important exhibit was that of the Rookwood Pottery, which was universally so characterized, and to which the judges gave the following testimonial:

"The Judges wish to call particular attention to the ornamental works from the Rookwood Pottery of Cincinnati. They desire to express their highest admiration of these exceedingly beautiful works of art, and to state that their inability to classify it with the other exhibits alone prevented its receiving one of the very highest awards." ROOKWOOD POTTERY, Cincinnati.

FIGURE 4.6. Rookwood advertisement, 1887. From Century 34, 6 (October 1887): 22.

discomfiture to Taylor, who wrote to an agent in New Brunswick, "If the crazing is of more importance to you than the artistic quality of the ware . . . you will never have any success in selling it. Anyone who wants that sort of technical smoothness can find . . . all he wants in the commonest white ware."[46]

In other advertisements from the late 1880s, also published in Century, Taylor concentrated more on the "art" quality of Rookwood pottery in a clear bid to not only establish its desirability despite its imperfections, but also to distance it from porcelain such as Royal Worcester, which dominated the United States market.[47] In February of 1886 an advertisement (fig. 4.7) ran which noted that "The artistic quality that gives true value to faience is chiefly found in pieces 'thrown' upon the Potter's Wheel, where the subtle touch of the hand gives beauty to the form . . . the brush of the artist decorates. . . . [B]y these processes each piece of Rookwood has the individuality of a painting." An advertisement (fig. 4.8) from May of 1886 notes that "The work is done by artists trained not only in the great technical difficulties of underglaze painting, but in decoration as a fine art. They are also given the utmost freedom in the choice and character of their designs. The results obtained are entirely distinct from mechanically decorated ware." These advertisements,

ROOKWOOD POTTERY.

CINCINNATI.

The artistic quality that gives true value to faïence is chiefly found in pieces " thrown " upon the Potter's Wheel, where the subtle touch of the hand gives beauty to the form. These shapes, while yet soft clay, the brush of the artist decorates, and they are next fired into " biscuit "; then dipped in glaze for rare tones of color and again fired. By these processes each piece of Rookwood has the individuality of a painting.

The Rookwood Ware may be found with a leading dealer in each large city, or inquiries may be addressed to the Pottery.

FIGURE 4.7. Rookwood advertisement, 1886. From *Century* 31, 6 (April 1886): 19.

which link slight imperfections to the presence of the hand of the artist, effectively shore up the notion that artistic individuality is to be valued over and above technical perfection. They also signal an awareness of the Arts and Crafts tenets eschewing machinery and machine-made objects.

During the 1890s, Rookwood management was preoccupied with expansion of the physical plant, and most of the company's advertising was placed by its retail agents. This apathy toward advertising shifted in 1904, when in an effort to offset "extra-ordinary dullness in trade," William Taylor retained the Chicago office of J. Walter Thompson Company, one of the country's leading advertising agencies, to plan an advertising and promotion campaign. This crusade, discussed in more detail in chapter 6, included a new series of magazine advertisements and a publicity brochure that left absolutely no doubt about how management wished Rookwood to be viewed. The pamphlet begins: "Whatever artistic satisfaction lies in Rookwood is due first to the individuality of its artists, to their freedom of expression in the ever-changing language of an art that never repeats itself. . . . Rookwood cannot be understood without an appreciation of its radical difference from commercial industries. . . . Where artistic expression is the first consideration financial return must be secondary."[48]

> The beauty and originality of the decoration in Rookwood ware are gained in two ways.
> The work is done by artists trained not only in the great technical difficulties of underglaze painting, but in decoration as a fine art. They are also given the utmost freedom in the choice and character of their designs. The results obtained are entirely distinct from mechanically decorated ware.
>
> The Rookwood Ware may be found with a leading dealer in each large city, or inquiries may be addressed to the Pottery.
>
> ROOKWOOD POTTERY, CINCINNATI.

FIGURE 4.8. Rookwood advertisement, 1886. From *Century* 32, 6 (October 1886): 24.

Advertisements generated as part of this campaign reinforce the notion that Rookwood should be thought of as fine art and the manufactory as "an artist's studio" (fig. 4.9). For example, a 1905 pitch (fig. 4.10) suggests that Rookwood is the best gift because "no piece is ever duplicated and the piece you have is an original painting on pottery." Even more explicit is an advertisement (fig. 4.11) pointing out that "a vase made at Rookwood has the individuality of a fine painting. It is designed, decorated and signed by the artist just as a canvas is." Finally, in 1906 (fig. 4.12) prospective buyers were told that "The quality which distinguishes an object of art from a factory product demands of its makers originality in artistic conception and execution, the absence of mechanical repetition, and joined to these the highest technical skill."

Cultivating the Press

In addition to the magazine advertisements and company publicity, Taylor also courted serious writers for national publications. Very little had been written about American art pottery prior to 1891 when Edwin AtLee Barber of the Pennsylvania Museum and School of Industrial Art

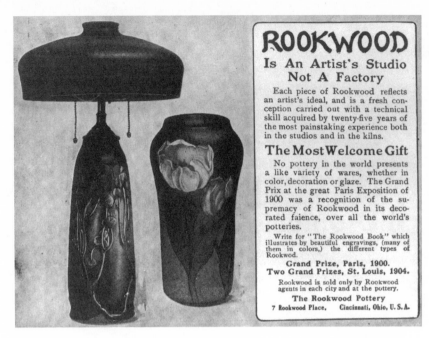

FIGURE 4.9. Rookwood advertisement, 1906–7. From *The Thompson Blue Book on Advertising* (Rochester, N.Y.: J. Walter Thompson Co., 1906–7).

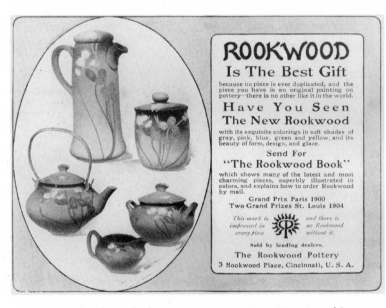

FIGURE 4.10. Rookwood advertisement, 1905. From *House Beautiful* 17, 5 (April 1905): 50. *Courtesy, The Winterthur Library: Printed Book and Periodical Collection.*

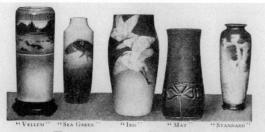

"VELLUM" "SEA GREEN" "IRIS" "MAT" "STANDARD"

Rookwood Pottery

In its unlimited range of color in glazes of varying texture Rookwood Pottery to-day offers contrasts surprising to persons familiar only with brown Rookwood or "Standard." And the Rookwood feeling is present in every type.

A vase made at Rookwood has the individuality of a fine painting. I is designed, decorated and signed by the artist, just as a canvas is. The idea is never duplicated; each piece is a new creation of the artist.

The high rank of Rookwood among the world's ceramics is expressed by the awards conferred upon it by experts at the world's great expositions. The gold medal at Paris in 1889, was followed by the highest honors at Chicago in 1893, and at Buffalo in 1901; the Grand Prix at Paris in 1900; and two grand prizes at St. Louis.

Rookwood is on sale by special agents in all large cities. A Book, giving an idea of the varied Rookwood types, with prices, will be sent upon request to the Rookwood Pottery, Cincinnati

Look for this mark on ever piece of Rookwood.

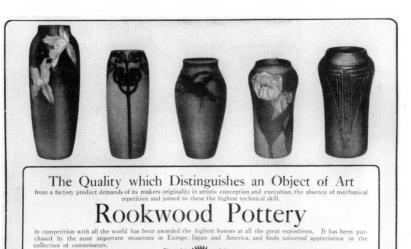

The Quality which Distinguishes an Object of Art

from a factory product demands of its makers originality in artistic conception and execution, the absence of mechanical repetition and joined to these the highest technical skill.

Rookwood Pottery

in competition with all the world has been awarded the highest honors at all the great expositions. It has been purchased by the most important museums in Europe, Japan and America, and finds universal appreciation in the collection of connoisseurs.

Grand Prix. Paris. 1900. This mark is impressed in every piece and there is no Rookwood without it **Two Grand Prizes. St. Louis, 1904.**

The Rookwood Book will be mailed on request to those who wish to see colored plates and other illustrations of the various types as far as they can be reproduced. Rookwood is sold only by Rookwood agents in each city and at the pottery. THE ROOKWOOD POTTERY COMPANY, 2 ROOKWOOD PLACE, CINCINNATI, U. S. A.

FIGURE 4.12. Rookwood advertisement, 1906. From Country Life in America 9, 4
(February 1906): 398. Courtesy, The Winterthur Library: Printed Book and Periodical Collection.

in Philadelphia published the first of several articles in the *Popular Science Monthly*. As mentioned earlier, Taylor assiduously cultivated Barber, exchanging letters and visits, and providing him with samples of various Rookwood wares which all but guaranteed Rookwood's inclusion in Barber's monumental treatise, *The Pottery and Porcelain of the United States*, published in 1893. Taylor also provided information and hospitality to other authors who enthusiastically subscribed to the ideal of the Rookwood Pottery as an "artist's studio, not a factory." For example, A. O. Elzner, writing in *The Architectural Record* in 1905, commented, "It must be noted that the Pottery is conducted not on the prevailing factory system. . . . [On] the contrary the effort is to attain a higher art rather than a cheaper process."[49] Nicholas Hungerford wrote that "The Pottery is managed in a fashion very unlike that of an ordinary commercial enterprise. . . . Like any other object of art the qualities of Rookwood are largely the result of the decorative processes peculiar to its making."[50] Another author writing in *The Clay Worker* in 1904 pointed out that "In the effort to attain a higher art, rather than cheaper processes, the Pottery is managed on lines opposite to the prevailing factory system. Mechanical repetition is avoided. Each piece is a fresh and independent rendering of its motive. . . . A spirit of liberality has encouraged the decorators in every way to cultivate individual artistic feeling."[51] These quotations demonstrate that culture and commerce were held in opposition. The factory was associated with profit and compromise of individuality. The artist's studio was without regard for profit and thereby uncompromised. Inevitably, Taylor himself wrote about the artistic aspects of Rookwood in *Forensic Quarterly* in September 1910. In this article he employs much of the same rhetoric found in the advertisements and the company brochures, many of which also came from his pen. Taylor claimed that Rookwood had "no theories about art." He further asserted the notion of individuality, saying, "Rookwood . . . does not say to its artists you must do this thing or that thing in this way or that way," and noted that "freedom to follow inspiration is the very breath of life to the artist. His initiative must be absolute."[52]

Rhetoric versus Reality

Taken together, donations to museums, vases and plaques that copy or imitate oil paintings, the advertisements, the company brochures, and journal articles by Taylor and others present a clear picture of the ways in which Taylor marketed Rookwood pottery as fine art. Yet the actual circumstances of production within the firm demonstrate a great deal of slippage between the rhetoric and the reality. For example, despite claims to the contrary, decorators did not have the freedom to paint what they wished. Indeed, Taylor's pronouncements in *Forensic Quarterly*, which implied total artistic freedom on the part of the decorators, were flatly contradicted by Albert Valentien, a senior decorator at Rookwood from 1881 to 1905 and head of the decorating department for several years. He wrote, "From time to time the individual artists had essayed to revolutionize Rookwood's styles of decorating . . . but all to no purpose . . . the pottery buying public must be pleased, salaries and expenses must be paid, etc. etc." He went on to note that "Much has been said and written from time to time in different magazine and newspaper articles that has been absolutely absurd in reference to Rookwood and which has been treated as huge jokes by the employees of that institution." Valentien's comments make it evident that despite claims in advertisements, brochures, and journal articles about "freedom of expression" and the "individuality of its artists," the decorators were not permitted to depart from the lines of decoration which had proven financially successful.[53]

This information points to a disjunction between management's marketing tactics, which included promoting the image of Rookwood ware as fine art, the company as an artist's studio, and the workers as individuals free to follow their inspiration, and the actual circumstances of production as gleaned from corporate correspondence and firsthand accounts. What then was the significance of presenting Rookwood ceramic ware as fine art? Why would a decorative object manufactory position itself as an artist's studio—that is, seek means actively to disguise the nature and scale of its production? Moreover, how do we explain

Rookwood's practice of copying Old Master paintings? Rookwood management prided itself—based the corporate identity—on unique art objects that bore none of the taint of reproductive processes. Yet Rookwood openly and unapologetically reproduced these paintings, going so far as to feature some of them in a promotional brochure published in 1901–2. What follows argues that Rookwood positioned itself as an "artist's studio, not a factory" in an effort to appropriate for its wares the aura and cachet of fine art. Notions of individuality, freedom of expression, and conceptions of fine art and culture are closely linked to the debate about machinery and industrialization during this period. In order to support these claims it is necessary first to historicize the boundaries between fine art and decorative art and to clarify some of what fine art signified in the United States during this period.

Boundaries between Fine Art and Decorative Art

One of the features of post-Centennial design reform (see chapter 3) was the integration of art into industry. Through this union it was thought that better objects could be produced which would both improve taste and appeal to those with a more discriminating eye. "Art" in this context was a vague and capacious term which included both fine art and decorative art.[54] In addition to the movement of art into industry, during the late nineteenth and early twentieth centuries many fine artists turned to decorative projects. Some "fine artists" approached decorative work as a means of recreation and entertainment, such as the twelve members of the Tile Club. Founded in 1877, its members met regularly for nearly ten years to decorate tiles and to socialize.[55] Others viewed decorative projects with considerable ambivalence, fearing that such work would threaten their standing as "serious" artists. For example, Maria Oakey Dewing, a painter of floral still lifes, considered her sorties into needlework less meaningful than her work as a painter in oils, admitting that she rarely let "these passing attacks have the least publicity."[56] Other artists—including many who worked at Rookwood—used

decorative work as a convenient means of supporting themselves dur-
ing their student years and abandoned it as soon as they had established
their reputations as painters.[57]

There were other artists in the United States who followed the ex-
ample of the influential teacher and popular French artist Jean-Léon
Gérôme, who treated decoration not as a matter of pleasure or profit
but with serious artistic purpose. Gérôme had engaged in several deco-
rative projects during his career, among them a number of murals and
the frieze on a large Sèvres vase.[58] Many of his American students demon-
strated a similar willingness to attempt decorative work. Will Low painted
murals and executed panels for furniture. Thomas Eakins produced re-
liefs for use as chimneypieces. One of the most celebrated of the artist-
decorators was John La Farge, perhaps the most articulate in discussing
contemporary perceptions about the boundaries between the fine and
the decorative arts. Like British reformers William Morris and John
Ruskin, La Farge found reason to lament that painting and sculpture had
been separated from decorative art, viewing this as a diminution of the
artist's function. "We have been seeing the artist (I have to use this spe-
cial term), as more and more and more separated from the artisan (an-
other term which is also disagreeable to me because it helps to keep up
this absurd artificial classing)." La Farge noted in 1906, "Instead of lift-
ing the artist, this has degraded him. . . . [He] sought to make his pic-
tures by recalling stories, or subjects, or intentions, or using studies
from nature, and polishing them out of their natural appearance, in-
stead of carrying all these things out through the physical qualities and
advantages of his art."[59]

Thus, in the late nineteenth and early twentieth centuries in the
United States there was some overlap between the fine arts and the dec-
orative arts. Fine artists worked on decorative projects as a means of en-
tertainment, for financial gain, or, rarely, as in the case of John La Farge,
as a primary means of expression. Yet despite calls for a breaking down
of boundaries on the part of fine artists like La Farge or proponents of
craft reform like Ruskin and Morris, there was nonetheless a perception
of difference between the fine arts of painting and sculpture, which had

higher status than the decorative arts and crafts. Some authors viewed this distinction as one of degree and not kind. According to the first president of the Society of Arts and Crafts, Boston, Charles Eliot Norton, decorative and fine art exist on a continuum, but fine art was more to be admired because it inevitably expresses more individuality.[60] What follows argues that Rookwood management sought to turn this distinction to its advantage by attaching to its ware the individual self-expression thought to accrue to painting and sculpture.

Art as an Ordering Force

It is hard to overestimate the reverence accorded to painting and sculpture in the United States during the late nineteenth and early twentieth centuries when, as discussed in chapter 3, many educated middle-class persons experienced anxiety and feelings of self-fragmentation as a consequence of myriad social, physical, and economic changes.[61] The contemplation of art was thought to provide a refuge from both feelings of fragmentation as well as the remorseless pressures of business life and cutthroat competition. This notion appears as early as 1855 in the *Crayon*, an art magazine published in New York City from 1855 until 1861. Editors W. J. Stillman and J. Durand proposed that "Beauty is the antidote to those wearing, consuming cares of the material life."[62] In an 1888 address before the Art Institute of Chicago entitled "Art: Its Influence and Excellence in Modern Times," president Charles Hutchinson asserted that art has the power to counter the dominant tendency of the age, materialism. He cautioned businessmen that they had no meaningful future ahead of them if they had "no time to devote to literature or art, no time for self-culture."[63] This latter role was underscored in an editorial in *Century* magazine in 1896, which pointed to art as a civilizing tool and strove to exercise "the good influence of art as an offset to the materializing tendencies of the age."[64] Thus, art and its contemplation were thought to play a therapeutic role by alleviating the physical

and psychological demands placed on the individual by the accelerated pace of the urban environment.

Similarly, art was viewed as a means to assist "foreign" or ethnic groups to adapt to mainstream Anglo-American cultural practices. This contention was based on the prevailing evolutionary paradigm in America in the late nineteenth and early twentieth centuries. Popularized by Herbert Spencer, it held that nature advanced harmoniously in an inherently moral universe toward higher forms of life.[65] In his scheme, evolution impelled human life toward a peaceful utopian state. Spencerian progress to a higher form of life was accomplished through adaptation to the environment (positive environmentalism). This meant that cultural institutions could have the all-important educational function of creating an environment that would promote harmonious integration among different segments of society. In line with the tenets of Spencerian evolution, architecture, the decorative arts, and especially the fine arts had an evolutionary role in promoting the forward trajectory of American society.[66] This notion of the therapeutic and assimilating potential of art and culture informed the founding of public art museums throughout the late nineteenth century. The country's first three major art museums—Museum of Fine Arts, Boston; the Corcoran Collection; and the Metropolitan Museum of Art—were all incorporated in 1870. Before the century was out they served as models for at least twenty-five art museums in other cities, among them the Cincinnati Art Museum (1881). Virtually all of these museums initially placed their emphasis on education, moral uplift, and social betterment.

Because instruction and moral uplift were primary goals and because funds for purchase were limited, acquisition of originals was not an overwhelming concern for the organizers of these early museums. When the quality of a museum collection was based on its educational value, authenticity and distinction, while not to be dismissed, counted less than coverage and reputation. As mentioned earlier with regard to the Cincinnati Art Museum, casts and photographs could supplement the initial inventory, in the interest of unfolding the vast yet clearly organized

panorama of art as deemed most worthy of notice in the history of art. Reproductions were widely available and provided an attractive means to acquire a comprehensive collection.[67] However, as will be discussed below, certain reproductions were considered to be acceptable substitutes for original works of art while others were not.

Around the turn of the century the focus of museums shifted from education and moral uplift toward aesthetic appreciation and specialized connoisseurship. In Boston, New York, and elsewhere, the 1890s brought more money and a new generation of trustees and advisors to the museums. These institutions now began to acquire more originals through donations, archeological expeditions, and purchase; by the early twentieth century, casts and other reproductions were increasingly viewed with derision. Henry James, writing about the Metropolitan, noted that "Acquisition—acquisition if need be on the highest terms—may, during the years to come, bask here as in a climate it has never before enjoyed. There was money in the air, ever so much money . . . and the money was to be all for the most exquisite things."[68] As reproductions were consigned to storage, museums increasingly played a role in choreographing the sacralization of art.[69] By lionizing the arts of Europe and of the past, often at the expense of living American artists, these institutions helped to solidify emerging definitions of what constituted "fine art." As interest in education waned, so too did the notion that art museums should play an assimilating role by being accessible to the working classes. In 1897 a plumber wearing overalls was denied entrance to the Metropolitan Museum on a weekday afternoon. In defense of this policy, museum director Louis P. di Cesnola told reporters, "We do not want, nor will we permit a person who has been digging in a filthy sewer or working among grease and oil to come in here, and, by offensive odors emitted from the dirt on their apparel, make the surroundings uncomfortable for others."[70]

Rookwood's obfuscation about the nature of their production and the alignment of their wares with painting and sculpture must be viewed within this evolving discourse of the late nineteenth and early twentieth centuries concerning art's role as an agent of instruction, assimilation,

and moral uplift (last quarter of the nineteenth century) and as a sought-after valuable commodity (after the turn of the century). A close reading of management-generated advertisements and brochures makes clear some of the ways in which Rookwood paralleled the discourse about art in the late nineteenth and early twentieth centuries. For example, Rookwood's advertisements prior to the J. Walter Thompson campaign were didactic and sought to educate the public about the pottery. To be sure, the ware was praised for its artistry, but it was presented more for its beauty and less as a status symbol (recall, for example, figs. 4.6, 4.7, and 4.8). The appearance of the advertisements with an emphasis on text suggests an effacement of the commercial in favor of educating the public. This approach parallels the way in which newly founded museums presented art objects, often reproductions, in the 1880s and 1890s —with an emphasis on education.

Rookwood's advertisements from the early twentieth century are much more expansive about the collectibility of the pottery as a status symbol and about its international awards. The advertisements are simpler with less text and more eye-catching typography and graphic design (recall, for example, figs. 4.9–4.12). Although Taylor seems to have been intent on positioning the company as an artist's studio throughout his tenure as Rookwood's manager (1883–1890) and president (1890–1913), there was a shift in emphasis at the time of the J. Walter Thompson advertising campaign. The 1904 campaign not only redirected the advertisements away from pure education toward consumption—emphasizing the ware as a commodity—but it was also the first time that so much individual attention had been focused on the decorators. Company literature issued prior to the J. Walter Thompson campaign had stressed the collective nature of labor involved in Rookwood production, with an 1890 advertisement showing a worker loading a kiln (fig. 4.13). An 1895 pamphlet, "A Visit to Rookwood," gives an account of a tour through the plant which concludes, "One is not then surprised to learn that a finished piece of Rookwood has passed through twenty-one hands."[71] In fact, prior to 1904, retailers occasionally wrote to Taylor to ascertain precisely who had decorated specific objects. Typically he replied, "In

regard to the individual decorator's signatures, I do not think it would be wise to give them. We have these put on mainly for our own convenience in tracing work and I think it rather misleading to attempt to give these in full . . . their merit is not great enough to deserve this much notice . . . the piece often is made what it is quite as much by the labor of others in the processes whose signature does not appear at all."[72] Certainly, there are many examples of workshop production from the Renaissance through the present. However, by 1904, Rookwood management clearly perceived one key difference between an artist's studio and a factory as a multiplicity of hands. At this juncture, one way to mark Rookwood as comparable to fine art was to focus on only one set of the twenty-one pairs of hands—the artist/decorator who signed the pot. Accordingly, lists of decorators and their ciphers (fig. 4.14) were published from time to time and buyers were encouraged to become collectors, even patrons, of the fine art of Rookwood pottery.[73] Again, this change coincides with the shift in emphasis of art museums from repositories of knowledge to segregated temples of the fine arts.

Art as a Status Symbol

It is hard to overestimate the role of the private collector/benefactor in building the collections of American art museums. In part, great collections were built in the late nineteenth and early twentieth centuries because of the concentration of wealth in the hands of the new industrial entrepreneurs, who had succeeded in 1895 in having the income tax declared unconstitutional. However, in addition to the increase in demand, there was also an increase in the supply of artworks available for purchase. As the great families of Europe experienced the results of revolt and reform, they began to have financial difficulties and consequently were willing to sell many of their possessions.[74] Because many of the wealthiest people in the United States at this time were of comparatively humble origin, a collection of masterpieces was viewed as a sure pathway to social acceptance.[75] Moreover the possession of rare art

The only award to American Pottery at the
Paris Exposition, 1889, was

A GOLD MEDAL TO ROOKWOOD POTTERY.

This ware may be found with a leading
dealer in each large city, or inquiries
may be addressed to

ROOKWOOD POTTERY, Cincinnati, Ohio.

FIGURE 4.13. Rookwood advertisement, 1890. From Century 41, 2 (December 1890): 42.

Decorators' Marks.

It is customary for the decorators to cut their initials in the clay on the bottom of pieces painted by them. The monograms are shown on the two pages below.

Mark	Name
A.R.V.	A. R. Valentien.
	Wm. P. McDonald.
	Matt. A. Daly.
a.m.V.	Anna M. Valentien.
	Grace Young.
H.E.W.	Harriet E Wilcox.
	K. Shirayamadani.
	Amelia B. Sprague.
	Sallie Toohey.
O.G.R.	O. Geneva Reed Pinney.
	Mary Nourse.
	Carrie Steinle.
C.A.B.	Constance A. Baker.
	Josephine E. Zettel.
LNL	Elizabeth Lingenfelter.
	Sallie E. Coyne.

44

Mark	Name
	John D. Wareham.
LA	Leonore Asbury.
SL	Sturgis Laurence.
R.	Fred. Rothenbusch.
	Edward G. Diers.
ETH	E. T. Hurley.
A.F.	Rose Fechheimer.
ERF	Edith R. Felten.
S.	Sara Sax.
	Charles Schmidt.
C.C.L.	Clara C. Lindeman.
LVB	Leona Van Briggle.
	Laura E. Lindeman.
I.B.	Irene Bishop.
S	Jeannette Swing.
HA.	Howard Altman.
VB.D	Virginia B. Demarest.
M	Marianne Mitchell.
C.F.B.	Caroline Bonsall.
G.H.	Grace M. Hall.
LEH	Lena E. Hanscom.

45

FIGURE 4.14. Decorator's marks, c. 1902.
From *Rookwood Pottery* (Cincinnati, 1902), n.p.
Collection of the author.

objects conferred a feeling of power and exclusivity with the additional benefit and satisfaction of beating rival purchasers. (It is ironic that art, which was thought to be an antidote to materialism, became, by the end of the century, one of the most conspicuous accouterments of the very wealthy.)[76] Finally, there was the nationalistic challenge of demonstrating that American wealth was capable of acquiring cultural achievements that could rival those of Europe. A great collection was one way of doing this.[77] American collections of mid-century were filled with the works of eminent academicians: Meissonier, Gérôme, Troyon, Fromentin, and Bouguereau as well as a few American artists such as Hunt, Church, Inness, and Cole. However, in the years after the Centennial, collectors began to include works by the Barbizon school and the Old Masters—especially seventeenth-century Dutch and Flemish works, eighteenth-century English paintings, and paintings by Velásquez.[78] Indeed, so avid were American collectors for Old Master paintings that European scholars became alarmed as an increasing number of national treasures were drained from their countries. Though there were no laws restricting exports in the 1890s, there was a 30 percent tax to import foreign artwork —this apparently was a "small" impediment for big-scale collectors like J. Pierpont Morgan et al. This resentment on the part of Europeans led to the publication of a number of articles with titles like: "American Competition in the Art Market and Its Dangers for Europe."[79] Throughout the 1880s and 1890s, European catalogues listed American-owned Old Master paintings in the "lost" column or disdainfully as "somewhere in the United States."[80] Not surprisingly, scholars in the United States took just the opposite view, commenting that "every Rembrandt and Velásquez that crosses the Atlantic gives a thrill of patriotic pride."[81] The American critic Frank Jewett Mather, Jr., in an article titled "The Drift of the World's Art toward America," suggested that the acceleration in American collecting could be dated to "the cultural moment of the Chicago World's Fair of 1893 . . . and to the Spanish American War of 1898, and our emergence as a world power."[82] As an example of the rate of collecting: in 1880 there were four Rembrandt paintings in the United States; ten more were added between 1880 and 1890; thirty-two more between 1890 and 1900; and forty more between 1900 and 1910.[83]

The quantity of Old Master paintings was not the only point of discussion; there was equal concern about the quality and about the prices paid. Americans were often depicted as "idiotic millionaire art-collectors," who were either too avaricious or too stupid to realize they were being cheated.[84] John Smith writing in the *Magazine of Art* in 1888 rather haughtily noted that "until I took up my residence in America, I never knew where the sweepings of the Parisian studios eventually congregated."[85] In the mid-1890s the average price for an Old Master painting was between $20,000 and $50,000. By 1910 Rembrandt paintings were selling for $250,000. H. O. Havemeyer, who had an entire room of Rembrandt paintings in his New York mansion, wrote in 1893 that "he preferred to put his money into 'blue-chip' pictures rather than to speculate on the avant-garde."[86] Because of the huge sums involved, many U.S. collectors worked with dealers such as Joseph Duveen and experts such as Bernard Berenson, both of whom acquired a great deal of power and influence and undoubtedly shaped many private collections of the late nineteenth and early twentieth centuries.[87] However, other experts such as Wilhelm von Bode, Max J. Friedlander, or T. W. R. Valentiner indirectly influenced collecting in the United States through their catalogues and journal articles. There is little doubt that an expert authentication could ensure or prevent an Old Master sale.[88] So, in the late nineteenth and early twentieth centuries in the United States, fine art became commodified. Old Master paintings were especially valued because of their comparative rarity, their status-conferring social cachet, and their ability to prove that American collectors were as good as, if not better than, Europeans (and by extension that America was as good as, if not better than, Europe). However, all of these later values—rarity, social cachet, nationalistic pride—were contingent upon the painting's authenticity and absolute uniqueness.

Not surprisingly, certain media that involved mechanical means of reproduction (such as the printmaking arts or photography) were problematic in the realm of high art. Chromolithography, the process by which original paintings were reproduced lithographically in color and sold in the millions to all segments of the population, was hailed by

some as a vehicle for bringing art within the reach of all classes. Yet E. L. Godkin, editor of the *Nation*, and a middle-class person traumatized by industrialization, inveighed against chromolithography as a force for cultural dilution. According to Godkin, chromolithography symbolized the packaged "pseudo-culture" that would lead to a "kind of mental and moral chaos." Not surprisingly, at the 1876 Philadelphia Centennial —when art was largely valued for its educational and morally uplifting attributes—chromolithographs were exhibited along with paintings and sculptures. However, at the 1893 World's Columbian Exposition—when art had been elevated to a status symbol—chromolithographs were classified as and exhibited with "commercial" arts.[89] The cultural exclusion of photography was closely related to the demotion of chromolithography. But while both photography and chromolithography could disseminate art among the masses, the camera could give a wide spectrum of people the very means of creating art. A process that rendered an expressive form relatively simple and accessible to large numbers of untrained amateurs was a radical departure from an ethos that judged art and culture to be the sacred unique products of the rare individual spirit.[90] Lawrence Levine has pointed out that "throughout the 1890s, anything mechanically reproduced—any expressive form in which a mechanical process stood between the creator and the product—struck many of the arbiters of culture as inauthentic and therefore not to be accorded artistic status. The Industrial Revolution had produced sufficiently unwelcome changes from within its factory citadels, it could not be allowed to invade the precincts of Art."[91] Presumably the lack of authenticity was attributable not only to the sheer fact of duplication but more importantly to the mechanically reproduced object ceasing to directly express the spirit or personality of its creator. It was commonly held that direct mental and physical involvement between artist and materials was of crucial importance in producing auratic qualities in an artwork. The artist was perceived as having both the imagination to conceive the work and the manual dexterity to execute it.[92] Writing about chromolithographs, an article in the *Nation* asserted that "The touch of the master's hand on the canvas can never be reproduced by

the press."[93] Writing in 1936, Walter Benjamin maintained that in "the age of mechanical reproduction" the "aura" of a work of art, its unique existence, withered and its traditional value was liquidated.[94]

With this in mind, one can more easily grasp the significance of Rookwood's language about one-of-a-kind art objects. In order to be valued as art, their "aura" had to be assured, and one way this could be accomplished was to banish any mention of industrial production or reproduction while simultaneously asserting the freedom of expression (a key quality separating fine art from decorative art) evident in the object's creation. However, Rookwood management also asserted the fine art status of its wares precisely through reproduction. Although Rookwood did not reproduce its own hand-painted wares, as mentioned earlier, it was not in the least reluctant to produce hand-painted copies of Old Master portraits. Indeed, there is a long history of copying well-known oil paintings onto ceramic ware.[95] Presumably this sort of duplication did not diminish the fine art status of Rookwood and other ceramic ware; rather it caused the aura of the original oil paintings to be transferred to or shared by these decorative objects. It might be said that the preservation of an object's aura was dependent on the degree to which the reproduction process was construed as an independent, aura-producing enterprise in its own right.[96] As mentioned above, some types of reproductions were perfectly acceptable, even desirable, in the hallowed halls of art. What was not acceptable was either a reproduction that did not exemplify a creative human presence (mechanical) or a reproduction which was deceptive (pretending to be what it was not).[97]

Although Rookwood's Tonalist vases and plaques were not copies in the same way the Old Master portraits were, their significance can nonetheless be examined by assessing their relationship to the Tonalist oil paintings they sought to emulate. These paintings by artists such as Thomas Wilmer Dewing, George Inness, Dwight Tryon, and Alexander Wyant among others evoke a mood of reverie, nostalgia, and unfulfilled longing. According to critic Sadakichi Hartman, they did not want "representation of facts, but of appearances or merely the blurred sugges-

tion of appearances."[98] They were fundamentally anti-realist and anti-scientific. They were unsympathetic to French Impressionism while sympathetic to the Barbizon School, which they felt held both an aesthetic and an attitude toward nature similar to their own.[99] For the most part, the Tonalist painters exalted themselves and demeaned the masses, holding the latter incapable of understanding the beauty and ideals of their art. For this reason Dewing refused to exhibit his work in the 1901 Pan-American Exposition, believing that it would be above the heads of the "great public" as his work belonged "to the poetic and imaginative world where a few choice spirits live."[100] George Inness reportedly sought a public "who would appreciate art for art's sake, buy pictures because they love them, and not be led by the nose by the dealer."[101] Detroit industrialist Charles Lang Freer was the most prominent collector of Tonalist paintings, patronizing both Thomas Wilmer Dewing and Dwight William Tryon.[102] However, many prominent Old Master collectors such as the H. O. Havemeyers also collected Barbizon paintings, which to the average viewer were very similar to the American works.[103] In 1904 a group of New York collectors had organized the Comparative Exhibition of Native and Foreign Art held in the galleries of the American Fine Arts building. The exhibition consisted of two hundred paintings from private collections, predominately landscapes by French Barbizon painters and American Tonalists. By placing American landscape painting alongside works by Barbizon artists, the organizers implied that the Americans were heirs to the European landscape tradition.[104] As mentioned earlier, Rookwood decorators would have had firsthand knowledge of Tonalist works from exhibitions held at the Cincinnati Art Museum. It is likely that they painted Tonalist landscapes for some of the same reasons they copied Old Master portraits, that is, to "borrow" their prestige and social cachet. It is not known why these two categories of fine art were selected, but possible partial explanations include their "blue chip" status and the availability of examples to copy (Old Master portraits) or to emulate (Tonalist landscapes). Quite apart from Rookwood's "fine art" pretensions, there was a long tradition of depicting landscapes on ceramic and glass ware. The careers of many Barbizon painters began

in the ateliers of porcelain manufacturers, where the subjects they depicted on plates were similar to those of their easel paintings.[105] Rookwood decorator Sturgis Laurence had painted landscape plaques during his tenure at Ceramic Art Company in the early 1890s.[106]

Unlike the short tenure of Old Master portraits, Rookwood continued to produce Tonalist vases and plaques until 1948. Although American painters of insubstantial, Tonalist landscapes and figures constituted an active and considerable group well into the second decade of the twentieth century, Rookwood's vases and plaques were marketed well past the time when this mode of expression was prestigious in fine art circles.[107] Anita Ellis has suggested these wares may have been produced as long as decorators who came of age as artists during the Tonalist era (1880–1910) remained at the Pottery.[108] While this is undoubtedly the case, the Pottery would not have continued production of any type of ware that did not find a ready market—leading to the question of just why these wares had such longevity. The most likely explanation seems to be that they were landscapes; a genre that transcends socioeconomic, geographic, and ethnic divisions both in the late nineteenth century and today.[109] Moreover, the subjects of the Rookwood Scenic Vellum ware—the Ohio River valley, the American West, and depictions of Venice—were likely to appeal to a broad range of tastes.[110] For example, the scenes of the Ohio River Valley might appeal to a local audience; views of the American West could play into the national fascination with the vanishing frontier (discussed in chapter 5); and representations of Venice would have reminded wealthy Americans of travel experiences as well as of fine art depictions of the city by Whistler, Sargent, or Maurice Prendergast.[111] At heart, these landscape depictions are profoundly conservative, ignoring more recent trends and fashions in painting such as Impressionism and Post-Impressionism.[112]

Although almost nothing specific is known about the consumers for the various Rookwood wares, we do know that many collectors of painting and sculpture also acquired some form of ceramics—usually from Europe or Japan. Although a Rookwood vase cost far less than an Old Master or a Tonalist painting, the prices of Rookwood ware (with

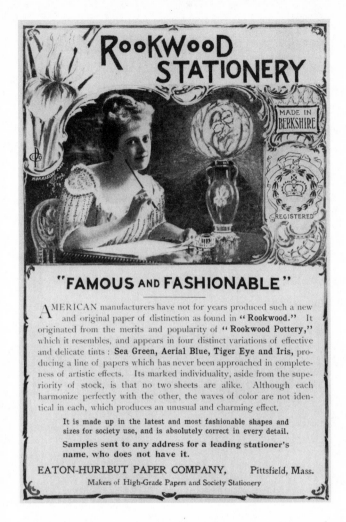

FIGURE 4.15. Rookwood Stationery advertisement, 1900. From *Ladies' Home Journal* 17, 12 (November 1900): 48. *Courtesy, The Winterthur Library: Printed Book and Periodical Collection.*

many objects costing $100 or more) seem to have limited its acquisition to middle- or upper-class consumers.[113] Indeed, the high cost of certain vases painted by certain well-known decorators may have reinforced their status as fine art. Although the price alone doesn't validate or invalidate such claims, it does say something about how various objects functioned in society. Rookwood's advertisements and promotional materials suggest that by claiming for Rookwood pottery the fine art attributes of authenticity, individuality, and uniqueness, management sought to invoke as well the rarity, social cachet, and nationalistic pride attached to fine art. In some measure these efforts were successful. The

Eaton-Hurlburt Paper Company used the Rookwood name for a line of stationery advertised (fig. 4.15) for its "artistic effects" and "marked individuality."[114] The Old Master portrait vases and plaques were the sole instance of fine art copying in the Rookwood corpus of this period. Here, ironically, fine art status was asserted precisely via reproduction. Whereas duplication would have destroyed the aura of a lesser image, duplication of Old Master paintings did not diminish the fine art status of Rookwood ceramic ware. Rather it caused the aura of the original oil paintings to be transferred to or shared by these decorative objects, just as art students slavishly copied these works in order to "absorb and then reflect" their positive qualities. Moreover, since these reproductions were images of originals owned by the rich, they permitted the less rich to share the wealth, share the same values, as part of the aesthetic trickle-down of this portable aura.

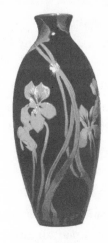

CHAPTER FIVE

AMERICANISM AND THE

CULTURE OF CRISIS

It is safe to assert that no ceramic establishment which has existed in the United States has come nearer to fulfilling the requirements of a distinctively American institution than the Rookwood Pottery of Cincinnati, Ohio.

Edwin AtLee Barber

IN addition to declaring the firm to be "an artist's studio, not a factory," Rookwood advertisements and promotional materials played up its awards from various international expositions. World's Fairs between the Centennial and America's entry into World War I featured a dizzying array of mechanical, artistic, and agricultural exhibits from many states and nations. Moreover, the rhetoric accompanying world's fairs made explicit the desire on the part of participants from the United States to distinguish themselves internationally, but as indisputably American, in both cultural and commercial spheres. At the time of the 1876 Centennial Exposition in Philadelphia, a self-conscious contemporary historian

wrote that many foreigners still had the impression that their host "was not fully out of the wood, that the chestnut burrs were still sticking in his hair, and that the wolf, the buffalo, and the Indian were among his intimate daily chums."[1] Ten years after the Centennial, the editor of *Courrier de l'Art* in Paris commented, "Blind those who do not wish to comprehend that on all sides, in the entire universe, they wage obstinate war against the industrial art supremacy of France."[2]

This chapter chronicles Rookwood's participation in major international expositions with attention not only to what was exhibited, but also to critical commentary from national and international sources. It is argued that Rookwood pottery, touted as distinctively American, must be viewed in an international context and that changes in the product line were often dictated by a need to remain internationally competitive. Contemporary fine art criticism helps elucidate what traits conveyed "Americanism." Although formal and thematic comparisons are of necessity imprecise, if only because of differences in media, the shared vocabulary between critical commentary on fine art and Rookwood pottery is indicative of their mutual engagement with the issues and themes of the Americanism discourse. Earlier scholarship has limited a consideration of Rookwood's Americanism to issues of native clay, workers, and decorative motifs.[3] Although such factors are undeniably important, there are clear exceptions (e.g., foreign workers or decorative motifs) that are still considered to be American. These are the cases that can best be explained by the close reading of contemporary commentary undertaken here.

The second half of the chapter is a case study of a group of objects considered to be particularly American that were featured in displays and publicity at all of the major international expositions from 1893 to 1904. These objects feature portraits of Native Americans copied from ethnographic photographs. Rookwood's Native American portraits functioned within the "culture of crisis" of the 1890s, wherein the very traits identified as distinctively American were thrown into question as a consequence of urbanization, industrialization, and immigration. They are enmeshed in the tensions within the doctrine of the strenuous life

that was proposed as a palliative for the crisis of individualism, namely the coexistence of nostalgia for Native Americans as a "vanishing" race and social Darwinian theories of racial superiority and imperial acquisition.

Participation in International Expositions

Rookwood missed no opportunity to exhibit its wares and gladly participated in many local exhibitions such as the Cincinnati Industrial Fairs and various Decorative Arts Society shows.[4] However, management clearly favored the larger international venues, which provided a wider exposure and potentially more prestigious rewards that could be used for advertising. The choicest pieces were hoarded for international displays, and these venues were utilized to focus public attention on new glaze lines and decorative motifs.[5]

Rookwood first received international exposure at the 1889 Exposition Universelle in Paris, winning a gold medal.[6] Manufactories were encouraged by the American government to exhibit at this exposition because it would be desirable for the advancement of the commercial interests of the United States. However, equally important was the sense of obligation to France for the assistance rendered during the Revolutionary War and the fact that 1889 was the centenary of the French Revolution, which gave impetus to "the establishment of republican institutions throughout the world."[7] Despite these governmental pleas, Rookwood and Hawkes cut glass were the only displays sent to Paris by U.S. potters and glassmakers. These wares were exhibited together in the booth of Davis Collamore and Co. of New York, a leading American retailer and importer of fine china, cut glass, and crystal. The Rookwood display was praised in the *Gazette des Beaux-Arts* for "the unusual brilliancy of color, and the combination of the use of artificially colored clay bodies, colored slip decoration and colored glazes, tinted with metallic oxides which were new to the European audience.[8] Maria Longworth Storer, as Maria Longworth Nichols had by now become, reported that

nothing else rivaled Rookwood's color and decorative effect except Gallé carved and LeGras's colored glass and that the ware created a real sensation.[9] Equally important for the Pottery was the sale of wares to foreign specialists or connoisseurs in ceramics.[10] These purchases meant that Rookwood ware was being studied by persons considered to be the world's experts on ceramics. Records indicate that Potter Palmer, a well known hotelier of Chicago, bought "the largest item in the display."[11]

Although the Rookwood display included an assortment of wares in production at that time, there is little doubt that the firm considered the premier attraction to be wares in the Tiger Eye and Goldstone glaze lines (plates 8 and 9).[12] In planning the shipment to Paris, Taylor noted that "these are the things to catch the experts and artists and one piece ought to have an entire small case to itself with a special colored drapery so as to give it every possible distinction."[13] He later wrote that when Goldstone was "shown at Paris in 1889 it roused a ceramic world which had been practically asleep for many decades."[14] Taylor was well aware of the likely appeal of these glaze lines and instructed Davis Collamore's representative in Paris, "we are willing to make a gift of the [Goldstone] vase to this committee. . . . [If] we seem close competitors for the highest prize it is likely to develop a hot fight before the jury and all sorts of influences will be brought to bear to prevent the award from leaving Europe and especially France to go to a little new American concern."[15]

Apparently, the "hot fight" predicted by Taylor did develop at the time the awards were conferred and published in August of 1889. Taylor, fretting about the possibility of the jury reversing its decision, threatened to cable Paris, "Beware possible intrigues against gold medal award Rookwood," but was persuaded not to by the Davis Collamore representative at the fair.[16] Nevertheless, once the award was assured Taylor immediately wired Paris for precise information about the classifications so that the announcement could be used for advertising purposes (fig. 5.1).

By 1893, Rookwood was featured at the World's Columbian Exposition in several different exhibits. This world's fair, America's first since the Centennial, was intended to "prove to the most doubting and criti-

AN Appropriate Gift for Christmas is a Piece of ARTISTIC POTTERY.

The
Rookwood Pottery

OF CINCINNATI,

has been awarded the

Gold Medal

AT THE PARIS EXPOSITION OF 1889.

The ROOKWOOD WARE may be found with a leading dealer in each large city, or inquiries may be addressed to the Pottery.

FIGURE 5.1. Rookwood advertisement, 1889. From *Century* 39, 2 (December 1889): 41. *Courtesy, The Winterthur Library: Printed Book and Periodical Collection.*

cal spirit that American art exists, that it is capable of great things and that it can do great things in a way distinctively its own." Moreover, the exhibition was virtually guaranteed to "increase the respect of foreigners for the people of the United States"—a point judged to be minor in comparison with the effect it would have for American self-esteem, which had been battered at the Centennial nearly twenty years earlier.[17] Rookwood's primary venue was the jewelry section of the Manufacturers and Liberal Arts Building.[18] The firm had been asked to participate in the collective exhibition of the U.S. Potters' Association but had declined. In explaining the reasons for this choice, Taylor wrote, "We have no desire to hold ourselves apart from the U.S. Potters' exhibit simply for the sake of separation, but our board are quite decided against collective exhibits themselves." Rookwood's solo installation mounted at the World's Columbian, shown in figure 5.2, was quite splendid, being bounded on two sides by heavy walls four feet high and three feet wide,

faced with large panels of fireclay body decorated with such designs as the whirling globe, typifying the potter's wheel; fire dragons; and the vase emerging from the glow of the kiln. On each side rose three slender columns of the same material twelve feet in height and of a rich malachite green which terminated in flame points of red and orange. At the back of the enclosure stood a cabinet containing the choicest pieces of Tiger Eye and Goldstone.[19] The second major display of Rookwood was comprised of ten pieces all decorated by Maria Longworth Storer on view in the Cincinnati Room in the Woman's Building. Cincinnati was the only city to have its own room in the Woman's Building, having been personally invited to do so by Bertha Palmer, president of the Board of Lady Managers and a Rookwood patron.[20] Reportedly, Rookwood was also exhibited in the Palace of Fine Art.[21]

Rookwood received a "highest award" at the Columbian Exposition, but since there was only one class of award, anyone who won received the same accolade.[22] In his report to the board of directors, William Watts Taylor dismissed the prize medal as "of trifling account" due to the system of awards.[23] However, the attention paid the ware by foreign and American critics was ultimately far more important than the official encomium. For example, Julius Lessing, in a lecture on recent acquisitions of objects of American Art for the Industrial Art Museum in Berlin, noted, "In American art pottery the collection of acquisitions contains some precious pieces, pitchers and vases from the Rookwood Pottery in Cincinnati; a wonderful effect is produced in them by the harmonious arrangement of color in refined gradations of tone."[24] A New York–based journal, *Engineering News*, reported that "M. Victor Champier, who was commissioned by the French minister of Public Instruction and Fine Arts to report on art industries and art schools at Chicago, presented Rookwood Pottery to the Museum of the Sèvres Manufactory, as being especially worthy of careful notice."[25] In a paper read before the Ceramic Congress at the World's Fair, Charles Fergus Binns of the Royal Worcester Porcelain Works began, "To take first the native production of which every American should be proud—the Rookwood Pottery of Cincinnati. You may handle and examine any piece of this ware, with

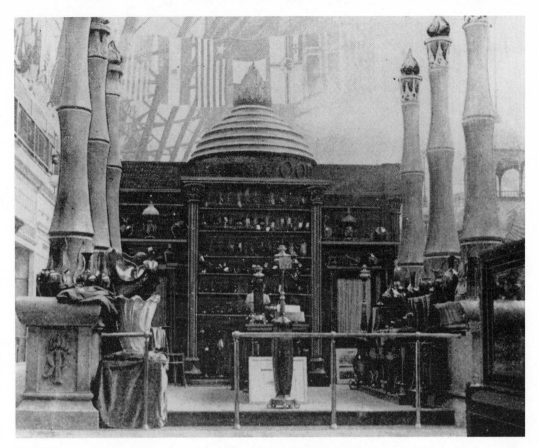

FIGURE 5.2. Rookwood exhibit at the World's Columbian Exposition, 1893. From Hubert Howe Bancroft, *The Book of the Fair* (Chicago and San Francisco: The Bancroft Company, 1893), 168. *Courtesy, The Winterthur Library: Printed Book and Periodical Collection.*

but very few exceptions, and derive the keenest satisfaction in doing so."[26] Finally, closer to home, Edwin AtLee Barber, ceramics scholar and author of *Pottery and Porcelain of the United States*, wrote, "The exhibit of Rookwood faience at Chicago commanded the admiration of the world. The English and French potters found in this marvelous development of an indigenous American art a never failing source of astonishment."[27] Taken together, these quotations support Taylor's claim to Rookwood's directors that "the tributes paid to the ware by the highest authorities at home and abroad and the permanent impression of its unique quality

made upon thousands who saw it for the first time, these are tangible results of the highest value."[28]

As had been the case at the 1889 Paris World's Fair, the main Rookwood display in the Manufacturer's and Liberal Arts Building included an assortment of ware currently in production. Reportedly, the pieces which attracted the most attention were some vases and plaques decorated with ideal and grotesque heads, figures of monks, and Native American portraits after engravings and photographs (see plate 10 and fig. 5.3). In addition, Rookwood had begun a collaboration with Gorham Manufacturing Company with the idea of having silver overlay designs applied to Rookwood pieces. These collaborative wares were among those included in the Chicago display (see fig. 5.4).[29]

William Watts Taylor went to Paris for five months in 1900 to supervise Rookwood's exhibit at the World's Fair, and to await the conferring of awards in what must be viewed as an acknowledgment of the tremendous importance of international expositions (for prestige, if not for direct financial gain).[30] Jules Roche, the minister of commerce, noted the symbolic importance of this year, adding, "the Exposition of 1900 will synthesize the nineteenth century and ascertain its philosophy."[31] Rookwood's display was in the Varied Industries Section, Esplanade des Invalides, where they were one of 138 exhibitors from the United States.[32] Many of the wares exhibited were illustrated in critical reviews of the exhibition and included a wide range of ware then in production as well as the new lighter Iris glaze line.[33] Maria Longworth Storer, who had begun working in bronze in 1894, mounted an individual display in the same general vicinity, for which she won a gold medal.[34]

This exhibition was reported in various journals, most extensively in *Keramic Studio*, where ceramic artist Marshal Fry wrote in the September 1900 issue that "after I have visited and re-visited the many collections at the exposition, I invariably come back to the Rookwood pottery, convinced that it has everything meritorious which the others have, and much more besides." He goes on to note that "many of the choicest gems in the present collection are harmonies in grays and light colors. The quality . . . is almost Whistler-esque and I feel sure that this great

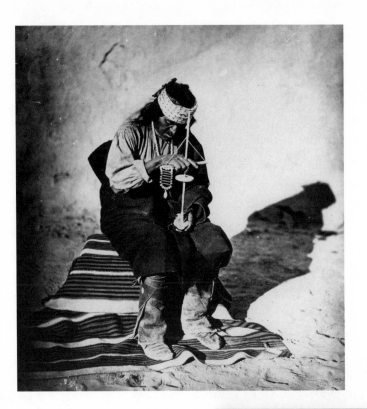

FIGURE 5.3. John K. Hillers, *Governor Ahfitche*, 1880, photograph. National Anthropological Archives, Smithsonian Institution.

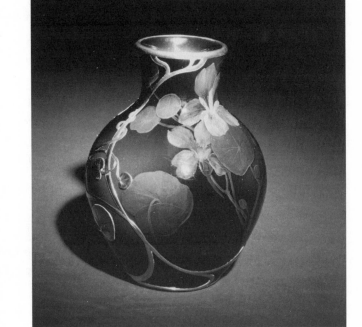

FIGURE 5.4. Rookwood Pottery Co., Elizabeth Lincoln, *Vase*, 1902, Standard glaze line with silver overlay. Private Collection.

master himself would find much to admire in this collection" (cf. plate 11).[35] Fry's comments bear remarking in that they demonstrate the way aesthetic language concerned with painting overlapped with language used in association with ceramics. Fry's invocation of Whistler also points to the vexing issue of how to define Americanism in art, which will be discussed later in this chapter. Taylor concurred with Fry's assessment of Rookwood's strengths in his report to the board of directors when he remarked, "Upon the whole the Iris type was most favorably regarded but all varieties sold."[36] The French reviewer, Alexandre Sandier (who was the artistic director of Sèvres) was critical of Rookwood's "too brilliant" luster but praised the pottery for the application of metal mounts and for their black Iris glaze.[37]

Rookwood received the Grand Prix after Taylor lodged two separate protests.[38] Individual awards were received by Albert Valentien (gold medal) and Stanley Burt (silver medal) for decorating and ware-making, respectively. Taylor protested this inequality but was informed that all juries assigned a slightly higher rank to the artistic section of any industry. Taylor himself received the Chevalier of the Legion of Honor, which he presented as "an additional and crowning honor to Rookwood."[39] No time was lost in converting the prize into advertisements. Taylor wrote to Zachary Clark from Paris, "We have got the Grand Prize but now we must let as many people know it as possible. So I have been working up various schemes to stir up our agents and the public."[40] Even before the ware was sent to Paris, the Pottery had it on view at a local Cincinnati retailer.[41] Winning the Grand Prize in an individual display in Paris apparently superseded all other awards to date. At the time of the Paris Exposition, Taylor concluded an agreement with Siegfried Bing, naming him exclusive sales agent of the Rookwood Pottery in Europe for a term of three years.[42] It was Bing who managed the exhibitions of Rookwood at the Exposition Internationale de Ceramiques et de Verrerie in St. Petersburg, Russia, in 1901, where the Pottery received the Grand Prix, and at the International Exposition of Modern Decorative Art in Turin, Italy, in 1902 where Rookwood was given a "Diploma

of Honor," the highest award. Bing also negotiated with European museums who wished to acquire Rookwood.[43]

Rookwood also sent exhibits to the Pan-American Exposition in Buffalo in 1901 and the Louisiana Purchase Exposition in St. Louis in 1904, among others.[44] At the Pan-American, Rookwood's exhibit included a variety of wares and was in many respects similar to that shown in Paris the previous year. William A. King wrote in *Crockery and Glass Journal* before the opening of the Pan-American: "I have the assurance of Mr. Taylor, president of the Rookwood Pottery Co., that the Pan-American exhibit will be in no way inferior to that made at Paris; in fact in some respects will be better for the Rookwood people are not content to rest on present laurels; they are ever seeking and discovering new effects."[45] Apparently the display lived up to pre-exhibition expectations. One reviewer noted, "The Mecca of all lovers of decoration in keramics was the Rookwood exhibit at the Pan-American, and to those who were capable of absorbing the best in art, a day with their latest work was more inspiring than a year's study anywhere else."[46]

In St. Louis, Rookwood wares were exhibited in four separate displays: in the Art Palace, in the Varied Industries Building, in the Mines Building (in the Clay Industries Exhibit), and in the Anthropology Building. At the Louisiana Purchase Exposition, applied arts were shown alongside fine arts for the first time, a change hailed as "a good note of promise for the Crafts worker."[47] The visionary behind the display of applied arts was Halsey C. Ives, former chief of the Art Department at the World's Columbian Exposition, who in turn gave Frederic Allen Whiting the job of implementing his ideas. Because Taylor had quarreled with Whiting over the content of the display (see chapter 3) and consequently had only fifteen pieces in the Fine Arts Building, Rookwood mounted a much larger display in the Varied Industries Building, showing products of all periods but premiering Vellum ware (see plates 4 and 5). One reviewer at the St. Louis exposition recognized the technical difficulty of developing a translucent mat glaze, noting that "Through this mat glaze, called 'vellum,' the painting in all its exquisite details and subtle shades is seen

as through a fine ground glass, the surface being absolutely without gloss. Technically it would seem that the mat glaze on pottery could develop no further."[48] Rookwood's Clay Industries exhibit was primarily architecture faience, including displays of some of their decorative work for the newly built New York subway. In their Anthropology Building display, a relatively new discipline in 1893, the Pottery "illustrated the application to modern art of the forms and decorative motives derived from the fictile art of the North American Indians."[49] Rookwood's Varied Industries display featured other wares with links to ethnographic photographs, which were also on view in the Anthropology Building. Because of the different types of ware shown in the various venues, it is likely that targeted clients were also different and that the ware would have been pitched differently. Unfortunately this cannot be confirmed as critical attention focused almost exclusively on the display in the Varied Industries Building.

The ceramics exhibited at the Louisiana Purchase Exposition were well chronicled, with particular attention to the "big four" in American ceramics: Rookwood, Grueby, Van Briggle, and Teco.[50] However, Rookwood was most often cited as "leading the ceramic world in America,"[51] and won two grand prizes in St. Louis.[52] Although it is not clear which displays received the grand prizes, it is likely that they were awarded for the large display in the Varied Industries Building. In fact, the applied arts displays in the Palace of Art received almost no mention in the press in part because critics were distracted by similar (and more splendid) exhibits located elsewhere within the exposition grounds.[53]

American and European Rivals

Beginning with the 1900 Paris Exposition, Rookwood began to feel competition from other American art potteries such as the Grueby Pottery of Boston (founded 1897), which also won an award. However, during the early years of Rookwood's existence, the market for ceramics in the United States was dominated by porcelain from England, the Continent,

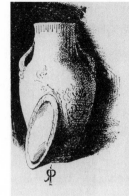

FIGURE 5.5. Rookwood Pottery advertisement, 1889. From *Century* 37, 3 (January 1889): 15. *Courtesy, The Winterthur Library: Printed Book and Periodical Collection.*

and American manufactories (see chapter 4). Taylor was contemptuous of American porcelain, remarking, "I dislike to have Rookwood classed among the 'pirates' who are making careful reproductions of European work and calling it 'American' art."[54] In 1888 and 1889 Rookwood had entered directly into competition with these American porcelain manufactories in exhibitions held by the Pennsylvania Museum and School of Industrial Art in Philadelphia (now Philadelphia Museum of Art). At the 1888 exhibition of pottery and porcelain, Rookwood received the first prize for pottery modeled and decorated and the first prize for painting underglaze—awards that quickly found their way into advertisements (fig. 5.5).[55]

The 1889 exhibition was more broadly based, including other types of industrial arts as well as pottery and porcelain. The United States Potters' Association, a trade organization that primarily comprised the commercial porcelain manufactories, formed a committee to devise a classification scheme to ensure a fair competition.[56] Members of this committee held it to be "the duty of the manufacturing potters . . . to take part in the proposed Pottery Exhibition to be held in Philadelphia during the coming autumn."[57] Rookwood entered the competition in class ten, "Semi-porcelain or faience," and was awarded a gold medal by the jury. Almost immediately the committee of the U.S. Potters'

Association lodged a protest, claiming that they had intended for Rookwood to be entered in class four, "Colored Bodies or Glazes." One committee member indicated that class four had been created "for just such goods as they [Rookwood] make."[58] Taylor responded to the protest saying, "[it] provokes us to be told that Class Four was made specially for us when it covers only a part of our display and class for an exhibit of 15 to 20 pieces and a *silver medal* as the highest award! What were the Potters thinking about? They knew what we showed last year and that we took two first prizes then and did they suppose that we were going in for a silver medal this time, which is universally understood as a second grade by a public which knows and cares nothing about Class Ten or Class Four?"[59] Given that the highest possible prize in class four was a silver medal for a display of fifteen to twenty pieces, and the highest possible prize in class ten was a gold medal for a display of one hundred pieces, Rookwood's rationale for selecting class ten instead of the (perhaps) more logical class four becomes obvious. What is less clear is the feverish opposition expressed by members of the U.S. Potters' Association.

The U.S. Potters' Association was concerned with setting standards for ceramic ware in terms of size, nomenclature, and price. But the association's efforts were frustrated because Rookwood's production was so difficult to categorize.[60] However, it is likely that the categories were an effort to inhibit Rookwood's exposure. This claim can be substantiated by the reviews of the 1888 exhibition, which almost all praised Rookwood to the relative exclusion of other entries. For example, a review in the *Studio* noted that Rookwood was the only exhibit in which equal pains would seem to have been expended on the manufacture and on the decoration of the ware. The reviewer goes on to point out that "It is not strictly fair to the manufacturers to bring them into competition with the Rookwood Pottery. The true position of this pottery is similar to that of a wealthy amateur who can afford to work without reference to commercial considerations."[61] Tastemaker Clarence Cook, writing in the *Art Amateur*, hailed the exhibition itself as "a first move in the direction of finding out where we stand in the matter of manufac-

turing and decorating pottery and in encouraging those who are work-
ing for the advancement of the art," and then noted that "on the part of
the manufacturers there is little or nothing that is new or even interest-
ing, unless we except the exhibit of the Rookwood Pottery."[62] Thus it
seems clear that the U.S. Potters' Association sought to create an unfa-
vorable situation for Rookwood perhaps to discourage them from par-
ticipating in future exhibitions. In this they were successful, but by the
time another such exhibition was held, Rookwood had already won a
gold medal in Paris and had largely ceased to be worried about compe-
tition from the American commercial manufactories.[63]

Although several major European porcelain manufactories contin-
ued to occupy a large market share in the United States and to garner
praise abroad, one in particular, the Royal Copenhagen Porcelain Manu-
factory in Denmark, produced wares that were most often compared to
Rookwood's. This was an invidious comparison, as Royal Copenhagen,
founded in the eighteenth century, was a world-famous concern.[64] To
be sure, the relative attention paid to various ceramics depended greatly
on the nationality of the reviewer. For example, the *Art Journal*, a British
publication, was prone to feature Royal Worcester, *Gazette des Beaux-Arts* to
feature Sèvres, and so forth.[65] In a fairly balanced review of the ceramics
at the Paris Exposition of 1900 for the American journal *Keramic Studio*,
Marshall Fry wrote, "The collections which have impressed me as being
the finest are those of the Rookwood and Copenhagen." He goes on to
praise Rookwood's new lighter glaze lines (e.g., Iris) noting that "it
is quite likely that this new departure may have been inspired by the
Copenhagen."[66] A slightly earlier article concurs in this assessment,
noting, "the Royal Danish porcelain, made at Copenhagen, is the only
Occidental product which can be at all compared with Rookwood."[67] A
review describing the Pan-American Exposition of 1901 noted that "we
have a rare right to feel proud of this American achievement in pottery.
There is no foreign ware that can compare with it. The Royal Copen-
hagen is the only manufactory which sends out ware that appeals so to
appreciation of mellowness in texture and color."[68] Rookwood manage-
ment was well aware of their competition; Taylor wrote to ceramics

scholar Edwin AtLee Barber urging him to "look at the Copenhagen ware when you are next in New York."[69] In addition, the firms acquired examples of each other's work; Philip Schou, director of Royal Copenhagen, visited Rookwood in 1888 to purchase several pieces.[70]

In the 1890s Rookwood was primarily known for its Standard glaze. Nonetheless, in early 1890, as mentioned, Rookwood began experimenting with lighter colored products, introducing three new glaze lines in 1894–95: Iris, Sea Green, and Aerial Blue.[71] The shortest lived of the three was Aerial Blue (see plate 12), which the pottery described as "a delicate mono-chromatic ware with a quiet decoration in celestial blue on a cool, grayish, white ground."[72] It is likely that the inspiration for this glaze was Royal Copenhagen. Anita Ellis has pointed out that by 1892 the Royal Danish firm was taking the market by storm with a porcelain ware decorated with natural flora and fauna on a pale blue ground.[73] Yet Rookwood was never able to perfect the line and discontinued production within a few months. It seems that Rookwood didn't mind "quoting" its competitor but didn't want to seem lacking in the comparison.

If Royal Copenhagen was Rookwood's primary European competitor, Grueby Pottery Company of Boston was the primary competitor in the United States, having received a gold medal at the 1900 Paris World's Fair, the Exposition Internationale de Ceramiques et de Verrerie in St. Petersburg in 1901, and the 1901 Pan-American Exposition.[74] Yet while Rookwood and Royal Copenhagen shared certain aesthetic strategies, Grueby pottery was very different from Rookwood's high gloss, underglaze painted decorations, featuring a mat glaze, usually green, with molded vegetal decorations (fig. 3.18). Thus, unlike with Royal Copenhagen, comparisons between Rookwood and Grueby were rarely drawn. Critics treated Rookwood and Grueby as separate but equal. Although primarily known for its Standard and Iris glaze lines, in 1900 the Pottery began producing more mat finishes and fewer pieces with high gloss glaze. This shift in production not only tracked closely with the burgeoning Arts and Crafts movement in the United States, but also heralded the arrival of a new type of competition—referred to by Taylor as "the counterfeiters." By the turn of the century, Rookwood

PLATE 1. Rookwood Pottery Co., Mathew Andrew Daly, *Claret Jug*, 1885, Dull Finish glaze line.
Private Collection.

PLATE 2. Rookwood Pottery Co., Albert R. Valentien, *Vase*, 1898, Standard glaze line.
Private Collection.

PLATE 3. Rookwood Pottery Co., Edward Timothy Hurley, *Plaque*, 1915, Vellum glaze line.
Private Collection.

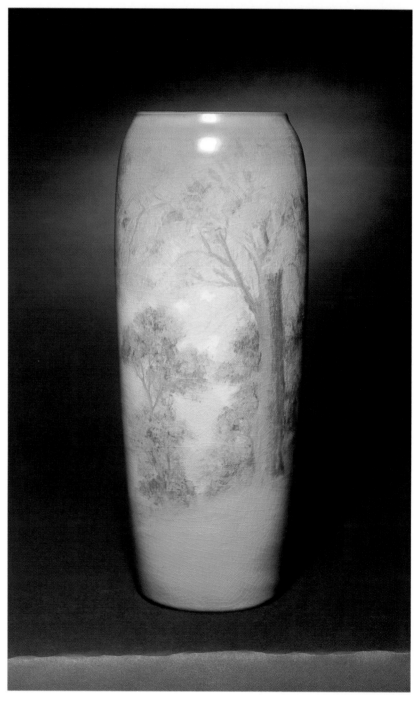

PLATE 4. Rookwood Pottery Co., Edward Timothy Hurley, *Vase*, 1920, Vellum glaze line. *Private Collection.*

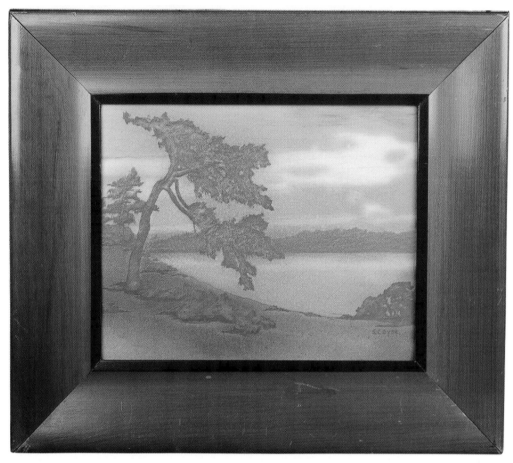

PLATE 5. Rookwood Pottery Co., Sally Coyne, Plaque, 1914, Vellum glaze line. *Private Collection.*

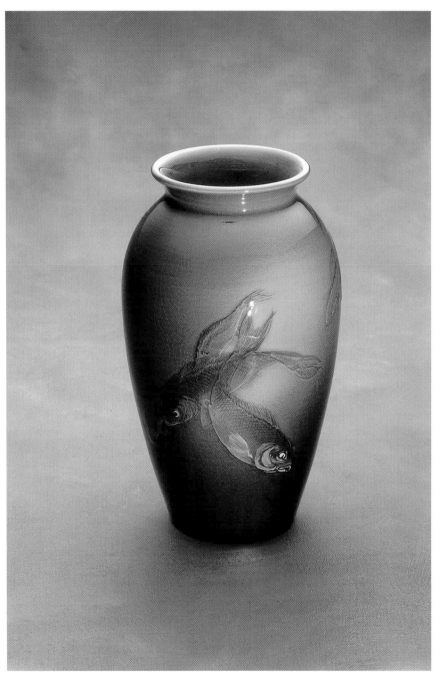

PLATE 6. Rookwood Pottery Co., Albert R. Valentien, *Vase*, 1894, Sea Green glaze line. *Private Collection.*

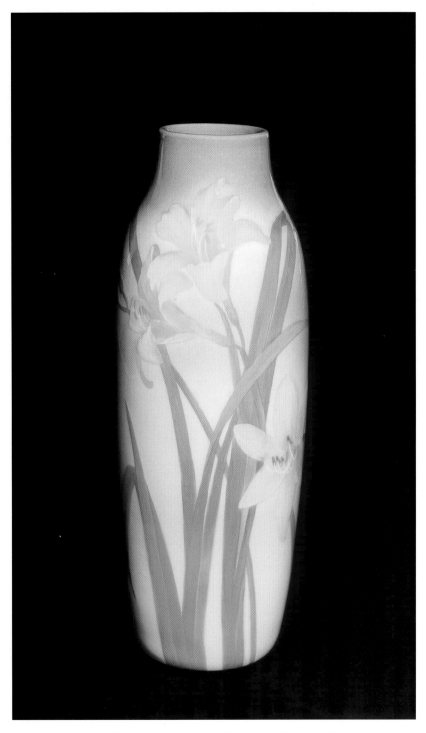

PLATE 7. Rookwood Pottery Co., Sara Sax, *Vase*, 1903, Iris glaze line.
Private Collection.

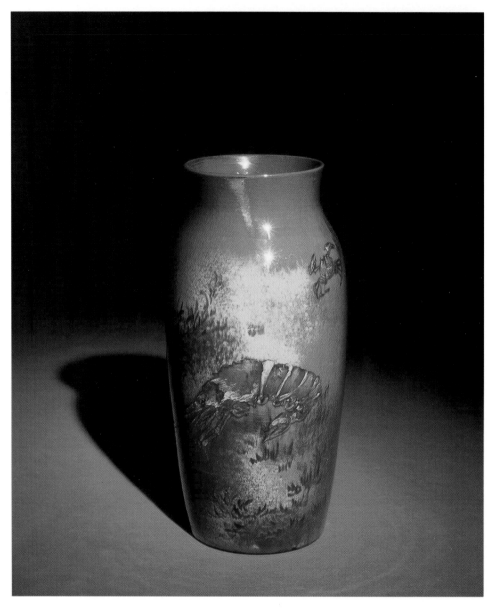

PLATE 8. Rookwood Pottery Co., Albert R. Valentien, *Vase*, 1889, Tiger Eye glaze line.
Private Collection.

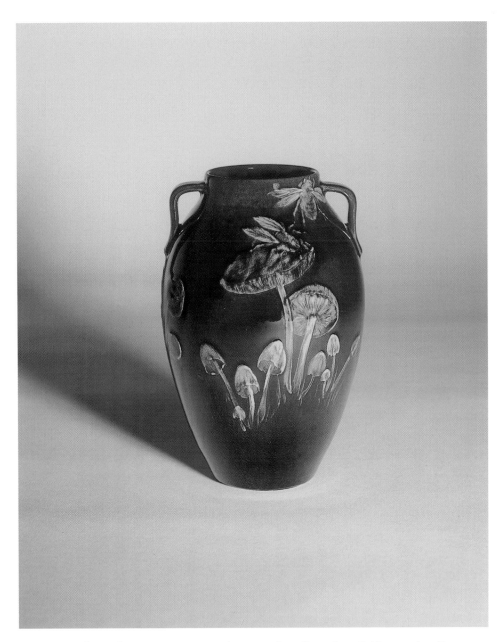

PLATE 9. Rookwood Pottery Co., Kataro Shirayamadani, *Vase*, 1894, Goldstone glaze line.
Cincinnati Art Museum, Boswell Buhr, Isabel and Sam Malcolm Levy, and William Taylor Endowments; Gloria Thompson Fund;
acquired in memory of Barbara Howe (1991.121).

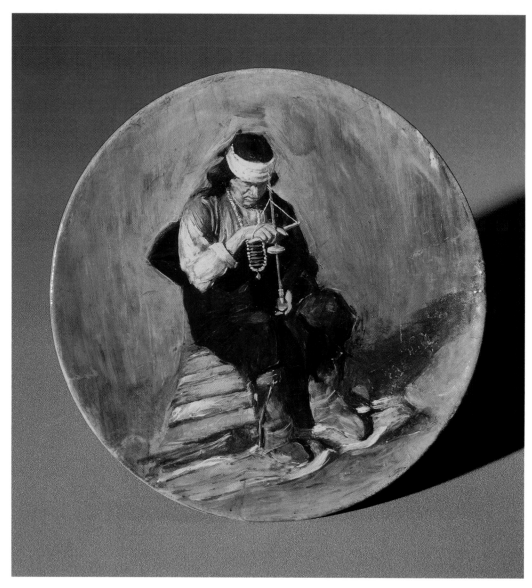

PLATE 10. Rookwood Pottery Co., Artus Van Briggle, Plaque: *Governor Ahfitche*, 1893, Standard glaze line. *Collection of Mrs. Charles J. Schott.*

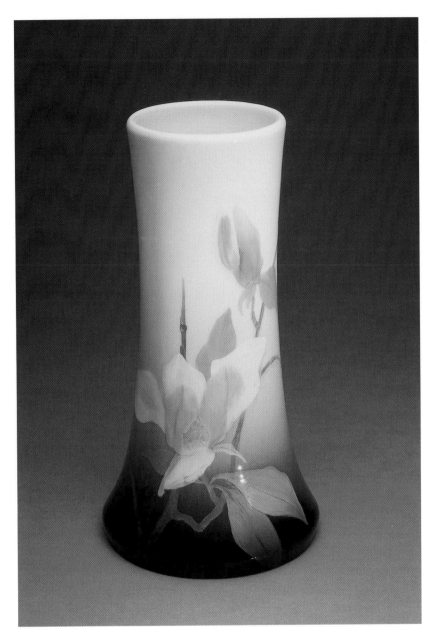

PLATE 11. Rookwood Pottery Co., Lenore Asbury, *Vase*, 1908, Iris glaze line.
Private Collectionn.

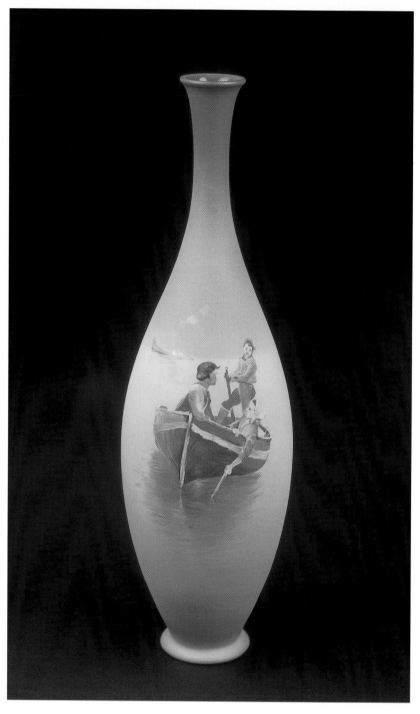

PLATE 12. Rookwood Pottery Co., Mary Luella Perkins, *Vase*, 1895, Aerial blue glaze line. *Private Collection.*

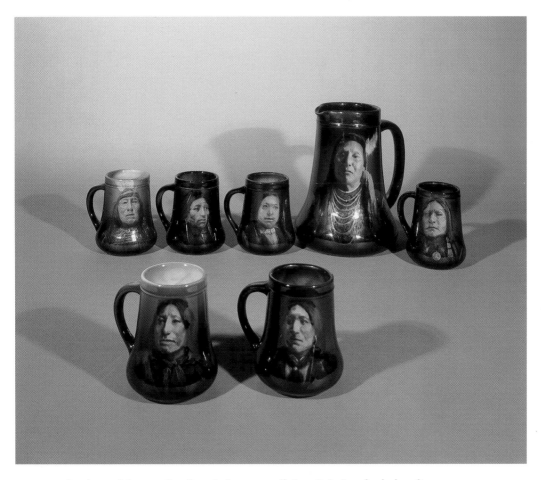

PLATE 13. Rookwood Pottery Co., Sturgis Laurence, *Ale Set*, 1898, Standard glaze line.
Collection of Mr. James J. Gardner.

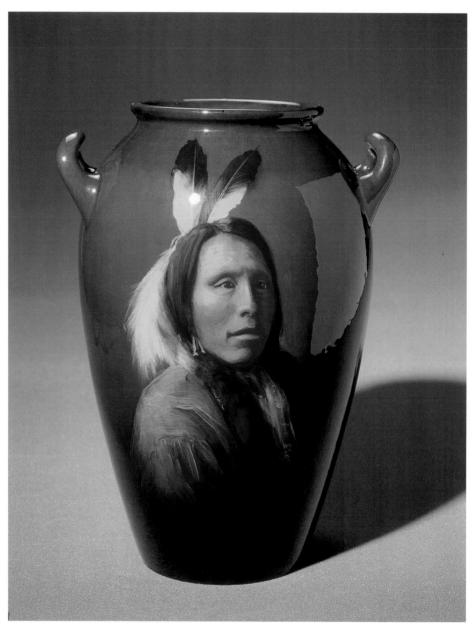

PLATE 14. Rookwood Pottery Co., Matthew Andrew Daly, *Vase: Lone Elk*, 1899, Standard glaze line. *Collection of Mr. and Mrs. W. Roger Fry.*

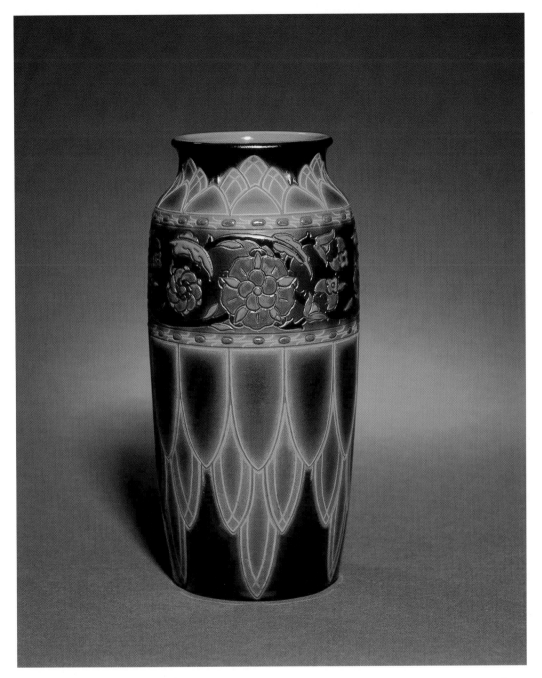

PLATE 15. Rookwood Pottery Co., Sara Sax, *Vase*, 1922, soft porcelain/jewel porcelain body, French Red glaze line. *Private Collection.*

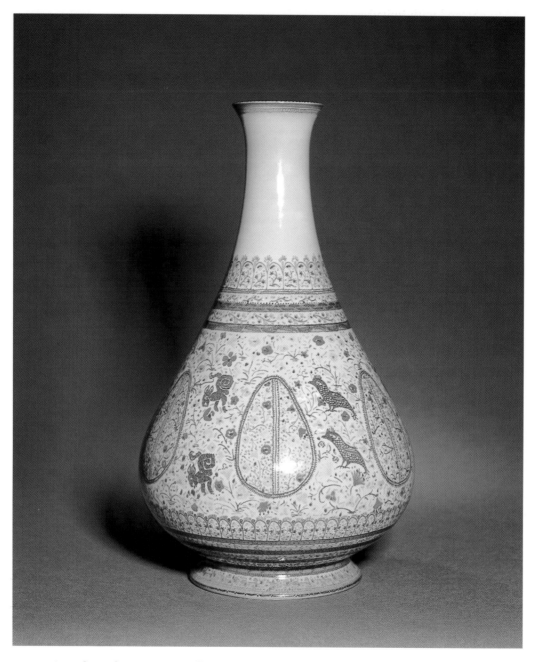

PLATE 16. Rookwood Pottery Co., William Hentschel, *Persian Bottle Vase*, 1920, soft porcelain/jewel porcelain body, Clear translucent gloss glaze. *Private Collection.*

had to contend with imitations of its Standard ware produced by such firms as Lonhuda, J. B. Owens, and Weller Potteries in Zanesville, Ohio, and Roseville Pottery Co. of Roseville, Ohio. After 1900 Rookwood encountered not only competition but imitators both in the United States and in Europe.[75] Thus, Rookwood's aesthetic shift may also be explained by the exposure and recognition both nationally and internationally garnered by Grueby and other potteries that favored mat glazes and conventional (abstract, non-naturalistic) decoration. This may be the more likely explanation given that Rookwood was acutely aware of who its competitors were, what they were producing, and how it was received. Although Rookwood constantly experimented with new glaze lines and decorative motifs in order to maintain a reputation for innovation, many key production decisions were market driven.

Assertion of National Identity

At all these fairs, there was pressure to be internationally competitive while simultaneously asserting national identity. As this chapter's opening quotation suggests, Rookwood as America's foremost art pottery was often remarked upon as being "distinctively American." For example, Oscar Lovell Triggs wrote that Rookwood's "art is as indigenous as that of the first potter."[76] Maude Haywood writing in 1892 noted that "there is no distinctively native industry of which Americans have more right to feel proud than Rookwood Pottery in Cincinnati. . . . Being entirely local in origin and growth, it is in itself a decisive proof of the real existence of an artistic element essentially American."[77] Susan Stuart Frackelton agreed, suggesting that "the fundamental idea of Rookwood was to promote the national growth of an Art Pottery out of local conditions, both material and artistic, and this idea has been followed out as literally as possible—native clay, native decorative subjects, and native artists."[78]

In some respects Frackelton was right. Rookwood did primarily employ native artists, use native clay, and depict native decorative subjects

such as indigenous flora. Given their insistent nationalism it comes as no surprise to find a portrait of George Washington above a Rookwood tile fireplace fixture in a photograph taken for advertising purposes.[79] Indeed, most of the Rookwood work force were American citizens—many of them from the Cincinnati area—with the exception of Kataro Shirayamadani, a Japanese national who joined the staff in 1887 and for the most part remained there until his death in 1948.[80] Furthermore, *Brush and Pencil* reported in 1902: "The clays used by the concern are found mainly in the Ohio Valley. A red variety is secured from Buena Vista, Ohio, a yellow material from Hanging Rock, Ohio, and a white or cream-colored clay from Chattanooga, Tennessee."[81] Although this report exaggerated the "local" nature of the clays given that only two out of eight were from Ohio, the clays were all from the United States, suggesting that "native" in this case was rather broadly defined.[82] There are also many examples of Rookwood ware being decorated with native decorative subjects such as the Ohio buckeye or local landscape vistas. Rookwood also introduced shapes and decorations supposedly derived from Native American pottery which the contemporary press praised as "indianesque" (recall fig. 3.16).[83] Another example of Rookwood's use of native decorative subjects was begun in 1893 at the World's Columbian Exposition where the Pottery exhibited plaques and vases decorated with portraits of Native Americans that were copied from ethnographic photographs (recall plate 10 and fig. 5.3).

Thus, Rookwood's products were American in terms of decorative subjects, materials, and producers. Yet these insistent nationalistic claims are puzzling because Rookwood's decorative aesthetic possessed an inescapable and admitted Japanese influence (cf. plate 1 and figs. 4.2, 5.6, and 5.7).[84] When her plan to install a bona fide Japanese Pottery was vetoed by her father, Maria Nichols sought out and employed Shirayamadani. Prior to this, however, Nichols's own taste in pottery decoration was described as having "the inevitable dragon coiled about the neck of the vase, or at its base varied with gods, wise men, the sacred mountain, storks, owls, monsters of the air and water, bamboo, etc., decorated in high relief, underglaze color, incised design, and an over-

glaze enrichment of gold."[85] During the early years of its existence, other Rookwood decorators sometimes copied Japanese shapes or decorative motifs; for example, figure 5.6 from 1887 features a fiery wheel, with a demon's head for its hub—its caption means "sundered wheel." It was copied directly from a Hokusai sketchbook.[86] In the years after Shirayamadani arrived, Japanese compositional elements had been assimilated into the mainstream of the Rookwood aesthetic (cf. figs. 4.2 and 5.7).[87] An unidentified writer in the *Art Amateur* fretted that the American character of Rookwood would be corrupted by the presence of a foreign workman, noting, "It will be a serious mistake if the artist who is to be brought here is required to do nothing but make Japanese pottery in America."[88]

The presence of an easily recognizable Japanese influence coupled with a Japanese decorator leads to the suspicion that in this discourse "Americanism" meant more than "native" clay, subjects, and artists. It signified objects that were noticeably different from European wares. In the article mentioned earlier, Susan Frackelton goes on to comment that "we, as a nation, may learn a lesson of deep significance from Rookwood —that if we are ever to have a national art it must be evolved from within. We cannot acquire it through foreign inspiration."[89] The fact that Americanism, despite the one anonymous comment in the *Art Amateur*, could encompass a Japanese person and Japanese-influenced decoration suggests that what was really at stake was being distinct from Europe.[90] There was a perception amongst ceramics scholars that art pottery concerns in the United States were thwarted because American buyers were so wedded to foreign goods. Jennie Young commented on this attitude in her 1878 history of ceramics:

> It is a singular fact that while native manufacture advances with rapid strides, and finds on all sides a public ready to give it a hearty reception, native art must force its way to recognition. His first honors must be won abroad. It must bear a foreign stamp to be accepted at all in the home of its birth. . . . Under such circumstances it is difficult for an art to struggle into existence. French art is to a Frenchman the finest and best the world ever saw. Englishmen support English art because it is their own. . . .

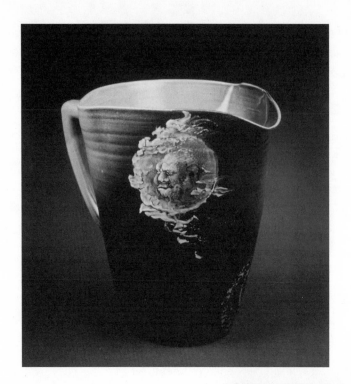

FIGURE 5.6. Rookwood Pottery Co., Matthew Andrew Daly, *Ale Pitcher*, 1887, Standard glaze line. *Private Collection.*

FIGURE 5.7. Rookwood Pottery Co., John D. Wareham, *Vase*, 1899, Standard glaze line. *Private Collection.*

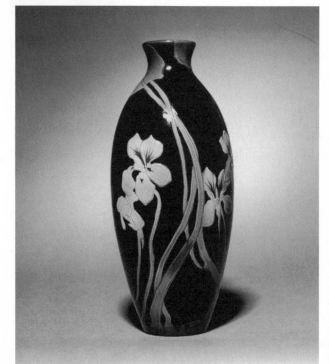

American art may be good, even equal to the best, but unfortunately it is American. Receiving no notice, the artist loses even the benefit of criticism, and concludes that his own people compliment themselves by believing that no work of art can be produced among them.[91]

In order to be truly American one had first to be "not-European." Japanese-influenced decoration provided a solution to this dilemma.

Neil Harris has noted that for most Americans the first opportunity to learn about Japan occurred at the 1876 Centennial Exposition where Japanese displays were surpassed in quantity by only a few countries much larger or much closer to the United States.[92] Although the size and costliness of the displays were much commented on, Americans seemed to take a special pleasure in the fact that Europe's boasted antiquity was diminished when compared to Japan. The Orient could be used to strike back at the pretensions of the Old World, which for so long had reminded Americans of their relative youth and lack of cultivation. One critic, comparing Japanese antiques with the treasures of famous Christian shrines, suggested, "What barbarous lumps of gold and silver stuck full of jewels of the rudest shape are the crowns." In the Japanese handicrafts, eight hundred years old or more, one found "grace and elegance of design and fabulous perfection of workmanship which rival or excel the marvels of Italian or ornamental art at its zenith."[93] The Japanese section in the main building featured porcelains, bronzes, silks, embroideries, and lacquered ware arranged on two large rectangular platforms placed diagonally to the main entrance.[94] According to James McCabe, the display was "one of the great surprises of the fair." He continued, "We have been accustomed to regard that country as uncivilized, or half-civilized at best, but we found here abundant evidence that it outshines the most cultivated nations of Europe in art which are their pride and glory which were once regarded as the proudest tokens of their high civilization."[95] Another critic wrote, "After the Japanese collection everything looks in a measure commonplace, almost vulgar."[96] Clearly, the spectacle of the Japanese beating Europeans at their own game held great appeal for Americans.

As early as 1877 George Ward Nichols (first husband of Maria Long-worth Nichols) had published a book, *Art Education Applied to Industry*, in which he prophesied that "the novelty, freshness, and infinite grace of the decoration of . . . Japanese ceramics, bronzes, screens, fans, and lac-quer work will exert a wide and positive influence upon American art industries, an influence more immediate and enduring in its action than that of any one country, or perhaps all of the countries combined."[97] He echoed this sentiment in an 1879 publication illustrated by Maria Long-worth Nichols with a series of Japanese-inspired sketches. *Pottery, How It Is Made* advocated that America turn away from Europe to Asia in order to build its own pottery tradition.[98] Some writers perceived that Rook-wood had done just that, noting, "outside of Japan and China, we do not know where any colors and glazes are to be found finer than those which come from Rookwood Pottery."[99] Another observed that "origi-nality of processes and an independence of foreign influences, except that of a single Japanese artist, have been practiced at the Rookwood potteries from the very beginning."[100]

It is paradoxical that Japanism emerged as a way to distinguish American wares from those of Europe since at the time of the Centen-nial, European fine and decorative arts were quite as much under the sway of Japanese influence as American wares were soon to be.[101] For example, one of the more remarked upon French decorative arts dis-plays was that of Haviland and Company of Limoges, France, featuring Félix Braquemond's "Le Service Parisien," which was strongly influenced by Japanese imagery depicting the atmospheric effects of the changing seasons.[102] In addition, there is little doubt that the "Japan craze" in the West was mirrored in the westernization craze that occurred simulta-neously in Japan. To accommodate Western taste, Japan adopted Western forms decorated with Japanese ornament.[103] Japanism may have seemed to provide a way to distinguish American from European production, but accommodation was in no way exclusive.

Moreover, Martin Eidelberg has pointed out that however much Americans wished to deny European influence, "American ceramists at the turn of the century had ample access to European ideas and objects,"

through foreign travel, contemporary periodicals, and the presence of actual European ceramics in this country. He notes that the large porcelain factories such as those at Sèvres, Copenhagen, and Berlin had strong commercial ties with the United States and their wares were on display in larger American cities.[104] Rookwood's flagship retailer, Davis Collamore and Co. of New York City, stocked Sèvres, ware from Vienna, Haviland dinner ware, and Royal Dresden figurines (fig. 5.8).[105] The French ceramics on view at the Centennial (see chapter 2) led Mary Louise McLaughlin and other Cincinnati art potters to experiment with the underglaze painted slip decoration that came to be Rookwood's signature technique. At the World's Columbian Exposition, French potters Delaherche and Chaplet exhibited their mat glazes, which probably inspired Rookwood to begin experiments in this direction (see chapter 3). Finally, there is the well-documented contact between Rookwood and Royal Copenhagen, which influenced the subsequent production of both firms. Not only did Rookwood try and fail to mimic Royal Copenhagen's pale blue ware, but after the 1889 Paris World's Fair, Royal Copenhagen began producing a glaze line similar to Tiger Eye known as Cat's Eye. Martin Eidelberg has noted that it cannot be mere coincidence that a popular image for Rookwood decorators was a sea gull flying over waves and a shoreline. Such imagery seems unrelated to an inland city like Cincinnati but was one favored—even celebrated—on the Royal Copenhagen vases where seabirds fly over crashing waves.[106]

From the above discussion two things emerge: it becomes apparent that Rookwood's "Americanism" cannot be understood simply as native clay, native subjects, and native artists; and there is no doubt that Rookwood pottery was imbricated in an international aesthetic.[107] It is obvious that the Pottery was markedly influenced by Japanism, but this too was an international phenomenon. What follows argues that we gain some understanding of what critics may have thought was so typically American about Rookwood pottery by examining echoes of this same discourse in contemporary art criticism and suggests reasons for its appearing how and when it did.

FIGURE 5.8. Davis Collamore & Co. advertisement, 1890. From *Century* 61, 1 (November 1890): 42. *Courtesy, The Winterthur Library: Printed Book and Periodical Collection.*

AMERICANISM IN FINE ART

Art critics of the late nineteenth century believed that a national art was by definition a reflection of national character. The interest in national character pervades criticism at the time, suggesting that it is an artifact of the economic and political competition of the late nineteenth century.[108] This view was echoed by many contemporary critics, including Irene Sargent, who wrote that "race-sentiment reaches one of its strongest and most pleasing manifestations in the arts—equally in the fine and in the industrial."[109] Although art critics were not the originators of theories on the national character, the qualities they refer to as "typically American" were discussed in detail by fellow intellectuals, often in the

same journals that published their criticism. Most of these characteristics can be grouped under the three rubrics of independence, energy, and crudeness.[110] American independence had been a driving force behind the early colonization of the New World and was subsequently institutionalized by the nation's founders. Closely linked to this spirit of independence were audacity, inventiveness, and self-reliance. Moreover, self-reliance could be further understood as individualism in the sense of being nonimitative. In 1894 Theodore Roosevelt wrote, "It is always better to be an original than an imitation, even when the imitation is of something better than the original."[111] Life in America was marked by movement and change; people were perceived as always impatient to move toward a future horizon. While some foreigners, such as the English reformer Matthew Arnold, found this a cause for concern, American writers seemed to look upon energetic restlessness as a hallmark of the national genius, and associated these qualities with the ambition, drive, and fortitude that had enabled them to carve a civilization of unprecedented prosperity out of a wilderness.[112] Finally, American crudeness was viewed in contradistinction to European overrefinement and was equated with an innocent, simple, if somewhat primitive, quality of life.

Linda Docherty has pointed out that during this period in the United States, it was those painters whose technical manner best represented the features of independence, energy, and crudeness who were regarded as most American. Consider this quote from *Scribner's Monthly* in 1875: "Our young artists must yield themselves to the influences of their time and their home, look into the life and nature around them for themselves, and report exactly what they see in the language natural to their own individualities. . . . [It] is only in this way that a great school of art can grow up in America."[113] Although Docherty does not deny that local subject matter was an essential feature of the late-nineteenth-century concept of "Americanism," she insists that for American art critics of this period the manner in which a subject was rendered was at least as significant as the subject itself.[114] To quote critic S. G. W. Benjamin, "It is not so much in the subjects as in the treatment that the individuality of

a national art is best demonstrated."[115] John Van Dyke echoed this sentiment, saying, "That of which a man speaks does not determine his nationality, but rather his individual thoughts and his manner of expressing them."[116] These comments make it clear that late-nineteenth-century art critics considered the painter's spirit or individuality an integral component of the subject matter. The typically American characteristics of independence, energy, and crudeness were best expressed through the artist's individuality.

Those painters whose technical manner best represented these features (e.g., Winslow Homer) were considered most American. Yet Homer had studied in Paris and clearly demonstrated a knowledge and understanding of European painting.[117] Nevertheless, for late-nineteenth-century American critics, Winslow Homer was the "Walt Whitman of the brush."[118] Both Whitman, who abandoned rhyme and conventional meter in his poetry, and Homer, who eschewed rigorous detail for a broadly painted style, were considered artistically "crude" within the traditional definitions of their media, and in both cases this crudeness was seen as a result of their American independence and energy.[119] Because Rookwood was usually thrown on the wheel and not molded, it could be viewed as stylistically crude when compared to porcelain.

A close reading of the commentary about Rookwood's "Americanism" reveals a marked similarity to the above-mentioned art criticism. Maria Longworth Storer was quoted in a published interview as saying, "My birthplace shall produce a pottery that shall smack of the soil in every respect. . . . Its clays shall come from deposits in [the] Ohio Valley; its workers shall be graduates of Cincinnati's art school. Its designs shall be original; individuality shall be the goal."[120] The pottery is referred to as "original, strong, and distinctive" by Progressive Era reformer Ida Tarbell writing in the *Chautauquan*.[121] Maude Haywood suggests that Rookwood is "a standing testimony to . . . the national life and character." She goes on to note that its local origin and growth proves that there is an essentially American artistic element. Moreover, because the manufactory did not owe anything to outside sources, having grown organically from within, there was "an originality and an individuality

in the work produced impossible under any other conditions."[122] W. P. Jervis, a well-known authority on ceramics, wrote glowingly about Rookwood's individuality in his *Rough Notes on Pottery* published in 1896. He said, "It is difficult to restrain one's enthusiasm when writing of Rookwood. Only a poet could do it justice. It is moreover a distinctly American production, the result of American brains and energy."[123] Jane Long Boulden, in a review of the Rookwood display at the Pan-American Exposition, noted, "In a field where as a nation we have little to be proud of, Rookwood takes its pre-eminent place and challenges the admiration of the world." Significantly, this author praises the ware not so much for its "outward beauty," but for the "individual spirit with which the ware was wrought."[124] These comments suggest that Rookwood's critics, in common with fine art critics, employed a very specific vocabulary to describe this "typical American pottery": individuality and originality. These attributes were in turn thought to express American character traits of independence, energy, and crudeness.

Americanism in Crisis: The Myth of the Frontier and the Cult of the Strenuous Life

Yet it was precisely during the 1890s in the United States that these character traits were felt to be most in jeopardy. At the most basic level, the huge number of immigrants flooding into the United States in the 1890s led to concern about "Americanism." Joseph Edgar Chamberlin, writing in *Century*, noted that "the whole population of the country, minus persons of foreign birth and parentage, native Negroes, and Indians, is 28,601,676. This is not much more than half the population. The problem [is] how two diverse masses of population . . . can be safely assimilated to each other."[125] In large part the immigrants came to fill the demand for industrial labor in the United States. Coincidentally, industrialization fueled a shift from an economy based on agriculture and life in small towns to one focused on industrial cities. In addition, the growth of cities was closely linked to the growth of a

national market economy, which for most Americans meant entanglement in the web of the market. A consequence of this spreading market relation was an undermining of individual autonomy and increased social interdependence, a sense that individual causal potency had diminished and a growing doubt that one could decisively influence one's personal destiny.[126] Indeed, during the 1890s there were good reasons to suspect the new industrial order. The stock market had crashed in 1893, some six hundred banks closed, more than fifteen thousand commercial houses failed, and seventy-four railroad corporations went into receivership. With unemployment at greater levels than at any time in living memory, people of all social classes had a lot to be anxious about. Yet economic changes were not the only factors causing anxiety. Changing belief systems in other areas, including science, religion, and psychology, sent many members of the middle class into self-crisis—a condition characterized by Jackson Lears as a feeling of "fragmentation."[127] This fragmentation was due in part to ideas about heredity that suggested the self might be subject to the play of inherited impulses. Influenced by the Italian criminologist Cesare Lombroso, a number of psychiatrists and social critics claimed that antisocial behavior such as alcoholism was a congenital deformity; the individual had not chosen depravity but inherited it. Another aspect of the evanescent self was the rising interest in a hypothetical unconscious. The lay public was fascinated by hypnotic trances and multiple personalities, indeed by any psychiatric experiment revealing a state of mind outside normal waking consciousness. Thus there was a crisis of self and a profound need for revision in the concept of individuality. The self seemed neither independent, nor unified, nor fully conscious, but rather interdependent, discontinuous, divided, and subject to the play of unconscious or inherited impulses.[128]

This sense of crisis was communicated by Frederick Jackson Turner during the World's Columbian Exposition in a seminal speech to the American Historical Association titled "The Significance of the Frontier in American History." Turner provided an early articulation and distillation of what has come to be known as the myth of the western frontier,

suggesting that American development or progress to date had been due to "the existence of an area of free land, its continuous recession, and the advance of American settlement Westward." Turner insisted that the frontier experience was the key to understanding American history. "The expansion westward with its new opportunities, it continuous touch with the simplicity of primitive society," he argued, "furnish the forces dominating [the] American character." The frontier experience, he continued, had produced a practical, inventive, self-reliant people who valued individualism and freedom because they had experienced them firsthand in the wide-open spaces and face-to-face communities of the West. According to Turner, everything unique about Americans—their individualism, ingenuity, impatience with the past, and hope for the future—derived from the existence of the frontier. The frontier was the formative experience of the nation. On the frontier Europeans became Americans. Thus, the current upheavals and feeling of fragmentation in the United States could be explained by the closing of the frontier. This later claim was based on an 1890 census report that the unsettled land of the West was so rapidly disappearing that the "frontier line" had finally disappeared.[129] The Turner thesis that the western frontier—now closed—accounted for American character offered a powerful explanation for the problems in the country: that the United States had reached a critical watershed in its history and needed to be revitalized.[130]

Theodore Roosevelt agreed with Turner's thesis, saying, "We need a greater and not a lesser development of the fundamental frontier virtues." As governor of New York in 1899, he also pointed to a solution in a speech delivered at the Hamilton Club in Chicago that described the cult of the "strenuous life."[131] Although the need to be revitalized wasn't explicitly gendered, Turner's version of national traits is entirely masculine, derived from the presumed experience of white male pioneers and settlers.[132] Moreover, the characteristics thought to be lost—independence, energy, and crudeness—were not commonly attributed to late nineteenth- and early-twentieth-century women.[133] In his speech, Roosevelt exhorted the American man to recover the courage to participate in the "righteous war," to "dare and to endure and to labor," while

the woman "must be the housewife, the helpmate of the homemaker, the wise and fearless mother of many children."[134] The closing of the frontier was accompanied by an organized drive to restore health and vigor that was far-flung and complex, comprising (in overlapping phases) wilderness cures, water cures, the sanitation movement, and athletic activities ranging from gymnastics to the strenuous feats of riding and hunting popularized by Roosevelt himself.[135] Some advocates of the strenuous life touted the regenerative benefits of renewed contact with the wilderness. Sarah Burns has noted that Winslow Homer—considered in the 1890s to be a very "American" painter—received this reputation almost entirely on the basis of his wilderness adventure scenes of hunting and fishing. These works were seen as part of the back-to-nature craze that seized the nation as frazzled city dwellers sought the wilderness life as a therapeutic alternative to their metropolitan backgrounds.[136] So pervasive was the nature craze that the State Dining Room of the White House, which was said to "represent the personality of the President of the United States," was decorated with a variety of stuffed animal heads (fig. 5.9).[137]

The cult of the strenuous life had many strands, some seemingly contradictory, but all of which were tinged with nostalgia for the Western frontier. Historian Richard Slotkin has argued that the image of the frontier came to have meaning in the industrialized East as a code understood by most everyone. It was common for newspapers to refer to laborers and immigrants as "savages" or "redskins," for Theodore Roosevelt to associate Indians with certain sorts of "unprogressive" whites, whom he called the "cumberers of the earth."[138] Cowboy life, in particular, exerted a mythical attraction for Eastern patricians such as Roosevelt, Owen Wister, and Frederic Remington. Remington wrote to a friend that his images of the West were "doing the 'Old America.'"[139] Alex Nemerov has argued that the iconography of cowboys and Indians that arose so vigorously around the turn of the century is best understood in relation to the urban industrial culture in which it was produced. In some circles the closing of the frontier was linked to an adulatory, if somewhat patronizing, attitude toward Native Americans,

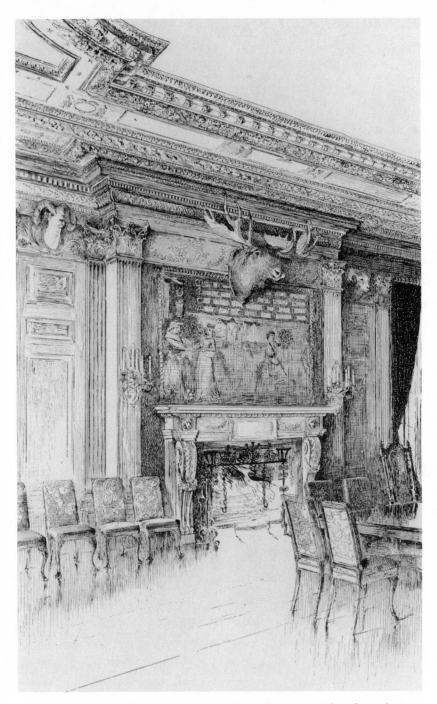

FIGURE 5.9. *The State Dining-Room—I*, 1903. From *Century* 65, 6 (April 1903): 822.

who were thought to be part of an earlier race that was much closer to the nature to which European Americans were trying to return. This adulation was accompanied by an interest in collecting, exhibiting, and popularizing Native American craft objects.[140] Yet there were others who used the nostalgia inherent in the cult of the strenuous life to buttress doctrines of racialism, militarism, and imperialism.[141] These individuals embraced war as a therapeutic alternative for a society suffering from social unrest and the anemia of modernity. They felt that what was needed to put America right again was a surrogate frontier.[142] Five years after Turner's 1893 speech, at the time of the Spanish-American War in 1898, Theodore Roosevelt argued that American colonies in the Pacific were the logical and necessary new frontier. Significantly, Roosevelt likened Filipinos to Apaches and anti-imperialists to "Indian lovers."[143] A tacit assumption in the Turner thesis, baldly apparent in Roosevelt's bellicose rhetoric, is that the conquest of the West (the signal event that created American character) was in large part the conquest of the Native Americans. That is, Native Americans occupied a world so entirely at odds with that of European Americans that their very opposition made a frontal encounter necessary for a definition of America itself.[144]

In the 1890s, Americans were presented with the closing of the frontier as an explanation for their crisis of individualism, with the cult of the strenuous life as a part of the solution. The cult of the strenuous life was capacious enough to include both a sentimental yearning for a simpler way of life, including a nostalgic adulation for Native Americans, as well as a bellicose insistence on finding new frontiers. Native Americans seemed to function as a perfect screen for these dual strands of thought. They could be viewed as closer to the revitalizing nature European Americans were seeking or they could function as a perfect foil for immigrant labor problems or imperial aspirations.

Between 1893 and 1904, Rookwood seemingly aspired to the cult of the strenuous life by producing a large number of ceramic objects decorated with portraits of Native Americans.[145] The more splendid Native American pieces were obviously considered an important part of the company's production insofar as they were featured prominently

in displays and in publicity at the World's Columbian Exposition in Chicago (1893), the Paris World's Fair (1900), the Pan-American Exposition in Buffalo (1901), and the Louisiana Purchase Exposition in St. Louis (1904). It should be noted that there were many other decorative art objects that employed Native American motifs as decoration. For example, Tiffany and Co. produced a series of pueblo-style vases for the 1893 Chicago Exposition (fig. 5.10), often including rubies or other precious or semiprecious stones such as turquoise. Coppersmith Joseph Heinrich used copper trimmed with silver for a wide variety of wares, such as punch sets with Indian faces, "birch bark," and real arrowheads.[146] Certainly, representations of Native Americans were far from unusual in the realm of painting and sculpture. For example, at the World's Columbian Exposition there were sculptures depicting Native Americans decorating the Agriculture Building and Transportation Building. The Art Palaces of these world's fairs—1893, 1900, 1901, 1904 —were replete with images of Native Americans. Julie Schimmel has pointed out that in the 1890s, fine art depictions of Native Americans in conflict with European Americans coexisted with nostalgic depictions of a vanishing race that served as allegorical reminders of the nation's frontier past. These two versions of Native Americans inhabit each other —they exist only in dichotomy and always invoke each other.[147] As discussed earlier, Rookwood was eager to have the pottery viewed as fine art, suggesting that their Native American portraits in their displays at important international world's fairs were another instance of their mimicking or imitating oil paintings. However, whereas they almost certainly shared similar motivations—the sense of crisis communicated by Turner—Rookwood's Native American portraits did not look like other decorative arts objects, paintings, or sculptures depicting Native Americans on view in the world's fairs. Instead they were identical to a different kind of visual representation of Native Americans: the ethnographic photograph.[148] What follows argues that these Native American portraits, though displayed in international contexts and defined as fundamentally decorative, were intended primarily for masculine domestic consumption and embody some of the tensions within the doctrine

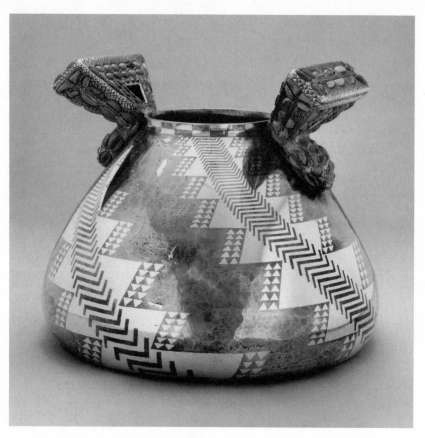

FIGURE 5.10. Tiffany & Co., *Pueblo Pattern Bowl*, 1900, silver, copper and turquoise. *Collection High Museum of Art, Virginia Carroll Crawford Collection (1984.170).*

of the "strenuous life"—specifically, coexistence of nostalgia for the "vanishing" Native Americans as representatives of a simpler, more wholesome way of life with theories of cultural degeneration, racial superiority, and imperial acquisition.

Ethnographic Images as Domestic Decoration

The nostalgia for Native Americans as a "vanishing species" is exemplified in a series of articles by Frederick Monsen published in the *Craftsman* bearing such titles as "The Primitive Folk of the Desert: Splendid

Physical Development That Yet Shows Many of the Characteristics of an Earlier Race Than Our Own."[149] This article sets out to prove "that the race is primitive physically as well as mentally; and . . . that the hardy life, vigorous exercise and freedom from all physical restraint has developed beautiful, strong bodies that are as absolutely natural and as suited to the circumstances of their lives and environment as is that of the tiger."[150] The article is illustrated with Monsen's photographs of nude children climbing rocks, running, playing war games, and so forth. One photograph depicts a toddler standing on a rock ledge with the caption, "A white child here would almost inevitably roll down and break his neck, but this placid, fearless, sure-footed Indian baby is as secure in his dizzy position as the ragged little Indian chicken following him home to roost."[151] Monsen was using ethnographic photography as part of his project to capture the "vanishing race."

Most if not all of Rookwood's Native American portraits were copied from ethnographic photographs. One of the prominent publicity stills for the 1900 Paris World's Fair was a photograph of decorator Matt Daly in his studio at the pottery—which reinforces the notion of Rookwood's individuality discussed earlier (fig. 5.11). Daly is painting a Native American portrait on a vase and at his left is an identical photograph on a small easel. Many examples of the same image on different types of vessels painted by different artists indicate a common source.[152] Rookwood decorators would have had the opportunity to see Native Americans at the Cincinnati Zoo in 1896 when the Zoological Society brought "The Only Genuine and Legitimate Wild West Show and Congress of Rough Riders of the World In or Near Cincinnati This Season." This event lasted three months and featured eighty-nine Sicangu Sioux men, women, and children transported from their homes on the Rosebud Reservation in South Dakota via train to Cincinnati. Many Cincinnatians are known to have sketched and photographed the Sicangu that summer, including an unknown photographer who provided photographs to Rookwood.[153]

The majority of the Native American photographs were not local in origin. For example, the photograph copied by Artus Van Briggle for the

FIGURE 5.11. Decorator Matthew Andrew Daly, c. 1900, photograph. *Cincinnati Historical Society Library.*

plaque shown at the Chicago Fair has been identified as having been taken by John K. Hillers, staff photographer for the Bureau of American Ethnology, which was administered by the Smithsonian Institution (plate 10 and fig. 5.3).[154] This bureau was created circa 1880 to continue the ethnographic work of earlier government-sponsored geographical and geological surveys of the western United States conducted from 1867 until 1879. These surveys had initially been concerned with military reconnaissance under the direction of the War Department, but had shifted to geological and ethnological studies controlled by the Department of the Interior. Photography was considered to be an important scientific tool to assist the government in gathering information about Native

American groups.[155] Although these photographs did not circulate widely, copies were available from the Smithsonian, and Rookwood records indicate that at least one decorator visited the Smithsonian and an unidentified photographer "famous for his pictures of Indians."[156] It is likely that the pottery owned copies of several of Hillers's photographs. Grace Young copied the young boy in Hillers's "Moki Rabbit Hunters" onto a charger in 1898 (figs. 5.12 and 5.13) while Sturgis Laurence copied the older man onto a three-handled cup the same year. The Van Briggle plaque is one of the few instances of a photograph copied in its entirety (unlike the division of the image of the rabbit hunters by Young and Laurence) and, significantly, one of the few times that the Native American subject was depicted as engaged in an activity.

Although the Bureau of American Ethnology photographs were posed, they do not appear to have been made in a photographic studio but rather to have been taken on site, demonstrating contemporary circumstances. Exceptions include a later Bureau of American Ethnology photograph by Hillers of "Nó Talq, Apache," copied onto a Rookwood vase by Grace Young (figs. 5.14 and 5.15) and a photograph by Wells Sawyer copied for the tankard depicting "Chief Joseph, Nez Percé" by Sturgis Laurence (fig. 5.16 and plate 13). Chief Joseph was probably, after Geronimo, the best-known Native American leader of the day and was not only famous but widely respected. His photograph was a popular collector's item and was widely reproduced in the press (fig. 5.17).[157] While it is not known who purchased this tankard and ale set, it seems likely that the appeal of these images would have been different than that of the workman represented on the Van Briggle plaque in plate 10. The copies otherwise are fairly close to the original portrait, but often are rendered in such a way that the subject looks younger, more naive, and softer. Nonetheless, these wares clearly played into the sentimental adulation accorded Native Americans as inhabitants of the former frontier and as members of a vanishing race. The portraits are beautifully and respectfully rendered and treat the subjects as individuals by giving their names and tribal affiliations.[158]

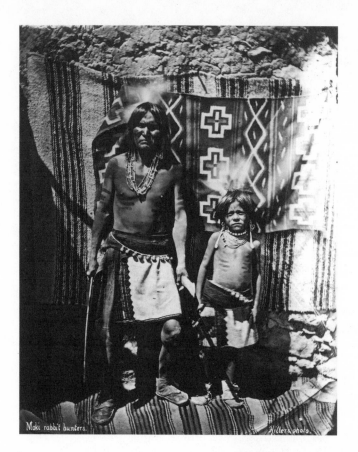

FIGURE 5.12. John K. Hillers, *Moki Rabbit Hunters,* 1879. *National Anthropological Archives, Smithsonian Institution.*

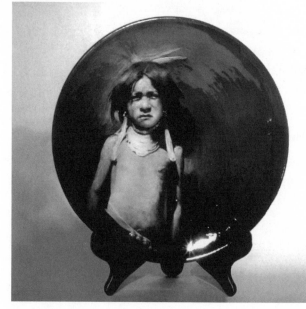

FIGURE 5.13. Rookwood Pottery Co., Grace Young, *Charger,* 1898, Standard glaze line. *Courtesy Cincinnati Art Galleries.*

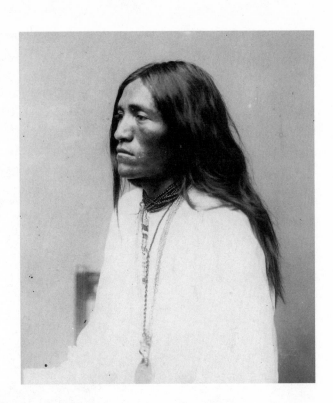

FIGURE 5.14. John K. Hillers, *Nó Talq, Apache*, before 1894. *National Anthropological Archives, Smithsonian Institution.*

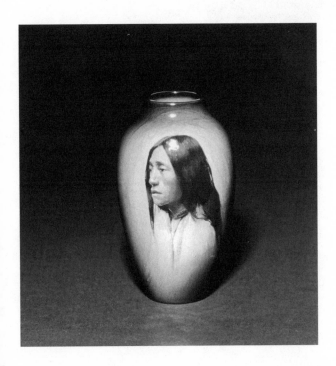

FIGURE 5.15. Rookwood Pottery Co., Grace Young, *Nó Talq, Apache*, 1899, Standard glaze line. *Private Collection.*

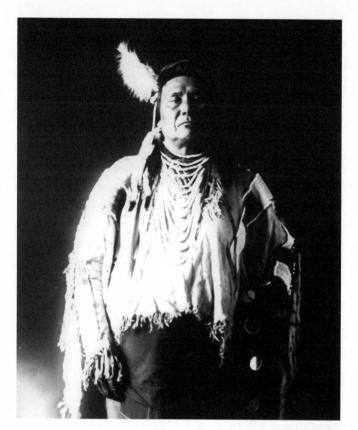

FIGURE 5.16. Wells M. Sawyer, *Chief Joseph, Nez Percé*, 1897, photograph. National Anthropological Archives, Smithsonian Institution.

FIGURE 5.17. Chief Joseph, *The Nez Percé*, 1884. From Century 28, 1 (May 1884): frontispiece. Courtesy, The Winterthur Library: Printed Book and Periodical Collection.

Social Darwinism and Cultures of Imperialism

At the same time as back-to-nature advocates like Frederick Monsen were working to create a nostalgic record of Native American life, other Americans were using aspects of the cult of the strenuous life to buttress doctrines of cultural degeneration, racial superiority, and imperial acquisition. These ideas stemmed from the era's concept of social Darwinism, which saw the conquest of the frontier as only the latest in a centuries-old pattern of Anglo-Saxon victories. In *The Winning of the West*, Theodore Roosevelt elaborately extended this pattern back to the German invasions of the late Roman Empire. Anglo-Saxon superiority could be explained in terms of a succession of frontiers from the Black Forest to the Black Hills.[159] Hence, when the United States was looking beyond its borders, annexing Puerto Rico, the Philippines, Guam, and the Hawaiian Islands and building the Panama Canal, these other cultures (Huns, Celts, Indians, and, with immigration, still more Huns and Celts) were viewed as relatively interchangeable. In 1885, the Reverend Josiah Strong wrote "that this race, unless devitalized by alcohol and tobacco, is destined to dispossess many weaker races, assimilate others, and mold the remainder, until, in a very true and important sense, it has Anglo-Saxonized mankind."[160]

One way this discourse can be examined it to study other activities at the various international expositions where Rookwood's Native American portraits were on view. What follows concentrates primarily on the 1893 World's Columbian Exposition, acknowledging that similar activities occurred at each of the fairs during this roughly ten-year period. Cultural historian Robert Rydell has written extensively about Native American petitions to officials of the World's Columbian Exposition for the opportunity to develop their own exhibits. They wrote, "With a Native American or Indian exhibit in the hands of capable men of our own blood, a most interesting and instructive and surely successful feature will be added [that] will show to both and all races alike, that our own advancement has been much greater than is usually supposed."[161] Fair officials agreed to include representations of Native Americans, but

certainly not on the terms set by the petitioners. Of the many Native American displays, most noteworthy were those in the Anthropology Building and on the Midway. Anthropology, then a fairly new discipline, attempted to contain the spectrum of human existence under one roof, all the while implying that Native Americans and other non-whites occupied the lower registers of that spectrum.[162] Exhibits concentrated on a living ethnographic display of Native Americans such as the birch bark huts of the Penobscot tribe, quarters of the Navajo, or the long cabin of the Six Nations.[163] North of this ethnological exhibit was what fair organizers and contemporary observers identified as the reverse side of the picture: a model government-run Indian school which provided "a contrast to the primitive life of the aborigines."[164] Also included in the Anthropology displays were laboratories for making physical measurements of "primitive" crania intended to "illustrate the anthropology of North American Indians." In an adjoining area, deliberately juxtaposed with these "primitive" crania, was another exhibit illustrating the "specifications for the ideal male and female university student," based on studies of students from Harvard and Radcliffe.

On the Midway, exhibits catered to public expectations of "primitive savagery," capitalizing on the macabre appeal of "Sitting Bull's Cabin" (in which he was supposedly killed) and a Wild West show put on by "Diamond Dick and his band of Sioux"—actually sixty Native Americans drawn from different tribal groups.[165] Other Native Americans could be seen as participants in Buffalo Bill's Wild West and Congress of Rough Riders of the World, which was set up just outside the entrance gates of the Chicago fair. These shows always featured mock battles of army scouts and Native Americans complete with ritualistic slayings of the latter.[166]

When one considers the stated purpose of the World's Columbian Exposition, the "unsuitability" or "impossibility" of the Native American's request to develop exhibits to demonstrate their own cultural advancement becomes readily apparent. That is, this World's Fair was intended to celebrate the voyage of Columbus, the subsequent peopling of the United States by Europeans and, most importantly, the amazing

progress of the past four centuries. However, as fair organizers pointed out, this mighty demonstration of progress would have no base without "the means of comparison." To quote Frederick Ward Putnam, head of the Department of Ethnology and Archaeology for the fair: "What, then, is more appropriate, more essential, than to show in their natural conditions of life the different types of peoples who were here when Columbus was crossing the Atlantic Ocean and leading the way for the great wave of humanity that was soon spread over the continent." Putnam went on to note that "these peoples, as great nations, have about vanished into history, and now is the last opportunity for the world to see them and to realize what their condition, their life, their customs, their arts were four centuries ago. The great object lesson then will not be completed without their being present."[167] "Civilization" required a "savagery" against which to distinguish itself. For Turner, for Roosevelt, and for the organizers of the World's Columbian Exposition, the demonstration of American progress involved in no small part the inevitable advance from low to high, from simple to complex, and from "Indian" to "American."[168]

This view of Native Americans, as the racially inferior, inert, timeless "other" or "object lesson" against which European Americans could measure their progress was particularly virulent during the decade in question, 1893–1904, and was graphically represented in a souvenir lithograph from the 1893 Chicago fair (fig. 5.18), which shows Columbia presenting the World's Columbian Exposition to whites as the high point of civilization and the ultimate product of Columbus's voyage to America, having transcended "inferior" non-white races such as Native Americans from the past. Thus, Native American participation in world's fairs was summarily confined to their being a sideshow attraction as well as "lower races in costume." These displays reveal a deep uneasiness and uncertainty about boundaries on the part of the organizers that was evidently intended to encourage sympathy with the exotic and simultaneously to keep a certain distance. Similarly, ethnographic photography with its obsessive classification and categorization of Native American

FIGURE 5.18. Allegory, "Proprieta Artistica," after a painting by Rodolfo Mor-gari. *Printed by Milano Oleografia Borzino, World's Columbian Exposition, 1893. Chicago Historical Society.*

peoples throughout this period is equally embedded in the anxiety about differentiating "civilized" Anglo-Americans from "barbaric" and/or childlike Native Americans.

In addition to Bureau of Ethnology photographs, another large group of Rookwood's Native American portraits were copied from photographs taken by Frank Rinehart and Adolph Muhr at the Trans-Mississippi Exposition held in Omaha, Nebraska, from June through October 1898.[169] The Trans-Mississippi provided a unique photographic opportunity because it was the site of the first "Indian Congress," held under the auspices of Bureau of American Ethnology of the U.S. Department of the Interior. Although the "Congress" degenerated into a Wild West Show, Rinehart and Muhr, hired to be the official photographers, took over

two hundred photographs of seventy tribes, recording the name and tribe of each individual or group.[170] Rinehart was also apparently the official photographer for the Indian Congress held at the Pan-American Exposition in Buffalo in 1901, where there were representatives of forty-two tribes.[171] Although Rinehart's project had scholarly ambitions, the main motivating factor was financial. Shortly after the exposition, he sold collections of these photographs through his studio as *The Rinehart Indian Photographs*.[172] The Rookwood Archive indicates that the Pottery owned a portfolio of photographs of Plains Indians inscribed "April 1899,"[173] and it is clear that decorators copied Rinehart photographs for many objects such as the vase painted by Matt Daly in 1899 of "James, Lone Elk" (fig. 5.19 and plate 14) and the vase by Sturgis Laurence decorated with a portrait of "Chief Wet Sit, Assiniboine" (figs. 5.20 and 5.21). It should also be noted that although the portraits discussed thus far were all of male Native Americans, Rookwood and ethnographic photographers also depicted and exhibited portraits of female Native American subjects, often including children.[174]

In addition, Rookwood also copied photographs taken by Heyn and Matzen of Omaha, who also took a large number of photographs at the Trans-Mississippi Indian Congress.[175] The studio photographs by Rinehart and Muhr and Heyn and Matzen often feature multiple poses of each subject, for example, front and profile views, as well as views in different sorts of clothing. The studio setting suppresses any evidence of the contemporary lives of the Native American subjects and represents a different sort of project than that undertaken by Hillers, Sawyer, and others of the Bureau of American Ethnology. It is not known exactly which of the multiple views circulated but it is clear that Rookwood decorators (or whoever selected the images for the Pottery) made certain choices. For example, most of the Rinehart photographs of Native American women show them bare-breasted, and it seems Rookwood decorators never copied these images.[176] Also, when there were active portraits, such as figure 5.22, depicting a bare-chested man with a quiver of arrows, these were invariably eschewed in favor of the more static poses (recall fig. 5.19).

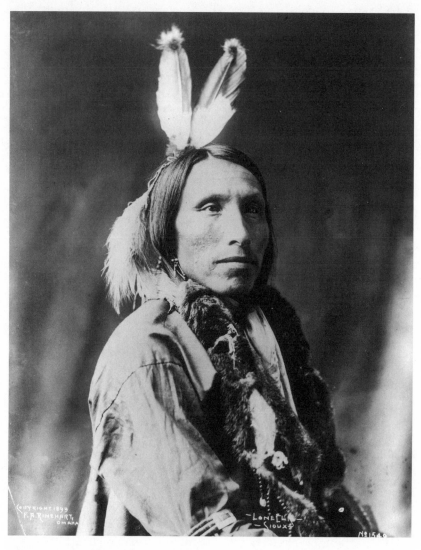

FIGURE 5.19. Frank Rinehart, Lone Elk, Sioux, c. 1899, photograph. *National Anthropological Archives, Smithsonian Institution.*

FIGURE 5.20. Frank Rinehart, *Chief Wet Sit, Assinaboine*, 1899, photograph. Library of Congress.

FIGURE 5.21. Rookwood Pottery Co., Sturgis Laurence, *Vase: Chief Wet Sit, Assiniboine*, 1900, Standard glaze line. Collection of Mr. James J. Gardner.

FIGURE 5.22. Frank Rinehart, *Lone Elk, Sioux*, c. 1899, photograph. *National Anthropological Archives, Smithsonian Institution.*

The static treatment of Native American portrait subjects suggests that Rookwood's depictions were probably also popular because they, like ethnographic photographs, permitted a view of the exotic Other while simultaneously suggesting a mastery or control by virtue of classification and ordering. It should be pointed out that the control function of these photographs was not lost on their subjects, some of whom called photographers "Shadow Catchers," recognizing that a photograph captured an element of their being which might be translated into power over them. These beautifully painted Rookwood portraits, especially the splendid works created for international expositions, cannot be viewed as simply nostalgic tributes to a "vanishing race." The turn-of-the-century discourse on Native Americans is more complicated than that and includes not only nostalgic yearnings for a simpler way of life but also notions of racial superiority and colonial aspirations. The Rookwood vases have a great deal in common with Orientalist oil paintings. Both are beautiful and have meticulously rendered details that signify the real in order to enforce the notion of a simple artless reflection and to deny the belief in white racial superiority that underlies the image.[177] There is an acute tension between the finished realism of both the vases and the paintings and the circumstances of their production.

Although the actual audience for these wares cannot be known with any degree of precision, as will be seen in the next chapter the intended audience can be read from marketing strategies and company publicity. For example, the wares decorated with Native American portraits range from classically inspired vases to vernacular household objects, but the majority of Rookwood's Native American portraits can be found on wares intended to appeal to men, such as ale sets, individual tankards, whiskey jugs, tobacco jars, and the like. With regard to Native American ale sets (such as shown in plate 13), Taylor instructed Davis Collamore and Co., "We would like to have you make a special display of [these] in the bay window and on Saturday afternoon if possible as well as Monday am. We think they will address themselves especially to the male sex and attract immediate attention."[178] This information indicates that these wares were in some measure consciously intended to appeal to men and

to participate in the cult of the strenuous life. The decision to quit copying photographs taken in situ by the Bureau of American Ethnology, which placed Native Americans in the present, in favor of studio poses taken at International Expositions, which appear timeless, suggests that these later wares were enmeshed in notions of racial control and superiority.

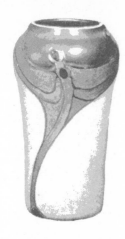

CHAPTER SIX

"GIVE THE LADY WHAT SHE WANTS"

As no piece of Rookwood is ever duplicated, it is impossible to issue a catalogue in the ordinary sense of the term. The pieces illustrated in this book were in the pottery studios at the time the Rookwood book was issued, but possibly when you receive this copy there may not remain unsold a single one of these pieces.

The Rookwood Book, 1904

Meanwhile, if you should happen to go to the Paris Exhibition, I should like very much to have you look at our Pottery exhibit. . . . I should be very much obliged for any criticism upon it which from you would be of great value to us. I would only wish to say in extenuation of the excess of floral decoration, which is not at all what I like best, that the agents demand it and we have to try in a measure to bend to popular taste by making things that sell. The Pottery would otherwise be far too expensive a luxury.

Maria Longworth Storer, 1889

Beyond the identity of a few high-profile collectors and American and foreign museums, very little is known about buyers of Rookwood pottery. According to Taylor, among those in the United States who admired and purchased Rookwood were these distinguished figures: H. H. Richardson, Henry Ward Beecher, Samuel Clemens, Thomas Nast, George W. Cable, Professor E. S. Morse, and John G. Low of the Chelsea Tile Works.[1] Other known American possessors of Rookwood include Potter Palmer, who purchased a vase at the Paris World's Fair of 1889; Henry Clay Frick, who acquired three pieces in the early 1900s—these were the only American ceramics in his collection; and President and Mrs. Woodrow Wilson, who received two pieces of Rookwood as wedding presents in 1915.[2] Currently, Gamble House, one of Charles and Henry Greene's "ultimate bungalows" in Pasadena, has sixty-five pieces of Rookwood in its collection, at least three of which were original to the house.[3] Rookwood management certainly encouraged well-known persons to acquire the ware. But given that approximately ten thousand pieces of pottery were produced per year throughout the 1890s and the early twentieth century, there have to have been many less prominent purchasers.[4]

This chapter imagines the intended audience for various Rookwood wares by examining the ways in which Rookwood management attempted to influence consumption through advertising, mail-order sales, and selection of retail agencies. For example, the print advertising for Rookwood art pottery was placed in magazines that catered to the higher social classes, such as Country Life in America, and the so-called quality group magazines, such as Century and Harper's New Monthly. Ads were also run in McClure's, which was less expensive but considered on a literary level to be the equal of the "quality group," and in "shelter" magazines such as House Beautiful and Ladies Home Journal targeted toward middle-class women.[5] Throughout the 1880s and 1890s, Taylor had prudently refused to even consider producing a catalogue, noting that "we issue no price list nor catalogue as the variety of our decorations and colors does not admit of it."[6] Despite these concerns, in 1904, as part of the J. Walter Thompson–directed promotional campaign, Taylor was persuaded to

introduce a mail-order catalogue, *The Rookwood Book*. This publication was intended to reach those living in small towns or rural areas who did not have access to Rookwood retail agents. In awarding agencies to retailers, Taylor sought "a first class trade," consolidating the ware in one outlet per city, initially a jewelry store or china dealer, but turning to department stores in the twentieth century. The failure of the mail-order scheme coupled with the choice of retail agents and sites for print advertising suggest that Rookwood clientele consisted primarily of urban, upper- and middle-class persons. In addition to sales outlets in larger cities, Rookwood "seconds" or defective pieces—considerably less expensive —were frequently sold in smaller towns, at charity events, or at vacation resorts. By assessing the demographics of subscribers to these various magazines and the clientele of the various sales venues, it is possible to imagine the intended, if not actual, consumers of Rookwood ware.

Although Rookwood managers clearly sought to manipulate the media in order to convince Americans to consume their product, they were also involved in a dialogue between the creators and receivers of the ware. Taylor and Maria Longworth Storer were constantly probing various segments of the market, usually retailers, for feedback on Rookwood. Taylor went so far as to write to a retail agent, "As long as we have been at the trouble of sending the ware we can at least get some information from it. Before returning it, look over the lot and give us your idea of what pieces would please your trade and at what prices."[7] Although precise responses are not known, a great deal can be inferred by what was produced and said.

The second part of this chapter argues that the consumption of Rookwood can be understood in terms of the mechanisms by which demand shaped supply. Rookwood depended on sales agents as information brokers to help them understand the marketplace, that is, to help them imagine consumers. These various intermediaries were specialists in linking supply and demand, for they labored at the nexus of production and consumption.[8] Both the shapes of the wares—traditional—and the predominant type of decoration—flowers—were seemingly dictated by Rookwood's consumers.

Historians of consumption have been influenced by the powerful analytical framework of Antonio Gramsci's theory of cultural hegemony. American scholars such as Stuart Ewen and T. J. Jackson Lears have called attention to the centrality of consumerism and have suggested that consumer tastes were reconstituted, rather than accommodated, as a vision of the American dream was constructed in the image of middle-class life.[9] However, this chapter is informed by more recent scholarship that challenges what are termed "conspiratorial portraits" of corporate hegemony by emphasizing the influence of the market on production. A particular influence is Lawrence Levine, who has advocated an alternative means of viewing and studying consumption, arguing for the possibility of negotiation, mutuality, or pluralism. Levine eschews the materialist model of domination and control and suggests that understanding how manufacturers developed their understanding of consumers, synthesized that knowledge, and generated salable goods is one of the primary avenues to deciphering the underpinnings of the culture of consumption.[10] Strictly speaking, models of mass consumption do not apply to Rookwood until circa 1915 when the majority of wares were relatively inexpensive and no longer signed by decorators. Nevertheless, evaluating the ways in which consumer feedback influenced what was made will enhance understanding of Rookwood's audience.

Ceramic Collections and Collectors

In their efforts to create a market for Rookwood ware, management was aided by the enormous popularity of ceramics in the United States in the years following the Centennial.[11] In 1877, author and collector William Cowper Prime declared, "Ten years ago there were probably not ten collectors of Pottery and Porcelain in the United States, today there are probably ten thousand."[12] These ten thousand American collectors drew on a well-established English and Continental precedent that included Queen Mary II (1662–94), the Duchess of Portland (1714–85), Lady

Betty Germaine (1680–1769), and Madame de Pompadour (1721–64).[13] Perhaps the greatest of all china collectors was Lady Charlotte Schreiber (1812–95), who wrote about herself and documented her collection of some twelve thousand pieces of English, Continental, and Chinese porcelain. The Schreiber collection, offered and accepted in 1884, was one of the most important gifts of the nineteenth century to the South Kensington Museum.[14]

Among the ten thousand collectors mentioned by Prime (whose own collection was donated to the Department of Art and Archeology at Princeton University in 1890) were individuals who reportedly made their initial purchases of ceramic objects in order to "accessorize" their painting collections (e.g., J. Pierpont Morgan, Henry Clay Frick, and Benjamin Altman).[15] Other collectors focused on the ceramic objects themselves and often acquired objects through dealers such as Henry Duveen of Boston, Murray Marks of London, or Siegfried Bing of Paris. In Cincinnati, the Taft Collection of approximately two hundred examples of Chinese porcelain is typical of a wealthy person's collection formed in the late nineteenth and early twentieth centuries in the United States: Anna Sinton and Charles Phelps Taft acquired nearly one-third of their collection from Duveen during 1902.[16] Other well-known ceramics collectors of the period include Charles Lang Freer, whose objects are now part of the Freer Gallery of the Smithsonian Institution; Edward S. Morse, whose collection of Japanese ceramics was sold to the Museum of Fine Arts, Boston; and William T. Walters, whose collection now resides in the Walters Art Gallery in Baltimore.[17] The Cincinnati Art Museum had acquired the core of a fine ceramics collection from thirty-two objects donated by its first director, Alfred T. Goshorn, who had also been director general of the Centennial. Goshorn's donation included Japanese porcelains, late-eighteenth- and early-nineteenth-century European porcelains, and various examples of tin-glazed earthenware (mostly eighteenth-century Turkish, French, and Dutch examples). The collection had been built largely through gifts acquired at the time of the Centennial from ceramics manufacturers.[18] This stupendous event, which

covered approximately 260 acres, had hundreds of ceramic exhibits and fueled an interest in pottery and porcelain among "all classes and conditions of people."[19] Figure 6.1 shows Centennial visitors, guide books in hand, examining the myriad ceramics on view at the exposition. Except for Frick, who owned a few pieces of Rookwood, and Freer, who was a patron of the Pewabic Pottery in Detroit, almost no one in the United States collected American Art Pottery.[20] English, Continental, and Asian ceramics were considered much more desirable.

CERAMICS IN THE HOME

In the years following the Centennial, ceramics, along with other types of home furnishings, were commonly used to express individuality, taste, and rank—to reinforce social meanings and relationships in an unstable culture. As the nation industrialized and expanded in the late nineteenth century, Americans became increasingly differentiated into several strata, and so too furnishings, dress, and manners evolved into badges that demarcated territories and interests broadly defined by factors like spatial associations and ethnicity. The display of objects having artful qualities in a parlor or dining room demonstrated a family's collective sensibilities and buttressed its social aspirations. Decorated ceramics were among the symbols of a family's gentility, if not simply tokens of their aspirations to membership in the genteel new urban middle class.[21] Not only well-to-do households in the northeast United States (fig. 6.2), but also more modest homes (fig. 6.3) were decorated with ceramics on the mantle, in china cabinets, on plate rails, and on top of furniture.

The associations between ceramics in the home and gentility were made explicit in household advice books, which were filled with prescriptions for the use and display of artistic ceramic ware. Charles Locke Eastlake's immensely popular *Hints of Household Taste* appeared in England in 1868 and in the United States in 1872.[22] In the years following the Centennial, there was a veritable industry of prescriptive literature from

FIGURE 6.1. "Visitors Taking Notes: Character Sketches in the Memorial Hall,"
1876. From Frank H. Norton, ed., *Frank Leslie's Historical Register of the United States
Centennial Exposition* (New York: Frank Leslie, 1877), 144. *Hagley Museum and Library.*

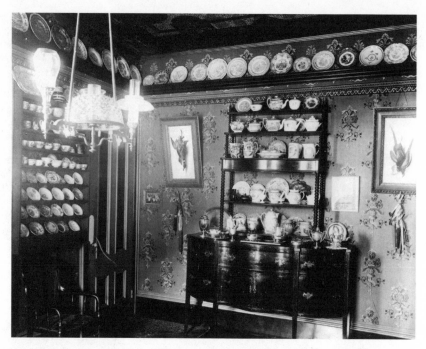

FIGURE 6.2. Dining room display of china, c. 1900. Jeremiah Page Dining Room, Salem, Massachusetts. Mary Northend Collection. *Courtesy, The Winterthur Library: Decorative Arts Photographic Collection.*

journals such as the *Art Amateur* and the *Art Interchange* to household guides like Clarence Cook's *The House Beautiful* (1878) and Candace Wheeler's *Household Art* (1893).[23] Wheeler's book was a collection of essays, most of which had been previously published elsewhere. Although household advice manuals varied in content and tone, they held in common the premise, discussed in chapter 2, that women were moral guardians of the arts and that the beautiful interior was both edifying and spiritually uplifting. The gender and class dimensions of this argument, positing middle-class women as the arbiters of taste and moral development within the home, were foregrounded in all the prescriptive literature.[24]

All of these manuals devoted attention to the role of ceramics in the home. Some authors, like Ella Rodman Church, describe its use in specific rooms. For example, Church notes that "The dining room sideboard is the proper sphere for those uncomfortable looking plates that are sometimes strung up on parlor walls, like so many culprits to be

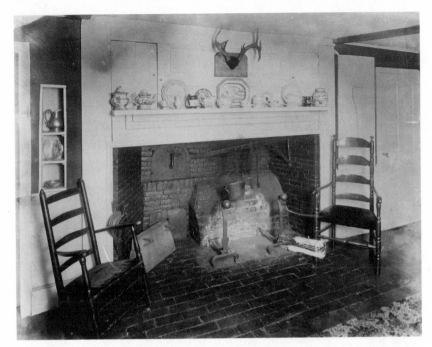

FIGURE 6.3. Peabody Fireplace, c. 1900. Salem Massachusetts. Mary Northend Collection. *Courtesy, The Winterthur Library: Decorative Arts Photographic Collection.*

hanged by the neck." About the parlor she writes, "Old-fashioned candlesticks, real silver if possible, are always in order for the mantle. . . besides the candlesticks, a pair of handsome vases with covers and handles and as a central figure, not a clock but a piece of Parian." In "the most attractive library we know," she observed that there are "marvels of faience and china scattered about." Finally, "Nowhere is pretty china more in harmony in the way of ornament than in the bedroom."[25] Other authors signaled the importance of ceramic ware to home decor by devoting entire chapters to "Bric-a-Brac," or to "The Plate Rail and Pottery Shelf."[26] Several authors specifically recommend Rookwood pottery for home decoration. Constance Cary Harrison, writing in 1882, was the first to commend Rookwood Pottery as within the reach of persons of limited means.[27] Mary Gay Humphreys in "The Progress of American Decorative Arts," applauded Cincinnati Pottery and Rookwood as exemplars of American art.[28] In an article published in the *Art Amateur*, Clarence

Cook had singled out Rookwood as "the only manufactory . . . that has accomplished much of value in the use of our native clays and in the invention of glazes."[29] Although not usually considered within the realm of advice literature, the *Craftsman* also advocated the use of pottery in decoration. Pottery (usually Grueby) appeared as accessories in Stickley's furniture catalogues and in *Craftsman* interiors (without comment), as appropriate to Stickley's concept of complete design.[30] By recommending, either explicitly or implicitly, the use of ceramics in home decoration, tastemaker authors ranging from Clarence Cook to Constance Cary Harrison and Gustav Stickley promoted consumption.

Advertising

The consumption of ceramic ware was also promoted through advertising closely linked to the emergence of national circulation magazines. Since most magazines circulated by mail, postal rates were very important. After the enactment of the Post Office Act of 1874, the rate for monthly and quarterly periodicals had been three cents per pound, and two cents a pound for weeklies. But in 1885, Congress passed a law reducing these rates to one cent a pound for all second-class mailings. This cheap postage had much to do with the boom in magazine publishing during the eight years preceding the panic of 1893.[31] Beginning in the 1870s, *Harper's Monthly*, *Atlantic Monthly*, *Scribner's*, *Century*, and the *North American Review* started "Proprietary Articles" and "Advertisers" sections in the back of their publications. Ads came from four primary sources: patent medicines, insurance, transportation, and traditional announcements of the magazines' own new books. In the 1880s, *Ladies' Home Journal*, *Cosmopolitan*, *Munsey's*, and *McClure's* began. Advertising was no longer segregated from text. This resulted in a shift in the role of the publisher from "being a seller of a product to consumers to being a gatherer of consumers for the advertisers."[32] The gains in advertising volume were striking. In the six months from November of 1882 through April 1883, *Century* carried 218 pages of paid advertising. In the comparable period of 1887–88 the total had reached 448 pages.[33]

Crockery and glass purveyors, both manufacturers and retailers, were among those encouraged to advertise their wares: "Advertising itself is an actual necessity to successfully carry on any business, and no business can succeed, in fact no business can exist, without advertising; for in the word advertise we embrace every means adopted by the possessor of an article to inform his possible or probable customers of the fact that he has wherewith to satisfy certain of their necessities."[34] A few years later ceramics manufacturers and retailers were urged to advertise because "You must keep the boiler heated if you want steam. If you bank your fires too long, it takes time to start up. Advertising is the steam which keeps business moving; I've studied the matter."[35]

Rookwood took this advice to heart, initially advertising exclusively in Century magazine. Management made it a point to avoid local advertising, feeling that this was the responsibility of the individual dealers.[36] Taylor pointed out to J. B. Hudson of Minneapolis, "You must be mistaken as to my promising any allowance for advertising for the reason that we have steadily declined to do local advertising. The expense of our announcements in the magazines etc. is all we can stand and if we advertised in one place we would have to do it in others and so be overwhelmed." He went on to observe, "Further, if you will consider it, the references to Rookwood in your own advertisements do not really add to what you would spend at any rate in this direction."[37] The national advertisements, located in the "Architecture & Art Decoration" section of Century, and designed by William Watts Taylor, were dense with text in an effort to obtain name recognition for the ware (fig. 6.4). Although the absence of illustrations was not unusual, digesting such a large amount of text necessitated more than a quick glance from the reader. A similar strategy, and similar texts, were used in a three-page advertising pamphlet published by the Pottery, probably at the time of the 1889 Paris Exposition.

In selecting Century as their sole advertising venue in the 1880s, Rookwood management chose one of the leaders in the field of national illustrated monthlies devoted to the publication of literary miscellany. Circulation peaked during the 1880s when the magazine ran a series on the Civil War as told by many of its leading participants. The "War Series"

FIGURE 6.4. Rookwood advertisement, 1887. From Century 33, 6 (April 1887): 15. *Courtesy, The Winterthur Library: Printed Book and Periodical Collection.*

began in November 1884 and continued for more than three years, its echoes reverberating for many months afterward. This was the climactic event in the history of the magazine, for it vastly increased Century's readership, prestige, and prosperity. After reaching a circulation of 250,000 during the War Series, Century's readership settled back by 1890 to about 200,000. However, this was an unprecedented number for a thirty-five cent monthly and still gave it the lead among the monthlies that dominated the periodical field.[38] Edited by Richard Watson Gilder, the magazine was also strong in serial biography, short fiction, and coverage of the visual arts.[39] Century published many reproductions of paintings and sculptures in features on art and artists, in reviews of national and international exhibitions, and as illustrations accompanying essays. In addition, it was well printed.[40] Both its cost and its use of wood engravings for reproductions of works of art suggested that it catered to the higher social classes.[41] Educators, reformers, and pleaders of special causes were eager to spread their messages through its pages, agreeing with Edward A. Atkinson's judgment that there was "no such circle of readers as that which can be reached by the Century."[42] The Journalist commented in 1890 that "To the man or woman who moves among cultured people, the

reading of the *Century* has practically become compulsory."[43] Certainly these class associations would have been welcome to the fledgling pottery company. However, *Century* had other associations that would have been equally if not more appealing for example, *Century* (like Rookwood) was viewed as "intensely American."[44]

There was an advertising revolution in the 1890s with a rapid increase in absolute expenditures on advertising as well as expenditures per capita.[45] For example, during the six-month period from November 1892 to April 1893, *Century* carried 646 pages of advertising—140 pages in the December issue and an average of more than one hundred pages in each of five other numbers. This sea change was noted in a self-congratulatory how-to-do-it text by Earnest Elmo Calkins and Ralph Holden, who wrote, "Men not very old have witnessed the entire development of modern advertising from being an untrustworthy instrument of quacks and charlatans to its place as an engine in the conduct and expansion of business."[46] Not only was there a change in the amount of advertising; there was also a shift in the type of advertising, with a new emphasis on national advertising of branded products, especially in magazines.[47] More importantly, there was a big increase in advertising for home furnishings in the 1890s, especially china, silver, and pianos.[48]

Throughout the 1890s, most Rookwood advertising was placed by its retail agents—usually in *Century*. On the rare occasions when Rookwood placed its own ads, it continued to advertise in *Century*, but the copy was much sparer and the advertisements presume name recognition (figs. 4.13 and 6.5).[49] Rookwood also published at least two different pamphlets during the 1890s. One of them, probably published in 1895, begins, "A Visit to Rookwood." It describes the physical plant, the production processes, the varieties of ware, the honors received by the Pottery, the marks on the pottery, and prints adulatory quotations taken from reviews of the ware at the time of the 1889 Paris World's Fair.[50] The other pamphlet was a reprint of an article written about the pottery by Rose G. Kingsley for the *London Art Journal*. It is not hard to see why management chose to reprint Kingsley's piece. *London Art Journal* was not widely circulated in the United States, and it is quite a flattering article.

The author views Rookwood as "The result of a number of fortuitous circumstances . . . first genius is needed to conceive the idea; indomitable determination and enterprise to shape it; wealth to carry it out; business capacity to make it succeed."[51] Taylor reported to shareholders that this pamphlet was intended to "counteract the activity of the counterfeiters of Rookwood and we have proof of its excellent results in that direction."[52]

The increase in the overall volume of advertising in the 1890s paralleled another significant change: the rise of the advertising agency. Through the fifty years since the first agency was founded in the United States in 1841, the business had grown to include hundreds of agencies by 1890. At the turn of the century large agencies like J. Walter Thompson or N. W. Ayer had over one hundred employees and served nearly one thousand clients. Thompson led in the field of magazine advertising, which soon became the main locus of modern national advertising. In 1904, the J. Walter Thompson Agency's *Blue Book* outlined to prospective clients "The Thompson Method." Thompson agreed to study the prospects of the client's product line, check out the products and positioning of rivals, advise on a selection of advertising media, prepare "new copy and new illustrations" and place them appropriately, with persistence and variation, over a period of time. Without question the "Thompson Method" was that of the modern advertising "campaign"—a military term already in common usage before 1900.[53] Market research, used only sporadically in the late nineteenth century, became standard procedure for most large agencies by 1900.[54] Although the N. W. Ayer agency had pioneered the technique, J. Walter Thompson was the first to systematically apply it. By 1903, the bureau of design in their Chicago office solicited reader reactions to full-page advertisements that had been inserted in twenty-five national magazines. They received over thirty thousand responses, discovering that "the public" did not like ads without illustrations (or any kind of advertisement for beer). This survey suggested that market research involved not only the measurement of objective data, such as income and place of residence, but also the slippery task of investigating cultural and psychological attitudes.[55] The appearance

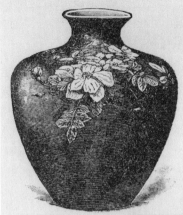

Rookwood.

The methods in use at the Rookwood Pottery are directed to making each piece individual in color and design. Hence it is impossible to issue a catalogue. The ware may be had at the Pottery, or from a leading dealer in each large city, whose address will be given upon application.

ROOKWOOD POTTERY, CINCINNATI.

FIGURE 6.5. Rookwood advertisement, 1892. From *Century* 45, 1 (November 1892): 35. *Courtesy, The Winterthur Library: Printed Book and Periodical Collection.*

of advertisements also changed during the 1890s. By 1901, J. Walter Thompson was advising clients that pictures "should show the goods in actual use." Prior to this, visuals were usually sketchy and decontextualized and were confined to small, stylized engravings.

At a Rookwood board of directors meeting held August 4, 1904, William Watts Taylor presented a plan proposed by the J. Walter Thompson Co. of Chicago to implement a system of advertising, pamphlets, and follow-up letters. Advertising expenses, including pamphlet production, had never exceeded $2,400 per annum. This campaign was budgeted at $7,500 for the first year alone. Taylor felt strongly enough about the feasibility of the plan to secure the bank loan with his company stock.[56] The purpose of the increased advertising was reportedly to "stimulate sales in the vase department."[57] However, two years and $17,000 later, Taylor reported to shareholders that the "Special advertising in the past two years, has not so far justified itself by any sufficient increase in sales in the vase department. On the other hand, it has introduced the ware to thousands of possible customers." He went on to observe, "What is of more importance is its obvious effect in interesting

and encouraging the dealer. Our agents average better in quality and their interest in Rookwood is livelier than a year ago."[58]

The Rookwood advertisements generated by the Thompson campaign turn to culture to foster commerce by focusing on Rookwood as an "artist's studio" and by presenting the ware as equivalent to paintings and sculpture. In choosing a site, the agency recommended that clients select "a journal of high character that has entrance in to better class of homes." It is likely that Rookwood's targeted magazines were also those with which the J. Walter Thompson agency had special rate arrangements.[59]

The new magazines recommended by the J. Walter Thompson agency included *Country Life in America*, an upscale quarto-sized publication, costing $4 per year, which featured articles on horticulture, animal husbandry, and antique furniture collecting.[60] Despite its title, the magazine was not designed for farmers but for city dwellers who had a country estate or who aspired to one.[61] By virtue of subscription numbers, a far more important, though less expensive, new site for Rookwood advertising was *McClure's*. Founded in 1893 by Samuel S. McClure, *McClure's* was one of the leading ten-cent magazines in the United States. Its first great success came after Ida Tarbell's celebrated serialized biographies of Napoleon and Lincoln appeared in the mid-1890s. By 1900 circulation reached 370,000 readers, exceeded only by three other monthlies— among them *Ladies' Home Journal*.[62] The years that Rookwood advertised in *McClure's* roughly coincided with Tarbell's searing nineteen-part series on John D. Rockefeller and the Standard Oil Company (November 1902 through August 1904). With a circulation of 500,000 in 1908, *McClure's* reportedly carried the greatest quantity of advertising of any magazine in the world.[63]

The House Beautiful, founded by William Gannett in Chicago in 1896, claimed to be the "only magazine in America devoted to simplicity, economy, and appropriateness in home decoration and furnishing." Although this may have been boastful, by giving attention to both traditional (i.e., Colonial revival) and progressive (i.e., American Arts and Crafts movement) ideas, the magazine hit upon a winning formula. Between 1900

and 1906 its circulation rose from 7,000 to 40,000 per month. *House Beautiful*, edited by Herbert S. Stone from 1897 to 1915, reported on international expositions, described salient features of Japanese and Chinese pottery, extolled the beauty of exotic textiles, and praised crafters of stained glass, decorated leather, bookbinding, metalcrafts, jewelry, and furniture. There were also monographs on artists such as Van Dyke, Velásquez, and Rembrandt and academic studies illustrating historical furniture styles. As one might expect at a time when defining a "national style" was an international obsession, modern American arts and artists were prominently featured. There were also regular series on home economics, gardening, and shopping.[64]

The *Ladies' Home Journal*, a monthly magazine founded in 1883 in Philadelphia, focused on the interests of young female readers. By the time Rookwood chose the magazine as an advertising venue in 1904, the *Journal* had become the first magazine in the world to surpass one million in paid circulation. The magazine's producers estimated that by 1910 one in every five American women was reading the *Journal*.[65] Early editorial statements and records demonstrate that the magazine was written for the middle classes, with a nod given to upper-middle-class tastes and interests. Edward Bok, *Journal* editor since 1889, testified in one of the early issues that he was writing to two classes, "the rich and the great majority." He noted with little apparent regret that the *Journal* could not reach the poor, remarking that "other men are helping them."[66]

In addition to reaching a readership of a million persons in the early twentieth century, the *Ladies' Home Journal* also ran upwards of a half million dollars' worth of advertising per year.[67] It is likely that the influential "tastemaking" aspect of these various publications in addition to their subscription demographics and circulation figures would have made them appealing as sites for Rookwood's advertisements. Two of Rookwood's competitors, Teco and Rozane, ran ads in the same magazines as did Rookwood. For example, the October 1904 issue of *Country Life in America* carried ads for all three potteries (figs. 6.6, 6.7, and 6.8). It is known that the J. Walter Thompson agency designed and placed the Teco ads. It is likely, based on appearance and copy, that they were also

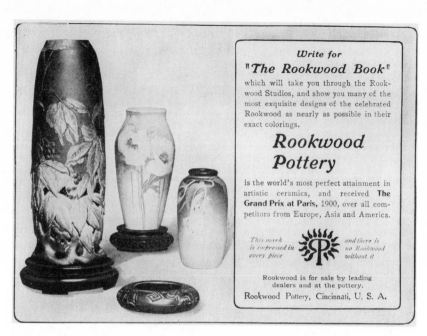

FIGURE 6.6. Rookwood advertisement, 1904. From *Country Life in America* 6, 6 (October 1904): 562. *Courtesy, The Winterthur Library: Printed Book and Periodical Collection.*

responsible for the Rozane ads.[68] All three feature prominent pictures of the ware, have a decorative border, a bold, easily identifiable trademark, and direct readers to descriptive booklets. In addition, all of these ads refer to the art nature of the pottery: Rookwood is defined as "the world's most perfect attainment in artistic ceramics"; Rozane as "art ware beyond compare"; and "Art lovers are instructed to send for the book about Teco Pottery." What is perhaps more interesting than the similarity of the ads is the vast difference in the appearance of the pottery. The ads sought to create a desire for products that are aesthetically very different by using virtually identical language and strategies. Although Rozane looked very much like the Rookwood Standard or Iris glaze lines, as discussed in chapter 3,[69] Teco had an entirely different aesthetic: Teco ware is molded, covered with a mat glaze (usually green), and has no applied decoration (recall fig. 3.19).

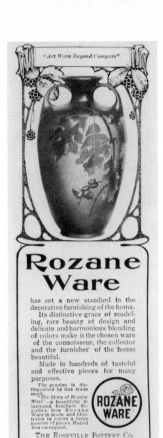

FIGURE 6.7. Rozane Ware advertisement, 1904. From *Country Life in America* 6, 6 (October 1904): 564. *Courtesy, The Winterthur Library: Printed Book and Periodical Collection.*

FIGURE 6.8. Teco advertisement, 1904. From *Country Life in America* 6, 6 (October 1904): 586. *Courtesy, The Winterthur Library: Printed Book and Periodical Collection.*

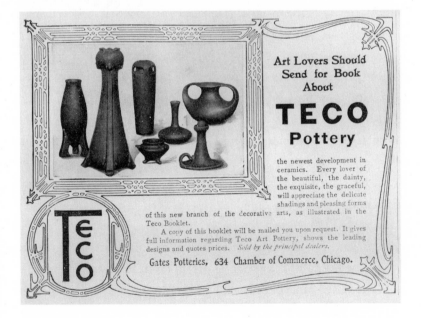

THE ROOKWOOD BOOK

Rookwood's ads were apparently constructed from a set number of images which could have different copy inserted as appropriate (figs. 6.9 and 6.10) and were virtually identical in the various types of publications in which they appeared, where they focused on Christmas gifts and June weddings. All advised readers to send for *The Rookwood Book*. The efficacy of *The Rookwood Book* as a mail-order catalogue will be taken up in detail below. What is of interest here is the way references to it demonstrate the heavy hand of the J. Walter Thompson agency. T. J. Jackson Lears has noted that all available evidence indicates that in the early years of the twentieth century, the most influential advertising agencies with the biggest accounts were staffed by a remarkably similar group of Anglo-Saxon males: college-educated, usually at prestigious Northeastern schools; Protestant, many the sons of Presbyterian or Congregationalist ministers; commonly from small towns or suburbs in the Midwest and Northeast. "They were the sons (only 3 percent were women) of the late nineteenth-century liberal Protestant elite, and they clung to a secularized version of their parent's worldview: a faith in inevitable progress, unfolding as if in accordance with some divine plan."[70] The J. Walter Thompson agency asserted in 1909 that "Advertising is revolutionary. . . . Its tendency is to overturn preconceived notions, to set new ideas spinning through the reader's brain. . . . It is a form of progress, and it interests only progressive people. That's why it thrives in America as in no land under the sun. Stupid people are not much impressed by advertising. They move in a rut of tradition."[71] This belief in progress and change pervades *The Rookwood Book*. For example, the first sentence refers to "the ever-changing language of an art that never repeats itself." The text goes on to describe the varieties of ware available and mentions the "many-sided development of Rookwood," as well as observing that "the knowledge gained by past experiments soon evolved new types and a greater perfection of glaze and decorations until today the latest types of Rookwood differ greatly from its first production."[72]

In the early years of the twentieth century the mail-order business

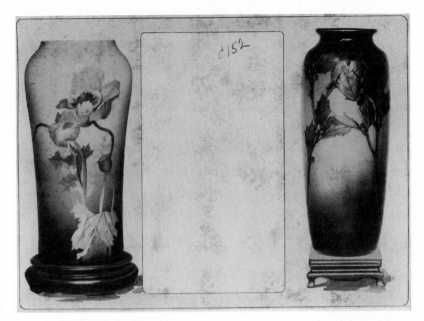

FIGURE 6.9. Rookwood advertising mockup, c. 1904. *Cincinnati Historical Society Library.*

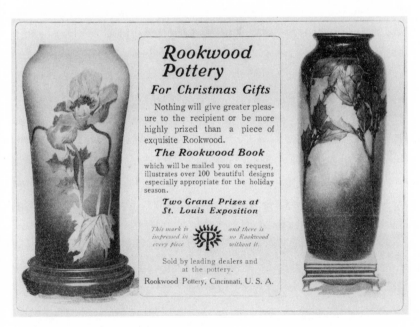

FIGURE 6.10. Rookwood advertisement, 1904. From House Beautiful 17, 1 (December 1904): 47. *Courtesy, The Winterthur Library: Printed Book and Periodical Collection.*

was considered "the greatest field of commercial endeavor for the bright man or woman with more or less capital, a desire to do things, and some commercial training." The first mail-order catalogue in the United States was published by A. Montgomery Ward in 1872.[73] Mail-order business grew rapidly in the 1890s as a consequence of the rural free delivery system, which had begun experimentally in 1897 and was rapidly increased during the first few years of the new century.[74] By the late nineteenth and early twentieth centuries many crockery and glass retail establishments and manufacturers produced catalogues.[75] However, The Rookwood Book was unusual because in it the very bedrock of catalogue shopping was overturned. The products pictured were not necessarily the same as those that would be received. Other art pottery manufacturers such as Newcomb Pottery who, like Rookwood, produced unique objects, contented themselves—as Rookwood had prior to 1904—with publishing informational brochures and urging potential customers to visit retail outlets.[76] In the Teco catalogue (fig. 6.11) the purchaser had a guarantee that the object pictured, ordered, and shipped would be identical. That this was not the case for Rookwood was made explicit in The Rookwood Book's ordering instructions, quoted at the beginning of the chapter, which emphasize that the objects pictured are unique and noting that they may be unavailable by the time the catalogue is received.[77] In addition, the objects are pictured separately from the price list—which further emphasizes the art quality and one-of-a-kind nature of the ware. The way prices are described, often with a range given, is another reminder of the variability of the products (figs. 6.12 and 6.13). Even the catalogue itself was atypical, being small in scale, bound in loose wraps, and hand-tied. The embossed cover and hand-made appearance of the paper served to enhance the artistic character of both the catalogue and its offerings. Although Taylor had reported to the board of directors that the catalogue "introduced the new types of ware to thousands of possible customers," it seems that "possible" is the operative word here, because catalog sales generated only about $700 in revenue—89 pieces were sold—during the first year of operation.[78]

Design No. 293. Vase in cat tail flag design by R. A. Hirschfeld. The decorative treatment of this piece is in itself restful to the eye, and its many practical uses make it a most desirable selection. Size 12 x 5 inches.

Price $12.00, express prepaid

Design No. 293

Design No. 283. Designed by F. Albert. Nine inches high. Classical Pompeian in style and particularly effective for mantel, den or book shelf.

Price $5.00, express prepaid

Design No. 283

Design No. 151. This beautiful vase is unique in its conception and was designed by W. J. Dodd expressly for cut flowers. The lower part of the vase holds the water while the flowers are carelessly arranged in the different openings, producing an exceptionally pleasing and artistic effect.

Price $10.00, express prepaid

Design No. 151

Design No. B-60. A very practical vase, as it can be used for so many purposes. Eight inches high, modelled design of daffodil blossoms and leaves. This is one of the most popular Teco vases and will give constant pleasure.

Price $4.00, express prepaid

Design No. B-60

Page Eight

FIGURE 6.11. *Hints for Gifts and Home Decoration* (Terra Cotta, Illinois: The Gates Potteries, 1905), 8. Collection of the author.

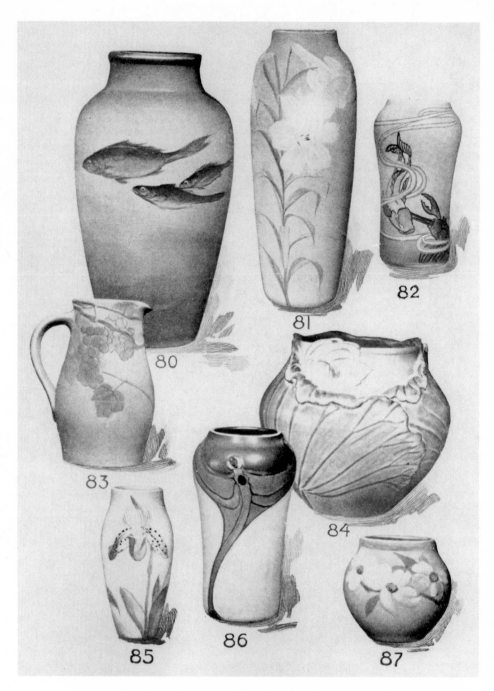

FIGURE 6.12. Items 80–87, *The Rookwood Book*, (Cincinnati, 1904), 29. Courtesy, The Winterthur Library: Printed Book and Periodical Collection.

PRICE LIST

NO.	TYPE		DESIGN	SIZE		PRICE
64	Incised Mat			5½ in. wide		$2.50
65	Modeled Mat			3 " "		1.00
66	" "		Grapes	15 " diam.		75 to 100
67	" "		Poppy	7½ " high		20.00
68	" "		Grapes	5⅝ " "		15.00
69	" "		Lobster	5⅝ " "		15 to 18
70	" "		Ivy	9 " "		20.00

LAMPS and ELECTROLIERS.

NO.	TYPE	DESIGN	SIZE		PRICE
71	Iris	Pine Cones	24 in. high		85.00
72	Modeled Mat Electrolier	Water Lily	14 " "		75.00
73	" " "	Thistle	22½ " "		85.00
74	Mat Glaze Candlestick		10½ " "		8.00
75	" " Lamp	{ Conventional Decoration in color }	33 " "		100.00
76	Modeled Mat Candlestick	Tulip	8¾ " "		25.00
77	Mat Glaze Lamp	{ Conventional Decoration in color }	22 " "		75.00
78	Modeled Mat Electrolier	Tulip	14 " "		75.00
79	Modeled and Painted Mat	{ with Special Modeled Base in metal }	24 " "		125.00
80	Vellum	Fish	9½ " "		25.00
81	"	Easter Lily	10½ " "		20.00
82	"	Conventional Fish	6½ " "		8 to 10
83	"	Jug	7½ " "		15.00
84	"	Modeled Lotus	7 " "		25.00
85	"	Orchid	6 " "		8 to 10
86	"	Conventional Dragon Fly	7½ " "		12.00
87	"	Dogwood	4¼ " "		8.00
88	"	Narcissus	8½ " "		15.00
89	"	Orchid	8¾ " "		15.00
90	"	Wild Carrot	7¾ " "		10 to 12
91	"	White Tulip	6½ " "		8 to 10
92	"	Teazel	7¼ " "		8 to 10
93	"	Lily of the Valley	5¾ " "		7 to 8
94	"	Jack-in-the-Pulpit	8 " "		12.00
95	"	Mistletoe	4¾ " "		7.00
96	"	Modeled Corn Flower	9 " "		18.00
97	"	{ Modeled Cherry Blossom with standard }	10 " "		25.00
98	"	Marine	10⅜ " "		25.00
98	"	with Flower Decoration			18.00
99	"	Modeled Fern Fronds	6½ " "		8 to 10
100	"	Modeled Mistletoe	7½ " "		12.00
101	"	Conventional Berry Design	6½ " "		10.00
102	"	Orchid	7¼ " "		15 to 18

FIGURE 6.13. Price list, *The Rookwood Book* (Cincinnati, 1904), 35.

Because entire sections from the catalogue were reproduced verbatim in articles about the pottery in popular magazines, *The Rookwood Book*, while unsuccessful as a mail-order catalogue, did have an extended life in the press.[79] The financial failure of the enterprise must be linked in some measure to the concepts which were the linchpin of Rookwood's self-identity: specifically, that it produced one-of-a-kind art objects.[80] It is apparent that management's attempt to democratize their product backfired because it contradicted Rookwood pottery's identification as distinctive and unique. In promoting its product as art, Rookwood succeeded in establishing that it was a luxury, and, for this target audience of rural or working-class persons, not affordable.

In order to be more precise about Rookwood's consumers it is necessary to determine who would have been able to afford the ware. Prior to the turn of the century, data on U.S. consumers are sketchy and often unreliable. Carroll D. Wright's survey for the Massachusetts Bureau of Statistics of Labor, however, systematically collected information about how working-class families spent their money and confirms the assertion that Rookwood would have been beyond their means. Wright reported that a typical family spent the majority of its income on food, clothing, and shelter—most working-class families earned no more than what was needed to cover the bare cost of their existence.[81] Economic data for middle-class families are available beginning in 1900, having been carefully collected by the U.S. Bureau of the Census. These data are revealing insofar as they present a broad pattern of consumption expenditures over time and provide snapshots of expenditures at given points in time. Even accepting the inherent limitations of mathematical averages, what the Census Bureau and related contemporaneous data suggest is at most modest expenditure for such items as furniture and decorative accessories among Americans at this time. For example, in 1909 furniture and furnishing comprised approximately 4 percent of the total consumption expenditures for the year, being superseded by food, alcoholic beverages, clothing, and shelter costs. When families were sorted by after-tax income class, the richest and poorest classes spent the least

amount of their total after-tax income on furnishings.[82] If a moderate middle-class income is defined for this period as $1,200 to $2,500 per annum, then roughly $48 to $100 per year would have been available for all home furnishings per year—about $1 to $2 per week. Thus, *The Rookwood Book*'s failure can be attributed to the cost of the wares, which would have put them beyond the reach of the rural or working-class population whose income would have been less than $1,200 per year.

Sales Venues

If Rookwood was beyond the reach of working-class or rural persons, and did not sell well via mail order, who did buy it and where did they do so? Initially, the ware was peddled by a single traveling salesman.[83] Writing about the early years of Rookwood's existence, Taylor remarked that "personal friends bought most of the pieces and helped float the enterprise. But our troubles began when we began to push beyond this very small circle."[84] However, when he took over as manager, Taylor fired the sales representative and named Davis Collamore and Co. of New York as national sales agent. Over the course of Taylor's leadership there were four types of sales venues: select retail establishments, national and international expositions, Women's Exchanges and charity events, and a salesroom at the Pottery itself. Retail establishments were limited to one per city. Although there were agencies in many smaller cities (e.g., Terre Haute, Indiana; Duluth, Minnesota; Bloomington, Illinois; Decatur, Illinois; and Cedar Rapids, Iowa) throughout the 1880s, by 1891 Rookwood was concentrating on Davis Collamore and Co. in New York; Briggs & Co. in Boston; Wright, Tyndale and Van Roden in Philadelphia; C. Hennecke and Co. in Chicago; and George Shreve and Co. in San Francisco.[85] During the 1880s and 1890s, Taylor favored upscale jewelry stores or fine china dealers, preferring "not to place our ware in a department store. . . . It inevitably injures the ware with the best class of trade."[86] However, by the twentieth century Rookwood was sold in select department stores,

such as Marshall Field's in Chicago.[87] The shift to department stores as prime retail venues was noted by other crockery and glass manufacturers. An editorial in *Crockery and Glass Journal* observed, "More and more as the years go by the department store is becoming an important factor in the china and glass business . . . now no department store worthy the title is complete without an array of china, glass, lamps and house furnishings."[88]

Occasionally, Taylor courted specific, "suitable" retail establishments hoping to interest them in the ware. During September of 1887 he wrote to Bailey, Banks and Biddle of Philadelphia: "We wish to place an agency for our ware in your city this season and would give your house the preference. It has met with great success this season in London where it is in the house of Messrs Howell and James and at their annual Exhibition of China Painting received from the judges the highest commendation." He also offered to "Place the ware with you on commission or to sell it outright as you might prefer. We do not know of any other make which approaches it in variety and richness of color."[89] He persisted the following year, writing that "We are honestly desirous of enlisting your hearty interest in the ware as we believe it would be of service to us and we think our production would be no discredit to the very beautiful stock the writer saw in your house. We will not go into second class trade and we preferred after receiving your letter to wait another season and try you again."[90] The ware was almost always sold on consignment, with the agent receiving 25 percent commission on the sale (except Davis Collamore and Co., which received 33 ⅓ percent).[91] Agents were required to submit detailed reports about what sold and at what price. Although they were encouraged to sell for the company list price, dispensation to discount was sometimes given and deals were occasionally cut to break into a new market as mentioned in Taylor's letter to Bailey, Banks and Biddle. Selling on consignment meant that Rookwood kept stock on their books which decreased their liquidity—something that proved to be quite a burden during economic downturns.

Taylor was cognizant of regional variability, telling Sloane and Mudge in Los Angeles that their selection of ware was "based to some extent on

your . . . sunshining climate." On another occasion he wrote to a dealer in Omaha that, "The fact is that in our experience the West is more critical about technical perfection than the East and we can sell pieces in New York which we would not send you at all. There are more people there who make collections and who do not care for roughness and small imperfections provided the color or decoration has artistic quality."[92] Taylor's eastern bias is apparent in this comment, suggesting as he does that sophisticated "collectors," as would be found in New York, don't care about technical perfection, whereas the rubes in Nebraska are preoccupied with this unimportant—and, for Rookwood, unattainable—feature. As mentioned earlier, the smaller outlets were dropped during the 1890s when demand exceeded supply. Moreover, when there was a shortage of ware (as happened the year the Pottery moved to the new building on Mount Adams) Davis Collamore and Co. of New York and to a lesser extent Briggs & Co. of Boston were given preferential treatment over other retailers.[93] Taylor explained this to Wright, Tyndale & Van Roden of Philadelphia: "Your customers ought not to complain of your stock as compared to Collamore's when New York takes as much in an average month as Philadelphia in a whole year—and Boston a close second." He went on peevishly: "We could never understand why your market shows so little interest in Rookwood. They are enthusiastic for 'home industries' but when it comes to buying give a market preference to 'foreign cheap labor.' Is not this so?"[94]

The largest, most splendid pieces almost certainly were sent to favored retail outlets or retained for the salesroom at the Pottery except when preparations were underway for a national or international exposition. As mentioned in chapter 5, special wares were hoarded for these venues and often new things were tried, for example, Standard glaze line vases with silver overlay for the World's Columbian Exposition (recall fig. 5.4). What is less well known is that during the 1880s and possibly beyond, Rookwood had a "secondary" market of Women's Exchanges and "watering holes" (e.g., Saratoga, New York; St. Augustine, Florida; Mt. Desert or Bar Harbor, Maine) where they sold pieces with minor flaws and imperfections.[95] In February of 1888, Taylor offered to send

some seconds to Miss Sophie Crawford of Essex County, New York, remarking that "We keep prices as low as possible and are particularly interested to see the ware go to people of moderate means but cultivated taste."[96] However, as with other low margin venues, by the 1890s few seconds were sent out and arrangements with Women's Exchanges were gradually terminated.[97] In a typical year without a major exposition, sales at the Pottery showroom accounted for about 15 percent of total sales.[98] Sales at the World's Columbian Exposition were $12,072 or 15 percent of total sales for 1893. Sales at the Paris World's Fair of 1900 were $10,400 or 12 percent of the yearly total.[99]

At all of these sales venues, but especially at the retail outlets, Taylor freely offered display advice, going so far as to suggest to one agent, "We think they ought to be put out of sight now and then. They are so conspicuous that left too long, customers get to thinking them 'shelf warmers'."[100] To another dealer he wrote, "We note with interest your intention with regard to Rookwood in your new store and quite agree with you that it needs a separate display in order to show at its best. We hope you can arrange a sunshiny nook with walls and draperies such as will bring out the beauty of the colors. The stronger the light the better for our wares always."[101] Despite Taylor's directives, the retailers were more than passive conduits between the Pottery and the public. They too sought to create desire for the objects. Trade magazines counseled merchants to "Give store arrangement greater consideration, and create in the mind of the customer a desire for other things she sees, as well as the article she asks for. People used to buy what they needed, now its what they want; and that want is created by store display or advertisement."[102] Although among department stores Field's twelve-story extravaganza was the pinnacle of luxury, it occupied one end of the spectrum rather than a class by itself. Scores of department stores across the country built new outlets and remodeled old ones according to their needs. But their goals were the same as those which animated Marshall Field: to make department stores into palaces of consumption.[103] The appeal of gracious appointments and lavishly displayed merchandise was reinforced by a range of services designed to make consumption more than

just the process of procuring goods. These amenities helped to equate purchasing with a genteel style of life, to make the department store the women's equivalent of a men's downtown club. Once department stores had become palaces of consumption, Rookwood and other china and glass manufacturers were eager to have their wares shown and sold there.

It is apparent that Rookwood's targeted consumer was a member of the urban upper or middle class.[104] Susan Porter Benson has observed, "The very lavishness of the store's presentation discouraged those of modest means from patronizing the store even though its goods might in fact be within their budgets. The features which so attracted wealthier patrons were intimidating or repellent to those of more modest means."[105] The gender of Rookwood's imagined consumer was most likely female since shopping, a significant component of upper- and middle-class activity, became the business of women during the late nineteenth century.[106] James H. Collins writing in 1901 in the advertising journal *Printer's Ink* noted, "Woman spends nineteen-twentieths of her husband's money in every community, whether her lord be a millionaire or a ditch digger."[107] Another author, writing in 1904, observed that "The emergence of women from the sphere of production into that of consumption of wealth has brought with it a disturbance of the economic conditions of the Anglo-Saxon world."[108] More importantly, by the late 1800s women were already viewed as the major consumers of household goods. An 1895 advertising brochure for the Lord and Thomas agency noted, "She who 'rocks the cradle' and 'rules the world' is directly and indirectly head of the buying department of every home. The advertiser who makes a favorable impression with her may be sure of the patronage of the family."[109] Because of these assumptions about the "feminization of American purchasing," advertisements as well as the retail venues where Rookwood was acquired would have directed their attention to the needs and desires of women shoppers in particular. Rookwood's vase production, which featured more floral decoration than any other motif, was also geared to the female consumer. Yet, as described in chapter 5 and displayed in plate 13 and figure 6.14, there exist a few examples that seem more likely to have appealed to the male purchaser,

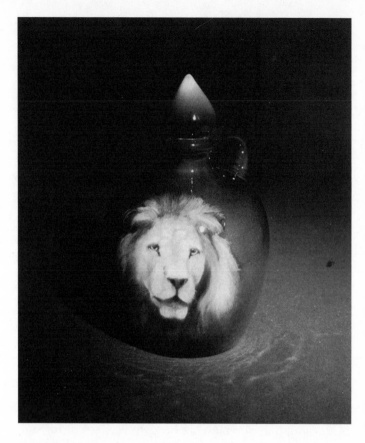

in both the type of object (e.g., whiskey jugs or ale sets) and the type
of decoration (e.g., nonfloral, often with Native American portraits or
animals). Although in most cases it is not known precisely which objects
the well-known male collectors mentioned above acquired, it is known
that H. H. Richardson purchased "a big tobacco jar that he could get
his hand into," and Henry Clay Frick acquired Native American portrait
vases.[110]

The foregoing discussion indicates that Rookwood's targeted con-
sumer was an urban, upper- or middle-class woman who may have
owned and studied one or more household advice manuals, read gen-
eral interest magazines like *Century*, *Harper's*, or *McClure's*, as well as publi-
cations having to do with home furnishings such as *House Beautiful*, *Ladies'
Home Journal*, or *Country Life in America*, and shopped in fine jewelry and china
establishments in addition to upscale department stores. However, there

were instances where management tried, sometimes unsuccessfully, to appeal to other market segments, for example, working-class, rural persons with *The Rookwood Book*, or male consumers, or small-town residents of limited means. The characterization of these imagined consumers can be extended by speculating about the ways in which market feedback may have influenced production. Although changes in production were governed by a need to remain internationally competitive, the basic premises of the ware were influenced by their target audiences. The balance between the projection of a distinct look or character, the adherence to the latest styles in design, and the maintenance of financial solvency based on product marketability was often precarious. Taylor acknowledged this, noting that "Industrial art at least is conditioned by the age it lives in. . . . It has to eat and be clothed. It should be content with plain living and high thinking—but it cannot go on all the time making things which people do not understand and do not want."[111]

Rookwood Shapes

The tobacco jar purchased by H. H. Richardson was probably based on a traditional vernacular design. However, the manuscript recording of Rookwood's products, the "Rookwood Shape Record Book," indicates that the Pottery copied such diverse models as antique examples from ancient Greece, Japan, and China to contemporary vessels made by French (Theodore Deck, Gallé, Haviland) and English (Doulton, Royal Worcester, Minton, Wedgwood) sources. Taylor acknowledged the Pottery's indebtedness to available source material in a letter to ceramics scholar Edwin AtLee Barber: "We have been greatly helped by the Art School and Museum here and especially by private collections and collectors both here and elsewhere."[112] Given the great collections of ceramics that were formed in the late nineteenth and early twentieth centuries in Cincinnati and elsewhere, it appears that Rookwood's appropriation of such well-known ancient and contemporary European and English forms was part of their effort to attract the "first class trade."

This is not to say that all Rookwood shapes were copied. A large number of them were designed at the Pottery (see chapter 3). But whatever their derivation, nearly all of them were traditional; very few were particularly innovative or new. During the late nineteenth century, Art Nouveau, literally the new art, held sway in France and Belgium and to a lesser extent elsewhere. The term "Art Nouveau" gained currency during the 1880s when it was applied in the context of painting to the production of Belgian socialist artists working outside the academic tradition. However, the term quickly came to refer to the abstract, curvilinear, and rhythmical style of furniture and decorative art produced in the 1890s and early 1900s, especially in Belgium by Henry van de Velde and Victor Horta and in France by Hector Guimard.[113] Art Nouveau in its most idiosyncratic form is easily recognized by lines and whiplash curves, a graceful integration of form and decoration, and a stylized interpretation of natural plant forms and women's bodies.

Art Nouveau was popularized in Paris by Siegfried Bing, who opened his shop Maison de L'Art Nouveau in 1895. Albert Valentien wrote in 1910 that Rookwood's artists "had also caught the [Art Nouveau] fever, in fact had already had it for several years previous to the general movement in that direction," but were discouraged from pursuing the truly new style.[114] The directive from management to decorators to avoid Art Nouveau is curious and slightly overdetermined, because the Pottery made some wares that most late-twentieth-century viewers would describe as Art Nouveau (fig. 6.15). Moreover, Rookwood management was eager to be internationally competitive, going so far as to arrange with Bing to act as Rookwood's Paris retail agent at the time of the International Exposition in 1900.[115] Valentien's comments demonstrate the need to understand what Art Nouveau meant to different individuals at the time.

Bing, one of the foremost proponents of Art Nouveau, had written about Rookwood in 1895 in an official report to the director of Beaux-Arts in France, Henri Roujon, who had asked him to comment on "the development of art in America."[116] Bing's remarks about painting, sculpture, and architecture were largely negative, but he felt that the applied

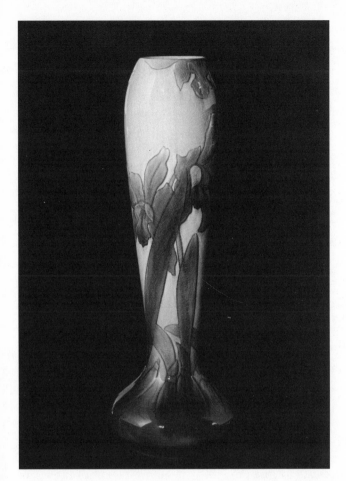

arts had some important lessons to teach European artisans. He singled
out the master silversmith Edward C. Moor and the glassmaker Louis
Comfort Tiffany as two of his models. With regard to pottery he re-
ported that "Only the Rookwood Pottery Company of Cincinnati has
gone boldly ahead in new artistic directions." Commenting that Rook-
wood shared with France the influence of Japanese ceramics, he noted,
"It may well be that in this area, so remote in origin, America will rap-
idly overtake us, given her energetic methods of tackling every prob-
lem."[117] Bing viewed Art Nouveau as a movement and not as a style,
and he could therefore admire, sell, and be an advocate for Rookwood
pottery as well. However, Bing's point of view concerning Art Nouveau
was not that of most critics in the United States.[118]

One can get some sense of the conflict surrounding Art Nouveau in the United States by considering a series of five articles that appeared in the *Craftsman* in the early years of the twentieth century. While not specifically about Rookwood, they raise issues that suggest some of the factors that would have influenced management in their decision to limit production of this style. The opening salvo was fired in June of 1902 by Irene Sargent in an article titled "The Wavy Line." Sargent claimed that although Art Nouveau deserves attention as a historical phenomenon, it breaks the continuity of artistic evolution toward simplicity. An object designed according to this aesthetic, she reasoned, "lacks the first great essential—it is not structural. . . . To allow the negative and chaotic in design to gain the ascendancy is to introduce a real danger into our environment."[119] The next issue contained an article by Josephine Locke who pointed to Art Nouveau's anti-academic qualities and noted that the style may be threatening to traditional artists because it is more instinctive than learned.[120]

A. D. F. Hamlin weighed in on the issue of Art Nouveau in December of 1902, also highlighting its anti-academic qualities and observing that because it is a movement away from something, in this case tradition, it is to be viewed as essentially negative. He wrote, "L'Art Nouveau is therefore . . . a movement away from a fixed point, not toward one; and its tendencies are for the present, as in all movement of protest or secession in their early stages, divergent and separative."[121] The last two articles in the series, by Jean Schopfer and Siegfried Bing, were adulatory about Art Nouveau, with Schopfer claiming it was not negative but positive: based on natural forms, inspiring cooperation of craftsmen, favoring beautiful materials, and open to influences from all cultures.[122] Bing's article was more descriptive and ended with the prediction that "America, more than any other country of the world, is the soil predestined to the most brilliant bloom of a future art which shall be vigorous and prolific."[123]

These articles make it possible to sketch out the terms of the debate and to gain understanding as to why Rookwood produced so few Art Nouveau–inspired shapes and why those that were produced were quite

conservative. All of the authors, pro and con, agree that the movement is anti-academic, which is to say anti-traditional. To Sargent, Locke, and Hamlin (all of whom were American) this was "admission of chaos," negative, anti-evolutionary, divisive, separative. These sentiments were echoed in an article in *Architectural Record* which gave voice to "A suspicion that the 'New Art' is only one of many expressions of 'fin de siècle' sensationalism which tries to whip jaded sensibility into new life by violent stimulation, and which authorizes any departures from traditional motives, however bizarre, formless, and even ugly, provided only that they are piquant and impertinent."[124] The two French authors in the *Craftsman* series, Schopfer and Bing, saw Art Nouveau's very newness as liberating. It is likely that Rookwood management and potential consumers would have agreed with the American authors given the myriad new situations they were encountering and the anxiety engendered by industrialization and urbanization. They found change threatening. It is tempting to speculate that the "French-ness" of the new art was also unwelcome. But, if so, it was the obviousness of the borrowing and not the act of copying a foreign style that was the perceived problem since Rookwood's underglaze decoration was itself derived from Haviland's *barbotine*. Finally, the "chaos" engendered by Art Nouveau may have also had unwelcome sexual connotations. Sargent wrote about Art Nouveau practitioners that "They are blind to all save 'the wavy line.' Their object of worship is the long, floating tress of a Lady Godiva or a Berenice, or yet again the knotted locks of a Medusa or the wind-tortured hair of a Maenad. Such are the leaders of the movement." She went on to point out that "A mirror frame produced in the Bing studios will serve as an illustration. 'The wavy line' is here found in a design executed in carving and composed of birds, flowers, and a female figure. . . . It is a specimen of a decadent, rather than a rising art, showing the same symptoms of dissolution [including] the use of the distorted female figure as a decorative unit."[125] Although several of Rookwood's Parisian-trained decorators produced small quantities of ceramic ware decorated with languid female figures, management discouraged this line of work. An example of the type is shown in figure 6.16, which is suggestive of a woman

rising from a plant form. Although the long hair and flowing tendrils reflect an Art Nouveau influence, the work is covered with a brown and yellow mat glaze, downplaying its erotic nature. Evidence suggests that the work was exhibited at the Pan-American exposition in 1901 as an example of Rookwood's new Mat glaze line and not as an example of Art Nouveau. Moreover, the ware remained in the possession of the decorator and was not sold by the Pottery.[126] Another example of Rookwood's limited Art Nouveau production can be seen in figure 4.3, a punch bowl with cabbage leaves and three nudes gracing the lip. Although the Pottery produced some wares that could be categorized as Art Nouveau, for the most part Rookwood management shied away from the more extreme Art Nouveau aesthetic of flowing lines and ripe organic forms. The most likely explanation for this avoidance is that they and their clients were uneasy with the charged eroticism and openly emotional character of the style.

Floral Decoration

Another example of production being tailored by consumer taste, feedback, and expectations was the use of floral decoration on the majority of the ware. Although Native American portraits and Old Masters were quite popular also, they were in production for a relatively short period of time. Taylor complained about the preponderance of floral decoration to a dealer in Detroit, remarking, "As to your own opinion of the inappropriateness of any but the most conventional patterns on a pot for holding plants and your preference for 'no decoration' at all we most cordially echo it. Yet every feeler we have put out in that direction has been a flat failure commercially. People will have everything covered with flower painting."[127] Maria Longworth Storer, writing to Elihu Vedder at the time of the 1889 Paris World's Fair, lodged a similar complaint (quoted at the beginning of this chapter).[128] Source material included living flowers from the Pottery's garden and the surrounding countryside, as well as illustrations found in the numerous periodicals and books

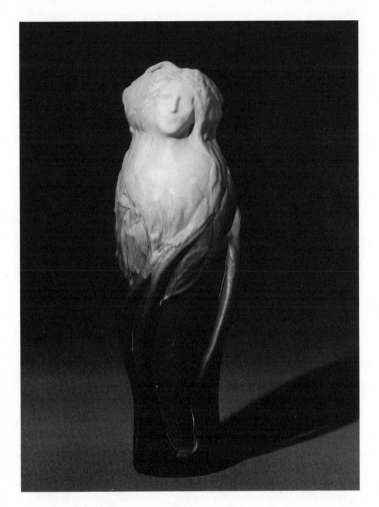

FIGURE 6.16. Rookwood Pottery Co., John Delaney Wareham, *Vase*, 1900, Modeled mat glaze line. *Courtesy of Cincinnati Art Galleries.*

housed in Rookwood's extensive design library.[129] On at least one occasion, Taylor ordered fresh water lilies to be sent from Briggs & Co. of Boston and then had them photographed to be added to the pottery's design repertoire.[130] Albert Valentien demonstrated his particular affinity for floral subjects by executing numerous studies of wild flowers on a trip to Germany in 1899 and 1900, and again when he traveled to California in 1903.[131] When applied to ceramic ware, the detailed floral portraits resembled botanical illustrations removed from any contextual setting. Decorator Albert Valentien expressed a particular fondness for the Iris glaze line: "I cannot say too much in favor of this type of Rookwood, it being one of my favorites, especially where we were compelled to use

flowers for decoration. In it I felt I could express all the quality of tenderness that the real flower contained, perhaps even more fully than on paper or canvas."[132]

It can be argued with justification that Rookwood featured floral decoration because that style was in fashion and tapped into a certain aesthetic of interior design. The second half of the nineteenth century witnessed a cultural reawakening to nature and focused tremendous attention on the natural landscape. Gardens and plants achieved heightened importance. There were many publications on gardening, landscaping, and especially flowers during this period. Large, multipurpose urban parks, such as Central Park in Manhattan and Prospect Park in Brooklyn, and arboreta such as Boston's Arnold Arboretum were opened in the 1870s, giving artists and the general public the opportunity to enjoy and study an amazing variety of plants, shrubs, and trees. The parks were intended to alleviate the stresses of urban overcrowding and of detachment from nature. Gardens, whether in a large public park or a small private border, were considered to be beneficial to everyone.[133] One author writing in 1871 observed, "A beautiful garden, tastefully laid out and well kept, is a certain evidence of taste, refinement, and culture."[134] Moreover, gardens and gardening were avidly pursued by cultured women of the day. There were many garden guides that catered directly to the amateur lady gardener. Other women actively studied botany and drew botanical prints. Unlike the "chaotic" immoral associations of Art Nouveau, the Victorians considered botany and horticulture an innocent, healthful preoccupation, God's pure bounty to all. Sarah Josepha Hale wrote that flowers signified goodness. They were "symbols of the affections, probably ever since our first parents tended theirs in the garden of God's own planting. They seem hallowed from that association, and intended, naturally, to represent pure, tender, and devoted thoughts and feelings."[135] In addition, special meanings were assigned to flowers. Books translating the "language of flowers," were popular throughout the nineteenth century.[136]

Yet, though Rookwood's emphasis on floral decoration was in keeping with the times, this does not explain why floral decoration rather

than some other style was in fashion. To know why consumers in the late nineteenth and early twentieth centuries preferred floral decoration to the alternatives, we need to know what it meant to them. Unfortunately, as Adrian Forty has pointed out, the reconstruction of consumer preferences in the past is a historical enterprise fraught with difficulties and generally leading to unsatisfactory results.[137] The best that can be done is to indicate the predisposing factors that might have led consumers to act in one way or another at a particular time. In general, the best historical evidence about consumer preferences comes from manufacturers who had their fingers on the pulse of the market. Rookwood's experiences with floral decoration largely confirm that, among other things, it was reassuring and familiar. Flowers, like parks and gardens, provided reminiscences of the older, more rural nation and suggestions of the poetic and picturesque.[138]

In the final analysis, Rookwood's character was shaped by being attuned to the desires of its customers. By keeping sight of what would sell, Rookwood managed to perpetuate its own characteristic style, despite foreign influences and changing styles in the decorative arts. It was the American public that had the final word in determining the extent to which Rookwood pottery could be innovative. Rookwood management was well aware of the need for compromise between the artistic avant-garde and the reality of a conservative public's tastes.

CHAPTER SEVEN

EPILOGUE

Master of Rookwood for a quarter century, he leaves behind
him an institution inspired by his ideals, strong in the capacity
for new growth which he planted in it, and sustained by a band
of trained associates devoted to its future.

Rookwood board of directors, January 23, 1914

Rookwood Pottery Company's first manager and president, William Watts
Taylor, died in 1913.[1] Taylor gave all of his stock in the company to a
board of twelve trustees to hold in trust and to go eventually to the
Cincinnati Museum Association. The trustees included all the officers and
directors of the Rookwood Pottery Company. Taylor's will specified that
the trustees were to receive all dividends paid on the stock and, after
paying expenses of the trust, could either accumulate them or use the
proceeds toward the benefit and improvement of the Pottery. The trustees
were also empowered to sell shares to any employee of Rookwood if they
thought it desirable to do so, with the proceeds going to the Cincinnati
Museum Association. Taylor also left $2,000 to be distributed among
present employees who had been with the company more than five

years. He left a legacy of $500 to decorator Sallie Coyne and of $250 to decorator Caroline Steinle. In later years, the Taylor trust often provided funds to keep the Pottery open.[2]

Taylor was succeeded by Joseph Henry Gest, director of the Cincinnati Art Museum and Rookwood's vice president since 1902. John D. Wareham, who had worked at Rookwood as a decorator since 1893, was named vice president. Although change due to forces outside the company was inevitable, perpetuation of Taylor's basic policies and philosophy seemed assured by the continuity of management.[3]

It was that very continuity of management however, that contributed to the eventual downfall of the Pottery. Management carried forward with Taylor's successful business plan, yet these years at Rookwood witnessed not merely a shift in production but a wholesale termination of what the Pottery had been up to World War I. The decade of the 1920s was the last period of economic solvency. Many long-time decorators left in 1931 when the Pottery closed to balance the budget, and by the end of 1932 all decorators were laid off. Decorators continued to be employed sporadically throughout the 1930s and 1940s when special orders were received. On April 16, 1941, Rookwood filed for bankruptcy. The Pottery was purchased by a group of local businesspeople who subsequently transferred ownership to the St. Thomas Institute and then to Sperti, Inc. In 1955, the company was purchased by William F. MacConnell and James M. Smith who sold it in 1959 to Herschede Hall Clock Company. In 1960, Herschede moved Rookwood to Starkville, Mississippi, where the company finally closed in the summer of 1967.

The constellation of factors examined throughout this book—women, culture, and commerce—continued to inform each other in the years after Taylor's death, but in new and different ways. For example, the studio pottery, where one person took responsibility for all aspects of production, broke down the gendered division of labor that had predominated at Rookwood, where tasks had been gender-specific: women were decorators and men were chemists and potters. In the broader sphere of industrial design, culture and commerce collaborated to introduce modern design to United States consumers.

"A Woman's Place Is in the War"

World War I , which engulfed continental Europe by 1914 and involved the United States by 1917, might seem a quintessential male experience. Male politicians and statesmen made the decisions that led to war. Male generals issued the orders that sent untold thousands of men to their death in battle. Yet the war also had a profound effect on women. Not only did thousands of women serve directly in the military and in volunteer agencies at home and in France, but a huge number of women workers invaded the war plants and munitions factories. The doctrine of separate spheres that had been so prescriptive (if not descriptive) of women's labor and domesticity in the late nineteenth and early twentieth centuries was overturned. In 1917–18, the patriotic slogan "A woman's place is in the war" replaced "A woman's place is in the home." About one million women worked in industry in 1917–18 in a variety of jobs ranging from streetcar conductors to bricklayers. In addition, the woman suffrage movement sped toward victory in 1917–18 on a tide of wartime idealism, and the Nineteenth Amendment was ratified in 1920. At Rookwood there were a few war-related changes in the staff, but the majority of the decorators continued to be women.[4] Tellingly, accounts of Rookwood in the popular press no longer stressed the oddity or uniqueness of the Pottery's founding by a woman or having a large number of female employees. For example, a 1913 article in the *Jeweler's Journal* makes reference to the "men and women artists on its staff" without further comment.[5] Advertising (fig. 7.1) not only acknowledged but boasted about "a large force of artists and craftsmen." Gone too was the association of amateurism with female decorators. Amateur pottery decorating had practically faded into oblivion by the end of the war, as evidenced by the new title and format of the once popular journal *Keramic Studio*. In 1924, *Keramic Studio* was renamed *Design-Keramic Studio* and geared toward the needs of art teachers and craft hobbyists.[6]

ROOKWOOD

Productions represent the conscientious efforts of a large force of artists and craftsmen toward an ideal.

We have an exclusive representative in all important cities and you may write to us direct.

THE ROOKWOOD POTTERY COMPANY
Rookwood Place, Cincinnati, Ohio

FIGURE 7.1. Rookwood advertisement, 1925. From *House and Garden* 48, 5 (November 1925): 163. Courtesy, The Winterthur Library: Printed Book and Periodical Collection.

Studio Ceramics

Rookwood suffered only a slight interruption in production during the war, but the ascendancy of modernism and the machine age in the aftermath of that conflict brought new social and cultural developments that adversely affected the Pottery. The intensive labor of handicraft and one-of-a-kind production fundamental to an art industry such as Rookwood came to be viewed as an anachronism. In the 1920s, dramatic changes were occurring in American ceramics. Universities, in particular Alfred University in New York and the Ohio State University, developed important studio ceramics departments. Individual studio artist-potters who

conceived and executed every step in producing their work advanced to the forefront of American ceramics.[7] Meanwhile, the established art potteries continued to differentiate duties among their employees and to cling to the now outmoded emphasis on decoration and glazes upon vessels. Rookwood and other such organizations were soon outside the main currents of development in art ceramics. Although Rookwood continued to produce artist-signed work that is clearly on par with their earlier wares, their art pottery production was no longer leading the way for others to follow.[8] In some measure this may be because from 1910 until the end of the 1940s Rookwood's output included many commercial wares such as architectural faience, garden pottery, and thousands of cheap industrial wares, in addition to art pottery. These commercial wares were acknowledged when Rookwood's promotional literature was amended to read that there were no duplicates of "signed, decorated pieces," where previously it had been asserted that "Absolutely no printing patterns are used nor any duplicates made."[9] Beginning in 1915, Rookwood dramatically increased the proportion of unsigned wares in an effort to boost its profit margin. Virtually all of these commercial wares were slip cast. Advertisements acknowledge this shift in production (fig. 7.2), pointing out that "Rookwood pieces may be impressive or they may be modest, but always they have distinction."

Changes in production necessitated more employees and larger facilities. In 1920, the Pottery employed over two hundred people and had fifteen kilns.[10] The atmosphere of domesticity, with the kilns virtually hidden from view, was no longer maintained or even possible. Although the same style of architecture was used as the Pottery expanded, the sprawling manufactory shown in figure 7.3 is a far cry from the domestic-looking structure of 1892. By 1915, the fifteen kilns filled the sky atop Mount Adams with clouds of smoke obliterating the charming garden setting (fig. 7.4). Company publicity touted the fact that in diversifying its productions, Rookwood had become several potteries: "experts have said that Rookwood is really the home of half a dozen potteries, each of which might well have a separate existence."[11] Management/labor relations were less cordial than in earlier years. In an effort to discourage

employee pilferage, a guard was stationed at the gate to inspect packages taken out by the workers. When one of the pottery's engineers emerged with a suitcase which he refused to open, he was shot three times in the heart.[12]

If the workplace no longer resembled the ideal merger of art and labor sought by Arts and Crafts proponents, Rookwood's new high-gloss glazes, brilliant colors, and highly refined porcelain bodies were also the very antithesis of Arts and Crafts simplicity. Introduction of soft porcelain in 1915 seemed to usher in the new era for the Pottery. Although the artist-signed wares continued to be either cast or thrown on a potter's wheel, the higher firing bodies and improved control of kiln temperatures and kiln conditions enabled the Pottery to eliminate many of the production problems Taylor had had to contend with—and which had influenced marketing to a great extent—for example, crazing and cracklature, pitting, kiln burns, firing cracks, and glaze runs. The vase shown in plate 15 is an example of the French Red glaze line on a soft porcelain body. This piece, with its contrasting interior color and repeated, stylized decoration, epitomizes one of Rookwood's major styles of the 1920s. Ken Trapp has noted that objects such as this one and other historicist wares based on Persian textile patterns (plate 16) "heralded a joyous release from austere simplicity."[13]

FIGURE 7.2. Rookwood advertisement, 1931. From *Arts and Decoration* 35, 6 (October 1931): 11. Courtesy, The Winterthur Library: Printed Book and Periodical Collection.

The Machine Age

Although repetitive, stylized decoration or historicist patterning was the norm for Rookwood during the 1920s, decorators still copied or emulated easel paintings, but their models were no longer Old Master portraits. Beginning in 1928, Rookwood decorator Jens Jensen decorated

FIGURE 7.3. Rookwood Pottery Company, c. 1915, photograph. *Cincinnati Historical Society Library.*

FIGURE 7.4. Rookwood Pottery Company, c. 1915, photograph. *Cincinnati Historical Society Library.*

pots with nudes in a neo-primitive style that was indebted to early European modernism (e.g., Matisse, Picasso, or the German Expressionists; see fig. 7.5). Technically these copies differed from earlier examples because Jensen decorated the vessel after it had been fired—not before. Just as Old Master paintings had been at the forefront of the art world in the late nineteenth and early twentieth centuries, in the years after the 1913 Armory Show, European modernism had shaken up notions about art in the United States. Unlike the Old Master portraits that had been endorsed by the Pottery, reportedly Rookwood management tried to restrain Jensen's depictions of nude figures, considering them inappropriate for the corporate image.[14] In other wares, the handcrafted objects of the Arts and Crafts movement, tied to nature, were supplanted by elemental geometric forms reflecting a modernist impulse, and devoid of the mark of the hand (with the exception of Vellum landscape scenes, which were produced well into the 1940s).[15] This new modern style was also defined by abstractions of machines and geometric forms as part of the emergent machine aesthetic known variously as Art Deco, Art Moderne, or Style Moderne.[16] As shown in figure 7.6, Rookwood participated in this movement by producing wares with slightly raised geometric decorations that often included horizontal ridges at the base of the vase to inhibit the glaze from flowing downward into the fire.

Artists and patrons continued to worry about the authenticity of the arts in an age in which mechanical reproduction—chromolithography, photography, and sound recordings—brought art to the masses. However, starting in 1934, machine parts themselves were treated like modern sculpture and installed in the Museum of Modern Art. In the first "Machine Art" show, industrial units (e.g., bearing springs, wire rope, outboard propellers), household and office equipment, kitchenware, home furnishings, scientific instruments, and laboratory glassware were displayed on pedestals and/or in vitrines with soft "boutique" lighting in denial of any practical function. The catalogue included quotations from Plato and Thomas Aquinas which made reference to the "beauty of shapes," to "proportion and harmony," and to "integrity and perfection," deployed so as to legitimate the machine as pure form or

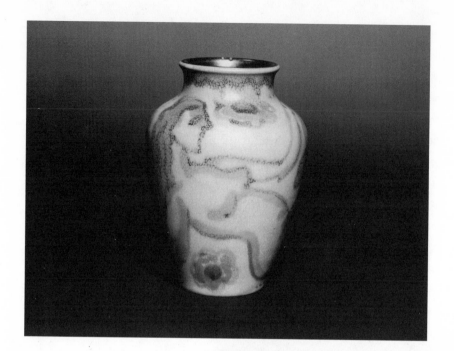

FIGURE 7.5. Rookwood Pottery
Co., Jens Jacob Herring Krog
Jensen, *Vase*, 1933, soft porcelain/
jewel porcelain body, Mat glaze.
Private Collection.

FIGURE 7.6. Rookwood Pottery
Co., William Hentschel, *Vase*,
1927, soft porcelain/jewel porce-
lain body, Later Mat glaze. *Private
Collection.*

as an idea which appeals to the intellect. These exhibitions blurred the boundaries between culture and commerce by assimilating anonymous, mass-produced, industrial goods under the umbrella term "modern design" by using a carefully crafted display strategy to aestheticize those objects so thoroughly that their functions were effectively denied. In this venue was conceived the notion that utilitarian ceramics made by industry could be art, whereas a vessel made by a potter was craft and by implication of lesser importance.[17]

Because Rookwood management could no longer afford to maintain connections with art museums, in 1941 the historical collection of Rookwood held on loan at the Cincinnati Art Museum since 1880 (numbering 2,292 pieces) was called back to the Pottery and eventually sold to raise much needed capital.[18] Nevertheless, Rookwood advertisements after 1913 (fig. 7.7) continued to refer to the wares as "art," and to comment on Rookwood's "perfection and permanence" (fig. 7.8). Even in ads emphasizing the Pottery's scientific expertise as a ceramic manufactory, art makes an appearance. For example, an advertisement from *Arts and Decoration* in March of 1927 notes, "Rookwood has the experience and resources for solving any technical or artistic problem in the field of pottery making" (fig. 7.9).

Isolationism and International Competition

Probably as a consequence of Taylor's death, Rookwood elected not to participate in the Panama-Pacific Exhibition held in San Francisco in 1915.[19] This was the first major world's fair Rookwood had missed since the Paris Exposition of 1889. The last exposition in which the Pottery is known to have participated was the National Conservation Exposition in Knoxville, Tennessee, in 1913, where they won a second prize.[20] In 1925, Herbert Hoover, then Secretary of Commerce, declined the French government's invitation to participate in the Exposition Internationale des Arts Décoratifs et Industriels Modernes held in Paris. This exhibition contained neither German nor American entries. Whereas Germany's

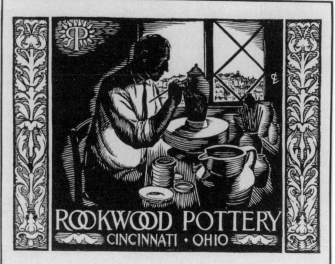

ROOKWOOD POTTERY
CINCINNATI · OHIO

Rookwood aims at a worthy contemporary ex-
pression while maintaining the tradition of an art
as old as time.

An exclusive representative will be found in all
important cities and direct inquiry is invited.

THE ROOKWOOD POTTERY CO.
Rookwood Place Cincinnati, Ohio

failure to take part was thought to be due to a purposely late invitation,
the United States declined because Hoover felt that objects of American
design could not meet the guidelines of "new inspiration and real origi-
nality."[21] Had the United States accepted the invitation to exhibit at the
1925 Exposition Internationale in Paris, it is not known whether Rook-
wood would have competed. What is known is that by 1933, with the
decorating force working only sporadically, management decided Rook-
wood could not afford the expense of mounting an exhibition at the
Century of Progress exhibition in Chicago. In an acknowledgment of the
importance of the venue, the Pottery did arrange to ship a large number

FIGURE 7.8. Rookwood Pottery advertisement, 1925. From *House and Garden* 48, 3 (September 1925): 163. *Courtesy, The Winterthur Library: Printed Book and Periodical Collection.*

FIGURE 7.9. Rookwood Pottery advertisement, 1927. From *Arts and Decoration* (March 1927): 90. *Courtesy, The Winterthur Library: Printed Book and Periodical Collection.*

of pieces to Marshall Field's department store, where they were displayed in a special ceramic exhibit for the duration of the Chicago fair.[22]

Although Hoover's decision not to take part in the Paris fair was ostensibly because he didn't find American design "modern" enough, the choice must also be viewed in terms of the cultural and political retrenchment that followed World War I as the United States became increasingly isolationist. As United States corporate and financial interests extended their international involvement, politically the nation turned inward, joining neither Woodrow Wilson's cherished League of Nations nor the Court of International Justice (the World Court), a League-sponsored agency to resolve international disputes. However, Hoover did send a committee of over one hundred members of trade organizations and art guilds to review the exposition.[23] In addition, Charles R. Richards, director of the American Association of Museums, was charged with selecting objects from the Exposition for an eight-city tour that arrived at the Metropolitan Museum of Art in 1926. This in turn spurred department stores to present thirty-six similar exhibitions within the next few years.[24] In short, culture and commerce collaborated to introduce French modernism to the United States. Taken together, Hoover's fact-finding committee and the rush to learn about Art Deco, admittedly a European style, suggests that the nation's business and financial institutions were poised for global expansion and that there was a concomitant need to remain internationally competitive. Perhaps because of this, notions of native clay, American-born decorators, and native flora and fauna in decoration were put aside in the years following World War I. During the 1920s three of the twelve newly hired Rookwood decorators were born in Europe.[25]

New Markets

It is still possible to conceptualize Rookwood's targeted consumers in the years after World War I, although there is less available information. On the high end, several presentation vases were made. The women of

Cincinnati gave a French Red vase to Charles Lindbergh in 1927 to com-memorate his historic flight to Paris. President Machado y Morales of Cuba received a vase in 1930 in recognition of the courtesy his govern-ment extended to the members of the Commercial Club of Cincinnati on their visit to Havana. The Chamber of Commerce of Cincinnati pre-sented President and Mrs. Hoover a piece from the Fiftieth Anniversary kiln in 1931. Rookwood pottery, while no longer an industry leader, was still considered a worthy gift for an American hero and world leaders.

In sales outlets, management continued to display a bias toward urban centers with an emphasis on the Northeast. Advertisements from the 1930s often list only the metropolitan New York retail outlets: Tiffany and Co., B. Altman and Co., and The Frederick Loeser Co. Although Davis Collamore and Co. of New York had been Rookwood's national sales agent since 1883, this relationship had ended circa 1916. According to a Davis Collamore representative, the firm discontinued the Rookwood alliance because "Rookwood did not keep abreast of changes."[26] In addition to the display at Marshall Field's at the time of the Century of Progress exhibition, Rookwood management also selected thirty-five pieces of its latest wares to travel to Dallas, Fort Worth, Oklahoma City, Kansas City, Omaha, Minneapolis, and Milwaukee as a promotional tour. Since Rookwood typically had not had a strong market in the Great Plains, this choice of cities suggests that management was struggling to find new consumers for the ware. Art pottery continued to be carried in upscale jewelry and department stores in larger cities but, at least in New York, there were multiple venues instead of an exclusive agency.

Rookwood advertisements continued to appear in elite "shelter" publications such as House Beautiful, Country Life in America, House and Garden, Town and Country, and Arts and Decoration. These advertisements were report-edly used to "keep the name and products of the Rookwood Potteries always prominently before the well-to-do people who have the means to buy such things and the interest in them."[27] These advertising sites demonstrate that the targeted consumer for Rookwood's art pottery hadn't changed much since the early years of the century. However, the ads themselves were quite different in that the wares were marketed

according to the type of clay body used and not by glaze line (e.g., soft
porcelain or jewel porcelain). Moreover, the Pottery did not consistently
name its artistic wares but rather described them in vague and ambigu-
ous terms. There is no ready explanation for either of these practices,
but it may be that the wares were simply not produced in sufficient
numbers to warrant naming them.[28] A final change in the advertise-
ments is the appearance of fresh flowers in Rookwood's vases; that is,
some of the wares are depicted in use and not exclusively as objects of
contemplation. An advertisement from 1926 (fig. 7.10) notes that "It is
a matter of much thought at Rookwood to produce pottery which has
in itself rare elements of beauty and is adaptable to the flowers of all
seasons."

The reasons for the financial failure of Rookwood Pottery Company

are myriad and in large part linked to the Great Depression, which led to the financial destruction of Rookwood's consumers. The Depression also led to a decrease in the retail value of the inventory.[29] Another key factor was the firm's consignment method, which left it rich in terms of finished pottery but poor in cash. Large inventories of finished pots were carried on the books until they were directly sold by franchisees. Consequences of the consignment method were twofold. First, it meant there was insufficient cash for production upgrades and overall efficiency improvements. For example, in 1928 one of the boilers had been condemned "on account of age and bad condition." An engineering firm advised purchasing two new boilers for general use and reconditioning the best of the old ones, at an estimated cost of $15,000. No action was taken because the funds were not available.[30] It was circumstances such as these that eventually led Harold Bopp, superintendent of Rookwood, to resign from the Pottery in 1939, and, in partnership with other disgruntled former Rookwood employees, establish Kenton Hills Porcelains, Inc. across the river in Erlanger, Kentucky.[31] Significantly, Bopp had first come to Rookwood in 1929 as head of the color and chemistry department, moving rather quickly into position as superintendent. He was one of very few employees considered part of management who had not been part of the Taylor regime.

Another vexing consequence of carrying large inventories of finished pots on Rookwood's books emerged in 1929—the same year as the boilers were condemned—when the United States Board of Tax Appeals found a deficit of $19,873 in income taxes due the federal government.[32] This deficit arose because of the way Rookwood's management allocated cost to inventory for the years 1923, 1924, 1925, and 1926. The amounts of profits each year cannot be completely determined without comparing the beginning and the closing inventories. However, as Judge Denison of the Sixth Circuit, United States Court of Appeals, observed, "This company was unique, in its commercial as well as in its artistic methods."[33] Factory stock contained some new articles which had never been sent out and some returned articles waiting reconsignment, and these returned articles could be one, two, or three years old.

The stock in the hands of dealers would have the same characteristics, varying from articles just received to those which had been in stock for some time. However, prior to 1927, the factory did not keep a record of the year of manufacture of the articles out on consignment, so it was impossible to make up this cost inventory of consigned goods on an absolutely accurate basis. Consequently, it apportioned the consignment goods among the different manufacturing years upon the same basis shown by the stock at the factory. It thus concluded that of the goods in the possession of a particular consignee, 30 percent were of the last year, 30 percent were of the year before, and 20 percent were of each of the two earlier years—or whatever proportions the factory inventory might indicate. This was crucial, because the percentage of cost for each year must be applied to the selling value of the total for that year, and because this percentage was rapidly changing and increasing. The Commissioner of Internal Revenue, however, applied to this entire final inventory of 1926 the cost proportion for the year 1926 and found a cost value of inventory that was considerably higher than management had claimed. Judge Denison ruled that the method of the commissioner was wrong since the stock in the hands of every consignee was made up of the product of several years. He went on to note that "to reach its cost upon the basis of the cost for the last year, the highest year of the period, brings a result which is plainly erroneous, and cannot possibly truly reflect the income."[34] Although Rookwood won its appeal, the cost of mounting it contributed to loss of solvency after 1929.

Corporate records demonstrate management's awareness of the perilous situation as well as an inability to do anything about it. On April 18, 1931, president Joseph H. Gest reported to Rookwood's stockholders that "The present capital is too completely absorbed in plant and inventories that must be carried in a business of the character of ours where a large variety of fine pottery is essential to the maintenance of the high artistic character of Rookwood."[35] Despite efforts to diversify the product line and to make subtle changes in their advertising copy, management's unwillingness to discontinue Taylor's policy of consignment sales suggests a general agreement with his overriding philosophy of the

artist-signed wares as unique art objects. Initially Taylor may have had to sell on consignment in order to get retail outlets to accept the ware. This was common practice for fledgling art potteries and other untested goods manufacturers. Yet, by 1892, demand for Rookwood exceeded supply, suggesting that Taylor continued this approach as a means of maintaining control of the wares so that Rookwood wares didn't get "buried with the painted cuspidors."[36] In the report quoted above, Gest goes on to note, "Each year new and better varieties of ware must be produced according to the ever higher standards prevailing at Rookwood."[37] In the years before World War I, Rookwood's management had successfully used the tools of modern marketing to blur the boundaries between art and industry—commerce and culture. In the end, the company failed because Taylor's successors were unable to adapt their policies and philosophy to the changing circumstances. They found it impossible to sell Rookwood as anything other than art.

ROOKWOOD

GLAZE LINES

This appendix draws on *Rookwood Pottery: The Glaze Lines* by Anita Ellis to provide a brief overview of the most important glaze lines produced by Rookwood from 1880 through 1913. A glaze is the glassy skin that envelops the object; it can be either translucent or opaque. A glaze line is a broader term and includes the glassy skin as well as the type of clay body, decoration used, and a given parameter of dates for its use. Because Rookwood marketed its products according to glaze lines, these categories offer the best basic understanding of their production.

Dull Finish (1884–c. 1900)—shown in plate 1 and figure 2.11—is a colorless, translucent glaze applied so thinly that the object appears to have no glaze at all. Dull Finish is a smear glaze which covers an object with a slip-painted decoration of flora and, to a lesser degree, fauna in the lighter tints of blues, whites, and pinks. This glaze was often used in combination with overglaze gilt decoration. In the mature glaze line, the clay body is usually yellow, but white, gray, or red are also found.[1]

Standard (1884–c. 1909)—shown in plates 2, 10, 13, and 14 and figures 4.2, 4.4, 4.5, 5.4, 5.6, 5.7, 5.13, 5.15, 5.21, and 6.14—is a yellow-tinted, translucent, gloss glaze covering an object with a slip-painted decoration of flora and/or fauna on ground colors in the darker tones of green, yellow or, most commonly, brown. Often one ground color fades into another. Before 1890 yellow is the most common clay in this glaze line. After 1890 white is usually used. However, sage green, ginger, red, and dark green are sometimes found. When Standard glaze is used on a red body it is called Mahogany, a subdivision of the Standard line. It is occasionally used with electro-deposited copper and/or silver and/or gold decorations (fig. 5.4).[2]

Tiger Eye (1884–c. 1900)—shown in plate 8—is a gloss, crystalline glaze that, when seen on a vessel looks like a sheet of gold foil shimmering beneath an extremely shiny surface, providing the appearance of great depth and luminosity. This glaze usually covers an object with relief, incised or slip-painted decorations of flora or fauna. Tiger Eye is most often found on a red clay body and is an offshoot of the Mahogany glaze line. This glaze line, like Goldstone (see below), was a serendipitous result of firing and could not be reliably reproduced.[3]

Goldstone (1884–c. 1900)—shown in plate 9—is a yellow-tinted, gloss, aventurine glaze that on a vessel looks like millions of flecks of gold beneath an extremely shiny, very deep surface. Goldstone is usually found covering incised or slip-painted decorations of flora or fauna. Fish are often seen on these pieces. A red clay body is used for this line.[4]

Sea Green (1893–c. 1904)—shown in plate 6 and figure 6.16—displays a green-tinted, translucent, gloss glaze covering an object with a slip-painted decoration of marine life, such as fish or waterfowl, rarely with floral decoration. It is most often found on a white clay body.[5]

Iris (1893–c. 1912)—shown in plates 7 and 11—is an incredibly crystal clear, translucent gloss glaze covering an object with a slip-painted decoration of flora or, rarely, fauna on background colors that shade imperceptibly from dark to light. Iris glaze is most frequently found on white clay bodies but some rare examples of blue-gray and green bodies do exist.[6]

Aerial Blue (1894–95)—shown in plate 12—displays a colorless, translucent, gloss glaze covering an object with slip-painted decorations of flora and/or fauna in tints and tones of white on a soft, sky-blue ground. Sometimes the blue ground is slip painted, but generally it is simply the blue of the clay body seen through the glaze. Decorations include ships, farms, Dutch landscapes, portraits, cows, wolves, etc. The body can be blue or white, but is most often blue.[7]

Mat Glaze (1898–1915) comes in several varieties whose dates vary slightly. For Incised Mat see figure 3.16. For Modeled Mat see figures 3.17, 4.3, and 6.15. Other types include Conventional Mat, Painted Mat, and Painted Mat Inlay. All of the mat glazes, except Vellum (see below), are opaque, usually of one solid color or variegated with different colors covering an object with incised, carved, or painted decorations. The clay body is most often light buff to white in color and generally more granular than the other bodies used at Rookwood.[8]

Vellum (1904–1948)—shown in plates 3, 4, and 5—is a slightly hazy, semi-translucent, mat glaze covering an object with slip-painted or carved landscape, seascape, floral or fauna decoration. The clay body is white.[9]

NOTES

CHAPTER ONE

1. See Charles Wyllis Elliott, "Pottery at the Centennial," *Atlantic Monthly* 38 (September 1876): 575; and Jennie Young, "Ceramic Art at the Exhibition," *Lippincott's* (December 1876): 701–16. Young, herself an American writing for an American publication, all but ignores the American ceramic displays. See also Rachael B. Crawford, "Ceramics at the 1876 Centennial," *Antiques Journal* 31 (May 1976): 16–18, 46.

2. Susan Stuart Frackelton, "Rookwood Pottery," *Sketch Book* 5 (February 1906): 274.

3. I have chosen these chronological boundaries because Rookwood was founded in 1880 and its first president and manager died in 1913. Also, the 1913 Armory Show, a cultural watershed, marked a shift toward modernism that had a deleterious effect on the prestige and marketability of art pottery. Archival materials include letterpress books from December 1886 through May 1892; and corporate minutes (including board of directors meetings and annual reports) from 1890 to 1934. The majority of the articles about Rookwood in periodicals were written between 1880 and 1915.

4. Dalton Dorr, "Art Museums and Their Uses," *Penn Monthly* 12 (July 1881): 562–63.

5. Sylvia Yount, "'Give the People What They Want': The American Aesthetic Movement, Art Worlds, and Consumer Culture, 1876–1890" (Ph.D. dissertation, University of Pennsylvania, 1995), 68.

6. Robert Rydell, "The Centennial Exhibition, Philadelphia, 1876: The Exposition as a 'Moral Influence,'" in *All the World's a Fair: Visions of Empire at American International Expositions, 1876–1916* (Chicago: University of Chicago Press, 1984), 9–37.

7. See *Penn Monthly* 9 (May 1878): 332; and Yount, 22.

8. For women's participation in the Centennial, see Mary Frances Cordato,

"Representing the Expansion of Woman's Sphere: Women's Work and Culture at the World's Fairs of 1876, 1893, and 1904" (Ph.D. dissertation, New York University, 1989); Jeanne Madeline Weimann, *The Fair Women: The Story of the Woman's Building, World's Columbian Exposition Chicago, 1893* (Chicago: Academy Chicago, 1981); and Yount, 109–32.

9. "The New England Log House," *New Century for Women* 10 (July 15, 1875): 75.

10. Roger B. Stein, "Artifact as Ideology: The Aesthetic Movement in Its American Cultural Context," in *In Pursuit of Beauty: Americans and the Aesthetic Movement*, ed. Doreen Bolger Burke (New York: Metropolitan Museum of Art, 1986), 22–52.

11. Yount, 120.

12. See Alice Cooney Frelinghuysen, "Americans and the Aesthetic Movement," *Antiques* (October 1986): 756–67; Doreen Bolger Burke, ed., *In Pursuit of Beauty: Americans and the Aesthetic Movement* (New York: Metropolitan Museum of Art, 1986).

13. Regina Lee Blaszczyk, "The Aesthetic Moment: China Decorators, Consumer Demand, and Technological Change in the American Pottery Industry, 1865–1900," *Winterthur Portfolio* 29, 2/3 (summer/autumn 1994): 121–53.

14. Charles F. Binns, "The Arts and Crafts Movement in America: Prize Essay," *Craftsman* 14, 3 (June 1908): 275.

15. Quoted in Robert C. Post, ed., *1876: A Centennial Exhibition* (Washington, D.C.: Smithsonian Institution, 1976), 111.

16. Elliott, 575.

17. "American Pottery," *Crockery Journal* 1 (January 23, 1875): 4. See also *Proceedings of the First Convention of the U.S. Potters' Association* (Trenton, N.J.: Murphy & Bechtell, Steam Power Book and Job Printers, 1875), 7.

18. "The National Potters' Association," *Crockery Journal* 1 (January 23, 1875): 4.

19. Ibid.

20. The fashion of representing white figures modeled in shallow relief against a light-colored background, generally blue, is called jasperware, popular in England in the late eighteenth century, when it was introduced by Josiah Wedgwood and his contemporaries. See Alice Cooney Frelinghuysen, *American Porcelain, 1770–1920* (New York: Harry N. Abrams, 1989), 175–76.

21. Jennie Young (1879) quoted in Frelinghuysen, *American Porcelain*, 166. See also *Crockery and Glass Journal* (February 8, 1883): 21–22. Parian, a medium developed in England in the early 1840s, is a type of porcelain having the appearance of marble.

22. *Crockery and Glass Journal* 3 (June 16, 1876): 14.

23. *Proceedings of the Thirteenth Convention of the U.S. Potters' Association* (East Liverpool, Ohio: J. H. Simms, 1889), 11.

24. Quoted in ibid., 17.

25. In an anonymous article titled, "Price and Art," *Crockery and Glass Journal* (November 16, 1882): 27, the author claimed, "It is not enough that a thing be

beautiful, or that it have the higher values of form, color and expression. It must cost something."

26. Frelinghuysen, *American Porcelain*, 43.

27. George Ward Nichols, *Pottery: How It Is Made, Its Shape and Decoration* (New York: G. Putnam's Sons, 1879), 1.

28. For general information on the American Art Pottery movement, see: Edwin AtLee Barber, *The Pottery and Porcelain of the United States* (New York: G. Putnam's Sons, 1893); Garth Clark and Margie Hughto, *A Century of Ceramics in the United States, 1878–1978: A Study of Its Development* (New York: E. P. Dutton, 1979); Paul Evans, *Art Pottery of the United States* (New York: Finegold and Lewis Publishing Corp., 1987); Alice Cooney Frelinghuysen, *American Art Pottery: Selections from the Charles Hosmer Morse Museum of American Art* (Seattle: University of Washington Press, 1995); Lucile Henzke, *Art Pottery of America* (Exton, Penn.: Schiffer Publishing Co., 1982); and Elaine Levin, *A History of American Ceramics* (New York: Harry N. Abrams, 1988). For bibliographic information see Ruth Irwin Weidner, *American Ceramics before 1930* (Westport, Conn.: Greenwood Press, 1982).

29. See Frelinghuysen, *American Art Pottery*, 12.

30. Lawrence Mendenhall, "Cincinnati's Contribution to American Ceramic Art," *Brush and Pencil* 17, 2 (February 1906): 47–61.

31. "War among the Potters," *Cincinnati Daily Gazette*, October 7, 1880.

Chapter Two

1. See "The Millionaires of Cincinnati," *Frank Leslie's Illustrated Newspaper* (January 15, 1881): 1; and Denny Carter Young, "The Longworths: Three Generations of Art Patronage in Cincinnati," in *Celebrate Cincinnati Art*, ed. Kenneth R. Trapp (Cincinnati: Cincinnati Art Museum, 1981), 29–48.

2. Quoted in Maria Longworth Storer, *History of the Cincinnati Musical Festivals and of the Rookwood Pottery* (Paris: Herbert Clarke, 1919), n.p.

3. Clara Chipman Newton, "Early Days at Rookwood Pottery," c. 1900, n.p. Clara Chipman Newton papers, Cincinnati Historical Society Library.

4. Maude Haywood, "Founded by a Woman," *Ladies' Home Journal* 9 (October 1892): 3.

5. Bellamy Storer was the last of a prestigious Cincinnati family (his father had been a judge on the Cincinnati Superior Court for eighteen years). He was a lawyer and Republican politician: first elected to Congress in 1891 and eventually serving as ambassador to Belgium and to Spain under President McKinley and then to Austria-Hungary under President Roosevelt. Storer was relieved of his post in 1905 when Maria Storer created a difficult and politically dangerous situation for Roosevelt by attempting to gain a cardinalship for Archbishop John Ireland of St. Paul, Minnesota. See Rose Angela Boehle, *Maria: A Biography of Maria Longworth* (Dayton, Ohio: Landfall Press, 1990), 80, 100, 138.

6. Quoted in the (Cincinnati) *Daily Gazette*, March 20, 1883, 4.

7. William Watts Taylor, letter to Mr. J. E. Beebe, Denver, Colorado, March 22, 1887. Letterpress Book 1886–87, 126. Rookwood Pottery Collection, Rookwood letterpress books, Mitchell Memorial Library, Mississippi State University (hereafter RPC, MML/MSU).

8. William Watts Taylor, letter to Mrs. Francis McDonald, Chicago, Ill., February 4, 1888. Letterpress Book, 1887–88, 229. RPC, MML/MSU.

9. William Watts Taylor, letter to Mrs. Delia L. Williams, Delaware, Ohio, March 12, 1888. Letterpress Book, 1887–88, 333. RPC, MML/MSU.

10. William Watts Taylor, letter to Mrs. E. R. Holbrook, Minneapolis, Minn., June 28, 1888. Letterpress Book, 1888–89, 63. RPC, MML/MSU.

11. William Watts Taylor, letter to Mr. E. R. Garezynski, Chicago, Ill., February 14, 1890. Letterpress Book, 1889–90, 173. RPC, MML/MSU.

12. William Watts Taylor, letter to Charles Fergus Binns, Alfred, N.Y., April 8, 1904. Charles Fergus Binns papers, Archives of American Art, roll no. 3606.

13. Scholars such as Nancy Cott have related the formation of separate gender spheres to the emergence of modern industrial work patterns between 1780 and 1835 and, by implication, to the dominance of the middle class and its ideals. See Nancy Cott, *The Bonds of Womanhood: Woman's Sphere in New England, 1780–1835* (New Haven: Yale University Press, 1977), esp. 19–100. Recent scholarship suggests that working-class women experienced "public and private," "separate spheres," and "domesticity" very differently than did those of the middle- and upper-classes. See Kathy Peiss, "'Charity Girls' and City Pleasures: Historical Notes on Working-Class Sexuality, 1880–1920," in *Powers of Desire: The Politics of Sexuality*, ed. Ann Snitow et al. (New York: Monthly Review Press, 1983), 74–87.

14. Barbara Welter, "The Cult of True Womanhood, 1820–1860," *American Quarterly* 18 (1966): 151–74. According to this ideology, the proper American female was to be pious, pure, submissive, and domesticated.

15. George Cotkin, "Woman as Intellectual and Artist," in *Reluctant Modernism: American Thought and Culture, 1880–1900* (New York: Twayne Publishers, 1992), 77.

16. Edward H. Clark, *Sex in Education; or, A Fair Chance for the Girls* (Boston: James R. Osgood, 1873; reprint New York: Arno Press, 1972).

17. Kathleen D. McCarthy, *Women's Culture: American Philanthropy and Art, 1830–1930* (Chicago: University of Chicago Press, 1991), 15–16.

18. E. A. Randall, "The Artistic Impulse in Man and Woman," *Arena* 24 (1890): 415.

19. Molly Elliot Seawell, "On the Absence of the Creative Faculty in Women," Critic (November 29, 1891): 292–94. See Christine Battersby, *Gender and Genius: Towards a Feminist Aesthetics* (Bloomington and Indianapolis: Indiana University Press, 1989), esp. 52–70 for an analysis of the history of male genius (and female lack thereof).

20. Charlotte Perkins Gilman, "The Yellow Wallpaper," *New England Magazine* (January 1892).

21. Barbara Ehrenreich and Deirdre English, *For Her Own Good: 150 Years of the Experts Advice to Women* (New York: Doubleday, 1978), 102.

22. See, for example, Linda Nochlin, "Why Have There Been No Great Women Artists?" in *Women, Art, and Power and Other Essays* (New York: Harper and Row, 1988), 145–78; Charlotte Streifer Rubenstein, *American Women Artists* (New York: Avon Books, 1982); and Jean Gordon, "Early American Women Artists and the Social Context in Which They Worked," *American Quarterly* 30 (spring 1978): 54–69.

23. Amanda Vickery emphasizes the prescriptive nature of these texts, noting that they are not descriptive in any simple sense. See "Historiographical Review: Golden Age to Separate Spheres? A Review of the Categories and Chronology of English Women's History," *Historical Journal* 36, 2 (1993): 383–84. See also Linda Kerber, "Separate Sphere, Female Worlds, Woman's Place: The Rhetoric of Women's History," *Journal of American History* 75 (1988): 9–39.

24. See Janet Wolff, "The Culture of Separate Spheres: The Role of Culture in Nineteenth-Century Public and Private Life," in *The Culture of Capital: Art Power and the Nineteenth-Century Middle Class*, ed. Janet Wolff and John Seed (Manchester: Manchester University Press, 1988), 117–34.

25. The designation "angel in the house" was derived from a poem of the same title written in 1854–56 by Coventry Patmore. See Wallace Alvin Briggs, comp., *Great Poems of the English Language* (New York: Tudor Publishing Co., 1935), 956–59.

26. See Martha Crabill McClaughterty, "Household Art: Creating the Artistic Home, 1868–1893" (M.A. thesis, University of Virginia, 1981).

27. Catharine Beecher and Harriet Beecher Stowe, *The American Women's Home: Or, Principles of Domestic Science* (1869; Hartford, Conn.: Stowe-Day Foundation, 1975), 84.

28. Harriet Spofford, *Art Decoration Applied to Furniture* (New York: Harper and Brothers, 1878), 232.

29. Henry Van Brunt, "Studies in Interior Decoration," *American Architect and Building News* 2 (February 24, 1877): 60.

30. John Ruskin, *Sesame and Lilies* (New York: John Wiley and Sons, 1866). For the impact of the ideas of Ruskin in the United States, see Roger B. Stein, *John Ruskin and Aesthetic Thought in America, 1840–1900* (Cambridge: Harvard University Press, 1967.)

31. "Editorial: Home and Woman's Influence," *Godey's Lady's Book and Magazine* 108 (1884): 298.

32. Mary Tillinghast, "Talks on Home Decoration: I. The Effect of the Properly Decorated Home," *Art Interchange* 36 (1896): 14–15. See also "Morality of Home Decoration," *Art Amateur* 5, 4 (September 1881): 80; and "The Influence of Material Things," *Craftsman* 1, 4 (January 1902): v.

33. See Karen J. Blair, *The Torchbearers: Women and Their Amateur Arts Associations in America, 1890–1930* (Bloomington and Indianapolis: Indiana University Press, 1994), esp. 76–117.

34. Mrs. I.M.E. Blandin, *A History of Higher Education of Women in the South Prior to 1860* (New York: Neale Publishing, 1909).

35. See "The Philadelphia School of Design for Women," *Frank Leslie's Illustrated Newspaper* (January 15, 1881): 330, 332; Anna Shannon McAllister, *In Winter We Flourish: Life and Letters of Sarah Worthington King Peter* (New York: Longmans, Green and Co., 1939), 141–50; F. Graeme Chalmers, "The Early History of the Philadelphia School of Design for Women," *Journal of Design History* 9, 4 (1996): 237–52; and Diana Korzenik, "The Art Education of Working Women, 1873–1903," in *Pilgrims and Pioneers: New England Women in the Arts*, ed. Alicia Faxon and Sylvia Moore (New York: Midmarch Arts Press, 1987), 33–41; and McCarthy, 32.

36. At the time of its founding in 1848, the mandate of the Philadelphia School of Design for Women was to prepare young women for meaningful employment in design-related fields. However, by the 1880s fine art instruction had become equally important with design training, and by the twentieth century the school was decidedly genteel and less relevant to the working woman. See Chalmers, 250.

37. Table 4, "Women in Selected Occupations, 1870–1930," in Margery W. Davies, *Woman's Place is at the Typewriter: Office Work and Office Workers, 1870–1930* (Philadelphia: Temple University Press, 1982), 182–83.

38. For more information about the "feminization of culture," see McCarthy; Ann Douglas, *The Feminization of American Culture* (New York: Alfred A. Knopf, 1978); Alan Trachtenberg, *The Incorporation of America: Culture and Society in the Gilded Age* (New York: Hill and Wang, 1982); and Nancy Ring, "New York Dada and the Crisis of Masculinity: Man Ray, Francis Picabia, and Marcel Duchamp in the United States, 1913–1921" (Ph.D. dissertation, Northwestern University, 1991).

39. Candace Wheeler, "Art Education for Women," *Outlook* 55 (January 2, 1897): 82.

40. See Kirsten N. Swinth, "Painting Professionals: Women Artists and the Development of a Professional Ideal in American Art, 1870–1920" (Ph.D. dissertation, Yale University, 1995); and Marcia Hyland Green, "Women Art Students in America: An Historical Study of Academic Art Instruction during the Nineteenth Century" (Ph.D. dissertation, American University, 1990).

41. Lois Marie Fink, *American Art at the Nineteenth-Century Paris Salons* (Cambridge: Cambridge University Press, 1990), 287. Fink notes that "virile" and "virility" became new terms of praise for artists at the turn of the century.

42. Deborah Cherry has noted that history painting became the most contentious arena of women's cultural intervention, in which women challenged the sexual differencing of the artistic hierarchy that ascribed the most prestigious category of history painting to men and allocated the less valued forms of still life to women. Artist families did not treat daughters and sons in the same ways, offering women sexually differentiated professional identities. Daughters and

wives not infrequently worked in categories of art of a lower status in the artistic hierarchy to those practiced by the male members of the dynasty. Deborah Cherry, *Painting Women: Victorian Women Artists* (London: Routledge, 1993), 21, 187.

43. Kirsten Swinth has demonstrated that contrary to these prevalent stereotypes, women artists very rarely defined themselves as flower painters. See Swinth, 172.

44. Recent evidence of decorative work by ambitious male artists (e.g., John La Farge, Louis Comfort Tiffany, Thomas Eakins, and others) suggests that the "axiom" was more a cultural conceit than based in reality. See H. Barbara Weinberg, *The Decorative Work of John La Farge* (New York: Garland Publishing Co., 1977); Dianne H. Pilgrim, "Decorative Art: The Domestic Environment," in *The American Renaissance, 1876–1917*, ed. Richard Guy Wilson (New York: Pantheon Press, 1979), 100–51; Doreen Bolger Burke, "Painters and Sculptors in a Decorative Age," in *In Pursuit of Beauty*, 296; and Yount, 159–70. This point is taken up in some detail in chapter 3.

45. Edwin AtLee Barber, "The Exhibition of Paintings on China," *Magazine of Art* 1 (1878): 178–79.

46. At least one author took exception to this stereotype, stating that, "As a matter of fact, there are many who paint flowers creditably, and only a few, and those not usually women, who paint them worthily." See Katharine De Mattos, "Flowers and Flower-Painters," *Magazine of Art* 6 (1883): 454.

47. "Art-Work for Women," *Art Journal* (March 1, 1872): 66. See also Leader Scott, "Women at Work: Decoration," *Magazine of Art* 6 (1883): 278–79; and idem, "Women at Work: Their Functions in Art," *Magazine of Art* 7 (1884): 98–99.

48. Randall, 415–20.

49. Candace Wheeler, ed., *Household Art* (New York: Harper and Brothers, 1893), 195–96, and *Yesterdays in a Busy Life* (New York: Harper and Brothers, 1918), 212.

50. "Woman's Position in Art," *Crayon* (February 1860): 26.

51. McCarthy, 76–77; see also Anthea Callen, *Women Artists of the Arts and Crafts Movement* (New York: Pantheon Books, 1979), esp. 50–93; and Sara M. Dodd, "Art Education for Women in the 1860s: A Decade of Debate," in *Women in the Victorian Art World*, ed. Clarissa Campbell Orr (Manchester: Manchester University Press, 1995), 187–200.

52. McCarthy, 46–47.

53. Yount, 239–41.

54. "Women's Mistakes about Work," *Lippincott's Monthly* 24 (August 1879): 236–43.

55. See *Art Interchange* 12 (August 28, 1884): 2.

56. McCarthy, 47.

57. Ibid., 49–50.

58. Wheeler, *Yesterdays in a Busy Life*, 224.

59. See "The New York Exchange for Woman's Work," *Lippincott's Monthly* 23 (March 1879): 384–85.

60. See Lucy M. Salmon, "The Women's Exchange: Charity or Business?" *Forum* 13 (May 1892): 395.

61. See Salmon, 397. The NYSDA was active as well, netting estimated annual revenues around the $40,000 mark from the turn of the century. See Max West, "Revival of Handicrafts," *Bulletin of the Bureau of Labor* (1904): 1605, 1607; and Kathleen Waters Sander, "'Not a Lady Among Us': Entrepreneurial Philanthropy and Economic Independence as Expressed through the Woman's Exchange Movement, 1832–1900" (Ph.D. dissertation, University of Maryland, 1994).

62. See Alice Kessler-Harris, "Independence and Virtue in the Lives of Wage-Earning Women: The United States, 1870–1930," in *Women in Culture and Politics: A Century of Change*, ed. Judith Friedlander et al. (Bloomington: Indiana University Press, 1986), 3–17. See also Mary Gay Humphreys, "Women Bachelors in New York," *Scribner's* 20, 5 (November 1896): 626–36; and Thomas J. Schlereth, "Working," in *Victorian American: Transformations in Everyday Life, 1876–1915* (New York: Harper Perennial, 1991), 33–85.

63. See Robert E. Riegel, "Changing American Attitudes toward Prostitution," *Journal of the History of Ideas* 29 (July–September 1968): 437–52. Riegel notes that in the middle of the nineteenth century only about 30 percent of prostitutes surveyed at the women's prison on Blackwell's Island claimed "destitution" as the prime motivating factor; yet by the 1890s the discussion of prostitution had become involved with such matters as better pay and working conditions. According to her biographer, Sarah Worthington King Peter founded the Philadelphia School of Design for Women as a consequence of her experiences working with former prostitutes in the Rosine Society for Magdalens in the early 1840s. See N. de Angeli Walls, "Art and Industry in Philadelphia: Origins of the Philadelphia School of Design for Women, 1848–1876," *Pennsylvania Magazine of History and Biography* 17, 3 (1993): 182.

64. Wheeler, *Yesterdays in a Busy Life*, 226.

65. Quoted in Chalmers, 237.

66. Cherry, 79.

67. Wheeler, *Yesterdays in a Busy Life*, 215. In addition to Candace Wheeler and her circle, many other middle- and upper-class women also participated in philanthropic enterprises. Indeed, before women won the vote in 1919, philanthropic endeavors provided the primary means through which the majority of middle- and upper-class women fashioned their public roles. These women used their philanthropic ventures to wield political power, to create new institutions, and to effect social change. Women's philanthropy was also firmly rooted in the doctrine of separate spheres. Because women were thought to be natural care givers they were ideally suited to the "domestic" tasks of the philanthropist. See

also Robyn Muncy, *Creating a Female Dominion in American Reform, 1890–1935* (New York: Oxford University Press, 1991).

68. "The Decline of the Amateur," *Atlantic Monthly* 73 (1894): 859. On the meaning of "amateur" see also Burton J. Bledstein, *The Culture of Professionalism: The Middle Class and the Development of Higher Education in America* (New York: W. W. Norton, 1976), 31.

69. "Art Work for Women, III. How the Work May Be Done," *The Art Journal* (1872): 130.

70. See Tamar Garb, "'L'Art Féminin': The Formation of a Critical Category in Late Nineteenth-Century France," *Art History* 12, 1 (March 1989): 39–65; Anne Higonnet, "Amateur Pictures: Images and Practices," in *Berthe Morisot's Images of Women* (Cambridge, Mass.: Harvard University Press, 1992), 36–60; and Clarissa Campbell Orr, introduction to *Women in the Victorian Art World* (Manchester: Manchester University Press, 1995), 1–27.

71. Lewis F. Day, "The Woman's Part in Domestic Decoration," *Magazine of Art* (1881): 458.

72. Quoted in Callen, 28.

73. "China-Painting Amateurs," *Crockery and Glass Journal* (July 2, 1885): 33.

74. By the eighteenth century, the production of high-quality porcelain had become a hobby of European nobility and having one's own factory became a status symbol for the titled. See Bevis Hiller, *Pottery and Porcelain, 1700–1914: England, Europe and North America* (New York: Meredith Press, 1968), 35–45. For needlework see Nancy Dunlap Bercaw, "Solid Objects/Mutable Meanings: Fancywork and the Construction of Bourgeois Culture, 1840–1880," *Winterthur Portfolio* 26, 4 (winter 1991): 240.

75. China painting was regarded as a good substitute for needlework. See "Amateurs in China Painting," *Crockery and Glass Journal* (January 4, 1883): 14.

76. The lower number was reported in "White China for Amateurs," *Crockery and Glass Journal* (May 17, 1895), and the higher number was reported in Weimann, 416.

77. "The Summer Term of the Art Academy of the Cincinnati Museum Association," *Studio* 6, 27 (June 6, 1891): 267. See also Cynthia A. Brandimarte, "Darling Dabblers: American China Painters and Their Work, 1879–1920," *American Ceramic Circle Bulletin* 6 (1988): 7–28; Cynthia A. Brandimarte, "Somebody's Aunt and Nobody's Mother: The American China Painter and Her Work, 1870–1920," *Winterthur Portfolio* 23, 4 (winter 1989): 203–24; Ellen Paul Denker, "The Grammar of Nature: Arts and Crafts China Painting," in *The Substance of Style: Perspectives on the American Arts and Crafts Movement*, ed. Bert Denker (Winterthur, Del.: Henry Francis du Pont Winterthur Museum, 1996), 281–300; and Ruth Irwin Weidner, "The Early Literature of China Decorating," *American Ceramics* 2 (spring 1983): 28–33.

78. For examples of this debate in the periodical literature see "A Class in

Design," *Keramic Studio* 3, 4 (August 1901): 75–80; "Editorial," *Keramic Studio* 7, 3 (July 1905): 1; "Editorial," *Keramic Studio* 9, 1 (May 1907): 1; "Editorial," *Keramic Studio* 9, 3 (July 1907): 1; "Editorial," *Keramic Studio* 13, 10 (February 1912): 207.

79. *China Decorator*, edited by china painter and teacher Mrs. O. L. Barumuller, was issued from New York; *Keramic Studio*, issued from Syracuse, N.Y., was edited by china painter, teacher, and later renowned ceramist Adelaide Alsop Robineau and china painter and teacher Anna B. Leonard; *Ceramic Monthly* was issued from Chicago and later from New York. See Weidner, "The Early Literature of China Decorating," 32–33.

80. See for example, "The Fourth Annual Exhibition of Paintings on China," *Magazine of Art* (1878): 269–72; "The Fifth Annual Exhibition of Paintings on China," *Magazine of Art* (1881): 392–95. These exhibitions held at Howell and James in London were patronized by members of the royal family and judged by members of the Royal Academy such as E. J. Poynter and architects such as Richard Normal Shaw. See Cheryl Buckley, *Potters and Paintresses* (London: The Women's Press, 1994), 63. See also "China Painting at the Brussels Exhibition," *Magazine of Art* (1881): 157–59; and "The 'Royal Academy' of China Painting," *Magazine of Art* (1884): 245–50.

81. In 1895 Edwin AtLee Barber described the career of Edward Lycett, a well-known china painter who came to the United States from England in 1861, as representing "the history of china painting in the United States." "The Pioneer of China Painting in America," *New England Magazine* 13, 1 (September 1895): 33–48.

82. Anita J. Ellis has pointed out that while McLaughlin's book is written for women, the author never directly addresses them in its 69 pages, using only male pronouns throughout. Ellis speculates that because McLaughlin self-identified as a professional, she was reluctant to preclude a male readership for her book. To do so would have been to preclude a readership important to her own identity. See Anita J. Ellis, "The Ceramic Career of M. Louise McLaughlin," unpublished manuscript, 94–95.

83. Brandimarte, "Darling Dabblers," 12.

84. In her biography of McLaughlin, Anita J. Ellis reports that she most emphatically did not self-identify as a "china painter," believing this to be the province of amateurs. See Ellis, "The Ceramic Career of M. Louise McLaughlin," 247–48. Interestingly, all three women went on to have distinguished careers as art potters. McLaughlin and Frackelton both quit china painting c. 1890; and Robineau quit around the turn of the century. See Ellis, "The Ceramic Career of M. Louise McLaughlin," 243; George Weedon, "Susan S. Frackelton and the American Arts and Crafts Movement" (Master's thesis, University of Wisconsin-Milwaukee, 1975), 15–16; and Peg Weiss, "Adelaide Alsop Robineau: Syracuse's Unique Glory," in *Adelaide Alsop Robineau: Glory in Porcelain* (Syracuse, N.Y.: Syracuse University Press, 1981), 14.

85. Edwin AtLee Barber, *The Pottery and Porcelain of the United States*, 512. See also Susan F. Frackelton, "Organized Effort," *Keramic Studio* 3 (September 1901): 100–101.

86. Ellen Paul Denker has suggested that china painting was closely related to canvas and watercolor painting. Denker observes that the vocabulary used to instruct the techniques of china painting was taken entirely from fine art. Denker, "The Grammar of Nature," 289–90.

87. Herbert F. Brousson, *Practical Help to Amateurs and Artists for Painting and Decorating the Latest Productions in Pottery* (London: Artists Colour Manufacturing Co., 1886), 8. See also Brandimarte, "Somebody's Aunt," 217–18. Another author noted that, "The path of the women employed in this way is not strewn with riches; and we know that behind these impaneled hollyhocks are weariness, disappointment, and struggle." "Working Women in New York," *Harper's New Monthly Magazine* 61 (June 1880): 34. Still another pointed out that "For her who hopes to find remuneration for her toil awaits disappointment and chagrin." See "Amateurs in China Painting," 14.

88. Brandimarte, "Somebody's Aunt," 219.

89. Most of this growth was due to immigration, after 1840 specifically by the Germans, who surpassed the Irish and all others in coming to Cincinnati. In 1830 the Germans were 5 percent of the city's population, in 1850 they were 27 percent, and by 1900 more than 41 percent. See Boehle, 27–28.

90. See Philip D. Spiess II, "The Cincinnati Industrial Expositions, 1870–1888: Propaganda or Progress?" (Master's thesis, University of Delaware, 1970).

91. See Robert C. Vitz, *The Queen and the Arts: Cultural Life in Nineteenth-Century Cincinnati* (Kent, Ohio: Kent State University Press, 1989), 13, 35. See also Louis Leonard Tucker, "Cincinnati: Athens of the West, 1830–1861," *Ohio History* 75 (winter 1966): 11–25; Donald R. MacKenzie, "Early Ohio Painters: Cincinnati, 1830–1850," *Ohio History* (spring 1964): 111–18; and Ophia D. Smith, "A Survey of Artists in Cincinnati: 1789–1860," *Cincinnati Historical Society Bulletin* (January 1967): 3–20.

92. Records, Ladies' Academy of Fine Arts. Cincinnati Historical Society Library.

93. *Cincinnati Gazette*, May 27, 1854. See also Lea Brinker, "Women's Role in the Development of Art as an Institution in Nineteenth-Century Cincinnati" (Master's thesis, University of Cincinnati, 1970).

94. Helen Evastson Smith, "Women Art Patrons," (1893); quoted in Brinker, 25.

95. Life classes for male students were formally instituted c. 1878; a separate women's life class was instituted in 1885. Ellis, "The Ceramic Career of M. Louise McLaughlin," 23.

96. Vitz, 190.

97. Kenneth R. Trapp, "'To Beautify the Useful:' Benn Pitman and the

Women's Woodcarving Movement in Cincinnati in the Late Nineteenth Century," *Nineteenth Century* 8, 3–4 (1982): 175–91; and Anita J. Ellis, "Cincinnati Art Furniture," *Magazine Antiques* 121 (April 1982): 930–41.

98. The mission statement for the woodcarving department indicated that instruction was to be offered, "particularly to the operative classes." However, available records suggest that this goal was not realized as the majority of the students were women from families of social prominence. See [Benn Pitman], "Wood Carving Department," in *School of Design Annual Catalogue, 1873–74* (Cincinnati: A. Pugh, 1874), 10, 12, 13.

99. Cincinnati Inquirer, April 23, 1876, 1.

100. Benn Pitman, *A Plea for American Decorative Art* (Cincinnati: C. J. Krehbiel & Co., 1895), 12.

101. See Newton, "Early Days at Rookwood Pottery," n.p. See also Elizabeth Williams Perry, "Decorative Pottery of Cincinnati," *Harper's New Monthly Magazine* 62 (May 1881): 834.

102. Vitz, 191.

103. Mendenhall, "Cincinnati's Contribution to American Ceramic Art," 47–61.

104. The committee included Maria Longworth Nichols, Sarah Worthington King Peter, Elizabeth Williams Perry, and Louise Taft, among others. See Ellis, "The Ceramic Career of Mary Louise McLaughlin," 54. Alfred T. Goshorn, who had achieved renown as the director of the Cincinnati Industrial Fairs, was the director of the Centennial Exhibition (he would subsequently be named first director of the Cincinnati Art Museum). See Brinker, 36–40.

105. See Carol Macht, *The Ladies, God Bless 'Em: The Women's Art Movement in Cincinnati in the Nineteenth Century* (Cincinnati: Cincinnati Art Museum, 1976), 7.

106. Elizabeth Williams Perry, 834.

107. Lawrence Mendenhall, "Mud, Mind and Modelers," *Frank Leslie's Popular Monthly* 42 (December 1896): 669.

108. Mary Louise McLaughlin, "Miss McLaughlin Tells Her Own Story," *Bulletin of the American Ceramic Society* 17 (May 1938): 218. See also "The Cincinnati School of Design Wood Carving Exhibit," *New Century for Women* 5 (June 10, 1876): 33.

109. Kenneth R. Trapp, "Maria Longworth Storer: A Study of Her Bronze Objets D'Art in the Cincinnati Art Museum" (master's thesis, Tulane University, 1972), 22.

110. Haviland & Company was founded in Limoges, France, in 1842 by David Haviland, an American importer of fine china. Although noted for its fine porcelain, it was not Haviland's porcelain that engendered acclaim in 1876 but its faience. Haviland faience was produced in Auteuil, a suburb of Paris, having been developed by Ernest Chaplet in the early 1870s. In the United States, the

Haviland product became known as "Limoges" faience even though it was developed at the Auteuil studio some 225 miles north of Limoges. See "David Haviland," *Art Amateur* 2, 3 (February 1880): 55; "Ceramics at Philadelphia," *American Architect and Building News* 1 (July 29, 1876): 244; and Jean d'Albis and Laurens d'Albis, *Céramique Impressioniste: L'Atelier Haviland de Paris-Auteuil, 1873–1882* (Paris: Editions Sous le Vent, 1974).

111. George Ward Nichols, *Art Education Applied to Industry* (New York: Harper and Brothers, 1877); quoted in Vitz, 194.

112. McLaughlin carried out her earliest experiments at the Coultry pottery and eventually came to believe they had appropriated her discoveries. This problem of attribution occurred frequently, and it should be noted that work parallel to McLaughlin's (but following the French exactly) had been done by Charles Volkmar and Hugh Robertson at about the same time. McLaughlin published the results of her studies in *Pottery Decoration under the Glaze* (Cincinnati: Robert Clarke and Company, 1880).

113. McLaughlin served as president, Clara Chipman Newton as secretary, Alice Belle Holabird as treasurer. There were eight other known members although sources do not always agree as to who they were. See Ellis, "The Ceramic Career of M. Louise McLaughlin," 148–49.

114. Clara Chipman Newton, "The Cincinnati Pottery Club," manuscript in Clara Newton Papers, Cincinnati Historical Society Library; edited and published in the *Bulletin of the American Ceramic Society* 19 (September 1940): 345–51.

115. McLaughlin, "Miss McLaughlin Tells Her Own Story," 219.

116. Benn Pitman, letter to Mrs. Elizabeth Perry, Cincinnati, Ohio, February 1, 1879. Papers of the Women's Art Museum Association, Letter #91. Cincinnati Historical Society Library. In 1884 the School of Design was taken over by the Cincinnati Museum Association and renamed the Cincinnati Museum Association Art School. In May of 1886 the Cincinnati Art Museum opened its doors, and in November 1887, the Art School, now renamed the Cincinnati Art Academy, opened at a site adjacent to the museum in Eden Park.

117. Alice C. Hall, "Cincinnati Faience," *Potter's American Monthly* 15, 107 (November 1880): 359.

118. "Cincinnati Reports," *Crockery and Glass Journal* (March 18, 1880): 28; "Cincinnati Reports," *Crockery and Glass Journal* (June 24, 1880): 4; and Elizabeth Williams Perry, 841.

119. Mary Gay Humphreys, "The Cincinnati Pottery Club," *Art Amateur* 8, 1 (December 1882): 20.

120. Elizabeth Williams Perry, 843.

121. Carroll Smith-Rosenberg has suggested that hysteria was one way in which conventional women could express dissatisfaction with one or several aspects of their lives. With this in mind, it is interesting to view pottery making as

an alternative way of taking charge. See "The Hysterical Woman: Sex Roles and Role Conflict in Nineteenth-Century America," in *Disorderly Conduct: Visions of Gender in Victorian America* (New York: Oxford University Press, 1985), 208.

122. Elizabeth Williams Perry, 837, 843.

123. Alice C. Hall, 362.

124. Lillian Whiting, "Ceramic Progress in Cincinnati," *Art Amateur* 3, 2 (July 1880): 32.

125. In a catalogue essay for an 1892 exhibition of her work at Frederick Keppel & Co. in New York City, Mary Louise McLaughlin went to some trouble to note that she was "a lady of independent means who had never been forced to produce 'pot boilers' or pieces that sacrificed artistic integrity to marketability. She was totally untrammeled by the sordid necessities which have forced so many artists to play false to their own artistic conscience." Catalogue in the Theodore Ashmead Langstroth Collection, Mary R. Schiff Library, Cincinnati Art Museum. Quoted in Ellis, "The Ceramic Career of M. Louise McLaughlin," 247.

126. However, it should be noted that the male pottery employees not only created the forms the women decorated but also glazed and fired the pieces. See Elizabeth Williams Perry, 845.

127. Humphreys, 20.

128. "Cincinnati Trade Reports," *Crockery and Glass Journal* (February 10, 1881): 26. Kenneth Trapp has observed that men were attracted to art pottery as a career once it appeared that it could develop into a profitable business. For more on the rivalry among the art potters, see Kenneth R. Trapp, "Toward a Correct Taste: Women and the Rise of the Design Reform Movement in Cincinnati, 1874–1880," in *Celebrate Cincinnati Art*, ed. Kenneth R. Trapp (Cincinnati: Cincinnati Art Museum, 1981), 66–67.

129. Elizabeth Williams Perry, 845.

130. "The Cincinnati Exposition," *Crockery and Glass Journal* 12, 12 (September 16, 1880): 10.

131. "Mrs. Nichols' Decorated Pottery," *Crockery and Glass Journal* 12, 13 (September 23, 1880): 16.

132. George Ward Nichols, to whom Maria Longworth was married in 1868, had originally come to Cincinnati in 1857 to catalogue the Longworth collection of paintings, sculptures, porcelain, and ceramics. The couple lived separate lives after 1872 when George was diagnosed with tuberculosis. Maria's biographer points out that the disease was highly contagious and suggests that Maria dissociated herself from her husband in order to protect her two children and to be certain that there were no more pregnancies. See Boehle, 60–62. Mary Louise McLaughlin suggested that "The fact that she was not happily married to Geo. Ward Nichols was the original cause of the starting of Rookwood Pottery. Her father did not approve of divorce and his influence and authority and his efforts to assist his daughter prevented her from divorcing Nichols." Mary Louise

McLaughlin, a letter to Ross C. Purdy, [no place given], February 25, 1938. Mary Louise McLaughlin papers, Cincinnati Historical Society Library.

133. "Mrs. Nichols' Decorated Pottery," 16.

134. Nichols quoted in Storer, *History of the Cincinnati Musical Festivals and of the Rookwood Pottery*, n.p.

135. Elizabeth Williams Perry, 835.

136. "Cincinnati Reports," *Crockery and Glass Journal* 19, 11 (March 13, 1884): 8. Apparently many of the commercial potteries were also on the banks of the Ohio, as this article claims that "The potteries of Cincinnati were all under water except the smallest establishments."

137. Storer, *History of the Cincinnati Musical Festivals and of the Rookwood Pottery*, n.p.

138. McLaughlin's brother George, a Cincinnati attorney, had kept careful records which proved that M. Louise McLaughlin had developed the technique well in advance of Wheatley's patent. See "A Ceramic Claimant," *Art Amateur* 3, 6 (November 1880): 112. As mentioned earlier, McLaughlin did not duplicate the French *procès barbotine* exactly, nor did Wheatley.

139. *Cincinnati Daily Gazette*, October 7, 1880.

140. William Watts Taylor, "The Rookwood Pottery," *Forensic Quarterly* 1 (September 1910): 204.

141. *Cincinnati Daily Gazette*, October 13, 1881, 8.

142. "Art and Artists: More about the Pottery Club Reception," *Cincinnati Commercial*, May 1, 1881, 2; and Newton, "The Cincinnati Pottery Club," 349.

143. "Cincinnati Reports," *Crockery and Glass Journal* 15, 3 (January 19, 1882): 36.

144. Ibid., 38; and "Cincinnati Reports," *Crockery and Glass Journal* 18, 13 (September 27, 1883): 44. Oscar Wilde visited the pottery in 1882 and was reportedly not as impressed as the local crowd. See "Oscar Wilde on Pottery Decoration," *Art Amateur* 6, 5 (April 1882): 105.

145. Albert Valentien, "Rookwood Pottery," 4. Albert Valentien papers, Cincinnati Historical Society Library.

146. Taylor had come to Cincinnati from Louisiana as a child. Poor health prevented him from attending Harvard beyond one year; instead he joined his father's commission house, Taylor and Brother, as a clerk. Following his father's death in 1869, he became a partner with his uncle, a position he held until he joined Rookwood.

147. "Cincinnati Reports," *Crockery and Glass Journal* 16 (September 21, 1882): 46.

148. William Watts Taylor, letter to Miss Cornelia S. Cassady, Cleveland, Ohio, September 17, 1890. Letterpress Book, 1889–90, 420. RPC, MML/MSU.

149. Newton, 9.

150. Barber, *Pottery and Porcelain of the United States*, 294.

151. William Watts Taylor, "The Rookwood Pottery," *Forensic Quarterly*, 204.

152. Quoted in *Cincinnati Commercial-Gazette*, March 20, 1883, 8.

153. Quoted in *Cincinnati Commercial-Gazette*, March 25, 1883, 4.

154. See *The Cincinnati Society Address Book: The Social Register, 1900* (Cincinnati and New York, 1900).

CHAPTER THREE

1. Paul S. Boyer, *The Enduring Vision: A History of the American People* (Lexington, Mass.: D.C. Heath and Company, 1993), 619; Daniel T. Rodgers, "In Search of Progressivism," *Reviews in American History* 10 (1982): 113–32; and Robert H. Wiebe, *The Search for Order, 1877–1920* (New York: Hill and Wang, 1967).

2. See Daniel T. Rodgers, *The Work Ethic in Industrial America, 1850–1920* (Chicago: University of Chicago Press, 1978); James B. Gilbert, *Work without Salvation: America's Intellectuals and Industrial Alienation, 1880–1910* (Baltimore: Johns Hopkins University Press, 1977); T. J. Jackson Lears, *No Place of Grace: Antimodernism and the Transformation of American Culture, 1880–1920* (Chicago: University of Chicago Press, 1981; reprint 1994); and Alan Trachtenberg, *The Incorporation of America: Culture and Society in the Gilded Age* (New York: Hill and Wang, 1982).

3. Lears, *No Place of Grace*, xvi.

4. For the Arts and Crafts movement in the United States see Eileen Boris, *Art and Labor: Ruskin, Morris, and the Craftsman Ideal in America* (Philadelphia: Temple University Press, 1986); Leslie Greene Bowman, *American Arts and Crafts: Virtue in Design* (Los Angeles: Los Angeles County Museum; Boston: Little, Brown and Co., 1990); Robert Judson Clark et al., *The Arts and Crafts Movement in America, 1876–1916* (Princeton, N.J.: Princeton University Press, 1972; reprint 1992); Bert Denker, ed., *The Substance of Style: Perspectives on the American Arts and Crafts Movement* (Winterthur, Del.: The Henry Francis du Pont Winterthur Museum, 1996); Wendy Kaplan et al., *The Art That Is Life: Arts and Crafts Movement in America, 1875–1920* (Boston: Boston Museum of Fine Arts; New York Graphic Society, 1987); and Kenneth R. Trapp et al., *The Arts and Crafts Movement in California: Living the Good Life* (New York: Abbeville Press, 1993).

5. William Morris, "A Factory as It Might Be," in *William Morris: Artist, Writer, Socialist*, ed. May Morris (New York: Russell and Russell, 1966), 130–40; Boris, 28–29.

6. William Watts Taylor, "The Rookwood Pottery," *Forensic Quarterly* 1 (September 1910): 213.

7. Oscar Lovell Triggs, "Rookwood: An Ideal Workshop," in *Chapters in the History of the Arts and Crafts Movement* (Chicago: Bohemia Guild of the Industrial Art League, 1902), 160.

8. Madeline Yale Wynne, "What to Give: Some Christmas-Tide Suggestions," *House Beautiful* 2 (1901): 26.

9. Peter Stansky, *Redesigning the World: William Morris, the 1880s, and the Arts and Crafts* (Palo Alto, Calif.: Society for the Promotion of Science and Scholarship, 1985), 12.

10. Peter Stansky, *William Morris, C. R. Ashbee, and the Arts and Crafts* (London: Nine

Elms Press, 1984), 1. See also Paul Atterbury and Clive Wainwright, eds., *Pugin: A Gothic Passion* (New Haven: Yale University Press, 1994).

11. Ruskin preached about the dignity of labor and its essential contribution to human life in lectures, essays, and his two most famous books: *The Seven Lamps of Architecture* (1849) and *The Stones of Venice* (1851 and 1853).

12. Morris had founded Morris, Marshall, Faulkner and Co. in 1861 to produce furniture, stained glass, wall-painting, painted tiles, embroidery, table glass, metalwork, chintzes, and wallpapers. After the firm was reorganized as Morris and Co. in 1875, carpets and tapestries were also made. See J. W. Mackail, *The Life of William Morris*, 2 vols. (1899; reprint New York: Benjamin Blom, 1963), 32, 37, 58–59.

13. Norton had a forty-five-year friendship with John Ruskin that had a major effect upon his ideas about the role of art in society. See Charles Eliot Norton, ed., *Letters of John Ruskin to Charles Eliot Norton*, 2 vols. (Boston: Houghton Mifflin, 1905). Elbert Hubbard, founder of the Roycroft press and community, claimed to have met William Morris in 1894; and furniture manufacturer Gustav Stickley was said to have been influenced by the designs of C. F. A. Voysey and Ashbee during a trip to England in 1898. See Elbert Hubbard, *The Roycroft Shop, Being a History* (East Aurora, N.Y.: Roycrofters, 1908), 19; and John Crosby Freeman, *The Forgotten Rebel: Gustav Stickley and His Craftsman Mission Furniture* (Watkins Glen, N.Y.: Century House, 1967), 44.

14. Bowman, 33.

15. For information on the Boston Society of Arts and Crafts, see May R. Spain, *The Society of Arts and Crafts, 1897–1924* (New Haven: Yale University Press, 1923); Beverly Kay Brandt, "'Mutually Helpful Relations': Architects, Craftsmen and the Society of Arts and Crafts, Boston, 1897–1917" (Ph.D. dissertation, Boston University, 1985); and Marilee Boyd Meyer, ed., *Inspiring Reform: Boston's Arts and Crafts Movement* (New York: Harry N. Abrams, 1997).

16. Arthur Astor Carey—second president of the BSAC in 1900—and Mary Ware Dennett, guided by a sense of social mission, argued for a wide ethical framework, close to the spirit of Ruskin and Morris. See Mary Ware Dennett, "Aesthetics and Ethics," *Handicraft* 1 (May 1902): 29–147; and Mary Ware Dennett, "The Arts and Crafts: An Outlook," *Handicraft* 2 (April 1903): 3–17.

17. Frederick Allen Whiting, "What the Arts and Crafts Movement Has Accomplished," address at the Meeting of the American Federation of Arts, May 18, 1910. Boston Society of Arts and Crafts Papers, Archives of American Art, Roll 300, Frames 275–78.

18. Langford Warren, "Our Work and Prospects," *Handicraft* 2 (December 1903): 179–202, esp. 185–86.

19. See Bruce Robert Kahler, "Art and Life: The Arts and Crafts Movement in Chicago, 1897–1910" (Ph.D. dissertation, Purdue University, 1986).

20. See Triggs, Appendix II in *Chapters in the History of the Arts and Crafts Movement*, 195–98; Oscar Lovell Triggs, "The Workshop & School," *Craftsman* 3, 1 (October 1902): 20–31; Oscar Lovell Triggs, "The New Industrialism," *Craftsman* 3, 2 (November 1902): 93–106; Oscar Lovell Triggs, "A School of Industrial Art," *Craftsman* 3, 4 (January 1903): 215–23; and Oscar L. Triggs, "The Meaning of Industrial Art," *House Beautiful* 12 (May 1904): 355–57.

21. See Frank Lloyd Wright, "The Art and Craft of the Machine," *Brush and Pencil* 8, 2 (May 1901): 77–90.

22. In addition to Arts and Crafts manufactories, there were also some 150 craft communes such as Byrdcliffe, Rose Valley, and Elbert Hubbard's Roycroft Shops. Because the focus here is on the Rookwood company, comparisons will, for the most part, be limited to other manufactories.

23. The magazine, which was published from 1901 to 1916, evolved according to the particular interests of its editors. See Marilyn Fish, "Evolution of *The Craftsman*: The Voices of its Principal Editors," *Style 1900* 9, 4 (autumn/winter 1996/97): 29–33.

24. Gustav Stickley, "Foreword," *Craftsman* 1, 1 (October 1901): i.

25. Richard Guy Wilson has noted that "Stickley advocated capitalism but he distrusted great concentrations of wealth and the robber barons. Instead he wanted little and humane capitalists like himself." See "Gustav Stickley and *The Craftsman*: Social and Political Issues," *Arts and Crafts Symposium Catalogue* (Arts and Crafts Quarterly Press, 1992), 30.

26. Gustav Stickley, "The Use and Abuse of Machinery, and Its Relation to the Arts and Crafts," *The Craftsman* 11, 2 (November 1906): 204.

27. Neither motto can be uncritically accepted since both the Aesthetic movement and the Arts and Crafts movement were embedded in both culture and commerce.

28. Competitive publications included *Ladies' Home Journal*, *Studio*, *Art Amateur*, and *House Beautiful*. See Marilyn Fish, "Other Voices of the Arts and Crafts Movement: *The Craftsman's* Competitors," *Arts and Crafts Quarterly* 7, 2 (summer 1994): 36–38.

29. Lears, *No Place of Grace*, 77–78; Rodgers, 80–81; and David Shi, *The Simple Life: Plain Living and High Thinking in American Culture* (New York: Oxford University Press, 1985), 189–93.

30. Some scholars foreground the movement's philosophical tenet that inspiration and process are more important than the resultant product; others are preoccupied solely with the objects themselves. Others, such as Kenneth R. Trapp, find "comfort in regarding the Arts and Crafts movement as a kind of dynamic organism that grew and adapted and mutated into forms that confound any attempt at taxonomy." Trapp, *The Arts and Crafts Movement in California*, 11.

31. Clara Chipman Newton, "Early Days at Rookwood Pottery," c. 1900, n.p.

Clara Chipman Newton papers, Cincinnati Historical Society Library (hereafter CCNP/CHSL).

32. Precise financial information is not available, but in December of 1888 Taylor wrote to a woman who wanted to start her own pottery that, "We do not exaggerate the difficulties at all for we have been through them and scarcely saw daylight at all until perhaps $40,000 had gone in and plenty more has gone in since and not a dollar of profit yet." William Watts Taylor, letter to Effie A. Hutchinson, Columbus, Mich., December 22, 1888. Letterpress Book 1888–89, 460–61. Rookwood Pottery Collection, Rookwood letterpress books, Mitchell Memorial Library, Mississippi State University (hereafter RPC, MML/MSU). For Rookwood's profitability in 1889, see William Watts Taylor, "The Rookwood Pottery," *The Forensic Quarterly* 1 (September 1910): 205. The Pottery's first annual report was in 1891. It shows a profit of $7,001.44. Annual Report, February 10, 1891. Corporate Minutes of the Rookwood Pottery Company, 153. Collection of Dr. and Mrs. Arthur Townley (hereafter Corporate Minutes).

33. Board of directors meeting, November 22, 1890, Corporate Minutes, 7. Rookwood was a privately held company. At the time it was incorporated in May of 1890 there were 13 shareholders. Taylor subscribed to 380 shares (at $100 each). Of the remained 12 shareholders, 10 of them subscribed to 10 shares each and two to 5 each. Shareholders were Cincinnati professionals and were probably involved as a courtesy to Taylor and/or to Maria Longworth Storer (whose husband was one of the original shareholders). Over the years minimal dividends were paid, and most of the profit went right back into the pottery. See Articles of Incorporation, May 31, 1890. Corporate Minutes, 4.

34. William Watts Taylor, letter to Moses King Corporation, Boston, Mass., July 11, 1890. Letterpress Book 1889–90, 346. RPC, MML/MSU. Taylor expressed similar sentiments to a dealer: "We hope to have the most picturesque workshop in America." William Watts Taylor, letter to C. H. Gale, Cleveland, Ohio, June 19, 1891. Letterpress Book 1890–91, 449. RPC, MML/MSU.

35. Annual Report, February 29, 1892. Corporate Minutes, 157. The Proctor House was published in *American Architect and Building News* 25 (May 4, 1889): 211.

36. For McLauglin's portfolio see *Avery Index to Architectural Periodicals*, 2nd edition, vol. 9 (Boston: G. K. Hall and Co., 1973), 361–62.

37. William Watts Taylor, letter to H. Neill Wilson, Pittsfield, Mass., June 6, 1891. Letterpress Book, 1890–91, 425–26. RPC, MML/MSU. When the building was added onto in 1899 and in 1904, the Cincinnati firm of Elzner and Anderson prepared the plans.

38. William Watts Taylor, letter to H. Neill Wilson, Pittsfield, Mass., April 30, 1891. Letterpress Book, 1890–91, 333. RPC, MML/MSU.

39. William Watts Taylor, letter to Edwin AtLee Barber, West Chester, Penn., September 3, 1891. Letterpress Book, 1891–92, 80. RPC, MML/MSU.

40. William Watts Taylor, letter to Mr. L. Wertheimer & Co., New York, N.Y., January 25, 1892. Letterpress Book 1891–92. RPC, MML/MSU.

41. See William Hosley, *The Japan Idea: Art and Life in Victorian America* (Hartford, Conn.: Wadsworth Atheneum, 1990), 39.

42. William Watts Taylor, letter to Manager, Standard Oil, Chicago, Ill., February 2, 1891. Letterpress Book, 1890–91, 203–4. RPC, MML/MSU. Taylor also told him that "if you can arrange for us to use successfully any form of your product the fact is likely to be more widely advertised to your incidental benefit than from any purely industrial establishment of twenty times our capacity."

43. Annual Report, February 29, 1892. Corporate Minutes, 157.

44. This addition had been in the works since 1898 when the property was acquired. Construction actually began in March of 1899, and the new facilities were occupied in September of 1899. See Annual Reports, March 26, 1898; February 25, 1899; February 17, 1900. Corporate Minutes, 191, 198, 203. Another extension was built onto the north side of the original building to house the architectural faience department in 1904. See Annual Report, June 4, 1904. Corporate Minutes, 225.

45. "Shadow-Brook" was published in *American Architect and Building News* 40 (April 1, 1893): 14; "Rookwood Pottery" was published in *American Architect and Building News* 41 (July 1, 1893): 15.

46. The flower garden, an early example of industrial landscaping, was tended by Taylor's mother (Frances A. Taylor). Herbert Peck, *The Book of Rookwood Pottery* (New York: Crown Publishers, 1968), 45–46.

47. *House and Garden* 2 (May 1902): xi.

48. Although Ould designed the exterior, the interior of Wightwick Manor is considered to be one of the most complete Morris & Co. interiors, with decorations, light fittings, wall-coverings, embroidery, and upholstery purchased from the firm. See Peter Davey, *Arts and Crafts Architecture* (London: Phaidon, 1980; reprint 1995), 31. The Tudor style is loosely based on a variety of early English building traditions ranging from simple folk houses to late medieval palaces. The earliest American houses in the style date from the late nineteenth century. These tended to be architect-designed landmarks that rather closely copied English models. See Virginia and Lee McAlester, *A Field Guide to American Houses* (New York: Alfred A. Knopf, 1988), 354–71. See also "Good Taste and Bad Taste in Small Houses," *Ladies' Home Journal* (November 1905): 21. Tudor style houses were considered to be "good taste."

49. Susan Stuart Frackelton, "Rookwood Pottery," *Sketch Book* 5 (February 1906): 273.

50. William Watts Taylor, letter to H. Neill Wilson, Pittsfield, Mass., February 17, 1891. Letterpress Book, 1890–91, 216–17. RPC, MML/MSU.

51. It should be noted that although the Beaux Arts buildings were the most

famous and influential architectural examples at the World's Columbian Exposition, the Tudor style was present in the Victoria House, the British national pavilion.

52. Mary Chase Stratton, "Pewabic Records." Pewabic Pottery papers, Archives of American Art, Roll 1020, Frames 1146–56.

53. *New Orleans Picayune*, October 2, 1902, and October 18, 1902. Quoted in Jessie Poesch, *Newcomb Pottery: An Enterprise for Southern Women, 1895–1940* (Exton, Penn.: Schiffer Publishing Co., 1984), 37.

54. Susan Stuart Frackelton, "Our American Potteries—Newcomb College," *Sketch Book* 5, 9 (July 1906): 433.

55. See Grace Wickham Curran, "An American Potter, Her Home and Studio," *American Homes and Gardens* (September 1910): 364–66. Curran notes that Robineau designed the pottery in concert with Catharine Budd, a New York architect.

56. Barbara Maysles Kramer, "Saturday Evening Girls and the Paul Revere Pottery," *Style 1900* 8, 4 (fall/winter 1995/96): 37–40.

57. See W. Jervis, "Women Potters of America," *Pottery, Glass and Brass Salesman* (December 13, 1917): 91–97; and also Joan Siegfried, "American Women in Art Pottery," *Nineteenth Century* 9 (spring 1984): 12–18.

58. The Gates Potteries produced art pottery marketed as Teco. Of the twenty-three persons identified as Teco designers, only one woman is listed: Blanche Ostertag. See Sharon S. Darling, *Teco: Art Pottery of the Prairie School* (Erie, Penn.: Erie Art Museum, 1898), 169–76. Of the twenty-seven persons identified as Grueby employees, thirteen women are listed. See Susan S. Montgomery, *The Ceramics of William H. Grueby: The Spirit of the New Idea in Artistic Handicraft* (Lambertville, N.J.: Arts & Crafts Quarterly Press, 1993), 109–13. Despite this high percentage of female employees, Jervis does not include Grueby in his "Women Potters of America."

59. Cynthia A. Brandimarte, "'To Make the Whole World Homelike': Gender, Space, and America's Tea Room Movement," *Winterthur Portfolio* 30, 1 (spring 1995): 1–19.

60. For the "parlorization" of artist's studios see Elizabeth Bisland, "The Studios of New York," *Cosmopolitan* 7, 1 (May 1889): 3–22; and W. A. Cooper, "Artists in Their Studios," *Godey's Magazine* 80, 777 (March 1895): 291–305. The Cooper series ran monthly from March 1895 through February 1896. See also Sarah Burns, "The Price of Beauty: Art, Commerce, and the Late Nineteenth-Century American Studio Interior," in *American Iconology*, ed. David C. Miller (New Haven: Yale University Press, 1993), 209–38; and Martha Ward, "Impressionist Installations and Private Exhibitions," *Art Bulletin* 73, 4 (December 1991): 599–622.

61. The Shape Book is housed in the Rookwood Pottery Collection, Cincinnati Historical Society Library.

62. William Watts Taylor, letter to H. B. Russell, Saratoga Springs, N.Y., June 24, 1887. Letterpress Book, 1886–87, 288. RPC, MML/MSU.

63. Elizabeth Weldon Brain memoirs, 1898. Private Collection.

64. Peck, *The Book of Rookwood Pottery,* 44.

65. *The Rookwood Book,* Cincinnati, 1904. Rookwood Pottery Collection, Cincinnati Historical Society Library.

66. From 1877 through 1900, the highest wages paid to skilled male laborers in the commercial potteries of Ohio were about $16.50 per week. The highest wages paid women were around $6.00. See Don Anthony Shotliff, "The History of the Labor Movement in the American Pottery Industry: The National Brotherhood of Operative Potters, 1890–1970" (Ph.D. dissertation, Kent State University, 1977), 398. For more general information about wages in the commercial potteries, see Census Office, "Clay Products," *Report on Manufacturing Industries in the United States at the Eleventh Census: 1890. Part III. Selected Industries* (Washington, D.C.: Government Printing Office, 1895): 507. This report demonstrates that the majority of all commercial pottery employees earned under $5.00/week. See also Davis R. Dewey, *Employees and Wages* (Washington, D.C.: United States Census Office, 1903), 86. This later document (which is broken down by occupation) reports wages of $6.00–$8.00/week from 1890 to 1900 for female decorators in commercial potteries.

67. William Watts Taylor, letter to Mr. Louis Wertheimer, St. Louis, Mo., May 2, 1887. Letterpress Book, 1886–87, 183–84. RPC, MML/MSU. See also "Overture of Cincinnati Ceramics," *Bulletin of the Cincinnati Historical Society* 25 (January 1967): 83.

68. Quoted in Virginia Raymond Cummins, *Rookwood Pottery Potpourri* (Cincinnati: Cincinnati Art Galleries, 1991), 60.

69. Alice Kessler-Harris has pointed out that women with middle-class aspirations frequently turned down higher paying factory jobs in favor of higher status, less remunerative positions as department store clerks. See "Independence and Virtue in the Lives of Wage-Earning Women," in *Women in Culture and Politics: A Century of Change,* ed. Judith Friedlander et al. (Bloomington: Indiana University Press, 1986), 10.

70. In the commercial potteries of Trenton, N.J., women held only 24 percent of all pottery jobs in 1890; in the commercial potteries of East Liverpool, Ohio, women held 27 percent of all jobs in 1886. These figures stayed steady throughout the decade. In addition, children (defined as boys under 16 years and girls under 15 years) made up around 5 percent of the workforce in the commercial potteries. See Marc J. Stern, "The Potters of Trenton, New Jersey, 1850–1902: A Study in the Industrialization of Skilled Trades" (Ph.D. dissertation, State University of New York at Stony Brook, 1986), 274.

71. Statistics are similar for the commercial potteries where young, unmarried women predominated. Only 12 percent of Trenton's female pottery workers were married in 1890; this figure fell to 10 percent in 1900. Marc Stern reports that single women often objected to married women in the shop, charging that they "[kept] out girls who have no husband to support them." Quoted in Stern, 275.

72. See "Rookwood Decorators (Chronologically)," in Anita J. Ellis, *Rookwood Pottery: The Glaze Lines* (Atglen, Penn.: Schiffer Publishing Co., 1995), 237–39.

73. Donald S. Hall identifies thirty decorators of great or good collector interest (presumably judged by price paid for their work). Of those working 1880–1913, fifteen are female and fifteen are male. Of those, seven in the highest category (great interest), two are female and five are male. See "Ranked Decorator List," in Ellis, *The Glaze Lines*, 236.

74. See Annual Reports, November 22, 1890; April 27, 1895; May 26, 1904. Corporate Minutes, 7, 20, 83. For a sense of how unusual a business practice stock grants were, see Milton L. Rock, ed., *Handbook of Wage and Salary Administration* (New York: McGraw-Hill, 1994), 46/1.

75. William Watts Taylor, letter to C. W. A. Veditz, Philadelphia, Penn., April 14, 1891. Letterpress Book, 1890–91, 306–7. RPC, MML/MSU.

76. In an effort to explain increased costs in his report to shareholders, Taylor noted that the senior decorators had spent much time in developing new styles of decoration and that such work could not be expected to be immediately profitable. See Annual Report, March 26, 1898. Corporate Minutes, 188. Kenneth R. Trapp has noted that senior decorators were usually assigned to work with new glazes since they required considerable skill in application. See *Ode to Nature: Flowers and Landscapes of the Rookwood Pottery: 1880–1940* (New York: The Jordan-Volpe Gallery, 1980), 36.

77. Rookwood's first experienced thrower, William Auckland, had come from England in 1879 to work in the commercial potteries in Trenton, joining the staff at Rookwood shortly thereafter. He committed suicide in the autumn of 1888. See William Watts Taylor, letter to Mrs. Jane Auckland, Yorkshire, England, November 3, 1888. Letterpress Book, 1888–89, 319–20. RPC, MML/MSU. Other shape designers included Maria Longworth Nichols, Taylor, various decorators, other employees, and members of the board of directors.

78. For more information about the decorative practices of the commercial potteries, see Shotliff; Stern; and Herman J. Stratton, "Factors in the Development of the American Pottery Industry, 1860–1929" (Ph.D. dissertation, University of Chicago, 1929). The Sèvres archive also includes evidence of piecework in the French Royal Porcelain Factory. See Lynn Springer Roberts, "The *Londonderry Vase*: A Royal Gift to Curry Favor," *The Art Institute of Chicago: Museum Studies* 15, 1 (1889): 77, 79.

79. See Cummins, passim.

80. Peck, *The Book of Rookwood Pottery*, 63.

81. This interest in Orientalism and in the Arabian Nights was in keeping with Rookwood's cosmopolitan leanings. Orientalism had been a staple of French visual culture throughout the nineteenth century, but it was given a new twist and a new lease on life by the publication in 1899 of a fresh translation by Dr. J.-C. Mardrus of *The Thousand and One Nights*, published by the leading journal of the

avant-garde, the symbolist *Revue Blanche,* and appearing serially volume by volume over the next five years. See Peter Wollen, "Out of the Past: Fashion/Orientalism/ The Body," in *Raiding the Icebox: Reflections on Twentieth Century Culture* (Bloomington: Indiana University Press, 1993), 1–34.

82. Peck, *The Book of Rookwood Pottery,* 31.

83. "Fertilization of Flowers," given by a Mr. Gibson in 1895–96, was judged by Taylor to be "of benefit to the decorators especially." See Annual Report, February 15, 1896. Corporate Minutes, 176. "Japanese Art," given by Professor E. F. Fenellossa, was also "mainly for the benefit of the decorators" according to Taylor. See Annual Report, February 20, 1897. Corporate Minutes, 182.

84. See the Brain memoir about holiday presents, Elizabeth Weldon Brain memoirs, 1898. Private Collection. About the World's Columbian Exposition, Taylor reported to shareholders that "Every employee was given a week to visit the Fair without deduction of pay and this policy is believed to have been a wise one." Annual Report, February 17, 1894. Corporate Minutes, 165.

85. This policy was instituted in part because "so many decorators had been absent with absences so strung along as to throw other departments out of gear." Annual Report, February 17, 1900. Corporate Minutes, 201.

86. Quoted in Boris, 149.

87. See for example, Philip S. Foner, ed., *The Factory Girls* (Urbana: University of Illinois Press, 1977); Agnes L. Thompson, "New England Mill Girls," *New England Galaxy* 26, 2 (fall 1974): 43–49; and Helena Wright, "The Uncommon Mill Girls of Lowell," *History Today* 23, 1 (January 1973): 10–19. For more information on the prevalence of business welfarism, see Daniel Nelson, *Managers and Workers: Origins of the New Factory System in the United States, 1880–1920* (Madison: University of Wisconsin Press, 1975), 101–21.

88. United States patent issued to Laura A. Fry for Art of Decorating Pottery-Ware, Letters Patent No. 339,029, March 5, 1889.

89. "Fry v. Rookwood Pottery et al." (Circuit Court Southern District Ohio, December 2, 1898, No. 4,531) *Federal Reporter* 90 (December 1898–February 1899): 494–500. Taylor referred to this litigation as an "annoying and expensive affair" in his 1899 report to shareholders. See Annual Report, February 25, 1899. Corporate Minutes, 195–96.

90. "Fry v. Rookwood Pottery et al." (Circuit Court of Appeals, Sixth Circuit, May 8, 1900, No. 746) *Federal Reporter* 101 (May–July 1900): 723–27. See also "Suit against Rookwood Pottery," *Ceramic Monthly* 8 (January 1899): 2. About this appeal Taylor reported, "This can scarcely but be the end of this vexatious and expensive incident and it seems probable that the Court below will be sustained." Annual Report, February 17, 1900. Corporate Minutes, 203. In the Annual Report dated March 2, 1901, under the heading "Fry Litigation," Taylor wrote, "I am pleased to refer to this matter for the last time the decision on Miss Fry's appeal by the U.S. Circuit Court last Spring having finally disposed of the case in our favor. The

amount paid out in the account last year was $873.20 or something over $2,500 since the beginning." Corporate Minutes, 212.

91. Official Transcript, July 7, 1899, Laura A. Fry v. The Rookwood Pottery and William Taylor. No. 746, United States Circuit Court of Appeals: Sixth Circuit, 183. Despite the less than complimentary tone of this testimony, Valentien and the others who described their complaints were witnesses for the Pottery.

92. Although some of the menial workers at Rookwood had come from the commercial potteries (e.g., Auckland came from Trenton, N.J.), there is no record of their having been members of NBO. Moreover, Rookwood workers were untouched by the May Day Strikes of 1886 which were intended to force manufacturers to adopt a universal eight-hour day. In Cincinnati, approximately 32,000 men and women—35 percent of the city's working population—were said to have participated. See Steven Joseph Ross, "Workers on the Edge: Work, Leisure, and Politics in Industrializing Cincinnati, 1830–1890" (Ph.D. dissertation, Princeton University, 1980), 459.

93. *Proceedings of the First Convention of the United States Potters' Association* (East Liverpool, Ohio: J. H. Simms, Book and Job Printer, 1875), 3–10.

94. Tabulated from the *Proceedings of the First Convention of the United States Potters' Association* (1875) through the *Proceedings of the Twenty-First Convention of the United States Potters' Association* (East Liverpool, Ohio: J. H. Simms, Book and Job Printer, 1900).

95. See *Proceedings of the Fifteenth Convention of the United States Potters' Association* (East Liverpool, Ohio: J. H. Simms, Book and Job Printer, 1890), 9, which indicates Rookwood's wish to join the group; *Proceedings of the Sixteenth Convention of the United States Potters' Association* (East Liverpool, Ohio: J. H. Simms, Book and Job Printer, 1892), 1, which lists them as a member; and *Proceedings of the Seventeenth Convention of the United States Potters' Association* (East Liverpool, Ohio: J. H. Simms, Book and Job Printer, 1898), 1, where they are no longer listed. Possible explanations for Rookwood joining are taken up in chapter 4.

96. Stickley's major discussion is "The Guild Stamp and the Union Label," *Craftsman* 13, 4 (January 1908): 375–84. See also "Als Ik Kan," *Craftsman* 13, 6 (March 1908): 742–25; "Als Ik Kan," *Craftsman* 12, 6 (September 1907): 704–6; and "Chips from the Craftsman Workshop," *Craftsman* 5, 4 (January 1904): 414–16.

97. Boris, 152.

98. "William Morris's Views about Pottery," *Art Amateur* 5, 4 (October 1883): 106.

99. Maria Longworth Storer (formerly Nichols) wrote that the first wheel at the pottery had been turned for the potter's use by woman-power, "this being at that time more easily controlled than steam. At the present [1890] steam is the more docile, and a potter's wheel is now run by steam at the Rookwood Pottery." Storer, *History of the Cincinnati Musical Festivals and of the Rookwood Pottery* (Paris: Herbert Clarke Printer, 1919), n.p.

100. William Watts Taylor, letter to Henry Yelland, [no location given, possibly

East Liverpool, Ohio], August 27, 1888. Letterpress Book 1888–89, 129. RPC, MML/MSU. Yelland was hired to replace Auckland, the thrower who had committed suicide. Taylor described Auckland as "an indifferent thrower," who corrected many faults "by his skill in turning." On the effects of mechanization in art pottery production, see Nelson, *Managers and Workers*, 6–14.

101. William Watts Taylor, letter to C. S. Raymond, Omaha, Nebr., October 29, 1887. Letterpress Book, 1887–88, 32. RPC, MML/MSU.

102. William Watts Taylor, letter to J. C. Crakey, East Saginaw, Mich., November 9, 1887. Letterpress Book, 1887–88, 53. RPC, MML/MSU.

103. Taylor, "The Rookwood Pottery," (1910): 207.

104. For example, Frank Lloyd Wright explained his use of conventionalized decorative motifs in his stained glass window designs saying, "Nothing is more annoying to me that any tendency toward realism of form in window-glass, to get mixed up with the view outside." Quoted in Bowman, 221.

105. See John Grant Rhodes, "Ornament and Ideology: A Study in Mid-Nineteenth-Century British Design Theory" (Ph.D. dissertation, Harvard University, 1983), i–ii.

106. The nation's first ceramic course at the college level was offered at Ohio State University in 1895. The first degree work in ceramic art was offered at Alfred University in 1900 under the direction of Charles Fergus Binns. However, design schools and institutions like the Massachusetts Normal Art School taught drawing and modeling in the 1890s. See Dorothy Wilson Perkins, "Education in Ceramic Art in the United States" (Ph.D. dissertation, Ohio State University, 1956), 82; and Susan J. Montgomery, "'The Spirit of the New Idea in Artistic Handicraft': The Ceramics of William H. Grueby" (Ph.D. dissertation, Boston University, 1990), 342.

107. Taylor, "The Rookwood Pottery," (1910): 215.

108. The high gloss glazes had a very high lead content. Lead poisoning in the workplace was considered to be an occupational hazard of the pottery industry. See W. C. Garrison, *Health Conditions of the Pottery Industry, The Eight Hour Movement, Wages and Production in the Glass Industry* (Trenton, N.J.: MacCrellesh and Quigley, 1905), esp. 117; Zoe La Forge, "Health Hazards of Pottery Workers," *Public Health Nurse* 12 (January 1920): 26–31; and P. E. Sprague, "Chronic Lead Poisoning Banished in New Jersey Potteries," *Ceramic Age* 10 (October 1927): 131–32, 139. It is not known what if any effect this information may have had on Rookwood's aesthetics. There were several different types of mat glazed wares used, including incised, painted, conventional, modeled, vellum, and decorated. Ellis, *The Glaze Lines*, 56–94.

109. Annual Report, March 2, 1901. Corporate Minutes, 212. On Van Briggle see Albert Valentien, "Rookwood Pottery," ca. 1910, 12. Albert Valentien Papers, Cincinnati Historical Society Library. Van Briggle, who left Rookwood in 1899,

moved to Colorado in the hope of curing his tuberculosis. Reportedly, he was contacted by Taylor about the recipe for mat glaze, and believing himself fatally ill, sent it immediately. See also George D. Galloway, "The Van Briggle Pottery," *Colorado Springs Gazette*, August 25, 1901, 10.

110. See Montgomery, *The Ceramics of William H. Grueby*, 18.

111. Annual Report, March 2, 1902. Corporate Minutes, 212.

112. Kenneth R. Trapp, "Rookwood Pottery, The Glorious Gamble," in *Rookwood Pottery: The Glorious Gamble*, ed. Anita J. Ellis (New York: Rizzoli, 1994), 11–41, 27.

113. Anita J. Ellis, "Eight Glaze Lines: The Heart of Rookwood Pottery," in *Rookwood Pottery: The Glorious Gamble*, ed. Anita J. Ellis (New York: Rizzoli, 1994), 53. There were a few decorators who mastered the difficult technique of painting vessels with mat glazes. These wares, discussed in the appendix, include conventional mat, painted mat, and painted mat inlay.

114. Annual Report, March 2, 1901. Corporate Minutes, 208.

115. Charles Venable, writing about silver production during this period, has pointed out that "the aesthetics which the arts and crafts movement espoused worked to de-skill many craftsmen." See "Silver in America, 1840–1940: Production, Marketing, and Consumption" (Ph.D. dissertation, Boston University, 1993).

116. See for example, Boris, 143.

117. Triggs, "The Rookwood Pottery: An Ideal Workshop," 157–62.

118. Frederic Allen Whiting, letter to William Watts Taylor, Cincinnati, Ohio, March 17, 1904. Louisiana Purchase Exposition—Department of Art Papers, Archives of American Art, Roll 1748.

119. See *Official Catalogue of Exhibitors: Universal Exposition, St. Louis, U.S.A., 1904* (St. Louis: Official Catalogue Co. Inc., 1904), passim.

120. William Watts Taylor, letter to Frederic Allen Whiting, Boston, Mass., April 9, 1904. Louisiana Purchase Exposition—Department of Art Papers, Archives of American Art, Roll 1748.

121. *Exhibition of the Society of Arts and Crafts* (Boston: Society of Arts and Crafts, 1899): 5.

122. On their conformity to the Arts and Crafts aesthetic, see Diana Stradling, "Teco Pottery and the Green Phenomenon," *Tiller* (March/April 1983): 8–35. Perhaps not surprisingly, Grueby's decorators, who were referred to as modelers, were largely trained in ceramic arts as opposed to easel painting. See Montgomery, "The Spirit of the New Idea in Artistic Handicraft: The Ceramics of William H. Grueby," 340. Teco ware was molded and did not have applied decoration.

123. "The Rookwood Pottery: 'Dux Foemina Facti,'" *Craftsman* 3 (January 1903): 247–48.

1. *The Rookwood Book*, Cincinnati, 1904. Rookwood Pottery Collection, Cincinnati Historical Society Library.

2. William Watts Taylor, letter to Zachary Clark, Cincinnati, Ohio, October 13, 1900. Zachary Clark papers, Cincinnati Historical Society Library.

3. Ibid.

4. Annual Report, March 8, 1902. Corporate Minutes of the Rookwood Pottery Company, 219. Collection of Dr. and Mrs. Arthur Townley (hereafter Corporate Minutes).

5. Smithsonian acquisition number 16,362. See Anita J. Ellis, "Collecting Ceramics in the Late 19th Century: The Cincinnati Art Museum," *American Ceramic Circle Bulletin* 7 (1989): 33.

6. "An Historical Collection of the Rookwood Pottery," *Keramic Studio* 8 (April 1907): 274. Anita J. Ellis notes that only about sixteen of these pieces were actually owned by the museum; the rest were loans, which were withdrawn and sold in 1941 when Rookwood was facing financial disaster. See Ellis, "Collecting Ceramics in the Late 19th Century," 33.

7. Florence N. Levy, ed., *American Art Annual, 1900–1901* (Boston: Noyes, Platt & Company, 1900), 105.

8. Frederic Allen Whiting, "The Arts and Crafts at the Louisiana Purchase Exposition," *International Studio* 23 (October 1904): ccclxxxv. This assertion has proved difficult to confirm.

9. "The Pedestal Fund Art Loan Exhibition," *Art Amateur* 10, 2 (January 1884): 41–48.

10. About this, Ripley Hitchcock wrote, "No application of art can be more appropriate than . . . the modeling and decorating of pottery in a city where . . . the beds of native clay are within easy reach." See "The Western Art Movement," *Century* 32, 10 (October 1886): 578.

11. Kenneth R. Trapp, "Rookwood Pottery: The Glorious Gamble," in *Rookwood Pottery: The Glorious Gamble*, ed. Anita J. Ellis (New York: Rizzoli, 1992), 21.

12. Annual Report, February 2, 1897. Corporate Minutes, 185.

13. Artus Van Briggle (1893–96), Stanley Burt (1894), Albert Valentien (1894), William McDonald (1899), and John Wareham (1899) were all sent by the Pottery to study in Europe during the 1890s. See Annual Reports for 1894–99. Corporate Minutes, 164–94. It is known that Van Briggle studied painting and sculpture at the Académie Julien and at the Ecole des Beaux-Arts, but it isn't clear precisely where or what the others studied. In addition to decorators funded by the Pottery, Sallie Toohey was given a scholarship by Maria Longworth Storer in 1903 for European study. See "Resident Artists of Mount Adams, 1880–1950," manuscript in Cincinnati Historical Society Library. Anna Bookprinter Valentien

was given a leave of absence from the Pottery so that she could accompany her husband to Paris. While there she enrolled at the Academy Colorossi to study with Jean Antonin Injalbert and also enrolled at the Academy Rodin under Emile Bourdelle, Jules Des Bois, and Auguste Rodin. See Bruce Kamerling, "Anna & Albert Valentien: The Arts and Crafts Movement in San Diego," *Arts and Crafts Quarterly* 1, 4 (July 1987): 13.

14. Louis Marie Fink, *American Art at the Nineteenth-Century Paris Salons* (Cambridge: Cambridge University Press, 1990), 125.

15. Anita J. Ellis notes that Matt Daly, Anna Bookprinter Valentien, Albert Valentien, Edward Hurley, Irene Bishop, and John Dee Wareham exhibited in the Annual Exhibition of American Art; Bruce Horsfall, Anna Bookprinter Valentien, Albert Valentien, Artus Van Briggle, Edward Hurley, Irene Bishop, Harriet E. Wilcox, and John Dee Wareham with the Society of Western Artists. See "American Tonalism and Rookwood Pottery," in *The Substance of Style*, ed. Bert Denker (Winterthur, Del.: Henry Francis du Pont Winterthur Museum, 1996), 306–7. See also Nick Nicholson and Marilyn Nicholson, "Rookwood Artists: Endeavors in Other Media," *Journal of the American Art Pottery Association* 12, 6 (January–February 1996): 5–9. Cincinnati city directories also reveal that Rookwood decorators self-identified as "artists" not as "china decorators."

16. See J. H. Gest, "The Annual Exhibition of American Art in Cincinnati," *Brush and Pencil* 2, 5 (August 1898): 230. Gest notes that "there is no sensation but of pleasure upon finding this pottery among other works of art, which one gladly forgoes classifying as 'minor art' or 'fine art.'"

17. Horsfall's work was featured in *Brush and Pencil* 2, 5 (August 1898): 193–98.

18. Nicholson and Nicholson, 5–6.

19. Kamerling, 12–13. The *Daily Interocean* reported that "The Ariadne of Mrs. Anna M. Valentine . . . is the most beautiful, as it is the most ambitious work not only in the Cincinnati room but in the entire Women's building"; see *Daily Interocean*, August 9, 1893, 2.

20. A. Talbot, "A Clever Artist in Many Mediums," *Brush and Pencil* 11, 2 (November 1902): 123–29; "Frontispiece—Moonlight on the Little Miami," *Brush and Pencil* 11, 4 (January 1903): 240; Elbert Hughes, "Some Recent Etchings by E. T. Hurley," *Brush and Pencil* 14, 3 (June 1904): 226–28. See also Cincinnati Art Galleries, *The Etchings of E. T. Hurley* (Cincinnati: Cincinnati Art Galleries, 1996).

21. Catalogue, Early Auction Co., Milford, Ohio, October 22–23, 1979. Collection of Gerald and Virginia Gordon.

22. Munich school portraits feature figures against an indefinite dark background with a strong flat light brightly illuminating portions of the figures. These works were very much influenced by seventeenth-century Spanish and Dutch portraits. Although Munich school works were considered to be out of date in New York by the 1890s, in cities such as Indianapolis and Cincinnati, where

colonies of Munich-trained artists worked, the style persisted well into the twentieth century. See Michael Quick, *Munich and American Realism in the 19th Century* (Sacramento: E. B. Crocker Art Gallery, 1978), 36.

23. Guest registers of the Riijksmuseum and of the Frans Hals Museum demonstrate that many American artists made pilgrimages there to study and copy paintings in the late nineteenth century. See D. Dodge Thompson, "Frans Hals and American Art," *Antiques* 136 (November 1989): 1170–83; see also Mariana Griswold Van Rensselaer, "Frans Hals," *Century* 26, 3 (July 1883): 427–28. Van Rensselaer notes that "If one of our younger American painters were asked to name those artists of bygone times whose influence is most potent in the studios to-day, he would surely cite Frans Hals among the very first."

24. Doreen Bolger Burke, *J. Alden Weir: An American Impressionist* (Newark: University of Delaware Press, 1983), 76. See also Michael Quick, *American Painter Abroad: Frank Duveneck's European Years* (Cincinnati: Cincinnati Art Museum, 1987), 17; Ronnie L. Zakon, *The Artist and the Studio: In the Eighteenth and Nineteenth Centuries* (Cleveland: Cleveland Museum of Art, 1978), 43–49; and Tara Tappert, "Choices—The Life and Career of Cecilia Beaux: A Professional Biography" (Ph.D. dissertation, George Washington University, 1990), 165–66.

25. Frank Duveneck taught at the Cincinnati Art Academy from 1890 to 1892, and from 1900 to 1919. During the 1890s his painting class was primarily comprised of other academy teachers. See Quick, *American Painter Abroad*, 93–95; and Denny Carter, *The Golden Age: Cincinnati Painters Represented in the Cincinnati Art Museum* (Cincinnati: Cincinnati Art Museum, 1979), 29. At art academies in the United States, students apparently copied from copies of Old Master paintings. See Kathleen McCarthy, *Women's Culture: American Philanthropy and Art, 1830–1930* (Chicago: University of Chicago Press, 1991), 31.

26. In 1886, a "Rembrandt" painting, *Portrait of Utenbogardus*, signed and dated 1635, was given to the Cincinnati Art Museum by Mr. A. Gunnison. It turned out to be a copy by an unknown artist. See Carol Macht, *The Ladies, God Bless 'Em: The Women's Art Movement in Cincinnati in the Nineteenth Century* (Cincinnati: Cincinnati Art Museum, 1976), 9. Ripley Hitchcock, writing in 1886 about the holdings of the Cincinnati Art Museum, indicated that "The paintings represent German art, with the exception of some copies of 'old masters,' a few American pictures, and three or four French works of the academic order." See "The Western Art Movement," 576–93. See also A. T. Goshorn, "The Art Museum and the Art Academy," *New England Magazine* 6, 5 (September 1888): 466–67.

27. Ruth Krueger Meyer, "The Taft Collection: The First Ten Years of Its Development," in *The Taft Museum: A Cincinnati Legacy*, ed. Ruth Krueger Meyer (Cincinnati: Cincinnati Historical Society, 1988), 8. See also Millard F. Rogers et al., *Cincinnati Art Museum: Art Palace of the West* (Cincinnati: Cincinnati Art Museum, 1981), 67–77.

28. See Christopher White et al., *Rembrandt in Eighteenth Century England* (New Haven: Yale Center for British Art, 1983), 1.

29. See for example, "Rembrandt," *Nation* 58 (January 4, 1894): 13–15; and "Rembrandt," *Nation* 75 (August 14, 1902): 136.

30. *Berlin Photographic Catalogue*, 1894. Winterthur Trade Catalogue Collection, Winterthur Library.

31. *Autotype Fine Art Catalogue*, April 1893. Winterthur Trade Catalogue Collection, Winterthur Library. This same Rembrandt was copied by Rookwood's competitor J. B. Owens Pottery Company of Zanesville, Ohio. See Marion John Nelson, *Art Pottery of the Midwest* (Minneapolis: University of Minnesota, 1988), 26.

32. Rembrandt's *Man with a Fur Bonnet* was also reproduced as a frontispiece in *Century* 27, 4 (February 1884). Also, the Rookwood archive at the Cincinnati Historical Society contains several Velásquez reproductions.

33. Kenneth R. Trapp was the first to recognize the Tonalist philosophy in Rookwood's Vellum glaze line. See *Ode to Nature: Flowers and Landscapes of the Rookwood Pottery, 1880–1940* (New York: The Jordan-Volpe Gallery, 1980). See also Todd Volpe, "Rookwood Landscape Vases and Plaques," *Antiques* 117, 4 (April 1980): 838–46; and Ellis, "American Tonalism and Rookwood Pottery."

34. Ellis, "American Tonalism and Rookwood Pottery," 304.

35. These plaques may have been an extended form of the ornamental tile already produced by the pottery. In composition they were identical to the vases, not to architectural faience tiles, which contained other elements to reduce warpage and provide structural stability. See Richard H. Lippincott, "Rookwood Architectural Faience Tiles" (M.A. thesis, Ball State University, 1993), 33.

36. Trapp, "Rookwood Pottery: The Glorious Gamble," 31–32; and idem, *Ode to Nature*, 34–35.

37. The American Barbizon painter Alexander Wyant was from Cincinnati, as were Frank Duveneck and John Twachtman, who sometimes worked in the American Barbizon or Tonalist mode. See Anthony F. Janson, "The Cincinnati Landscape Tradition," in *Celebrate Cincinnati Art*, ed. Kenneth R. Trapp (Cincinnati: Cincinnati Art Museum, 1981), 11–28.

38. Ellis, "American Tonalism and Rookwood Pottery," 307.

39. *Rookwood Pottery*, Cincinnati, 1902. Rookwood Pottery Collection, Cincinnati Historical Society Library. Visitor's registers housed in the Rookwood Pottery Collection, Mitchell Memorial Library, Mississippi State University bear this out.

40. Moses Foster Sweetser, *King's Handbook of the United States*, 1896 (Moses King, 1896; reprint New York: Benjamin Blom, 1972), 674–75.

41. Alice Cooney Frelinghuysen, *American Porcelain, 1770–1920* (New York: Harry N. Abrams, 1994), 3, 177.

42. William Watts Taylor, letter to C. A. Selzer, Cleveland, Ohio, May 25, 1888.

Letterpress Book, 1887–88, 481. Rookwood Pottery Collection, Rookwood letterpress books, Mitchell Memorial Library, Mississippi State University (hereafter referred to as RPC, MML/MSU).

43. William Watts Taylor, letter to Sloane and Mudge Co., Los Angeles, Calif., May 29, 1888. Letterpress Book 1887–88, 486. RPC, MML/MSU.

44. Anita J. Ellis, *Rookwood Pottery: The Glaze Lines* (Atglen, Penn.: Schiffer Publishing Co., 1995), 47.

45. For information about the glaze lines see the appendix.

46. William Watts Taylor, letter to Messrs. D. Flood and Sons, St. John, New Brunswick, August 26, 1891. Letterpress Book, 1891–92, 70. RPC, MML/MSU.

47. Deborah Anne Federhen et al., *Accumulation and Display: Mass Marketing Household Goods in America, 1880–1920* (Winterthur, Del.: Henry Francis du Pont Winterthur Museum, 1986), 85–86.

48. *The Rookwood Book*, Cincinnati, 1904.

49. A. O. Elzner, "Rookwood Pottery," *Architectural Record* 17 (April 1905): 297.

50. Nicholas Hungerford, "The Work of American Potteries: Article Three—The Story of Rookwood," *Arts and Decoration* 1 (February 1911): 161.

51. "Rookwood, America's Foremost Art Pottery—A Trip through the Great Plant," *Clay-Worker* 41 (January 1904): 25.

52. William Watts Taylor, "The Rookwood Pottery," *Forensic Quarterly* 1 (September 1910): 214–15.

53. Albert R. Valentien, "Rookwood Pottery," ca. 1910, 10–11. Albert R. Valentien papers, Cincinnati Historical Society Library.

54. For more on this period definition of "art," see Janet C. Mainzer, "The Relation between the Crafts and the Fine Arts in the United States from 1876 to 1980" (Ph.D. dissertation, New York University, 1988), esp. Appendix D.

55. Original members of the Tile Club included Winslow Homer, Edwin Austin Abbey, F. Hopkinson Smith, J. Alden Weir, Arthur Quarterly, William Mackay Laffan, and Earl Shinn. Later additions included William Merritt Chase, Elihu Vedder, Augustus Saint-Gaudens, John Twachtman, Frank Millet, and Stanford White. See Doreen Bolger Burke, "Painters and Sculptors in a Decorative Age," in *In Pursuit of Beauty: Americans and the Aesthetic Movement* (New York: Metropolitan Museum of Art, 1986), 296; Sylvia Yount, "'Give the People What They Want': The American Aesthetic Movement, Art Worlds, and Consumer Culture, 1876–1890" (Ph.D. dissertation, University of Pennsylvania, 1995), esp. 159–70; and Dianne H. Pilgrim, "Decorative Art: The Domestic Environment," in *The American Renaissance, 1876–1917* (New York: Pantheon Press, 1979), 138–39.

56. Burke, "Painters and Sculptors in a Decorative Age," 299. See also Yount, 159. Yount suggests that Maria Dewing's concern that decorative art production would compromise her reception as a "fine artist" may have had gender overtones since members of the all-male Tile Club did not share her anxiety.

57. C. Philips touted the financial benefits of decorative work noting, "The law of supply and demand will sooner or later regulate inexorably the actual number of professional painters in the country; that is, painters depending on their legitimate work for a livelihood. The useful arts, designing in all its many branches, illustrating, decorating, wood-carving, the ceramic arts, pottery etc., will in the future absorb the attention and reward the well-directed efforts of an army of artists whose mission it is safe to say will be of more immediate and real importance . . . than the output of the painters studios." See *Brush and Pencil* 7, 3 (December 1900): 175.

58. Gerald M. Ackerman and Richard Ettinghausen, *Jean-Léon Gérôme* (1824–1904) (Dayton, Ohio: Dayton Art Institute, 1977), 10–11. Decoration, or *la décoration*, was a prevailing interest of early modern art in France as manifested in the work (paintings, ceramics, stained glass) of Henri Matisse, the Nabi painters, Monet's series paintings, and the like. See John H. Neff, "Matisse and Decoration, 1906–1914: Studies of the Ceramics and the Commissions for Paintings and Stained Glass" (Ph.D. dissertation, Harvard University, 1974); Gloria Groom, *Edouard Vuillard: Painter-Decorator Patrons and Projects, 1892–1912* (New Haven: Yale University Press, 1993); and Paul Hayes Tucker, *Monet in the 90's: The Series Paintings* (New Haven: Yale University Press, 1989).

59. John La Farge, "'Minor Arts' Lecture," typescript [1906?], La Farge Papers, 11. Collection of American Literature, The Beinecke Rare Book and Manuscript Library, Yale University, New Haven. Quoted in Burke, "Painters and Sculptors in a Decorative Age," 304. See also H. Barbara Weinberg, *The Decorative Work of John La Farge* (New York: Garland Publishing Co., 1977).

60. Charles Eliot Norton, "The Craftsman as an Artist," *The Architectural Review* (London) 5 (1898): 81.

61. T. J. Jackson Lears, *No Place of Grace: Antimodernism and the Transformation of American Culture, 1880–1920* (Chicago: University of Chicago Press, 1981; reprint 1994), see esp. 26–32.

62. *Crayon* 1, 1 (January 1855): 1.

63. Charles L. Hutchinson, "Art: Its Influence and Excellence in Modern Times," *Saturday Evening Herald*, March 31, 1888.

64. "Editorial," *Century* 52, 5 (September 1896): 791. See also Rémy Saisselin, *The Bourgeois and the Bibelot* (New Brunswick, N.J.: Rutgers University Press, 1984), 89; and Lawrence Levine, *Highbrow Lowbrow: The Emergence of Cultural Hierarchy in America* (Cambridge: Harvard University Press, 1988), 201–11.

65. Spencer's ten volumes on evolutionary thought, published between 1862 and 1896, sold half a million copies in America. See Kathleen Pyne, "Evolutionary Typology and the American Woman in the Work of Thomas Dewing," *American Art* 7, 4 (fall 1993): 14–15.

66. Ibid., 15. See also Kathleen Pyne, "The American Response to Darwin-

ism," in *Art and the Higher Life* (Austin: University of Texas Press, 1996), 11–47; and George Cotkin, "The 'Tangled Bank' of Evolution and Religion," in *Reluctant Modernism: American Thought and Culture, 1880–1900* (New York: Twayne Publishers, 1992), 1–26.

67. Not only museums but private individuals acquired reproductions of established masterworks. For example, Christopher Newman, the American protagonist of Henry James's *The American* (first serialized in 1876) commissions a series of copies from the Louvre. In addition, artists such as Edmonia Lewis were known to have produced small scale copies for collectors, cf. her *Moses* (c. 1870) after Michelangelo, now in the collection of the National Museum of American Art.

68. Henry James, *The American Scene* (1907; reprint New York: Penguin Books, 1994), 143.

69. See Levine, passim; Paul DiMaggio, "Cultural Entrepreneurship in Nineteenth-Century Boston: The Creation of an Organizational Base for High Culture in America," *Media, Culture and Society* 4 (1982): 33–50; and Neil Harris, "The Gilded Age Revisited: Boston and the Museum Movement," *American Quarterly* 14, 4 (winter 1962): 545–66. Whereas DiMaggio argues that the Boston Museum of Fine Art's founders were Brahmins who sought to reinforce their hegemony, Harris suggests that they were more altruistic in intent. I agree with Harris, but believe that the pattern described by DiMaggio occurred during the acquisitive phase of the 1890s.

70. Quoted in Calvin Tomkins, *Merchants and Masterpieces: The Story of the Metropolitan Museum of Art* (New York: Henry Holt and Company, 1970; reprint 1989), 85.

71. *Rookwood Pottery*, Cincinnati, 1895 (probably). Rookwood Pottery Collection, Cincinnati Historical Society Library.

72. William Watts Taylor, letter to Edwin AtLee Barber, West Chester, Penn., July 18, 1891. Letterpress Book, 1891–92, 13–14. RPC, MML/MSU.

73. This practice was somewhat unusual for decorative arts. Indeed, manufacturers often refused to divulge the names of artisans in their employ for fear of losing them to a rival producer. An editorial in *International Studio* asserted that "you have got to teach the manufacturers and tradesmen that they must give honour and recognition to the artist. What connoisseur would think of buying a picture without knowing the name of its painter, and why should one buy a beautiful piece of wood-carving or metal-work without knowing who designed and executed it?" See "The Lay Figure," *International Studio* 9 (1900): 146; and Lewis F. Day, "Art and Handicraft," *Magazine of Art* 11 (1888): 410–11.

74. See Alexis Gregory, *Families of Fortune: Life in the Gilded Age* (New York: Rizzoli, 1993), 134; and John Russell Taylor and Brian Brooke, *The Art Dealers* (New York: Charles Scribner's Sons, 1969), 12.

75. Saisselin, *The Bourgeois and the Bibelot*, xv. See also Frank Jewett Mather, "The

Drift of the World's Art toward America," *World's Work* 45 (December 1922): 203; and Wesley Towner, *The Elegant Auctioneers* (New York: Hill and Wang, 1970), 152–53.

76. Saisselin has suggested that art collecting was a sublimely pleasurable, novel form of capital formation. *The Bourgeois and the Bibelot*, 103.

77. W. G. Constable, *Art Collecting in the United States* (London and New York: Thomas Nelson and Sons, Ltd., 1964), 101.

78. René Brimo, *L'Évolution du Goût aux États-Unis* (Paris: James Fortune, 1938). See also Neil Harris, "Collective Possession: J. Pierpont Morgan and the American Imagination," in *Cultural Excursions: Marketing Appetites and Cultural Taste in Modern America* (Chicago: University of Chicago Press, 1990), 250–75; and Saisselin, *The Bourgeois and the Bibelot*, 83.

79. Article by Wilhelm Bode, director of Berlin's Kaiser-Friedrich Museum, published in *Kunst und Künstler*, 1902. Quoted in Frances Weitzenhoffer, *The Havemeyers: Impressionism Comes to America* (New York: Harry N. Abrams, 1986), 62–63. See also Aline B. Saarinen, *The Proud Possessors* (New York: Random House, 1958), 79; and Harris, "Collective Possession," 260–62.

80. Louis A. Holman, "America's Rembrandts," *Century* 80 (October 1910): 883.

81. Ramsay Traquair, "Man's Share in Civilization," *Atlantic Monthly* 134 (October 1924): 502.

82. Mather, "The Drift of the World's Art toward America," 200.

83. Holman, 883.

84. Frank Jewett Mather, "Great Masters in American Galleries," *World's Work* 30 (May 1910): 12933–34. See also Frank Jewett Mather, "The Art Collector: His Fortes and Foibles," *Nation* 88 (May 13, 1909): 494–97.

85. John Smith, "Some Plain Words on American Taste in Art," *Magazine of Art* 11 (1888): 114–15.

86. Havemeyer quoted in Weitzenhoffer, 91. At least two Rembrandts were subsequently demoted to lesser attributions. See McCarthy, 122.

87. Behrman, *Duveen* (New York: Random House, 1951); *Duveen Pictures in Public Collections of America* (New York: The William Bradford Press, 1941); Saisselin, *The Bourgeois and the Bibelot*, 133–68; Taylor and Brooke, passim; and Tomkins, 168.

88. David Shi notes that in a commercial environment increasingly detached from spiritual priorities and the integrity of local markets, people craved the moorings of both product credibility and artistic veracity. *Facing Facts: Realism in American Thought and Culture, 1850–1920* (New York: Oxford University Press, 1995), 95.

89. For an account of chromolithography, see Peter C. Marzio, "The Democratic Art of Chromolithography: An Overview," in *Art and Commerce: American Prints of the Nineteenth Century* (Charlottesville: University of Virginia Press, 1978), 77–102. For Godkin's views see "Chromo-Civilization," *Nation* (September 24, 1874).

90. Levine, 160–61.

91. Ibid., 163.

92. Michelle Bogart has noted that this conception of the artist was more easily applied to painters than to artists who worked in other media. For example, in sculpture, the individual who carved or cast a finished work was usually not the same as the person who conceived the original model. Because the physical circumstances of production of the work of art were at variance with the romantic concept of the artist, the immediate relationship between the finished work of art and the artist as imaginative and skillful genius could not exist. See "Attitudes toward Sculpture Reproductions in America, 1850–1880" (Ph.D. dissertation, University of Chicago, 1979).

93. "Chromo-Lithographs, American, English, and French," *Nation* (October 31, 1867): 359.

94. Walter Benjamin, "The Work of Art in the Age of Mechanical Reproduction," in *Illuminations*, trans. Harry Zohn, ed. Hannah Arendt (New York: Schocken Books, 1968), 221. Sigfried Giedion also condemned the second half of the nineteenth century for its lack of fresh vision, its mania for reproducing every kind of art object, and its dedication to confusing the human environment through mechanization. In Giedion's mind reproductions reduced paintings to anecdotes and because of their massive numbers, led to a devaluation of art as a moral symbol. See *Mechanization Takes Command* (New York: W. W. Norton, 1969), 344–64.

95. The Royal Worcester factory routinely copied Angelica Kauffman's paintings as did the Imperial Porcelain Factory in St. Petersburg. See Wendy Roworth, ed., *Angelica Kauffman: A Continental Artist in Georgian England* (London: Reaktion Books, 1992). The French Royal Porcelain factory at Sèvres frequently copied a variety of paintings on both vases and plaques. See *Sèvres: Une Collection de Porcelaines, 1740–1992* (Paris: Réunion des Musées Nationaux, 1992), esp. 66–68. Apparently oil paintings in private collections were sometimes copied onto large china slabs in order to provide a durable copy for exhibition and to preserve the original. See "Art in the Pottery Trade," *Crockery and Glass Journal* (March 2, 1882): 18.

96. Michael Leja has pointed out that wood engravings were able to enjoy a measure of materiality, of objecthood, that was denied to photography and by extension to photomechanical prints. See "The Illustrated Magazines and Print Connoisseurship in the Late 19th Century," *Block Points* 1 (1993): 73.

97. This later category, in addition to the aforementioned chromolithographs, also included copies which aimed at identical repetition in size and material. See Michael R. Clapper, "Popularizing Art in Boston, 1865–1910: L Prang and Company and the Museum of Fine Arts" (Ph.D. dissertation, Northwestern University, 1997), 219.

98. Sidney Allan [Sadakichi Hartmann], "The Value of the Apparently Meaningless and Inaccurate," *Camera Work* 3 (July 1903): 18.

99. Wanda M. Corn, *The Color of Mood: American Tonalism, 1880–1910* (San Fran-

cisco: M. H. DeYoung Memorial Museum and the California Palace of the Legion of Honor, 1972), 4–5. See also Clara Ruge, "The Tonal School of America," *International Studio* 27, 107 (January 1906): lvii–lxvi.

100. Thomas Dewing, letter to Charles Freer, Detroit, Mich., February 16, 1901. Freer Gallery letter no. 110.

101. Quoted in Corn, 20.

102. See Thomas Lawton and Linda Merrill, *Freer: A Legacy of Art* (New York: Harry N. Abrams, 1993); Linda Merrill, *An Ideal Country: Paintings by Dwight William Tryon in the Freer Gallery of Art* (Washington, D.C.: Freer Gallery of Art, 1990); and Pyne, *Art and the Higher Life: Painting and Evolutionary Thought in Late Nineteenth-Century America.*

103. Weitzenhoffer, 91–95. Wesley Towner has noted that "As the reverence for art expanded, the ensign of taste became the seven golden men of Barbizon. Every scrap of canvas the so-called Men of 1830 had ever touched was seized upon and sold, along with many a picture that they had never touched at all. Good, bad, or blatantly forged, a Corot of some kind—preferably a large landscape with pool and silvery birches—was standard equipment in any household with serious pretensions to luxury or fashion." *The Elegant Auctioneers,* 123.

104. Jack Becker, "The 1904 Comparative Exhibition: Taking Stock of American Painting." Paper delivered at conference on "Aesthetic Value in the Gilded Age," Freer Gallery of Art, Smithsonian Institution, Washington, D.C., September 28, 1996.

105. See Steven Adams, "Panorama, Parks and Porcelain: Nature and Popular Culture," in *The Barbizon School and the Origins of Impressionism* (London: Phaidon Press, 1994), 57–92. Beginning as early as 1630 landscapes were used extensively to decorate Chinese porcelain. See "Chinese Porcelains of the Seventeenth-Century: Landscapes, Scholars' Motifs and Narratives," *The Portico: A Publication of the Taft Museum* 11, 1 (December 1995–February 1996). *Keramic Studio* also published designs and instructions for "Landscape Painting on China." See *Keramic Studio* 2, 8 (December 1900): 169; and *Keramic Studio* 2, 10 (February 1901): 208. For information about landscape depictions in glass (e.g. Daum or Gallé), see Victor Atwas, *Glass: Art Nouveau to Art Deco* (New York: Harry N. Abrams, 1987).

106. Ellen Paul Denker, *Lenox China: Celebrating a Century of Quality, 1889–1989* (Trenton: New Jersey State Museum, 1989), 26. There is a long history of landscape painting on porcelain. See John Twitchett and Henry Sandon, *Landscapes on Derby and Worcester Porcelain* (Oxon: Henderson and Stirk, 1984).

107. Charles Rudy, in "American Art in Berlin," *Connoisseur* 8 (June 1910): 106–9, noted that American painters excelled in painting objects "half-shrouded or veiled." Rudy went on to point out that many modern Americans were disciples of Inness or Whistler. Birge Harrison, in "The 'Mood' in Modern Painting," *Art and Progress* 4 (July 1913): 1020, identified vague, vaporous paintings with a

modern sensibility that now permeated the whole cultural fabric. See Sarah Burns, "The Poetic Mode in American Painting: George Fuller and Thomas Dewing" (Ph.D. dissertation, University of Illinois, 1979), 325.

108. Ellis, "American Tonalism and Rookwood Pottery," 309–10.

109. See Saul E. Zalesch, "What the Four Million Bought: Cheap Oil Paintings of the 1880s," *American Quarterly* 48, 1 (March 1996): 77–109. Zalesch demonstrates that landscapes were the "bread and butter" of painting manufactures in the 1880s. See also David Halle, "Empty Terrain: The Vision of the Landscape in the Residences of Contemporary Americans," in *Inside Culture: Art and Class in the American Home* (Chicago: University of Chicago Press, 1993), 59–86. Halle shows that all social classes studied prefer calm, depopulated landscapes.

110. Simon Schama argues that landscape is itself reflection: the reciprocal process whereby we map the world physically, intellectually, and imaginatively. He claims that it is our way of understanding ourselves, by interpreting what lies outside us. *Landscape and Memory* (New York: Alfred A. Knopf, 1995). For more information on the western landscape, see Angela Miller, *The Empire of the Eye: Landscape Representation and American Cultural Politics, 1825–1875* (Ithaca: Cornell University Press, 1993).

111. See Margaretta M. Lovell, *A Visitable Past: Views of Venice by American Artists, 1860–1915* (London: The University of Chicago Press, 1989); and Theodore E. Stebbins, Jr., *The Lure of Italy: American Artists and the Italian Experience, 1760–1914* (New York: Harry N. Abrams, 1992).

112. Although American critics and collectors were slow to accept French Impressionism, by 1893 it was acknowledged to be a major force in painting at the World's Columbian Exposition. After the Caillebotte bequest to the Luxembourg in 1894, American collectors such as H. O. Havemeyer began to acquire these works in large numbers. See Weitzenhoffer, 109–22; Hans Huth, "Impressionism Comes to America," *Gazette des Beaux-Arts* 29 (April 1946): 225–52; and Kenneth Coy Haley, "The Ten American Painters: Definition and Reassessment" (Ph.D. dissertation, State University of New York at Binghampton, 1975).

113. Eileen Boris, *Art and Labor: Ruskin, Morris and the Craftsman Ideal in America* (Philadelphia: Temple University Press, 1986), 141. See also Bruce A. Austin, "Product Price Structure at the Roycroft and the Creation of Consumer Culture," in *Head, Heart and Hand*, ed. Marie Via and Marjorie B. Searl (Rochester: University of Rochester Press, 1994), 149–55.

114. Another firm tried to manufacture Rookwood soap. Management denied the request. Board of director's meeting, April 6, 1901. Corporate Minutes, 57. Others, like Elbert Hubbard, compared their wares to Rookwood in advertisements. Hubbard, leader of the Roycroft colony, advertised Roycroft modeled leather as "like Rookwood pottery or Tiffany glass. Beauty knows no rival. There is simply other beauty." See "Roycroft Advertisement," *Fra* 6, 6 (1911): iv–v.

1. Edward C. Bruce, *The Century: Its Fruits, and Its Festival* (Philadelphia: J. B. Lippincott and Co. 1877), 65.

2. Quoted in Ripley Hitchcock, "The Western Art Movement," *Century* 32, 10 (May–October 1886): 580.

3. "Louisiana Purchase Exposition Ceramics: Rookwood Pottery," *Keramic Studio* 6, 9 (January 1905): 193; Susan Stuart Frackelton, "Rookwood Pottery," *Sketch Book* 5 (February 1906): 274; and Walter Ellsworth Gray, "Latter-Day Developments in American Pottery II," *Brush and Pencil* 9 (March 1902): 357.

4. See Philip D. Spiess II, "The Cincinnati Industrial Expositions (1870–1888): Propaganda or Progress?" (Master's thesis, University of Delaware, 1970).

5. William Watts Taylor, letter to Davis Collamore, New York, N.Y., November 26, 1888. Letterpress Book, 1888–89, 388. Rookwood Pottery Collection, Mitchel Memorial Library, Mississippi State University (hereafter RPC, MML/MSU). In this letter Taylor suggests that the retailer "lay aside two or three choice pieces" from the Philadelphia lot for the Paris Fair of 1889. See also William Watts Taylor, letter to C.W. Bonfils, Davis Collamore, New York, N.Y., December 21, 1888. Letterpress Book, 1888–89, 458. In this letter Taylor again suggests laying aside a few fine specimens for Paris.

6. *Reports of the United States Commissioners to the Universal Exposition of 1889 at Paris,* Vol. II (Washington, D.C.: Government Printing Office, 1891), 302. This report notes that Rookwood competed in "Class 20: Ceramics" where there were 616 exhibitors of whom 335 were French, 65 French colonials, and 216 from other countries.

7. "The Paris Exposition of 1889," *Crockery and Glass Journal* 28, 20 (November 15, 1888): 22–23.

8. Edouard Garnier, "Les Industries d'Art," *Gazette des Beaux-Arts* (December 1889): 575–77.

9. William Watts Taylor, letter to Mrs. Sheldon, [no place given], May 29, 1889. Letterpress Book, 1889, 320. Rookwood Pottery Collection, Cincinnati Historical Society Library (hereafter RPC, CHSL).

10. Rookwood was acquired by the proprietors of the Royal Worcester Works of England, the director of the Musée des Art Decoratifs of Paris, Mr. Theodore Haviland of Limoges, Mr. Christofle, the jeweler, and Princess Gortchakoff of Russia. See Herbert Peck, "Some Early Collections of Rookwood Pottery," *Auction* (September 1969): 20–23.

11. "Quite a triumph," *Art Amateur* 21, 3 (August 1889): 67.

12. See appendix for more information on these glaze lines.

13. William Watts Taylor, letter to C.W. Bonfils, Davis Collamore, New York, N.Y., February 18, 1889. Letterpress Book, 1889, 106–7. RPC, CHSL.

14. William Watts Taylor, "Rookwood Pottery," *Forensic Quarterly* 1 (September 1910): 208.

15. William Watts Taylor, letter to C.W. Bonfils, Davis Collamore, New York, N.Y., June 1, 1889. Letterpress Book, 1889, 326. RPC, CHSL.

16. William Watts Taylor, letter to Davis Collamore, New York, N.Y., August 24, 1889. Letterpress Book, 1889, 461. RPC, CHSL.

17. "What the Columbian Exposition Will Do for America," *Century* 44, 6 (October 1892): 954.

18. "Department H. Manufacturers," *World's Columbian Exposition Official Catalogue, Part VII* (Chicago: W. B. Conkey Co., 1893), 21. Rookwood's display was classified in Group 91, No. 244. See also William Watts Taylor, letter to Duncan Haynes, Baltimore, Md., April 20, 1891. Letterpress Book, 1890–91, 322. RPC, MML/MSU; and William Watts Taylor, letter to Duncan Haynes, Baltimore, Md., May 6, 1891. Letterpress Book, 1890–91, 350. RPC, MML/MSU.

19. The display was pictured in *Art Interchange* 34 (January 1895): 3; in Hubert Howe Bancroft, *The Book of the Fair* (Chicago: Bancroft Publishing Co., 1893), 168; and described in Barber, *The Pottery and Porcelain of the United States* (New York: G. Putnam's Sons, 1893), 298–99.

20. "Woman's Building," *World's Columbian Exposition Official Catalogue, Part XIV* (Chicago: W. B. Conkey Co., 1893), 27.

21. *Rookwood Pottery*, Cincinnati, 1895 (probably), 23. See also Frederic Allen Whiting, "The Arts and Crafts at the Louisiana Purchase Exhibition," *International Studio* 23 (October 1904): ccclxxxv.

22. *Final Report of Executive Committee of Awards, World's Columbian Exposition* (Washington, D.C.: John F. Sheary, 1895), 5.

23. Annual Report, February 17, 1894. Corporate Minutes of the Rookwood Pottery Company, 165. Collection of Dr. and Mrs. Arthur Townley (hereafter Corporate Minutes).

24. Quoted in *Rookwood Pottery*, 1895 (probably), 31.

25. Ibid.

26. Ibid., 29–30. For more information on the Ceramics Congress see "The Ceramic Congress in Chicago," *Art Amateur* 29, 4 (September 1893): 92; "The Ceramic Congress at Chicago," *Art Amateur* 29, 5 (October 1893): 118; "The Ceramic Congress at Chicago," *Art Amateur* 29, 6 (November 1893): 147.

27. Edwin AtLee Barber, "A Typical American Pottery," *Art Interchange* 34 (January 1895): 2.

28. Annual Report, February 17, 1894. Corporate Minutes, 165.

29. Many ceramics and glass firms collaborated with Gorham for silver overlay. See Jayne E. Stokes, *Sumptuous Surrounds: Silver Overlay on Ceramic and Glass* (Milwaukee: Milwaukee Art Museum, 1990).

30. Although the pottery had made a profit at the World's Columbian Exposition (with expenses of $3,243.15 or 26.86 percent of the gross sales of

$12,072.85$), the profit margin at the Paris Exposition of 1900 was rather slim (with expenses of $9,753.85 or 93.78 percent of the gross sales of $10,400). See Annual Report, February 17, 1894 and March 2, 1901. Corporate Minutes, 165, 211.

31. This may have been the case, but rumors circulating that Kaiser Wilhelm II planned a world's fair for Berlin in 1900 almost certainly supplied a more immediate stimulus. See Robert W. Brown, "Paris 1900: Exposition Universelle," in *Historical Dictionary of World's Fairs and Expositions, 1851–1988*, ed. John E. Findling and Kimberly D. Pelle (New York: Greenwood Press, 1990), 155.

32. About this, Taylor reported to shareholders that "We had excellent position in the American Department of Varied Industries in the Invalides Building and though the light was very disappointing the installation was admirably planned and showed to advantage." See Annual Report, March 2, 1901. Corporate Minutes, 210.

33. "Rookwood Pottery for Paris Exhibit," *Keramic Studio* 1 (March 1900): 221, 228, 231; see appendix for more information on these glaze lines.

34. *Report of the Commissioner-General for the United States to the International Universal Exposition, Paris, 1900, Vol. IV* (Washington, D.C.: Government Printing Office, 1901), 152, 196, 205; and "Individual Exhibits at the Paris Exposition," *Keramic Studio* 1 (September 1900): 1. See also Kenneth R. Trapp, "Maria Longworth Storer: A Study of Her Bronze Objets D'Art in the Cincinnati Art Museum" (Master's thesis, Tulane University, 1972).

35. Marshal Fry, "Notes from the Paris Exposition," *Keramic Studio* (September 1900): 99.

36. Annual Report, March 2, 1901. Corporate Minutes, 210.

37. Sandier compared the Rookwood glaze to a polished agate. "Le décor se fond sous la glaçure en des finesses d'agate polie . . . le lustre devient aussi trop brilliant." (The decoration of the glaze is like a finely polished agate . . . the luster becomes almost too bright.) Alexandre Sandier, "La Céramique à l'Exposition," *Art et Décoration* (December 1900): 196.

38. H. Hulbert, letter to J. H. Gore, [no place given], June 7, 1900. Paris Exposition of 1900, State Department Records, National Archives Administration. See also handwritten tally of jurors polled for various protests lodged by American firms. Ibid.

39. Annual Report, March 2, 1901. Corporate Minutes, 210.

40. William Watts Taylor, letter to Zachary Clark, Cincinnati, Ohio, October 13, 1900. Zachary Clark papers, Cincinnati Historical Society Library.

41. "Rookwood Paris Exhibit on View Here Feb. 6 & 7." Poster in Newspaper clippings, Rookwood Pottery Collection, Cincinnati Art Museum Library.

42. Annual Report, March 2, 1901. Corporate Minutes, 209.

43. Gabriel Weisberg, *Art Nouveau Bing: Paris Style 1900* (New York: Harry N. Abrams, 1986), 225, 228, 229. Rookwood was acquired by the Musée National

de Ceramique, Sèvres, France; Museum of Decorative Art, Budapest, Hungary; Museum of Decorative Art, Copenhagen, Denmark; Royal Industrial Art Museum, Berlin, Germany; Museum of Industrial Arts, Christiania, Norway; Museum of Decorative Arts, Bergen, Norway; Museum of Art and Industry, Hamburg, Germany; Victoria and Albert Museum, London, England; State Hermitage Museum, St. Petersburg, Russia; Moravian Industrial Museum, Brno, Czechoslovakia; Industrial Arts Museum, Prague, Czechoslovakia; Royal Industrial Art Museum of Wurttemberg, Stuttgart, Germany; Bavarian Industrial Museum, Nuremberg, Germany; Museum of Decorative Arts, Mulhouse, France. Other European museums reportedly acquired Rookwood but either lost the pieces during World War II or sold the ware. Museums tended to acquire the more splendid examples of the ware in the Goldstone or Tiger Eye glaze lines. See Herbert Peck, "Rookwood Pottery and Foreign Museum Collections," *Connoisseur* 172, 691 (September 1969): 43–49.

44. Rookwood also received a gold medal for their display at the Jamestown Tercentennial Exposition and the Grand Prix at the 1910 Alaska-Yukon-Pacific Exposition in Seattle.

45. William A. King, "Ceramic Art at the Pan-American Exposition," *Crockery and Glass Journal* 53, 22 (May 30, 1901): 15.

46. "Rookwood at the Pan-American," *Keramic Studio* 3 (November 1901): 146–48.

47. "Editorial," *Keramic Studio* 5, 11 (March 1904): 1.

48. "Louisiana Purchase Exposition Ceramics: Rookwood Pottery," 193.

49. Geijsbeek, "The Ceramics of the Louisiana Purchase Exposition," *Transactions of the American Ceramic Society* 7 (1905): 325, 349.

50. Jean Hamilton, "Arts and Crafts at the Exposition," *House Beautiful* 16 (October 1904): 45.

51. "Louisiana Purchase Exposition Ceramics: Rookwood Pottery," 194.

52. Board of Directors Meeting, November 18, 1904. Corporate Minutes, 88.

53. Beverly K. Brandt, "American Arts and Crafts at the Louisiana Purchase Exposition, 1904," *Archives of American Art Journal* 28, 1 (1988): 13.

54. William Watts Taylor to Gordon Shillito, Cincinnati, Ohio, July 9, 1887. Letterpress Book, 1886–87, 319. RPC, MML/MSU.

55. "The Philadelphia Exposition," *Crockery and Glass Journal* 28, 20 (November 15, 1888): 23.

56. "The Next Pottery Exhibition," *Crockery and Glass Journal* 29, 14 (March 28, 1889): 23.

57. *Proceedings of the Thirteenth Convention of the U.S. Potters' Association* (East Liverpool, Ohio: J. H. Simms, 1889), 17.

58. Haynes, letter to Thomas Hockley, Philadelphia, Penn., October 25, 1889. Records of the Pennsylvania Museum, Archives of American Art, Roll 4557.

59. William Watts Taylor, letter to Mrs. Gillespie, Philadelphia, Penn., November 12, 1889. Letterpress Book, 1889, 629–30. RPC, CHSL.

60. *Proceedings of the Second Yearly Meeting of the U.S. Potters' Association* (Trenton, N.J.: John L. Murphy, State Gazette Printing House, 1876), 11–13; and *Proceedings of the Third Yearly Meeting of the U.S. Potters' Association* (Trenton, N.J.: John L. Murphy, State Gazette Printing House, 1877), 24–26.

61. "An Exhibition of American Pottery and Porcelain, Including a Competition for American Workmen," *The Studio* 3, 2 (October 1888): 166.

62. Clarence Cook, "The Exhibition of Pottery and Porcelain," *Art Amateur* (December 1888): 5–6.

63. However, as late as 1891 Rookwood was still obtaining samples of American porcelain for their study collection. See William Watts Taylor, letter to Edwin AtLee Barber, West Chester, Penn., July 18, 1891. Letterpress Book, 1891–92, 13–14. RPC, MML/MSU.

64. See Arthur Hayden, *Royal Copenhagen Porcelain: Its History and Development from the Eighteenth Century to the Present Day* (New York: McBride, Nast & Company, 1912).

65. "Glass and Ceramics at the Chicago Exhibition," *Art Journal* (London) (1893 supplement): xxix–xxxi; and Roger Marx, "La Décoration et les Industries d'Art," *Gazette des Beaux-Arts* 25, 3 (1901): 135–68.

66. Fry, 98–99.

67. John Valentine, "Rookwood Pottery," *House Beautiful* 4 (September 1898): 125.

68. William McDonald, "Rookwood at the Pan-American," *Keramic Studio* 3 (November 1901): 146.

69. William Watts Taylor, letter to Edwin AtLee Barber, West Chester, Penn., April 25, 1892. Letterpress Book, 1891–92, 446. RPC, MML/MSU.

70. William Watts Taylor, letter to Mr. C. R. Feddersen, Copenhagen, Denmark, December 5, 1890. Letterpress Book, 1890–91, 63–64. RPC, MML/MSU. See also William Watts Taylor, letter to Davis Collamore, New York, N.Y., April 9. 1892. Letterpress Book, 1891–92, 426. RPC, MML/MSU. Rookwood acquired a Royal Copenhagen plaque for its corporate collection.

71. See appendix for more information on these glaze lines. The vase shown in plate 12 features a painting very similar to Eugene L. Vail's *On the Thames* of 1886 which had been shown in the Art Palace at the World's Columbian Exposition in 1893. See Carolyn Kinder Carr, *Revisiting the White City: American Art at the 1893 World's Fair* (Hanover: University Press of New England, 1993), 334.

72. *Rookwood Pottery*, Cincinnati, 1895 (probably), 21.

73. Anita J. Ellis, *Rookwood Pottery: The Glaze Lines* (Atglen, Penn.: Schiffer Publishing, 1995), 50.

74. Susan Montgomery, "Success at Home and Abroad," in *The Ceramics of William H. Grueby: The Spirit of the New Idea in Artistic Handicraft* (Lambertville, N.J.: Arts & Crafts Quarterly Press, 1993), 41–54.

75. Kenneth R. Trapp points out that imitations of the Standard ware were in production in Britain and in scattered places across Europe. "Rookwood Pottery, the Glorious Gamble," in *Rookwood Pottery: The Glorious Gamble*, ed. Anita J. Ellis (New York: Rizzoli, 1992), 26.

76. Oscar Lovell Triggs, "Rookwood: An Ideal Workshop," in *Chapters in the History of the Arts and Crafts Movement* (Chicago: The Bohemia Guild of the Industrial Art League, 1902), 160–61.

77. Maude Haywood, "Founded by a Woman," *Ladies' Home Journal* 9 (October 1892): 3.

78. Frackelton, 274.

79. Advertisement in *Architectural Record* (April 1905): 297; and in *Keramic Studio* 6, 9 (January 1905): 194.

80. Shirayamadani had been part of a Japanese village which included an entire operational pottery, and the village traveled about the United States from 1885 to 1887. See Kenneth R. Trapp, "Rookwood and the Japanese Mania in Cincinnati," *Cincinnati Historical Society Bulletin* 39, 1 (spring 1981): 65–66.

81. Gray, 357.

82. Peck, *The Book of Rookwood Pottery*, 33–34.

83. "Louisiana Purchase Exposition Ceramics: Rookwood Pottery," 193.

84. I will use the term Japanism to discuss this influence, which is elsewhere variously referred to as Japonisme, the Japan craze, the Japanese art movement, or the cult of Japan.

85. Elizabeth Williams Perry, "Decorative Pottery of Cincinnati," *Harper's New Monthly Magazine* 62 (April 1881): 837.

86. See James A. Michener, ed. *The Hokusai Sketch-Books: Selections from the Manga* (Tokyo: Charles E. Tuttle Co., 1958), 229.

87. Trapp, "Rookwood and the Japanese Mania in Cincinnati," 66. For additional information on the Japanese influence upon the artistic and technical developments of Rookwood Pottery, see Kenneth R. Trapp, "Japanese Influence in Early Rookwood Pottery," *Antiques* (January 1973): 193–99; Trapp, "Maria Longworth Storer: A Study of Her Bronze Objets d'Art in the Cincinnati Art Museum"; and Rosemary T. Smith, "Japanese Influence and Rookwood Art Pottery," *Journal of the American Art Pottery Association* 14, 3 (May/June 1998): 14–17.

88. "Ceramic Enterprise in Cincinnati," *Art Amateur* 14 (December 1885): 19.

89. Frackelton, 276.

90. Similar claims have been made for the role of Japanese art (wood-block prints) in freeing American Impressionist painters from the French precedent. See Doreen Bolger, "American Artists and the Japanese Print: J. Alden Weir, Theodore Robinson, and John H. Twachtman," *Studies in the History of Art* 37 (1990): 14–27.

91. Jennie Young, *The Ceramic Art: A Compendium of the History and Manufacture of Pottery and Porcelain* (New York: Harper Brothers, 1878), 444.

92. Neil Harris, "All the World a Melting Pot?: Japan at American Fairs, 1876–1904," in *Cultural Excursions: Marketing Appetites and Cultural Tastes in Modern America* (Chicago: University of Chicago Press, 1991), 30.

93. "Characteristics of the International Fair," *Atlantic Monthly* 38 (July 1876): 91.

94. William Hosley, *The Japan Idea: Art and Life in Victorian America* (Hartford, Conn.: Wadsworth Atheneum, 1990), 36–37.

95. James D. McCabe, *The Illustrated History of the Centennial Exhibition* (Philadelphia: The National Publishing Co., 1876).

96. "Characteristics of the International Fair," 90.

97. George Ward Nichols, *Art Education Applied to Industry* (New York: G. P. Putnam's Sons, 1877), 203.

98. George Ward Nichols, *Pottery, How It Is Made, Its Shape and Decoration* (New York: G. Putnam's Sons, 1879), 79

99. "The World Famous Rookwood Ware," *Crockery and Glass Journal* 54 (December 12, 1901): 113.

100. "Rookwood Pottery: A Woman's Contribution to American Craftsmanship," *Independent* 77, 3406 (March 16, 1914): 377.

101. For discussion of the influence of Japanese art on French artists, see Shuji Takashina et al., *Le Japonisme* (Paris: Musée d'Orsay, 1984); and *The Great Wave: The Influence of Japanese Woodcuts on French Prints* (New York: Metropolitan Museum of Art, 1974). See also Gabriel Weisberg, *Japonisme: An Annotated Bibliography* (New York: Garland Publishing, 1990); and Klaus Berger, *Japonisme in Western Painting from Whistler to Matisse* (Cambridge: Cambridge University Press, 1992).

102. Charles Wyllis Elliott, "Pottery at the Centennial," *Atlantic Monthly* 38 (November 1876): 575. For more information about "Le Service Parisien," see Gabriel P. Weisberg, "Félix Braquemond and Japanese Influence in Ceramic Decoration," *Art Bulletin* 51, 3 (September 1969): 277–84.

103. Hosley, 41.

104. Martin Eidelberg, "Myths of Style and Nationalism: American Art Pottery at the Turn of the Century," *Journal of Decorative and Propaganda Art* (1994): 89–91.

105. Maude Haywood, "Pottery and Glass at Collamore's," *Decorator and Furnisher* (February 1891): 183–84.

106. Eidelberg, 92–93.

107. For the opposite viewpoint, see Marion John Nelson, "Indigenous Characteristics in American Art Pottery," *Antiques* 89, 6 (June 1966): 846–50.

108. This idea was popularized by Hippolyte Taine, an influential French aesthetician who lectured at the Ecole des Beaux-Arts in the 1860s and whose writings appeared in both French and English. See "Taine and the Science of Criticism," *Nation* 56 (March 16, 1893): 193–94.

109. Irene Sargent, "A Comparison of Critics, Suggestions by the Comments of Dr. Pudor," *Craftsman* 6, 3 (May 1904): 135.

110. In the early twentieth century, more lengthy and systematic efforts to define the national character were made by American intellectuals. These include Brander Matthews, *American Character* (New York: Thomas Y. Crowell & Co., 1906); Barrett Wendall, *Liberty, Union, and Democracy: The National Ideals of America* (New York: Charles Scribner's Sons, 1906); and Henry Van Dyke, *The Spirit of America* (New York: Macmillan Co., 1910).

111. Theodore Roosevelt, "What 'Americanism' Means," *Forum* 17 (April 1894): 200–201.

112. Matthew Arnold, *Civilization in the United States: First and Last Impressions of America* (Boston: Cullpes & Hurd, 1888), 187; "Mr. Arnold on American Civilization," *Independent* 40 (April 19, 1888): 491–92; and James B. Fry, "Mr. Matthew Arnold on America," *North American Review* 146 (May 1888): 515–19.

113. "About an American School of Art," *Scribner's Monthly* 10 (July 1875): 381.

114. Linda Jones Docherty, "A Search for Identity: American Art Criticism and the Concept of the "Native School," 1876–1893" (Ph.D. dissertation, University of North Carolina, 1985).

115. W. Benjamin, *Art in America: A Critical and Historical Sketch* (New York: Harper and Brothers, 1880), p 123–24.

116. John C. Van Dyke, *Principles of Art* (New York: Ford, Howard and Hulbert, 1887), 251–52.

117. Nicolai Chikovsky, Jr., et al., *Winslow Homer* (New Haven: Yale University Press, 1995), 100, 122–23, 158–59, 393.

118. Ernest Knaufft, "Art at the Columbian Exposition," *Review of Reviews* 7 (June 1893): 552.

119. Docherty, 157.

120. "Rookwood Pottery and Its Successes," [*Cincinnati Commercial*, *Cincinnati Enquirer*, or *Cincinnati Times-Star*], October 8, 1895, n.p. Newspaper article in Mrs. William Dodd's scrapbook, Cincinnati Art Museum Library.

121. Ida Tarbell, "Potters and Their Craft," *Chautauquan* 14 (November 1891): 173.

122. Haywood, "Founded by a Woman," 3.

123. Jervis, *Rough Notes on Pottery* (Newark, N.J.: W. Jervis, 1896), 94.

124. Jane Long Boulden, "Rookwood," *Art Interchange* 46 (June 1901): 129–30.

125. Joseph Edgar Chamberlin, "The Foreign Elements in Our Population," *Century* 28, 5 (September 1884): 761–62.

126. Jackson Lears, *No Place of Grace: Antimodernism and the Transformation of American Culture, 1880–1920* (Chicago: University of Chicago Press, 1981; reprint 1994), 17–20, 34.

127. Ibid., xvii.

128. Ibid., 38.

129. Frederick Jackson Turner, "The Significance of the Frontier in Ameri-

can History," in *Rereading Frederick Jackson Turner*, ed. John Mack Faragher (New York: Henry Holt and Co., 1994), 31–60.

130. Alan Trachtenberg has pointed out that Turner went on to call for a collective outlook among Americans in order to solve the new problems of cities and social conflict. This proposal for a redirection of thought is often overlooked both by critics and advocates of Turner. See Alan Trachtenberg, "Contesting the West," *Art in America* 79, 9 (September 1991): 119–20.

131. Theodore Roosevelt, "The Strenuous Life," in *The Call of the Wild, 1900–1916*, ed. Roderick Nash (New York: George Braziller, 1970), 79–84. See also Theodore Roosevelt, "The Strenuous Life," *Craftsman* 5, 4 (January 1904): 412.

132. Trachtenberg, "Contesting the West," 121.

133. See David M. Lubin, "Masculinity, Nostalgia, and the Trompe l'Oeil Still-Life Paintings of William Harnett," in *Picturing a Nation: Art and Social Change in Nineteenth-Century America* (New Haven: Yale University Press, 1994), 273–329.

134. Roosevelt, "The Strenuous Life," 81.

135. Sarah Burns, "Revitalizing the 'Painted-Out' North: Winslow Homer, Manly Health, and New England Regionalism in Turn-of-the-Century America," *American Art* 9, 2 (summer 1992): 28.

136. Ibid., 21.

137. Charles Moore, "The Restoration of the White House," *Century* 65, 6 (April 1903): 807.

138. Richard Slotkin, "Nostalgia and Progress: Theodore Roosevelt's Myth of the Frontier," *American Quarterly* 33, 5 (winter 1981): 627.

139. Quoted in Alex Nemerov, "'Doing the Old America': The Image of the American West, 1880–1920," in *The West as America: Reinterpreting Images of the Frontier, 1820–1920*, ed. William H. Truettner (Washington, D.C.: Smithsonian Institution Press, 1991), 286. See also Alex Nemerov, *Frederic Remington and Turn-of-the-Century America* (New Haven: Yale University Press, 1995).

140. See Melanie Herzog, "Aesthetics and Meanings: The Arts and Crafts Movement and the Revival of American Indian Basketry," in *The Substance of Style: Perspectives on the American Arts and Crafts Movement*, ed. Bert Denker (Winterthur, Del.: Henry Francis du Pont Winterthur Museum, 1996), 69–92.

141. David Shi, *Facing Facts: Realism in American Thought and Culture, 1850–1920* (Oxford: Oxford University Press, 1995), 217–18.

142. See Frank Norris, "The Frontier Gone at Last," *World's Work* 3 (1902): 1728–31.

143. Alan Trachtenberg, "The Westward Route," in *The Incorporation of America: Culture and Society in the Gilded Age* (New York: Hill and Wang, 1982), 11–37. See also Slotkin, 634–35.

144. European Americans were particularly bothered by the Native American's lack of personal property and helped to pass the Dawes Severalty Act in 1887, which treated Native Americans as individuals rather than as members of

tribes. This act was intended to correct a "weakness" of Native American life. See Trachtenberg, "The Westward Route," 33–34.

145. There were few Native American portrait wares produced after 1904. In part this was because the decorators who focused on Native Americans either left the Pottery or no longer decorated ware. Those decorators who produced Native American portrait ware and left the Pottery include Matt Daly in 1902, Sturgis Laurence in 1904, Grace Young in 1903, and Adeliza Sehon in 1902. Another factor is that the glaze lines most commonly employed for the Native American pieces also went out of production circa 1904. However, as argued below, the salience of the Native American as a decorative motif may have changed after 1904 also.

146. See Charles L. Venable, *Silver in America, 1840–1940: A Century of Splendor* (New York: Harry N. Abrams, 1994), 192–99.

147. In addition to architectural decorations, there were many freestanding sculptures such as *Indian Bear Hunt* by Douglas Tilden and *The Ghost Dance* by Paul Bartlett. There were also many oil paintings such as George Catlin's *Indians Lassoing Wild Horses in Northern Texas*, George de Forest Brush's *The Indian and the Lily*, and Henry Farny's *The Sioux Came*. See Carolyn Kinder Carr et al., *Revisiting the White City*; and Julie Schimmel, "Inventing 'The Indian,'" in *The West as America: Reinterpreting Images of the Frontier, 1820–1920*, ed. William H. Truettner (Washington, D.C.: Smithsonian Institution Press, 1991), 149–89.

148. "Ethnographic" is a problematic term because these photographs were made not only by persons from the Bureau of American Ethnology, whose interests were scholarly, but also by persons from the private sector, whose motivations were largely financial. There were painters, such as Elbridge Burbank, who produced images of Native Americans very like ethnographic photographs, but these works were not on view in the Art Palaces of the various World's Fairs. See Nemerov, "'Doing the Old America,'" 309.

149. Frederick Monsen, "The Primitive Folk of the Desert: Splendid Physical Development That Yet Shows Many of the Characteristics of an Earlier Race Than Our Own," *Craftsman* 12, 2 (May 1907): 164–78. See also idem, "The Destruction of Our Indians: What Civilization Is Doing to Extinguish an Ancient and Highly Intelligent Race by Taking Away Its Arts, Industries and Religion," *Craftsman* 11, 6 (March 1907): 683–91; idem, "Pueblos of the Painted Desert: How the Hopi Build Their Community Dwellings on the Cliffs," *Craftsman* 12, 1 (April 1907): 16–33; and idem, "Festivals of the Hopi: Religion the Inspiration and Dancing an Expression in All Their National Ceremonies," *Craftsman* 12, 3 (June 1907): 269–85.

150. Monsen, "The Primitive Folk of the Desert," 164.

151. Ibid., 167.

152. Although it is possible that these objects are an instance of junior deco-

rators copying senior decorators' work, to my knowledge this was not done at Rookwood during this period.

153. Cincinnati Historical Society, Rookwood Photograph Collection, SC 148, Box 6, Source Material. These photographs are referred to as "Zoo series" in pencil on the back side. See Susan Labry Meyn, "Mutual Infatuation: Rosebud Sioux and Cincinnatians," *Queen City Heritage* 52, 1/2 (spring/summer 1994): 30–48; and Susan Labry Meyn, "Who's Who: The 1896 Sicangu Sioux Visit to the Cincinnati Zoo," *Museum Anthropology* 16, 2 (June 1992): 21–26.

154. Anita J. Ellis, ed., *Rookwood Pottery: The Glorious Gamble* (New York: Rizzoli, 1992), 80–81.

155. Paula Richardson Fleming and Judith Luskey, *The North American Indians in Early Photographs* (New York: Barnes and Noble Books, 1987; reprint 1992), 14–24.

156. Trapp, "Rookwood Pottery: The Glorious Gamble," 30.

157. See, for example, "Frontispiece," *Century* 28, 1 (May 1884).

158. See also Kirsten Buick, "The Ideal Works of Edmonia Lewis: Invoking and Inverting Autobiography," *American Art* 9, 2 (summer 1995): 5–20.

159. Quoted in Nemerov, "'Doing the Old America,'" 300–1.

160. Quoted in Julius W. Pratt, *Expansionists of 1898: The Acquisition of Hawaii and the Spanish Islands* (Baltimore, 1936), 6.

161. [Unidentified Native American], "To the Commissioners of the Columbian Exposition," 1891, Frederic Ward Putnam papers, Box 34, Harvard University Archives. Quoted in Robert W. Rydell, "A Cultural Frankenstein? The Chicago World's Columbian Exposition of 1893," in *Grand Illusions: Chicago's World's Fair of 1893*, ed. Neil Harris et al. (Chicago: Chicago Historical Society, 1991), 160.

162. Frederick Starr, "Anthropology at the World's Fair," *Popular Science Monthly* 43 (May to October 1893): 610–21; George Cotkin, "Anthropology, Progress, and Racism," in *Reluctant Modernism: American Thought and Culture, 1880–1900* (New York: Twayne Publishers, 1992), 53–71; William Schneider, "Race and Empire: The Rise of Popular Ethnography in the Late Nineteenth Century," *Journal of Popular Culture* 11, 1 (summer 1977): 98–109; and Judy Elise Braun, "The Native American Exhibits at the 1876 and 1893 World Expositions: The Influence of Scientific Thought on Popular Attitudes" (Master's thesis, George Washington University, 1975).

163. "Types of Americans: The Ethnological Display at the Fair," *Chicago Inter-Ocean* 7 (June 1893): n.p.

164. Bancroft, 646, 663. The first such school had been the Carlisle Indian School in Pennsylvania, founded in 1879. The stated objective of the school was to promote Native American assimilation by isolating children from their native culture.

165. Rydell, "A Cultural Frankenstein?" 160.

166. Wild West shows were a staple of late-nineteenth- and early-twentieth-

century World's Fairs. In 1896 alone, Buffalo Bill's Wild West Show played in 132 towns and cities throughout the United States. See Dixon Wector, "The Dime Novel and Buffalo Bill," in *The Hero in America* (New York: Charles Scribner's Sons, 1941), 361. The Wild West Show also traveled extensively in England and Europe. See Daniele Florentino, "'Those Red-Brick Faces': European Press Reactions to the Indians of Buffalo Bill's Wild West Show," and Nailia Cierici, "Native Americans in Columbus's Home Land: A Show within the Show," both in *Indians and Europe: An Interdisciplinary Collection of Essays*, ed. Christian F. Feest (Aachen: Rader Verlag, 1987), 403–14; 415–26.

167. Quoted in Curtis M. Hinsley, "The World as Marketplace: Commodification of the Exotic at the World's Columbian Exposition, Chicago, 1893," in *Exhibiting Cultures*, ed. Ivan Karp and Steven D. Lavine (Washington, D.C.: Smithsonian Institution Press, 1991), 347.

168. Once this transition was assured, "Indian" came to stand for "American." This is best exemplified by the appearance of Native Americans on United States coins and postage stamps during the early years of the twentieth century. For example, the Indian head nickel was minted from 1913 to 1938; the $2.50 gold piece from 1908 to 1929; the $5.00 gold piece from 1908 to 1929; and the $10.00 gold piece from 1907 to 1933. See R. S. Yeoman, *A Guide Book of United States Coins* (Racine, Wis.: Western Publishing Company, 1995).

169. Rinehart's photography at the Trans-Mississippi was partially funded by the Bureau of American Ethnology and by the Exposition management. It is likely that Adolph Muhr actually took most of the pictures as Rinehart was reportedly too occupied with other projects to personally photograph the more than five hundred delegates. However, there is some evidence that Rinehart later traveled to Indian reservations to supplement the Omaha photos. See Robert Bigart and Clarence Woodcock, "The Rinehart Photographs: A Portfolio," *Bulletin of the Montana Historical Society* 24, 4 (October 1979): 24–37.

170. Robert W. Rydell, "The Trans-Mississippi and International Exposition: 'To Work Out the Problem of Universal Civilization,'" *American Quarterly* 33, 5 (winter 1981): 587–607.

171. *Historical Biography and Libretto, Indian Congresses, Pan-American Exposition, 1901*. Indexed in Robert W. Rydell, *The Books of the Fairs: Materials about World's Fairs, 1834–1916, in the Smithsonian Institution Libraries* (Chicago: American Library Association, 1992), 189, no. 1319. Although this project is not mentioned in any other source, the photographs reproduced in this booklet are signed by Rinehart and clearly labeled "Pan-American Exposition, 1901." Were this not the case, one might suspect that they were simply copies of portraits taken at the Trans-Mississippi.

172. Paula Richardson Fleming and Judith Lynn Luskey, *Grand Endeavors of American Indian Photography* (Washington, D.C.: Smithsonian Institution Press, 1993), 81–85. Rinehart also sold individual prints via catalogue as advertised in various

periodicals such as Brush and Pencil 5, 1 (October 1899), n.p.; and House Beautiful 7, 1 (December 1999), xxix.

173. Trapp, "Rookwood Pottery: The Glorious Gamble," n. 24.

174. In her project "Mudwomen and Whitemen" Barbara Babcock discusses the reproduction of Pueblo culture in the bodies of women and clay vessels. See "Bearers of Value, Vessels of Desire: The Reproduction of the Reproduction of Pueblo Culture," Museum Anthropology 17, 3 (October 1993); "'A New Mexico Rebecca': Imaging Pueblo Women," Journal of the Southwest 32, 4 (winter 1990): 400–37; and "Pueblo Cultural Bodies," Journal of American Folklore 107, 423 (inter 1994): 40–54.

175. Fleming and Luskey, The North American Indians in Early Photographs, 238. It is not known how these photographs circulated.

176. See Historical Biography and Libretto, Indian Congresses, Pan-American Exposition, 1901, passim.

177. There was also well-documented discrimination against African Americans at the World's Columbian Exposition, and doubtless at other fairs. See Elliott M. Rudwick and August Meier, "Black Man in the 'White City': Negroes and the Columbian Exposition, 1893," Phylon 26, 4 (winter 1965): 354–61; Ann Massa, "Black Women in the 'White City,'" Journal of American Studies 8, 3 (December 1974): 319–37; and Erlene Stetson, "A Note on the Woman's Building and Black Exclusion," Heresies 2, 4 (1979): 45–47. Rookwood decorators also painted African-American portraits on mugs during this period but probably did not exhibit them at world's fairs. The sources of these portraits have not been identified.

178. William Watts Taylor, letter to Davis Collamore, New York, N.Y., December 11, 1890. Letterpress Book 1890–91, 83. RPC, MML/MSU.

Chapter Six

The title of this chapter is indebted to a book by Lloyd Wendt and Herman Kogan. See Give the Lady What She Wants: The Story of Marshall Field and Company (South Bend: and books, 1952; reprint 1991).

1. William Watts Taylor, letter to Ida Tarbell, Meadville, Penn., November 8, 1887. Letterpress Book, 1887–88, 48–49. Letterpress books, Rookwood Pottery Collection, Mitchell Memorial Library, Mississippi State University (hereafter RPC, MML/MSU).

2. For the Potter Palmer purchase, see "Quite a Triumph," Art Amateur 21, 3 (August 1889): 67; the Frick collection is documented in Kahren J. Hellerstedt et al., Clayton: The Pittsburgh Home of Henry Clay Frick, Art and Furnishings (Pittsburgh: University of Pittsburgh Press, 1988), 49–50; the Wilsons' wedding gifts were described by Doug Anderson, National Trust for Historic Preservation, Woodrow Wilson House, letter to the author, January 31, 1996.

3. Bobbi Mapstone, Public Relations Coordinator, Gamble House, Pasadena, Calif., letter to the author, January 8, 1996. Ceramic holdings of the Gamble House were catalogued by Donald S. Hall and Joel E. Smith in February 1995. See also Donald S. Hall, "The Cincinnati Connection: Rookwood Pottery at the Gamble House," *Style 1900* 10, 1 (winter 1997): 50–53. Randell L. Makinson has pointed out that the writing desk for the Gamble master bedroom respected the client's interest in Rookwood pottery by adding similar decorative forms inlaid into elements of the desk design. *Greene and Greene: The Passion and the Legacy* (Layton, Utah: Gibbs Smith, 1998), 120–21.

4. Production numbers are available for 1890–1906. During this period at least 10,000 pieces per year were recorded. After the turn of the century, figures were usually closer to 13,000 pieces. See Annual Reports 1890–1906. Corporate Minutes of the Rookwood Pottery Company, 154–231. Collection of Dr. and Mrs. Arthur Townley (hereafter Corporate Minutes).

5. See Arthur John, *The Best Years of the Century: Richard Watson Gilder, Scribner's Monthly and the Century Magazine, 1870–1909* (Urbana: University of Illinois Press, 1981); Frank Luther Mott, *A History of American Magazines*, vol. 4 (*1885–1905*) (Cambridge, Mass.: The Belknap Press of Harvard University, 1957); James Playsted Wood, *Magazines in the United States* (New York: The Ronald Press Company, 1956); Marilyn Fish, "Other Voices of the Arts and Crafts Movement: The Craftsman's Competitors," *Arts and Crafts Quarterly* 7, 2 (summer 1994): 36–38; and Helen Damon-Moore, *Magazines for the Millions: Gender and Commerce in the Ladies' Home Journal and the Saturday Evening Post, 1880–1910* (Albany: State University of New York Press, 1994).

6. William Watts Taylor, letter to F. S. Pease, Buffalo, N.Y., June 20, 1887. Letterpress Book 1886–87, 293. RPC, MML/MSU.

7. William Watts Taylor, letter to J. H. Ward, Jamestown, N.Y., February 23, 1887. Letterpress Book, 1886–87, 85. RPC, MML/MSU.

8. For the "production-consumption nexus," see Philip Scranton, "Manufacturing Diversity: Production Systems, Markets, and an American Consumer Society, 1870–1930," *Technology and Culture* 35 (July 1994): 477.

9. Stuart Ewen, *Captains of Consciousness: Advertising and the Social Roots of the Consumer Culture* (New York: McGraw-Hill Book Company, 1976); Stuart Ewen and Elizabeth Ewen, *Channels of Desire: Mass Images and the Shaping of American Consciousness* (New York: McGraw-Hill Book Company, 1982); Stuart Ewen, *All Consuming Images: The Politics of Style in Contemporary Culture* (New York: Basic Books, 1988); T. J. Jackson Lears, *No Place of Grace: Antimodernism and the Transformation of American Culture, 1880–1920* (Chicago: University of Chicago Press, 1981; reprint 1994); Lears, "Beyond Veblen: Rethinking Consumer Culture in America," in *Consuming Visions: Accumulation and Display of Goods in America 1880–1920*, ed. Simon J. Bronner (New York: W. W. Norton and Company, 1989), 73–97; Lears, "Some Versions of Fantasy: Toward a Cultural History of American Advertising, 1880–1920," *Prospects* 9 (1984): 349–405; and

Lears, "AHR Forum: Making Fun of Popular Culture," *American Historical Review* 97 (December 1992): 1417–26.

10. Lawrence W. Levine, "The Folklore of Industrial Society: Popular Culture and Its Audiences," *American Historical Review* 97 (December 1992): 1369–99; idem, "AHR Forum: Levine Responds," *American Historical Review* 97 (December 1992): 1427–30; Louis Galambos, "What Makes Us Think We Can Put Business Back into American History?" *Business and Economic History*, 2d ser., 20 (1991): 1–11; and Regina L. Blaszczyk, "Imagining Consumers: Manufacturers and Markets in Ceramics and Glass, 1865–1965" (Ph.D. dissertation, University of Delaware, 1995), 1–18.

11. Many scholars have pointed out the Victorian enthusiasm for objects. See, for example, Rémy G. Saisselin, *The Bourgeois and the Bibelot* (New Brunswick: Rutgers University Press, 1984); Regina Lee Blaszczyk, "The Aesthetic Moment: China Decorators, Consumer Demand, and Technological Change in the American Pottery Industry, 1865–1900," *Winterthur Portfolio* 29 (summer/autumn 1994): 121–53.

12. William Cowper Prime, *Pottery and Porcelain of All Times and All Nations* (New York: Harper and Brothers, 1879), 1. See also Marie Elwood, "Two 19th Century Collectors and Their Collections," *American Ceramic Circle Bulletin* 7 (1989): 7–24.

13. Ann Eatwell, "Private Pleasure, Public Beneficence: Lady Charlotte Schreiber and Ceramic Collecting," in *Women in the Victorian Art World*, ed. Clarissa Campbell Orr (Manchester: Manchester University Press, 1995), 127.

14. Bevis Hiller, *Pottery and Porcelain, 1700–1914* (New York: Meredith Press, 1968), 294–95; and Eatwell, 125.

15. Alice Cooney Frelinghuysen, "The Forgotten Legacy: The Havemeyer's Collection of Decorative Arts," in *Splendid Legacy: The Havemeyer Collection*, ed. Alice Cooney Frelinghuysen et al. (New York: Metropolitan Museum of Art, 1993), 99.

16. Edward J. Sullivan and Ruth Krueger Meyer, *The Taft Museum: Its History and Collections* (New York: Hudson Hills Press, 1995), 569.

17. See Thomas Lawton and Linda Merrill, *Freer: A Legacy of Art* (New York: Harry N. Abrams, 1993); and Julia Meech and Gabriel Weisberg, *Japonisme Comes to America: The Japanese Impact on the Graphic Arts, 1876–1925* (New York: Harry N. Abrams, 1990), 45.

18. Anita J. Ellis, "Collecting Ceramics in the Late 19th Century: The Cincinnati Art Museum," *American Ceramic Circle Bulletin* 7 (1989): 38–39.

19. See "Where Do All the Fine Goods Go?" *Crockery and Glass Journal* 24 (November 11, 1886): 2. See also Blaszczyk, "The Aesthetic Moment," passim; and Lizabeth Cohen, "Furnishing a Working Class Victorian Home," *Nineteenth-Century* 8, 3–4 (1982): 233–43.

20. For Freer's patronage of Pewabic, see Lillian Myers Pear, *The Pewabic Pottery: A History of Its Products and Its People* (Des Moines, Iowa: Wallace-Homestead Book Co., 1976), 193.

21. Historians who have acknowledged that household goods are demarca-

tors of middle-class life in America include Richard L. Bushman, *The Refinement of America: Persons, Houses, Cities* (New York: Alfred A. Knopf, 1992), esp. 238–79; John F. Kasson, *Rudeness and Civility: Manners in Nineteenth-Century Urban America* (New York: Hill and Wang, 1990); and Karen Halttunen, *Confidence Men and Painted Women: A Study of Middle Class Culture in America, 1830–1870* (New Haven: Yale University Press, 1992).

22. Americans were exposed to Eastlake's ideas at least as early as 1865. *New Path*, a short-lived magazine founded by the American followers of John Ruskin, published an anonymous contribution which discusses both Eastlake and Viollet-le-Duc and applies Eastlake's ideas to the American situation. See Martha Crabill McClaugherty, "Household Art: Creating the Artistic Home, 1868–1893," *Winterthur Portfolio* 18 (spring 1983): 4.

23. Clarence Cook, *The House Beautiful: Essays on Beds and Tables, Stools and Candlesticks* (New York: Scribner, Armstrong and Co., 1878). The book was a replication of a series of ten articles, "Beds and Tables, Stools and Candlesticks," in *Scribner's Monthly* (June 1875–May 1877). Candace Wheeler, ed., *Household Art* (New York: Harper and Brothers, 1893).

24. Sylvia Yount, "'Give the People What They Want': The American Aesthetic Movement, Art Worlds, and Consumer Culture, 1876–1890" (Ph.D. dissertation, University of Pennsylvania, 1995), 230.

25. Ella Rodman Church, *How to Furnish a Home* (New York: Appleton, 1881), 35–36, 57, 73, 92.

26. See, for example, Harriet Prescott Spofford, *Art Decoration Applied to Furniture* (New York: Harper and Brothers Publishers, 1878), 224–30; and Alice M. Kellogg, *Home Furnishing: Practical and Artistic* (New York: Frederick A. Stokes Company, 1905), 207–14.

27. Harrison notes (without substantiation) that the first customer at Rookwood's kilns was an appreciative blacksmith of the neighborhood. Constance Cary Harrison, *Woman's Handiwork in Modern Homes* (New York: Charles Scribner's Sons, 1882), 110–11.

28. Mary Gay Humphreys, "The Progress of American Decorative Arts," in *Household Art*, Candace Wheeler, ed. (New York: Harper and Brothers Publishers, 1893), 122–68, esp. 150. Humphreys's article had originally been published in *London Art Journal*.

29. Clarence Cook, "The Exhibition of American Pottery and Porcelain," *Art Amateur* (December 1888): 5.

30. See also "The Planning of a Home," *Craftsman* 1, 5 (February 1902): 50; and Irene Sargent, "A House and a Home," *Craftsman* 2, 5 (August 1902): 242–45.

31. Wood, 100.

32. Charles Goodrum and Helen Dalrymple, *Advertising in America: The First 200 Years* (New York: Harry N. Abrams, 1990), 31.

33. Most late-nineteenth-century periodicals were bound without their ad-

vertisements and one can only gain a sense of the quantity by examining the rare unbound series as is available at the Henry Francis du Pont Winterthur Library.

34. "Intelligent Advertising," *Crockery and Glass Journal* (May 27, 1880): 16. See also "Does Advertising Pay?" *Crockery and Glass Journal* (April 22, 1880): 16; "Business Men Must Advertise," *Crockery and Glass Journal* (May 5, 1880); and "The Secret of Advertising," *Crockery and Glass Journal* (November 18, 1880): 19.

35. "Why It Pays to Advertise," *Crockery and Glass Journal* (January 12, 1882): 14. See also "The Age of Advertising," *Crockery and Glass Journal* (February 23, 1882): 14.

36. See William Watts Taylor, letter to Davis Collamore, New York, N.Y., December 2, 1890. Letterpress Book 1890–91, 57. RPC, MML/MSU; William Watts Taylor, letter to Briggs & Co., Boston, Mass., April 9, 1892. Letterpress Book 1891–92, 427. RPC, MML/MSU.

37. William Watts Taylor, letter to J. B. Hudson, Minneapolis, Minn., January 28, 1891. Letterpress Book, 1890–91, 178. RPC, MML/MSU.

38. John, 132–33.

39. *Century*, published from November 1870 until spring 1930, was officially titled *Scribner's Monthly, an Illustrated Magazine for the People* (1870–1881); then *Century Illustrated Monthly Magazine* (1881–1929); and finally *Century Quarterly* (1929–1930). See Mott, 457.

40. Mott, 43.

41. *Century*, *Harper's*, and *Scribner's* have been described as comprising the "quality group" of general circulation monthly magazines. See Mott, 15. See also Michael Leja, "The Illustrated Magazines and Print Connoisseurship in the Late 19th Century," *Block Points* 1 (1993): 66–67.

42. Edward A. Atkinson, letter to Richard Watson Gilder, New York, N.Y., December 7, 1889. Century archive, New York Public Library.

43. *Journalist* 12 (December 13, 1890): 2.

44. *Life* 5 (May 14, 1885): 273.

45. Richard Ohmann, *Selling Culture: Magazines, Markets, and Class at the Turn of the Century* (London and New York: Verso, 1996), 83.

46. Earnest Elmo Calkins and Ralph Holden, *Modern Advertising* (New York: D. Appleton and Company, 1905; reprint 1912), 1. The "quacks" were patent-medicine manufacturers, who had dominated advertising for years and who were viewed as charlatans in the business world.

47. Although there are no statistics that divide national from local advertising for this period, it is possible to make an informed guess by extrapolating from numbers in the *U.S. Census of Manufacturers*, reporting on revenue for all serial publications. See Ohmann, 83. Arthur John points out that about seventy-five concerns advertised in national magazines before 1890. John, 134.

48. Mott, 20–24; Ohmann, 90. See also William Borsodi, *House Furnishings*

Advertising: A Collection of Selling Phrases, Descriptions, and Illustrated Advertisements as Used by Successful Advertisers (New York: The Advertisers Cyclopedia Company, 1909?).

49. The cost of an advertisement in *Century* was about $270 per page in 1880 and $300 per page in 1890. See John, 134; and Mott, 21. Although the size of the page varied slightly, among the general circulation magazines *Century* and *Harper's* had the most expensive ad space.

50. Twenty thousand pamphlets were printed. Annual Report, February 15, 1896. Corporate Minutes, 178.

51. Rose G. Kingsley, "Rookwood Pottery," *London Art Journal* 33 (November 1897): 341–46. The pamphlet was published in 1899.

52. Annual Report, February 25, 1899. Corporate Minutes, 197.

53. *The Thompson Blue Book on Advertising* (Rochester, N.Y.: J. Walter Thompson Co., 1904), 7–8. As early as 1891 a *Printer's Ink* article advised taking a year to plan a campaign for a new product. Quoted in Ohmann, 378, n. 52.

54. Ralph M. Hower, *The History of an Advertising Agency: N.W. Ayer and Son at Work, 1869–1939* (Cambridge: Harvard University Press, 1939), 88–93. See also Peggy J. Kreshel, "Toward a Cultural History of Advertising Research: A Case Study of J. Walter Thompson, 1908–1925." (Ph.D. dissertation, University of Illinois 1989).

55. Jackson Lears, *Fables of Abundance: A Cultural History of Advertising in America* (New York: Basic Books, 1994), 211. For a useful survey of the rise of market research see Susan Strasser, *Satisfaction Guaranteed: The Making of the American Mass Market* (New York: Pantheon Books, 1989; reprint 1995).

56. Board of Director's Meeting, August 4, 1904. Corporate Minutes, 87–88. It should be noted that total expenses for the year were $78,361. Thus the advertising expense was 10 percent of the total outlay for the year. See Annual Report, April 22, 1905. Corporate Minutes, 228. J. Walter Thompson held the Rookwood account for two years, 1904–6. Confirmation provided by Russell S. Koonts, archivist, John W. Hartman Center for Sales, Advertising, and Marketing History, Duke University, letter to the author, March 12, 1997.

57. Annual Report, April 22, 1905. Corporate Minutes, 229.

58. Annual Report, April 21, 1906. Corporate Minutes, 232.

59. See *J. Walter's Thompson's Illustrated Catalogue of Magazines Compiled for the Use of Advertisers*, 1887. The Hagley Museum and Library, Trade Catalogue Collection. It is not clear why advertisements for the Pottery were included in both *Century* and *Harper's* as the two magazines charged about the same amount for space and attracted similar readers. J. Walter Thompson recommended both of them in their own promotional materials. See Mott, 21; Ohmann, 96; and *J. Walter Thompson's Illustrated Catalogue of Magazines Compiled for the Use of Advertisers*, 34–35, 78–79.

60. Mott, 338.

61. Ibid., 596.

62. *Printer's Ink* 28 (August 30, 1899): 13; and *Ayer's American Newspaper Annual and Directory*, 1908, 1233, quoted in Mott, 599.

63. Fish, 37.

64. Damon-Moore, 1.

65. "Editorial," *Ladies' Home Journal* (April 1891): 10.

66. Damon-Moore, 151.

67. In 1891, one quarto-size page ad in the *Ladies' Home Journal* cost $2,000. By 1900 *Ladies' Home Journal*'s advertising revenue was half a million dollars. Mott, 21.

68. Confirmation that the J. Walter Thompson agency handled the Teco account provided by Russell S. Koonts, archivist, John W. Hartman Center for Sales, Advertising, and Marketing History, Duke University, letter to the author, December 18, 1996.

69. Rozane was produced by Roseville Pottery of Zanesville, Ohio, and is commonly accepted to be an imitation of Rookwood's Standard and Iris wares. See Paul Evans, "Roseville Pottery," in *Art Pottery of the United States* (New York: Feingold and Lewis Publishing Group, 1987), 264.

70. Lears, *Fables of Abundance*, 154.

71. *The Thompson Blue Book on Advertising* (Rochester, N.Y.: J. Walter Thompson Co., 1909), 8–9, 22.

72. *The Rookwood Book*, Cincinnati, 1904, n.p. This emphasis on change and progress could have also been intended to differentiate Rookwood from Grueby, at the time its most significant American competitor. Grueby was criticized for lacking scope and variety. See Susan J. Montgomery, *The Ceramics of William H. Grueby: The Spirit of the New Idea in Artistic Handicraft* (Lambertville, N.J.: Arts and Crafts Quarterly Press, 1993), 84.

73. William Leonard Berkwitz, *The Encyclopedia of the Mail Order Business* (New York: s.n., 1908), 9. See also Thomas J. Schlereth, "Mail-Order Catalogues as Resources in Material Culture Studies," in *Cultural History and Material Culture: Everyday Life, Landscapes, Museums* (Charlottesville and London: University Press of Virginia, 1990), 55–84; Thomas J. Schlereth, "Country Stores, County Fairs, and Mail-Order Catalogues: Consumption in Rural America," in *Consuming Vision: Accumulation and Display of Goods in America, 1880–1920*, ed. Simon J. Bronner (New York: W. W. Norton & Co., 1989), 339–75; and Deborah Anne Federhen et al., *Accumulation and Display: Mass Marketing Household Goods in America, 1880–1920* (Winterthur, Del.: Henry Francis du Pont Winterthur Museum, 1986), esp. 85–95.

74. Mott, 20.

75. See Richard E. McKinstry, ed., "Ceramics and Glassware," in *Trade Catalogues at Winterthur* (Winterthur, Del.: Henry Francis du Pont Winterthur Museum, 1984), 55–84.

76. *Newcomb Pottery, New Orleans, Louisiana*, 1905. Winterthur Trade Catalogue Collection, #2083.

77. *The Rookwood Book*, Cincinnati, 1904.

78. Annual Report, April 22, 1905. Corporate Minutes, 229.

79. See, for example, "Rookwood, America's Foremost Art Pottery," *Clay*

Worker 41, 1 (January 1904): 25–29; and A. O. Elzner, "Rookwood Pottery," *Architectural Record* 17 (April 1905): 294–304. Taylor also quotes directly from the catalogue in "The Rookwood Pottery," *Forensic Quarterly* 1 (September 1910): 203–18.

80. Concern about breakage during shipping was probably not a factor in the catalogue's failure since many other ceramics manufacturers ran successful mail-order campaigns. See Federhen et al., 85–96.

81. Quoted in Daniel Horowitz, *The Morality of Spending: Attitudes toward the Consumer Society in America, 1874–1940* (Baltimore: Johns Hopkins University Press, 1985), 123–24.

82. U.S. Bureau of the Census, *Historical Statistics of the United States, Colonial Times to 1970*, Bicentennial ed., Parts I and II (Washington, D.C.: U.S. Government Printing Office, 1975), 320, 321.

83. Charles Wellington Withenbury was hired as a traveling sales representative in June 1882. His compensation was based on salary, commission, and expenses. See Herbert Peck, *The Book of Rookwood Pottery* (New York: Crown Publishers, 1968), 19.

84. William Watts Taylor, letter to W. A. Long, Steubenville, Ohio, June 8, 1891. Letterpress Book, 1890–91, 428–29. RPC, MML/MSU.

85. William Watts Taylor, letter to Briggs & Co., Boston, Mass., July 31, 1891. Letterpress Book 1891–92, 4. RPC, MML/MSU.

86. William Watts Taylor, letter to Arthur Kaye, Louisville, Ky., September 9, 1890. Letterpress Book 1889–90, 409. RPC, MML/MSU.

87. Corporate correspondence after May 1892 is lost, so it is difficult to tell exactly where Rookwood was sold. However, an advertisement published in *House Beautiful* in June 1905 (p. 38) lists sales venues and includes Marshall Field & Co., Chicago, suggesting that Taylor's ban on department stores had been lifted. In addition a Marshall Field & Co. brochure published in 1907 makes reference to a "Rookwood Room." Marshall Field & Co. papers. Chicago Historical Society Library.

88. "The Department Store and Its Relation to the Crockery and Glass Business," *Crockery and Glass Journal* (February 18, 1904): 28. See also "Department Stores and the Chromo Annex," *Crockery and Glass Journal* (August 26, 1886): 25; and "Fancy Pottery," *Crockery and Glass Journal* 29, 24 (June 13, 1889).

89. William Watts Taylor, letter to Bailey, Banks and Biddle, Philadelphia, Penn., September 10, 1887. Letterpress Book 1886–87, 414. RPC, MML/MSU.

90. William Watts Taylor, letter to Bailey, Banks and Biddle, Philadelphia, Penn., February 18, 1888. Letterpress Book, 1887–88, 273. RPC, MML/MSU.

91. Hawkes cut glass had a similar consignment arrangement with Davis Collamore. See Jane Shadel Spillman, *The American Cut Class Industry: T. G. Hawkes and His Competition* (Woodbridge, Suffolk, England: The Antiques Collectors Club, 1996), 164.

92. William Watts Taylor, letter to C. S. Raymond, Omaha, Nebr., October 29, 1887. Letterpress Book 1887–88. RPC, MML/MSU.

93. Both of these establishments were family-owned crockery and glass merchants. They handled both American and imported wares. For a brief history of Boston importers, see "Boston Crockery Merchants," *Crockery and Glass Journal* 8 (July 11, 1878): 5–6.

94. William Watts Taylor, letter to Wright, Tyndale & Van Roden, Philadelphia, Penn., November 21, 1891. Letterpress Book 1891–92, 211. RPC, MML/MSU.

95. William Watts Taylor, letter to A. G. Rose, Charleston, S.C., September 17, 1887. Letterpress Book, 1886–87, 435. RPC, MML/MSU; William Watts Taylor, letter to Miss Vajen, Indianapolis, Ind., October 28, 1887. Letterpress Book 1887–88, 29. RPC, MML/MSU; William Watts Taylor, letter to Ida Tarbell, Meadville, Penn., February 28, 1888. Letterpress Book, 1887–88, 293. RPC, MML/MSU.

96. William Watts Taylor, letter to Sophie Crawford, Essex County, N.Y., February 3, 1888. Letterpress Book, 1887–88, 220. RPC, MML/MSU.

97. William Watts Taylor, letter to E. Almey, Providence, R.I., November 7, 1891. Letterpress Book 1891–92, 195. RPC, MML/MSU; and William Watts Taylor, letter to Emily S. Cook, Washington, D.C., November 7, 1891. Letterpress Book 1891–92, 195. RPC, MML/MSU.

98. For a summary of sales at retail establishments and at the Pottery for 1892–95 see Annual Report, February 15, 1896. Corporate Minutes, 179.

99. Annual Report, February 17, 1894 and March 2, 1901. Corporate Minutes, 164, 209.

100. William Watts Taylor, letter to Davis Collamore, New York, N.Y., March 19, 1887. Letterpress Book, 1886–87. RPC, MML/MSU.

101. William Watts Taylor, letter to Sloane and Mudge, Los Angeles, Calif., February 10, 1888. Letterpress Book, 1887–88, 244. RPC, MML/MSU.

102. Sidney Wilson, "How Retailer Keeps Trade at Home," *Dry Goods Economist* 67 (March 1, 1913): 47.

103. Susan Porter Benson, "Palace of Consumption and Machine for Selling: The American Department Store, 1880–1940," *Radical History Review* 21 (fall 1979): 203.

104. In agreement with this, Mary Corbin Sies has shown that persons who commissioned Arts and Crafts houses in exclusive suburbs were upper-middle-class white Anglo-Saxon Protestants who were also members of the professional-managerial class. See "George W. Maher's Planning and Architecture in Kenilworth, Illinois: An Inquiry into the Ideology of Arts and Crafts Design," in *Substance of Style: Perspectives on the American Arts and Crafts Movement*, ed. Bert Denker (Winterthur, Del.: Henry Francis du Pont Winterthur Museum, 1996), 415–45.

105. Porter, 206.

106. Elaine S. Abelson, *When Ladies Go A-Thieving: Middle-Class Shoplifters in the Victorian Department Store* (New York: Oxford University Press, 1989). On gendered

consumerism, see also William Leach, "Transformations in a Culture of Consumption: Women and Department Stores, 1890–1925," *Journal of American History* 71 (September 1984): 319–42.

107. James H. Collins, "The Eternal Feminine," *Printer's Ink* 35, 13 (June 26, 1901): 3–5.

108. Bertha June Richardson, *The Woman Who Spends: A Study of Her Economic Function* (Boston: Whitcomb and Barrows, 1904), 3.

109. Quoted in Damon-Moore, 24.

110. William Watts Taylor, letter to R. A. Robertson, Jr., Providence, R.I., November 24, 1887. Letterpress Book 1887–88, 92. RPC, MML/MSU.

111. Quoted in Susan Stuart Frackelton, "Rookwood Pottery," *Sketch Book* 5 (February 1906): 277.

112. William Watts Taylor, letter to Edwin AtLee Barber, West Chester, Penn., April 17, 1891. Letterpress Book 1890–91, 314–15. RPC, MML/MSU.

113. See Nancy J. Troy, *Modernism and the Decorative Arts in France: Art Nouveau to Le Corbusier* (New Haven: Yale University Press, 1991), 7.

114. Albert R. Valentien, "Rookwood Pottery," ca. 1910, 10–11. Albert R. Valentien papers, Cincinnati Historical Society Library.

115. Annual Report, March 2, 1901. Corporate Minutes, 209.

116. Bing described his mission and findings in the dedication to Directeur Roujon, following the title page of "La Culture Artistique en Amérique, 1895." See Samuel Bing, *Artistic America, Tiffany Glass, and Art Nouveau*, trans. Benita Eisler, ed. Robert Koch (Cambridge: MIT Press, 1970), 10. Bing's first name is variously given as Siegfried or Samuel.

117. Ibid., 170.

118. Marion John Nelson believes that Rookwood's wares were proto-Art Nouveau because they stand clearly apart from any ceramic style preceding them. He observes that because their decoration is under-the-glaze and in slight relief, it is more nearly a part of the ceramic body it adorns. Nelson views this an intermediate step to form and decoration becoming one—a characteristic of fully realized Art Nouveau ceramics. See "Art Nouveau in American Ceramics," *Art Quarterly* 26, 4 (1963): 444–45.

119. Irene Sargent, "The Wavy Line," *Craftsman* 2, 3 (June 1902): 138.

120. Josephine C. Locke, "Some Impressions of L'Art Nouveau," *Craftsman* 2, 4 (July 1902): 201–4.

121. A. D. F. Hamlin, "L'Art Nouveau, Its Origin and Development," *Craftsman* 3, 3 (December 1902): 129.

122. Jean Schopfer, "L'Art Nouveau: An Argument in Defense," *Craftsman* 4, 4 (July 1903): 229–38.

123. S. Bing, "L'Art Nouveau," *Craftsman* 5, 1 (October 1905): 15.

124. Herbert Croly, "The New World and the New Art," *Architectural Record* 12 (July 1902): 137.

125. Sargent, 138. Jan Thompson has noted that the exaggeration and illustration of women's hair was repeatedly used as a dominating motif by Art Nouveau artist, almost to the point of obsession, thereby extending the erotic qualities already associated with Woman. See "The Role of Woman in the Iconography of Art Nouveau," *Art Journal* 30, 2 (winter 1971–72): 161–62.

126. See Ellis, *Rookwood Pottery: The Glorious Gamble*, 120.

127. William Watts Taylor, letter to M. S. Smith and Co., Detroit, Mich., May 5, 1887. Letterpress Book 1886–87, 190. RPC, MML/MSU.

128. Maria Longworth Storer, letter to Elihu Vedder, June 30, 1889. Maria Longworth Storer papers, Cincinnati Historical Society Library.

129. In 1888, Taylor attempted to acquire a collection of flower drawings by Alfred Parsons. William Watts Taylor, letter to Harper Brothers, New York, N.Y., February 23, 1888. Letterpress Book 1887–88, 280; and William Watts Taylor, letter to Harper Brothers, New York, N.Y., February 29, 1888. Letterpress Book 1887–88, 301. RPC, MML/MSU.

130. William Watts Taylor, letter to Briggs & Co., Boston, Mass., July 22, 1891. Letterpress Book 1891–92, 18. RPC, MML/MSU.

131. During Valentien's eight-month trip to California in 1903, he painted 130 different examples of California plants. Of these renderings, 14 are in the Cincinnati Art Museum. See Kenneth R. Trapp, *Ode to Nature: Flowers and Landscapes of the Rookwood Pottery, 1880–1940* (New York: The Jordan Volpe Gallery, 1980), 26, 27. As mentioned earlier, Valentien eventually left Rookwood to pursue his interest in flower painting.

132. Valentien, 10.

133. U. P. Hendrick, *A History of Horticulture in America to 1860* (Portland, Ore.: Timber Press, 1988), 557–81.

134. Mrs. S. O. Johnson, *Every Woman Her Own Flower Gardener* (1871), quoted in Hendrick, 567–68.

135. Quoted in Jack Kramer, *Women of Flowers: A Tribute to Victorian Women Illustrators* (New York: Steward, Tabori and Chang, 1996), 21.

136. For a bibliography of "language of flowers" books, see Kramer, 219.

137. Adrian Forty, *Objects of Desire: Design and Society Since 1750* (London: Thames and Hudson, 1986), 17.

138. Hubert Beck, "Urban Iconography in Nineteenth-Century American Painting: From Impressionism to the Ash Can School," in *American Icons: Transatlantic Perspectives on Eighteenth- and Nineteenth-Century American Art*, ed. Thomas W. Gaehtgens and Heinz Ickstadt (Santa Monica, Calif.: Getty Center for the History of Art and the Humanities, 1992), 319–48. Beck discusses the creation of "urban pastorals" and "the repression of the city" by American painters. See also H. Barbara Weinberg, Doreen Bolger, and David Park Curry, *American Impressionism and Realism: The Painting of Modern Life, 1885–1915* (New York: Harry N. Abrams, 1994), 89–92, for a discussion of Childe Hassam's paintings of Celia Thaxter's garden.

1. See "Obituary: The Death of William Watts Taylor," *Clay Worker* (Christmas 1913): 641–42.

2. See Herbert Peck, *The Book of Rookwood Pottery* (New York: Crown Publishers, 1968), 96–97. For an example of loans given by the Trust to the Pottery, see Board of Directors Meeting, April 25, 1929. Collection of Dr. and Mrs. Arthur Townley (hereafter Corporate Minutes), 249.

3. See Anita J. Ellis, *Rookwood Pottery: The Glaze Lines* (Atglen, Penn.: Schiffer Publishing Co., 1995), 10–11.

4. Several decorators enlisted and other joined the Student's Army Training Corps to prepare for a commission. See Peck, 102.

5. See "Rookwood Highest Ceramic Art: Pottery Rivaling Famous Chinese and Japanese Wares Now Coming from Its Kiln," *Jeweler's Journal* (1913): 17.

6. Barbara Perry, "*Keramic Studio*: Promoting the Arts and Crafts Aesthetic," *Style 1900* 10, 4 (fall/winter 1997/98): 45.

7. The basic factors within the sphere of ceramics that contributed to the development of the studio pottery movement were a public receptive to works made of clay, which established clay as an acceptable medium for making art; knowledge of materials and techniques based on the discoveries of the art potteries; and the establishment of schools of clayworking and ceramics. See Barbara Perry, "American Ceramics, 1920–1950," in *American Ceramics: The Collection of the Everson Museum of Art*, ed. Barbara Perry (New York: Rizzoli, 1989), 121.

8. There were a few art potters before World War I who preferred to pursue their work more independently, completing each step of production themselves. Examples include Adelaide Alsop Robineau, Susan Goodrich Frackelton, and George Ohr. See Barbara Perry, "Modernism and American Ceramics," in *Craft in the Machine Age: The History of Twentieth-Century American Craft, 1920–1945*, ed. Janet Kardon (New York: Harry N. Abrams, 1995), 98.

9. See Karen McCready, *Art Deco and Modernist Ceramics* (New York: Thames and Hudson, 1995) and Kenneth R. Trapp, *Toward the Modern Style: Rookwood Pottery the Later Years, 1915–1950* (New York: The Jordan-Volpe Gallery, 1983).

10. *Soft Porcelain*, Cincinnati, 1915, n.p. Rookwood Pottery Collection, Cincinnati Historical Society Library. Marion John Nelson has pointed out that diversification was necessary for art potteries to stay in business. He notes, "American art potteries . . . were forced into marriages with industries if they were not already so lucky as to be children of them." *Art Pottery of the Midwest* (Minneapolis: University Art Museum, Univeristy of Minnesota, 1988), 4.

11. *Clay Decoration at Rookwood*, Cincinnati, 1910 (probably), n.p. Rookwood Pottery Collection, Hagley Library, Wilmington, Del.

12. Peck, 110.

13. Kenneth R. Trapp, "Rookwood Pottery: The Glorious Gamble," in *Rookwood Pottery: The Glorious Gamble*, ed. Anita J. Ellis (New York: Rizzoli, 1994), 33.

14. Anita J. Ellis, "Eight Glaze Lines: The Heart of Rookwood Pottery," in *Rookwood Pottery: The Glorious Gamble*, 156.

15. Although the years between the wars were dominated by the machine, there were undercurrents that ran counter to this tendency such as folk/historic revivalism, e.g. Colonial revival, indigenous "folk" handicrafts of Southern Appalachia, and the expressions of African-American, Hispanic, and Native American communities. See Richard Guy Wilson et al., *The Machine Age in America, 1918–1941* (New York: Harry N. Abrams, 1986); and Janet Kardon, ed., *Revivals! Diverse Traditions: 1920–1945* (New York: Harry N. Abrams, 1994).

16. In the purest sense, "Art Deco" is applied only to French decorative arts of the years between 1910 and the late 1920s. It is applied here in the more populist usage to describe a lively, stylized, and eclectic style of decorative art that began around 1910 and found expression internationally during the 1920s. See McCready, 11.

17. See Russell Lynes, *Good Old Modern* (New York: Atheneum, 1973), 91.

18. The collection was sold in New York by B. Altman and Company, which had been a Rookwood agent for ten years. See Herbert Peck, "The Rookwood Pottery Sale of the Century," *Antique Trader Weekly* (October 28, 1981): 94–96.

19. This fair was apparently dominated by the Fulper Potteries of Flemington, New Jersey, which had introduced their Vasekraft art pottery line in late 1909. Newcomb Pottery also participated and won an award for their "model room" display. See Evelyn Marie Stuart, "Pottery Art at the Panama Pacific Exposition," *Fine Arts Journal* 32 (January 1915): 32–36; Michael Williams, "Arts and Crafts at the Panama Pacific," *Art and Progress* 6 (August 1915): 375–77; and Jessie Poesch, *Newcomb Pottery: An Enterprise for Southern Women* (Exton, Penn.: Schiffer Publishing Co., 1984), 64–65.

20. Poesch, 64.

21. "Modernism in Industrial Art," *American Magazine of Art* 15 (October 1924): 540.

22. Board of Director's Meeting, April 14, 1933. Corporate Minutes, 285.

23. U.S. Department of Commerce, *Report of the U.S. Commission Appointed by the Secretary of Commerce to Visit and Report upon the International Exposition of Modern Decorative and Industrial Art in Paris, 1925* (Washington, D.C.: Government Printing Office, 1926). See also Alastair Duncan, *American Art Deco* (New York: Harry N. Abrams, 1986), 20.

24. In February 1928, Lord & Taylor mounted an "Exhibition of Modern French Decorative Art" and Macy's organized an "Art in Trade" exposition. In another example of the fluidity of culture and commerce, it should be noted that these department store exhibitions were planned in collaboration with Robert W. de Forest, president of the Metropolitan Museum of Art. See Frank Purdy, "The

New Museum," *Arts and Decoration* (December 1920): 116; and Winifred E. Howe, *A History of the Metropolitan Museum of Art*, Volume II, 1905–1941 (New York: Columbia University Press, 1946), 192–98.

25. Louise Abel was born in Germany, Jens Jacob Herring Krog Jensen in Denmark, and Catherine Pissoreff Cavalenco in Russia. See Virginia Raymond Cummins, *Rookwood Pottery Potpourri* (Cincinnati: Cincinnati Art Galleries, 1991), 63–63, 66–67. Kataro Shirayamadani, the only non-American decorator in the years before World War I, returned to the pottery in 1925 after spending nearly ten years in Japan.

26. Quoted in Peck, *The Book of Rookwood Pottery*, 118.

27. "Advertising and Sales Material for Rookwood Dealers," Cincinnati, 1924. Rookwood Pottery Collection, Hagley Library, Wilmington, Del.

28. These various glaze lines have been defined by Anita J. Ellis using Rookwood's 1943 notebook of glazes. See Ellis, *Rookwood Pottery: The Glaze Lines*, passim.

29. Board of Directors Meeting, February 26, 1931. Corporate Minutes, 258.

30. Board of Directors Meeting, April 20, 1928. Corporate Minutes, 246.

31. Nick Nicholson and Marilyn Nicholson, *Kenton Hills Porcelains Inc.: The Story of a Small Art Pottery, 1939–1944*. (Loveland, Ohio: D. A. Nicholson, 1998), 5–6.

32. Rockwood Pottery Co. v. Commissioner of Internal Revenue. 9 *American Federal Tax Reports* 499 (45 F.2d 43), 11/12/1930, 607.

33. Ibid., 608.

34. Board of Directors Meeting, April 25, 1929. Corporate Minutes, 249.

35. Board of Directors Meeting, April 18, 1931. Corporate Minutes, 265.

36. William Watts Taylor, letter to Zachary Clark, Cincinnati, Ohio, October 13, 1900. Zachary Clark papers, Cincinnati Historical Society Library.

37. Board of Directors Meeting, April 18, 1931. Corporate Minutes, 265.

Appendix

1. For more information, see Anita J. Ellis, *Rookwood Pottery: The Glaze Lines* (Atglen, Penn.: Schiffer Publishing Co., 1995), 21–23.

2. Ibid., 24–29.

3. Ibid., 30–31.

4. Ibid., 32–35.

5. Ibid., 35–39.

6. Ibid., 40–45.

7. Ibid., 46–47.

8. Ibid., 56–70.

9. Ibid., 71–86.

SELECTED BIBLIOGRAPHY

Items that are component parts of published works or archive dossiers, though individually cited in endnotes, are not repeated here. The following periodicals were surveyed over the time periods indicated; selected articles are listed below; others are given in endnotes.

Periodicals

Art Amateur (1879–1903)

Brush and Pencil (1897–1907)

Century (1880–1907)

Craftsman (1901–1916)

Crockery and Glass Journal (1880–1913)

Handicraft (1902–1912)

Harper's Monthly (1880–1913)

International Studio (1902–1913)

Keramic Studio (1899–1913)

Magazine of Art (1878–1903)

Scribner's (1887–1911)

Studio (1893–1902)

Archival Sources

Archives of American Art, Washington, D.C.:

 Charles Fergus Binns papers

Louisiana Purchase Exposition—Department of Art papers

Records of the Pennsylvania Museum

Pewabic Pottery papers

Adelaide Alsop Robineau papers

Society of Arts and Crafts, Boston papers

Cincinnati Historical Society Library:

Zachary Clark papers

Ladies Academy of Fine Arts papers

Mary Louise McLaughlin papers

Clara Chipman Newton papers

Rookwood Pottery Collection

Maria Longworth Nichols Storer papers

Albert R. Valentien papers

Women's Art Museum Association papers

Duke University Library, Hartman Center for Sales, Advertising, and Marketing Research, J. Walter Thompson archive

Hagley Library, Wilmington, Delaware, Rookwood Pottery Collection

Mississippi State University, Mitchell Memorial Library, Rookwood Pottery Collection

National Archives Administration, State Department Records, Paris Exposition of 1900

New York Public Library, Century archive

Smithsonian Institution, National Anthropological Archives, Bureau of American Ethnology Collection

Smithsonian Institution, National Museum of American History:

Books of the Fairs

Proceedings of the U.S. Potter's Association

Warshaw Collection of Business Americana

Winterthur Library, Winterthur, Delaware:

Decorative Arts Photographic Collection

Trade Catalogue Collection

GOVERNMENT DOCUMENTS

Census Office. "Clay Products." *Report on Manufacturing Industries in the United States at the Eleventh Census: 1890. Part III. Selected Industries.* Washington, D.C.: Government Printing Office, 1895.

Dewey, Davis R. *Employees and Wages.* Washington, D.C.: United States Census Office, 1903.

Fry v. Rookwood Pottery et al. Circuit Court of Appeals, Sixth Circuit, May 8, 1900, No. 746. *The Federal Reporter* 101 (May–July 1900): 723–27.

Fry v. Rookwood Pottery et al. Circuit Court Southern District Ohio, December 2, 1898, No. 4,531. *Federal Reporter* 90 (December 1898–February 1899): 494–500.

Official Transcript, July 7, 1899, "Laura A. Fry v. The Rookwood Pottery and William Taylor." No. 746, United States Circuit Court of Appeals: Sixth Circuit.

Report of the Commissioner-General for the United States to the International Universal Exposition, Paris, 1900, Vol. IV. Washington, D.C.: Government Printing Office, 1901.

Reports of the United States Commissioners to the Universal Exposition of 1889 at Paris, Vol. II. Washington, D.C.: Government Printing Office, 1891.

U.S. Bureau of the Census. *Historical Statistics of the United States, Colonial Times to 1970,* Bicentennial ed., Parts I and II. Washington, D.C.: U.S. Government Printing Office, 1975.

U.S. Department of Commerce. *Report of the U.S. Commission Appointed by the Secretary of Commerce to Visit and Report upon the International Exposition of Modern Decorative and Industrial Art in Paris, 1925.* Washington, D.C.: Government Printing Office, 1926.

United States patent issued to Laura A. Fry for Art of Decorating Pottery-Ware, Letters Patent No. 339,029, March 5, 1889.

Manuscripts, Theses, Dissertations

Blaszczyk, Regina L. "Imagining Consumers: Manufacturers and Markets in Ceramics and Glass, 1865–1965." Ph.D. dissertation, University of Delaware, 1995.

Brandt, Beverly Kay. "'Mutually Helpful Relations': Architects, Craftsmen and the Society of Arts and Crafts, Boston, 1897–1917." Ph.D. dissertation, Boston University, 1985.

Brinker, Lea. "Women's Role in the Development of Art as an Institution in Nineteenth-Century Cincinnati." Master's thesis, University of Cincinnati, 1970.

Brunsman, Sue. "The European Origins of Early Cincinnati Art Pottery: 1870–1900." Master's thesis, University of Cincinnati, 1973.

Clapper, Michael R. "Popularizing Art in Boston, 1865–1910: L. Prang and Company and the Museum of Fine Arts." Ph.D. dissertation, Northwestern University, 1997.

Docherty, Linda Jones. "A Search for Identity: American Art Criticism and the Concept of the 'Native School,' 1876–1893." Ph.D. dissertation, University of North Carolina, 1985.

Ellis, Anita J. "The Ceramic Career of M. Louise McLaughlin." Unpublished manuscript.

Green, Marcia Hyland. "Women Art Students in America: An Historical Study of

Academic Art Instruction during the Nineteenth Century." Ph.D. dissertation, American University, 1990.

Kahler, Bruce Robert. "Art and Life: The Arts and Crafts Movement in Chicago, 1897–1910." Ph.D. dissertation, Purdue University, 1986.

Larson, Kate Clifford. "The Saturday Evening Girls: A Social Experiment in Class Bridging and Cross Cultural Female Dominion Building in Turn-of-the-Century Boston." Master's thesis, Simmons College, 1995.

Lippincott, Richard H. "Rookwood Architectural Faience Tiles." Master's thesis, Ball State University, 1993.

Macdowell, Betty Ann. "American Women Stained Glass Artists, 1870 to 1930s: Their World and Their Windows." Ph.D. dissertation, Michigan State University, 1986.

McClaughterty, Martha Crabill. "Household Art: Creating the Artistic Home, 1868–1893." Master's thesis, University of Virginia, 1981.

Montgomery, Susan J. "'The Spirit of the New Idea in Artistic Handicraft': The Ceramics of William H. Grueby." Ph.D. dissertation, Boston University, 1990.

Perkins, Dorothy Wilson. "Education in Ceramic Art in the United States." Ph.D. dissertation, Ohio State University, 1956.

Shotliff, Don Anthony. "The History of the Labor Movement in the American Pottery Industry: The National Brotherhood of Operative Potters, 1890–1970." Ph.D. dissertation, Kent State University, 1977.

Spiess, Philip D., II. "The Cincinnati Industrial Expositions, 1870–1888: Propaganda or Progress?" Master's thesis, University of Delaware, 1970.

Stern, Marc J. "The Potters of Trenton, New Jersey, 1850–1902: A Study in the Industrialization of Skilled Trades." Ph.D. dissertation, State University of New York at Stony Brook, 1986.

Stratton, Herman J. "Factors in the Development of the American Pottery Industry, 1860–1929." Ph.D. dissertation, University of Chicago, 1929.

Swinth, Kirsten N. "Painting Professionals: Women Artists and the Development of a Professional Ideal in American Art, 1870–1920." Ph.D. dissertation, Yale University, 1995.

Trapp, Kenneth R. "Maria Longworth Storer: A Study of Her Bronze Objets D'Art in the Cincinnati Art Museum." Master's thesis, Tulane University, 1972.

Weedon, George. "Susan S. Frackelton and the American Arts and Crafts Movement." Master's thesis, University of Wisconsin-Milwaukee, 1975.

Yount, Sylvia. "'Give the People What They Want': The American Aesthetic Movement, Art Worlds, and Consumer Culture, 1876–1890." Ph.D. dissertation, University of Pennsylvania, 1995.

PRIMARY SOURCES

"Amateurs in China Painting." *Crockery and Glass Journal* (January 4, 1883): 14.

"American Art Ware Potteries." *American Pottery Gazette* 9 (June 1909): 34, 37.

"Cincinnati." *Die Kunst* (1900): 70, 71, 85.

"Cincinnati Art Pottery." *Harper's Weekly Magazine* 24 (May 29, 1880): 341–42.

"The Cincinnati Pottery Club." *Crockery and Glass Journal* (January 29, 1880): 14;
(May 31, 1880): 28.

"The Craft of Rookwood Potters." *World's Work* (August 1904): n.p.

"Glass and Ceramics at the Chicago Exhibition." *Art Journal* (London) (1893 supplement): xxix–xxxi.

"Have You No Rookwood?" *Ceramic Monthly* 2, 6 (January 1896): 4–5.

"An Historical Collection of the Rookwood Pottery." *Keramic Studio* 8 (April 1907): 274.

"Louisiana Purchase Exposition Ceramics: Rookwood Pottery." *Keramic Studio* 6 (January 1905): 193–94.

"The Norse Room of the Fort Pitt Hotel." *Clay Worker* 53 (January 1910): 57–60.

"Obituary: The Death of William Watts Taylor." *Clay Worker* (Christmas 1913): 641–42.

"Ombroso Pottery: A Recent Rookwood Product." *Art and Decoration* 1 (September 1911): 449.

"The Ornamentation of the New Subway Stations in New York," part 1, *House and Garden* 5 (February 1904): 96–99; part 2 (June 1904): 287-92.

"The Potters of America: Examples of the Best Craftsmen's Work for Interior Decorations: Number One." *Craftsman* 27 (December 1914): 295–303.

"Rookwood, America's Foremost Art Pottery—A Trip through the Great Plant." *Clay Worker* 41 (January 1904): 25–29.

"Rookwood Architectural Faience." *Keramic Studio* 5 (September 1903): 110–11.

"Rookwood Highest Ceramic Art: Pottery Rivaling Famous Chinese and Japanese Wares Now Coming from Its Kiln." *Jeweler's Journal* (1913): 17.

"The Rookwood Pottery: 'Dux Foemina Facti.'" *Craftsman* 3 (January 1903): 247–48.

"Rookwood Pottery for Paris Exhibit." *Keramic Studio* 1 (March 1900): 221, 228, 231.

"Suit against Rookwood Pottery." *Ceramic Monthly* 8 (January 1899): 2.

"The World Famous Rookwood Ware." *Crockery and Glass Journal* 54 (December 12, 1901): 113–14.

Bancroft, Hubert Howe. *The Book of the Fair.* Chicago: Bancroft Publishing Company, 1893.

Barber, Edwin AtLee. "Cincinnati Women Art Workers." *Art Interchange* 36 (February 1896): 29–30.

————. "The Pioneer of China Painting in America." *New England Magazine* 13, 1 (September 1895): 33–48.

————. *The Pottery and Porcelain of the United States.* New York: G. P. Putnam's Sons, 1893.

————. "Recent Advances in the Pottery Industry: The Development of American Industries Since Columbus. XI." *Popular Science Monthly* 40, 23 (January 1892): 289–322.

————. "The Rise of the Pottery Industry: The Development of American Industries Since Columbus. X." *Popular Science Monthly* 40, 12 (December 1891): 145–70.

————. "A Typical American Pottery." *Art Interchange* 34 (January 1895): 2–5.

Boulden, Jane Long. "Rookwood." *Art Interchange* 46 (June 1901): 129–31.

Bowdoin, W. G. "Some American Pottery Forms." *Art Interchange* 50 (April 1903): 87–90.

Brousson, Herbert F. *Practical Help to Amateurs and Artists for Painting and Decorating the Latest Productions in Pottery.* London: Artists Colour Manufacturing Co., 1886.

Burt, Stanley Gano. *Mr. S. G. Burt's Record Book of Ware at Art Museum (2,292 Pieces of Early Rookwood in the Cincinnati Art Museum in 1916).* Reprint. Cincinnati: Cincinnati Historical Society, 1978.

Cook, Clarence. "The Exhibition of American Pottery and Porcelain." *Art Amateur* (December 1888): 5–6.

DeKay, Charles. "Art from the Kilns." *Munsey's Magazine* 26 (October 1901): 45–53.

Elliott, Charles Wyllis. "Pottery at the Centennial." *Atlantic Monthly* 38 (November 1876): 575.

Elliott, Maud Howe. *Art and Handicraft in the Woman's Building of the World's Columbian Exposition/Chicago.* Paris: Goupil and Co., 1893.

Elzner, A. O. "Rookwood Pottery." *Architectural Record* 17 (April 1905): 294–304.

Fawcett, Waldon. "The Production of American Pottery." *Scientific American* 83, 9 (November 10, 1900): 296–97.

Frackelton, Susan Stuart. "Our American Potteries—Newcomb College." *Sketch Book* 5, 9 (July 1906): 433.

————. "Rookwood Pottery." *Sketch Book* 5 (February 1906): 272–77.

Fry, Marshal. "Notes from the Paris Exposition." *Keramic Studio* 2 (September 1900): 98–99.

Garnier, Edouard. "Les Industries d'Art." *Gazette des Beaux-Arts* (December 1889): 575–77.

Garrison, W. C. *Health Conditions of the Pottery Industry, The Eight Hour Movement, Wages and Production in the Glass Industry.* Trenton, N.J.: MacCrellesh and Quigley, 1905.

Geijsbeek, S. "The Ceramics of the Louisiana Purchase Exposition." *Transactions of the American Ceramic Society* 7 (1905): 325, 349.

Goodman, Guy. "Two Phases of American Pottery." *Arts for America* 12, 9/10 (June 1898): 542–46.

Gray, Walter Ellsworth. "Latter-Day Developments in American Pottery III." *Brush and Pencil* (March 1902): 353–60.

Hall, Alice C. "Cincinnati Faience." *Potter's American Monthly* 15, 107 (November 1880): 357–65.

Hamilton, Jean. "Arts and Crafts at the Exposition." *House Beautiful* 16 (October 1904): 44–46.

Haywood, Maude. "Founded by a Woman." *Ladies Home Journal* 9 (October 1892): 3.

———. "Pottery and Glass at Collamore's." *Decorator and Furnisher* 17, 5 (February 1891): 183–84.

Hitchcock, Ripley. "The Western Art Movement." *Century* 32, 10 (October 1886): 576–93.

Howe-Osgood, Laura. "League Notes." *Keramic Studio* (March 1900): 228, 231.

Humphreys, Mary Gay. "The Cincinnati Pottery Club." *Art Amateur* 8, 1 (December 1882): 20–21.

Hungerford, Nicholas. "The Work of American Potteries: Article Three—The Story of Rookwood." *Arts and Decoration* 1 (February 1911): 160–62.

Jervis, W. P. *Rough Notes on Pottery*. Newark, N.J.: W.P. Jervis, 1896.

———. "Women Potters of America." *Pottery, Glass and Brass Salesman* (December 13, 1917): 91–97.

Kingsley, Rose G. "Rookwood Pottery." *London Art Journal* 33 (November 1897): 341–46.

LeBoutillier, Addison B. "American Pottery." *Good Housekeeping* 38 (March 1904): 242–48.

Leonard, Anna B. "Pottery and Porcelain at the Paris Exposition." *Keramic Studio* 2, 4 (August 1900): 73–75.

Marx, Roger. "La Décoration et les Industries d'Art." *Gazette des Beaux-Arts* 25, 3 (1901): 135–68.

McDonald, W. P. "Rookwood at the Pan-American." *Keramic Studio* 3 (November 1901): 146–47.

McLaughlin, Mary Louise. *Pottery Decoration under the Glaze*. Cincinnati: Robert Clarke and Company, 1880.

Mendenhall, Lawrence. "Cincinnati's Contribution to American Ceramic Art." *Brush and Pencil* 17, 2 (February 1906): 47–61.

———. "Mud, Mind and Modelers." *Frank Leslie's Popular Monthly* 42 (December 1896): 669.

Minogue, Anna C. "A Visit to Rookwood Pottery." *Ladies' World* (October 1898): 6.

Nichols, George Ward. *Art Education Applied to Industry.* New York: G. P. Putnam's Sons, 1877.

———. *Pottery, How It Is Made, Its Shape and Decoration.* New York: G. P. Putnam's Sons, 1879.

Perry, Elizabeth Williams. "Decorative Pottery of Cincinnati." *Harper's New Monthly Magazine* 62 (May 1881): 834–45.

Preston, Thomas B. "Potters and Their Craft." *Chautauquan* 14 (November 1891): 171–75.

Prime, William Cowper. *Pottery and Porcelain of All Times and All Nations.* New York: Harper and Brothers, 1879.

Ruge, Clara. "American Ceramics: A Brief Review of Progress." *International Studio* 28 (March 1906): xxi–xxviii.

———. "American Ceramics: American Materials Fashioned by American Artists and Artisans Are Taking Their Place beside the World's Best Potteries." *Pottery and Glass* 1 (August 1908): 2–8.

———. "Amerikanische Keramik." *Die Kunst* 9 (1906): 167–76.

Salmon, Lucy M. "The Women's Exchange: Charity or Business?" *Forum* 13 (May 1892): 394–406.

Sandier, Alex. "La Céramique à l'Exposition." *Art et Decoration* 4, 12 (December 1900): 185-96; 5, 2 (February 1901): 53–68.

Sayre, Stuart. "A Rookwood Selling Campaign." *Glass and Pottery World* 15, 2 (February 1907): 13–14.

Storer, Maria Longworth. *History of the Cincinnati Musical Festivals and of the Rookwood Pottery.* Paris: Herbert Clarke Printer, 1919.

Stuart, Evelyn Marie. "Pottery Art at the Panama Pacific Exposition." *Fine Arts Journal* 32 (January 1915): 32–36.

Tarbell, Ida. "Pottery and Porcelain." *Chautauquan* 8, 4 (January 1888): 220–22.

Taylor, William Watts. "The Rookwood Pottery." *Faenza* 3 (January–March 1915): 10–15.

———. "The Rookwood Pottery." *Forensic Quarterly* 1 (September 1910): 203–18.

Triggs, Oscar Lovell. *Chapters in the History of the Arts and Crafts Movement.* Chicago: Bohemia Guild of the Industrial Art League, 1902.

Valentine, John. "Rookwood Pottery." *House Beautiful* 4 (September 1898): 120–29.

Verneuil, M.-P. "L'Exposition d'Art Décoratif Moderne à Turin." *Art et Décoration* (September 1902): 65–112.

Warringdon, Anne. "Something New in Pottery." *Sketch Book* 3, 1 (September 1903): 5–6.

Waterbury, Ivan C. "Great Industries of the United States: IX. Pottery." *Cosmopolitan* 38 (March 1905): 593–602.

Wheeler, Candace. *Yesterdays in a Busy Life.* New York: Harper and Brothers, 1918.

Williams, Michael. "Arts and Crafts at the Panama Pacific." *Art and Progress* 6 (August 1915): 375–77.

Wynne, Madeline Yale. "What to Give: Some Christmas-Tide Suggestions." *House Beautiful* 2 (1901): 20–26.

Young, Jennie. "Ceramic Art at the Exhibition." *Lippincott's* (December 1876): 701–16.

Secondary Sources: Books

Abelson, Elaine S. *When Ladies Go A-Thieving: Middle-Class Shoplifters in the Victorian Department Store.* New York: Oxford University Press, 1989.

Albis, Jean d', and Laurens d'Albis. *Céramique Impressioniste: L'Atelier Haviland de Paris-Auteuil, 1873–1882.* Paris: Editions Sous le Vent, 1974.

Aslin, Elizabeth. *The Aesthetic Movement: Prelude to Art Nouveau.* New York: Excalibur Books, 1969.

Behrman, S. N. *Duveen.* New York: Random House, 1951.

Benson, Susan Porter. *Counter Cultures: Saleswomen, Managers, and Customers in American Department Stores, 1890–1940.* Urbana: University of Illinois Press, 1986.

Berkhofer, Richard F., Jr. *The White Man's Indian: Images of the American Indian from Columbus to the Present.* New York: Alfred A. Knopf, 1978.

Bing, S. *Artistic America, Tiffany Glass, and Art Nouveau,* trans. Benita Eisler, ed. Robert Koch. Cambridge: MIT Press, 1970.

Blair, Karen J. *The Torchbearers: Women and Their Amateur Arts Associations in America, 1890–1930.* Bloomington and Indianapolis: Indiana University Press, 1994.

Boehle, Rose Angela. *Maria: A Biography of Maria Longworth.* Dayton, Ohio: Landfall Press, 1990.

Boris, Eileen. *Art and Labor: Ruskin, Morris, and the Craftsman Ideal in America.* Philadelphia: Temple University Press, 1986.

Bowman, Leslie Greene. *American Arts and Crafts: Virtue in Design.* Los Angeles: Los Angeles County Museum; Boston: Little, Brown and Co., 1990.

Brimo, René. *L'Évolution du Goût aux États-Unis.* Paris: James Fortune, 1938.

Buckley, Cheryl. *Potters and Paintresses.* London: The Women's Press, 1994.

Burke, Doreen Bolger, ed. *In Pursuit of Beauty: Americans and the Aesthetic Movement.* New York: Metropolitan Museum of Art, 1986.

Bushman, Richard L. *The Refinement of America: Persons, Houses, Cities.* New York: Alfred A. Knopf, 1992.

Callen, Anthea. *Women Artists of the Arts and Crafts Movement, 1870–1914.* New York: Pantheon Books, 1979.

Carter, Denny. *The Golden Age: Cincinnati Painters Represented in the Cincinnati Art Museum.* Cincinnati: Cincinnati Art Museum, 1979.

Cherry, Deborah. *Painting Women: Victorian Women Artists.* London: Routledge, 1993.

Clark, Edna Maria. *Ohio Art and Artists*. Richmond: Garrett and Massie, 1932.

Clark, Garth, and Margie Hughto. *A Century of Ceramics in the United States, 1878–1978: A Study of Its Development*. New York: E. P. Dutton, 1979.

Clark, Robert Judson, et al. *The Arts and Crafts Movement in America, 1876–1916*. Princeton, N.J.: Princeton University Press, 1972; reprint 1992.

Constable, W. G. *Art Collecting in the United States*. London and New York: Thomas Nelson and Sons, Ltd., 1964.

Corn, Wanda M. *The Color of Mood: American Tonalism, 1880–1910*. San Francisco: M. H. DeYoung Memorial Museum and the California Palace of the Legion of Honor, 1972.

Cotkin, George. *Reluctant Modernism: American Thought and Culture, 1880–1900*. New York: Twayne Publishers, 1992.

Cott, Nancy F. *The Grounding of Modern Feminism*. New Haven: Yale University Press, 1987.

Cummins, Virginia Raymond. *Rookwood Pottery Potpourri*. Cincinnati: Cincinnati Art Galleries, 1991.

Damon-Moore, Helen. *Magazines for the Millions: Gender and Commerce in the Ladies Home Journal and the Saturday Evening Post, 1880–1910*. Albany: State University of New York Press, 1994.

Darling, Sharon S. *Chicago Ceramics and Glass: An Illustrated History from 1871 to 1933*. Chicago: University of Chicago Press, 1979.

————. *Teco: Art Pottery of the Prairie School*. Erie, Penn.: Erie Art Museum, 1989.

Denker, Bert, ed. *The Substance of Style: Perspectives on the American Arts and Crafts Movement*. Winterthur, Del.: Henry Francis du Pont Winterthur Museum, 1996.

Dietz, Ulysses G. *The Newark Museum Collection of American Art Pottery*. Salt Lake City: Peregrine Smith Books, 1984.

Duveen Pictures in Public Collection of America. New York: William Bradford Press, 1941.

Eidelberg, Martin, ed. *From Our Native Clay: Art Pottery from the Collections of the American Ceramic Arts Society*. New York: Turn of the Century Editions, 1987.

Ellis, Anita J. *Rookwood Pottery: The Glaze Lines*. Atglen, Penn.: Schiffer Publishing Co., 1995.

————, ed. *Rookwood Pottery: The Glorious Gamble*. New York: Rizzoli, 1992.

Evans, Paul. *Art Pottery of the United States*. New York: Finegold and Lewis Publishing Corp., 1987.

Ewen, Stuart. *All Consuming Images: The Politics of Style in Contemporary Culture*. New York: Basic Books, 1988.

————. *Captains of Consciousness: Advertising and the Social Roots of the Consumer Culture*. New York: McGraw-Hill Book Company, 1976.

Ewen, Stuart, and Elizabeth Ewen. *Channels of Desire: Mass Images and the Shaping of American Consciousness*. New York: McGraw-Hill Book Company, 1982.

Faragher, John Mack. *Rereading Frederick Jackson Turner.* New York: Henry Holt and Co., 1994.

Federhen, Deborah Anne, et al. *Accumulation and Display: Mass Marketing Household Goods in America, 1880–1920.* Winterthur, Del.: Henry Francis du Pont Winterthur Museum, 1986.

Feest, Christian F., ed. *Indians and Europe: An Interdisciplinary Collection of Essays.* Aachen: Rader Verlag, 1987.

Findling, John E., and Kimberly D. Pelle. *Historical Dictionary of World's Fairs and Expositions, 1851–1988.* New York: Greenwood Press, 1990.

Fink, Lois Marie. *American Art at the Nineteenth-Century Paris Salons.* Cambridge: Cambridge University Press, 1990.

Fleming, Paula Richardson, and Judith Lynn Luskey. *Grand Endeavors of American Indian Photography.* Washington, D.C.: Smithsonian Institution Press, 1993.

———. *The North American Indians in Early Photographs.* New York: Barnes and Noble Books, 1987; reprint 1992.

Freeman, John Crosby. *The Forgotten Rebel: Gustav Stickley and His Craftsman Mission Furniture.* Watkins Glen, N.Y.: Century House, 1967.

Frelinghuysen, Alice Cooney. *American Art Pottery: Selections from the Charles Hosmer Morse Museum of American Art.* Seattle: University of Washington Press, 1995.

———. *American Porcelain, 1770–1920.* New York: Harry N. Abrams, 1994.

———, ed. *Splendid Legacy: The Havemeyer Collection.* New York: Metropolitan Museum of Art, 1993.

Gilbert, James B. *Work without Salvation: America's Intellectuals and Industrial Alienation, 1880–1910.* Baltimore: Johns Hopkins University Press, 1977.

Goodrum, Charles, and Helen Dalrymple. *Advertising in America: The First 200 Years.* New York: Harry N. Abrams, 1990.

Gregory, Alexis. *Families of Fortune: Life in the Gilded Age.* New York: Rizzoli, 1993.

Halttunen, Karen. *Confidence Men and Painted Women: A Study of Middle Class Culture in America, 1830–1870.* New Haven: Yale University Press, 1992.

Harris, Neil. *Cultural Excursions: Marketing Appetites and Cultural Tastes in Modern America.* Chicago: University of Chicago Press, 1990.

Hellerstedt, Kahren Jones, et al. *Clayton: The Pittsburgh Home of Henry Clay Frick, Art and Furnishings.* Pittsburgh: University of Pittsburgh Press, 1988.

Henzke, Lucile. *Art Pottery of America.* Exton, Penn.: Schiffer Publishing Co., 1982.

Hiller, Bevis. *Pottery and Porcelain, 1700–1914: England, Europe and North America.* New York: Meredith Press, 1968.

Hobbs, Susan A. *The Art of Thomas Wilmer Dewing: Beauty Reconfigured.* Washington: Smithsonian Institution Press, 1996.

Horowitz, Helen Lefkowitz. *Culture and the City: Cultural Philanthropy in Chicago from the 1880s to 1917.* Chicago: University of Chicago Press, 1976.

Hosley, William. *The Japan Idea: Art and Life in Victorian America.* Hartford, Conn.: Wadsworth Atheneum, 1990.

Howe, Winifred E. *A History of the Metropolitan Museum of Art,* vol. 2, 1905–1941. New York: Columbia University Press, 1946.

John, Arthur. *The Best Years of the Century: Richard Watson Gilder, Scribner's Monthly and the Century Magazine, 1870–1909.* Urbana: University of Illinois Press, 1981.

Kaplan, Wendy, et al. *The Art That Is Life: Arts and Crafts Movement in America, 1875–1920.* Boston: Boston Museum of Fine Arts; New York Graphic Society, 1987.

Kasson, John F. *Rudeness and Civility: Manners in Nineteenth-Century Urban America.* New York: Hill and Wang, 1990.

Kessler-Harris, Alice. *Out to Work: A History of Wage-Earning Women in the United States.* New York and Oxford: Oxford University Press, 1982.

Kircher, Edwin J., Barbara Agranoff, and Joseph Agranoff. *Rookwood: Its Golden Era of Art Pottery, 1880–1929.* Cincinnati, by the authors, 1969.

Kramer, Jack. *Women of Flowers: A Tribute to Victorian Women Illustrators.* New York: Steward, Tabori and Chang, 1996.

Lambourne, Lionel. *The Aesthetic Movement.* London: Phaidon Press Limited, 1996.

Lawton, Thomas, and Linda Merrill. *Freer: A Legacy of Art.* New York: Harry N. Abrams, 1993.

Lears, Jackson. *Fables of Abundance: A Cultural History of Advertising in America.* New York: Basic Books, 1994.

Lears, T. J. Jackson. *No Place of Grace: Antimodernism and the Transformation of American Culture, 1880–1920.* Chicago: University of Chicago Press, 1981; reprint 1994.

Levin, Elaine. *A History of Ceramics in the United States.* New York: Harry N. Abrams, 1988.

Levine, Lawrence. *Highbrow Lowbrow: The Emergence of Cultural Hierarchy in America.* Cambridge: Harvard University Press, 1988.

Lynes, Russell. *The Tastemakers.* New York: Harper and Brothers, 1949; reprint 1954.

Macht, Carol. *The Ladies, God Bless 'Em: The Women's Art Movement in Cincinnati in the Nineteenth Century.* Cincinnati: Cincinnati Art Museum, 1976.

McCarthy, Kathleen D. *Noblesse Oblige: Charity and Cultural Philanthropy in Chicago, 1849–1929.* Chicago: University of Chicago Press, 1982.

———. *Women's Culture: American Philanthropy and Art, 1830–1930.* Chicago: University of Chicago Press, 1991.

McCready, Karen. *Art Deco and Modernist Ceramics.* New York: Thames and Hudson, 1995.

Merrill, Linda. *An Ideal Country: Paintings by Dwight William Tryon in the Freer Gallery of Art.* Washington, D.C.: Freer Gallery of Art, 1990.

Meyer, Ruth Krueger, ed. *The Taft Museum: A Cincinnati Legacy.* Cincinnati: Cincinnati Historical Society, 1988.

Montgomery, Susan J. *The Ceramics of William H. Grueby: The Spirit of the New Idea in Artistic Handicraft*. Lambertville, N.J.: Arts & Crafts Quarterly Press, 1993.

Mott, Frank Luther. *A History of American Magazines*, vol. 4, 1885–1905. Cambridge, Mass.: The Belknap Press of Harvard University, 1957.

Muncy, Robyn. *Creating a Female Dominion in American Reform, 1890–1935*. New York: Oxford University Press, 1991.

Nelson, Marion John. *Art Pottery of the Midwest*. Minneapolis: University Art Museum, University of Minnesota, 1988.

Nicholson, Nick, and Marilyn Nicholson. *Kenton Hills Porcelains Inc.: The Story of a Small Art Pottery, 1939–1944*. Loveland, Ohio: D. A. Nicholson, 1998.

Nochlin, Linda. *Women, Art, and Power and Other Essays*. New York: Harper and Row, 1988.

Ohmann, Richard. *Selling Culture: Magazines, Markets, and Class at the Turn of the Century*. London and New York: Verso, 1996.

Orr, Clarissa Campbell. *Women in the Victorian Art World*. Manchester: Manchester University Press, 1995.

Parker, Rozika, and Griselda Pollock. *Old Mistresses: Women, Art and Ideology*. New York: Pantheon Books, 1981.

Pear, Lillian Myers. *The Pewabic Pottery: A History of Its Products and Its People*. Des Moines, Iowa: Wallace-Homestead Book Co., 1976.

Peck, Herbert. *The Book of Rookwood Pottery*. New York: Crown Publishers, 1968.

————. *The Second Book of Rookwood Pottery*. Published by the author, 1985.

Perry, Barbara Stone, ed. *American Ceramics: The Collection of the Everson Museum of Art*. New York: Rizzoli, 1989.

————. *Fragile Blossoms, Enduring Earth: The Japanese Influence on American Ceramics*. Syracuse, N.Y.: Everson Museum of Art, 1987.

Poesch, Jessie. *Newcomb Pottery: An Enterprise for Southern Women, 1895–1940*. Exton, Penn.: Schiffer Publishing Co., 1984.

Pyne, Kathleen. *Art and the Higher Life*. Austin: University of Texas Press, 1996.

Quick, Michael. *American Painter Abroad: Frank Duveneck's European Years*. Cincinnati: Cincinnati Art Museum, 1987.

————. *Munich and American Realism in the 19th Century*. Sacramento: E. B. Crocker Art Gallery, 1978.

Rodgers, Daniel T. *The Work Ethic in Industrial America, 1850–1920*. Chicago: University of Chicago Press, 1978.

Rogers, Millard F., et al. *Cincinnati Art Museum: Art Palace of the West*. Cincinnati: Cincinnati Art Museum, 1981.

Rydell, Robert W. *All the World's a Fair: Visions of Empire at American International Expositions, 1876–1916*. Chicago and London: University of Chicago Press, 1984.

————. *The Books of the Fairs: Materials about World's Fairs, 1834–1916, in the Smithsonian Institution Libraries*. Chicago: American Library Association, 1992.

Saarinen, Aline B. *The Proud Possessors*. New York: Random House, 1958.

Schlereth, Thomas J. *Cultural History and Material Culture: Everyday Life, Landscapes, Museums*. Charlottesville: University Press of Virginia, 1990.

———. *Victorian American: Transformations in Everyday Life, 1876–1915*. New York: Harper Perennial, 1991.

Sèvres: Une Collection de Porcelaines, 1740–1992. Paris: Réunion des Musées Nationaux, 1992.

Shi, David. *Facing Facts: Realism in American Thought and Culture, 1850–1920*. Oxford: Oxford University Press, 1995.

———. *The Simple Life: Plain Living and High Thinking in American Culture*. New York: Oxford University Press, 1985.

Slotkin, Richard. *Regeneration through Violence: The Mythology of the American Frontier, 1600–1860*. Middletown, Conn.: Wesleyan University Press, 1973.

Stein, Roger B. *John Ruskin and Aesthetic Thought in America, 1840–1900*. Cambridge, Mass.: Harvard University Press, 1967.

Stokes, Jayne E. *Sumptuous Surrounds: Silver Overlay on Ceramic and Glass*. Milwaukee: Milwaukee Art Museum, 1990.

Strasser, Susan. *Satisfaction Guaranteed: The Making of the American Mass Market*. New York: Pantheon Books, 1989; reprint 1995.

Susman, Warren I. *Culture as History: The Transformation of American Society in the Twentieth Century*. New York: Pantheon Books, 1984.

Taylor, John Russell, and Brian Brooke. *The Art Dealers*. New York: Charles Scribner's Sons, 1969.

Taylor, Joshua C. *The Fine Arts in America*. Chicago: University of Chicago Press, 1979.

Tomkins, Calvin. *Merchants and Masterpieces: The Story of the Metropolitan Museum of Art*. New York: Henry Holt and Company, 1970; reprint 1989.

Towner, Wesley. *The Elegant Auctioneers*. New York: Hill and Wang, 1970.

Trachtenberg, Alan. *The Incorporation of America: Culture and Society in the Gilded Age*. New York: Hill and Wang, 1982.

Trapp, Kenneth R. *Ode to Nature: Flowers and Landscapes of the Rookwood Pottery, 1880–1940*. New York: The Jordan-Volpe Gallery, 1980.

———. *Toward the Modern Style: Rookwood Pottery, the Later Years, 1915–1950*. New York: The Jordan-Volpe Gallery, 1983.

———, ed. *Celebrate Cincinnati Art*. Cincinnati: Cincinnati Art Museum, 1981.

Trapp, Kenneth R., and Vance A. Koehler. *American Art Pottery: Cooper-Hewitt Museum*. Seattle: University of Washington Press, 1987.

Trapp, Kenneth R., et al. *The Arts and Crafts Movement in California: Living the Good Life*. New York: Abbeville Press, 1993.

Truettner, William H., ed. *The West as America: Reinterpreting Images of the Frontier, 1820–1920*. Washington, D.C.: Smithsonian Institution Press, 1991.

Venable, Charles L. *Silver in America, 1840–1940: A Century of Splendor.* New York: Harry N. Abrams, Inc., 1994.

Via, Marie, and Marjorie B. Searl, eds. *Head, Heart and Hand.* Rochester, N.Y.: University of Rochester Press, 1994.

Vitz, Robert C. *The Queen and the Arts: Cultural Life in Nineteenth-Century Cincinnati.* Kent, Ohio: Kent State University Press, 1989.

Weidner, Ruth Irwin. *American Ceramics before 1930.* Westport, Conn.: Greenwood Press, 1982.

Weimann, Jeanne Madeline. *The Fair Women: The Story of the Women's Building, World's Columbian Exposition Chicago, 1893.* Chicago: Academy Chicago, 1981.

Weinberg, H. Barbara. *The Decorative Work of John LaFarge.* New York: Garland Publishing Co., 1977.

———. *The Lure of Paris: Nineteenth-Century American Painters and Their French Teachers.* New York: Abbeville, 1991.

Weisberg, Gabriel P. *Art Nouveau Bing: Paris Style 1900.* New York: Harry N. Abrams, 1986.

Weiss, Peg. *Adelaide Alsop Robineau: Glory in Porcelain.* Syracuse, N.Y.: Syracuse University Press, 1981.

Weitzenhoffer, Frances. *The Havemeyers: Impressionism Comes to America.* New York: Harry N. Abrams, 1986.

Wendt, Lloyd, and Herman Kogan. *Give the Lady What She Wants!: The Story of Marshall Field and Company.* South Bend, Ind.: and books, 1952; reprint 1991.

Wilson, Richard Guy, ed. *The American Renaissance, 1876–1917.* New York: Pantheon Books, 1979.

Wood, James Playsted. *Magazines in the United States.* New York: Ronald Press Company, 1956.

Secondary Sources: Articles

Bercaw, Nancy Dunlap. "Solid Objects/Mutable Meanings: Fancywork and the Construction of Bourgeois Culture, 1840–1880." *Winterthur Portfolio* 26, 4 (winter 1991): 231–41.

Bigart, Robert, and Clarence Woodcock. "The Rinehart Photographs: A Portfolio." *Bulletin of the Montana Historical Society* 24, 4 (October 1979): 24–37.

Blaszczyk, Regina Lee. "The Aesthetic Moment: China Decorators, Consumer Demand, and Technological Change in the American Pottery Industry, 1865–1900." *Winterthur Portfolio* 29, 2/3 (summer/autumn 1994): 121–53.

Bopp, H. F. "Art and Science in the Development of Rookwood Pottery." *American Ceramic Society Bulletin* 15 (December 1936): 443–45.

Brandimarte, Cynthia A. "Darling Dabblers: American China Painters and Their Work, 1879–1920." *American Ceramic Circle Bulletin* 6 (1988): 7–28.

————. "Somebody's Aunt and Nobody's Mother: The American China Painter and Her Work, 1870–1920." *Winterthur Portfolio* 23, 4 (winter 1989): 203–24.

————. "'To Make the Whole World Homelike': Gender, Space, and America's Tea Room Movement." *Winterthur Portfolio* 30, 1 (spring 1995): 1–19.

Brandt, Beverly K. "American Arts and Crafts at the Louisiana Purchase Exposition, 1904." *Archives of American Art Journal* 28, 1 (1988): 2–16.

Burns, Sarah. "The 'Earnest, Untiring Worker' and the Magician of the Brush: Gender Politics in the Criticism of Cecilia Beaux and John Singer Sargent." *Oxford Art Journal* 15, 1 (1992): 36–52.

————. "Revitalizing the 'Painted-Out' North: Winslow Homer, Manly Health, and New England Regionalism in Turn-of-the-Century America." *American Art* 9, 2 (summer 1992): 21–38.

Burt, Stanley Gano. "The Rookwood Pottery Company." *Journal of the American Ceramic Society* 6 (January 1923): 232–34.

"Ceramic History: Stanley G. Burt." *Bulletin of the American Ceramic Society* 18, 1 (January 1939): 33.

Chalmers, F. Graeme. "The Early History of the Philadelphia School of Design for Women." *Journal of Design History* 9, 4 (1996): 237–52.

"Cincinnati's Greatest Art Enterprise." *Clay Worker* 81 (January 1924): 24–26.

Cohen, Lizabeth. "Furnishing a Working Class Victorian Home." *Nineteenth-Century* 8, 3–4 (1982): 233–43.

Crawford, Rachael B. "Ceramics at the 1876 Centennial." *Antiques Journal* 31 (May 1976): 16–18, 46.

Crowley, Lilian H. "Now It's the Potter's Turn." *International Studio* 75 (September 1922): 539–46.

Davis, Chester. "The Later Years of Rookwood Pottery, 1920–1967." *Spinning Wheel* (October 1969): 10–12.

Denker, Ellen Paul. "The Grammar of Nature: Arts and Crafts China Painting." In *The Substance of Style: Perspectives on the American Arts and Crafts Movement*, ed. Bert Denker. Winterthur, Del.: Henry Francis du Pont Winterthur Museum, 1996. 281–300.

————. "Keeping the Fire Alive: China Painting and the Arts and Crafts Movement." *Arts and Crafts Quarterly* 4, 4 (winter 1992): 6–11.

DiMaggio, Paul. "Cultural Entrepreneurship in Nineteenth-Century Boston: The Creation of an Organizational Base for High Culture in America." *Media, Culture and Society* 4 (1982): 33–50.

Dressler, Constance W. "Rookwood." *Spinning Wheel* 11 (September 1955): 18, 20, 22–23.

Eidelberg, Martin. "American Ceramics and International Styles." *Princeton University Record of the Art Museum* 34, 2 (1975): 13–19.

————. "Myths of Style and Nationalism: American Art Pottery at the Turn of the Century." *Journal of Decorative and Propaganda Art* 20 (1994): 85–111.

Ellis, Anita J. "American Art Pottery at the Cincinnati Art Museum." *Journal of the American Art Pottery Association* 11, 4 (September–October 1995): 6–7.

———. "Cincinnati Art Furniture." *Magazine Antiques* 121 (April 1982): 930–41.

———. "Collecting Ceramics in the Late 19th Century: The Cincinnati Art Museum." *American Ceramic Circle Bulletin* 7 (1989): 25–50.

Elwood, Marie. "Two 19th Century Collectors and Their Collections." *American Ceramic Circle Bulletin* 7 (1989): 7–24.

Evans, Paul F. "Art Tiles of the New York Subway, 1904." *Spinning Wheel* 35 (November 1979): 8–12.

———. "Cincinnati Faience: An Overall Perspective." *Spinning Wheel* 28 (September 1972): 16–18.

Faude, Wilson. "Associated Artists and the American Renaissance in the Decorative Arts." *Winterthur Portfolio* 10 (1975): 101–30.

Fish, Marilyn. "Evolution of *The Craftsman*: The Voices of Its Principal Editors." *Style 1900* 9, 4 (autumn/winter 1996/97): 29–33.

———. "Other Voices of the Arts and Crafts Movement: *The Craftsman*'s Competitors." *Arts and Crafts Quarterly* 7, 2 (summer 1994): 36–38.

Fitzpatrick, Nancy. "America's First Art Pottery: Rookwood." *Spinning Wheel* 16 (October 1960): 16–17.

———. "Rookwood: Decoration and Decorators." *Spinning Wheel* 16 (November 1960): 14–15.

Fitzpatrick, Paul J. "Maria L. Nichols and the Rookwood Pottery." *Antiques Journal* 35 (October 1980): 24–29, 50–51.

Freeman, Helen. "The Rookwood Pottery in Cincinnati, Ohio." *House Beautiful* 47 (June 1920): 499–501, 530.

Frelinghuysen, Alice Cooney. "Americans and the Aesthetic Movement." *Antiques* (October 1986): 756–67.

Galambos, Louis. "What Makes Us Think We Can Put Business Back into American History?" *Business and Economic History*, 2d ser., 20 (1991): 1–11.

Hall, Donald S. "Glaze Craze." *Art and Antiques* 18, 10 (November 1995): 42–44.

Harris, Neil. "The Gilded Age Revisited: Boston and the Museum Movement." *American Quarterly* 14, 4 (winter 1962): 545–66.

Hasselle, Bob. "Rookwood: An American Art Pottery." *Ceramics Monthly* 26 (June 1978): 27–37.

Herzog, Charlotte. "Powder Puff Production: The Rookwood Pottery Girls." *Journal of the American Art Pottery Association* 14, 4 (July–August 1998): 6–13.

Humler, Riley. "The Rise, Fall and Rebirth of Rookwood Pottery." *Style 1900* 11, 4 (fall/winter 1998): 55–58.

Kamerling, Bruce. "Anna & Albert Valentien: The Arts and Crafts Movement in San Diego." *Arts and Crafts Quarterly* 1, 4 (July 1987): 1, 12–20.

Koch, Robert. "Rookwood Pottery." *Antiques* 77, 3 (March 1960): 288–89.

Kramer, Barbara Maysles. "Saturday Evening Girls and the Paul Revere Pottery." *Style 1900* 8, 4 (fall/winter 1995/96): 37–40.

La Forge, Zoe. "Health Hazards of Pottery Workers." *Public Health Nurse* 12 (January 1920): 26–31.

Leach, William. "Transformations in a Culture of Consumption: Women and Department Stores, 1890–1925." *Journal of American History* 71 (September 1984): 319–42.

Lears, T. J. Jackson. "AHR Forum: Making Fun of Popular Culture." *American Historical Review* 97 (December 1992): 1417–26.

———. "Some Versions of Fantasy: Toward a Cultural History of American Advertising, 1880–1920." *Prospects* 9 (1984): 349–405.

Leja, Michael. "The Illustrated Magazines and Print Connoisseurship in the Late 19th Century." *Block Points* 1 (1993): 56–73.

Levine, Lawrence W. "AHR Forum: Levine Responds." *American Historical Review* 97 (December 1992): 1427–30.

———. "The Folklore of Industrial Society: Popular Culture and Its Audiences." *American Historical Review* 97 (December 1992): 1369–99.

Lewis, Richard. "Rookwood: America's Finest Victorian Art Pottery." *Victorian Home* (fall 1989): 22–25, 106–7.

Lewis, Russell. "Everything under One Roof: World's Fairs and Department Stores in Paris and Chicago. " *Chicago History* 12, 3 (fall 1983): 28–47.

Macht, Carol. "Rookwood Pottery." *Ceramics Monthly* 14 (January 1966): 29.

MacKenzie, Donald R. "Early Ohio Painters: Cincinnati, 1830–1850." *Ohio History* (spring 1964): 111–18.

McClaugherty, Martha Crabill. "Household Art: Creating the Artistic Home, 1868–1893." *Winterthur Portfolio* 18 (spring 1983): 1–26.

McClinton, Katharine Morrison. "American Hand-Painted China." *Spinning Wheel* 23 (April 1967): 10–12, 43.

McLaughlin, Mary Louise. "Miss McLaughlin Tells Her Own Story." *Bulletin of the American Ceramic Society* 17 (May 1938): 217–33.

Meyn, Susan Labry. "Mutual Infatuation: Rosebud Sioux and Cincinnatians." *Queen City Heritage* 52, 1/2 (spring/summer 1994): 30–48.

———. "Who's Who: The 1896 Sicangu Sioux Visit to the Cincinnati Zoo." *Museum Anthropology* 16, 2 (June 1992): 21–26.

Nelson, Marion John. "Indigenous Characteristics in American Art Pottery." *Antiques* 89, 6 (June 1966): 846–50.

Nicholson, Nick, and Jim Fleming. "Rookwood Paperweights." *Journal of the American Art Pottery Association* 11, 3 (July–August 1995): 12–20.

Nicholson, Nick, and Marilyn Nicholson. "Rookwood Artists: Endeavors in Other Media." *Journal of the American Art Pottery Association* 12, 6 (January–February 1996): 5–9.

Nochlin, Linda. "Women and the Decorative Arts." *Heresies* 1, 4 (winter 1977–78): 43.

"Overture of Cincinnati Ceramics." *Bulletin of the Cincinnati Historical Society* 25 (January 1967): 70–84.

Peck, Herbert. "The Amateur Antecedents of Rookwood Pottery." *Cincinnati Historical Society Bulletin* 26 (October 1968): 317–37.

———. "Rookwood Pottery and Foreign Museum Collections." *Connoisseur* 172 (September 1969): 43–49.

———. "Rookwood Pottery Paperweights." *Pottery Collector's Newsletter* 2 (November 1972): 17–18.

———. "The Rookwood Pottery Sale of the Century." *Antique Trader Weekly* (October 28, 1981): 94–96.

———. "Some Early Collections of Rookwood Pottery." *Auction* 3 (September 1969): 20–23.

Purdy, Frank. "The New Museum." *Arts and Decoration* (December 1920): 116.

Pyne, Kathleen. "Evolutionary Typology and the American Woman in the Work of Thomas Dewing." *American Art* 7, 4 (fall 1993): 12–19.

"Rookwood Pottery: A Woman's Contribution to American Craftsmanship." *The Independent* 77, 3406 (March 16, 1914): 377.

Rydell, Robert W. "The Trans-Mississippi and International Exposition: 'To Work Out the Problem of Universal Civilization.'" *American Quarterly* 33, 5 (winter 1981): 587–607.

Schneider, William. "Race and Empire: The Rise of Popular Ethnography in the Late Nineteenth Century." *Journal of Popular Culture* 11, 1 (summer 1977): 98–109.

Shirley, Bernice Cook. "Rookwood Pottery." *American Antiques Journal* 3 (November 1848): 10–12.

———. "Rookwood Pottery." *Spinning Wheel* 5 (April 1949): 33, 46.

Siegfried, Joan. "American Women in Art Pottery." *Nineteenth Century* 9 (spring 1984): 12–18.

Slotkin, Richard. "Nostalgia and Progress: Theodore Roosevelt's Myth of the Frontier." *American Quarterly* 33, 5 (winter 1981): 608–37.

Smith, Kenneth E. "Laura Anne Fry: Originator of Atomizing Process for Application of Underglaze Color." *Bulletin of the American Ceramic Society* 17 (September 1938): 368–72.

Smith, Ophia D. "A Survey of Artists in Cincinnati: 1789–1860." *Cincinnati Historical Society Bulletin* (January 1967): 3–20.

Smith, Rosemary T. "Japanese Influence and Rookwood Art Pottery." *Journal of the American Art Pottery Association* 14, 3 (May/June 1998): 14–17.

Sprague, P. E. "Chronic Lead Poisoning Banished in New Jersey Potteries." *Ceramic Age* 10 (October 1927): 131–32, 139.

Stradling, Diana. "Teco Pottery and the Green Phenomenon." *Tiller* (March/April 1983): 8–35.

Testi, Arnaldo. "The Gender of Reform Politics: Theodore Roosevelt and the Culture of Masculinity." *Journal of American History* 81, 4 (March 1985): 1509–33.

Trapp, Kenneth R. "Japanese Influence in Early Rookwood Pottery." *Antiques* 103 (January 1973): 193–97.

———. "Rookwood and Japanese Mania in Cincinnati." *Cincinnati Historical Society Bulletin* 39 (spring 1981): 51–75.

———. "Rookwood's Printed-Ware." *Spinning Wheel* 29 (January/February 1973): 26–28.

———. "'To Beautify the Useful:' Benn Pitman and the Women's Woodcarving Movement in Cincinnati in the Late Nineteenth Century." *Nineteenth Century* 8, 3–4 (1982): 175–91.

Vickery, Amanda. "Historiographical Review: Golden Age to Separate Spheres? A Review of the Categories and Chronology of English Women's History." *Historical Journal* 36, 2 (1993): 383–414.

Volpe, Todd M. "Rookwood Landscape Vases and Plaques." *Antiques* 117 (April 1980): 838–46.

Walls, N. de Angeli. "Art and Industry in Philadelphia: Origins of the Philadelphia School of Design for Women, 1848–1876." *Pennsylvania Magazine of History and Biography* 17, 3 (1993): 177–99.

Weidner, Ruth Irwin. "The Early Literature of China Decorating." *American Ceramics* 2 (spring 1983): 28–33.

Weisberg, Gabriel P. "Félix Braquemond and Japanese Influence in Ceramic Decoration." *Art Bulletin* 51, 3 (September 1969): 277–84.

Welter, Barbara. "The Cult of True Womanhood, 1820–1860." *American Quarterly* 18 (1966): 151–74.

Yaeger, Dorothea. "Rookwood, Pioneer American Art Pottery." *American Collector* 12 (July 1943): 8–9, 19.

INDEX

cult of the strenuous life, 158, 159. *See also* American character; Americanism

Dallas, Frederick, 41, 42, 46
Dallas Pottery, 46
Daly, Matt, 163, 173, 271 n. 15, 290 n. 145
Davis Collamore and Co., 131, 151, 205, 206, 207, 233
de Forest, Robert W., 305–6 n. 24
decoration, 275 n. 58; *la décoration*, 275 n. 58
decorative art, versus fine art, 112–14
Decorative Art Society, 42; shows, 131
Delacherch, Auguste, 86
Denison, Judge, 235–36
Dennett, Mary Ware, 259 n. 16
department stores, 208–9. *See also* Marshall Field's
Des Bois, Jules, 271 n. 13
Design-Keramic Studio. See Keramic Studio
Dewing, Maria Oakey, 112, 274–75 n. 56
Dewing, Thomas Wilmer, 124, 125
Dodd, Jane Porter, 37
Dorr, Dalton, 2
Dresser, Christopher, 56
"Drift of the World's Art toward America, The" (Mather), 121
Duchess of Portland, 182
Duncanson, Robert, 14
Durand, J., 114
Duveen, Henry, 183
Duveen, Joseph, 122
Duveneck, Frank, 272 n. 25, 273 n. 37

Eakins, Thomas, 113
Eastlake, Charles Locke, 184, 296 n. 22
Eaton-Hurlburt Paper Company, 128
Eggers, Marie, 37
Elkington, Mason and Co., 100
Elliott, Charles, 5, 6
Elzner, A. O., 110
Europe: European modernism, 227; influence on American ceramics, 150–51
Exposition Internationale de Ceramiques et de Verrerie (1901), 138
Exposition Internationale des Arts Décoratifs et Industriels Modernes (1925), 229–30
Exposition Universelle (1889), 131
expositions, international, 131–36, 138–40

"Factory as It Might Be, A" (Morris), 53–54
factory system, 53–54
fine art, versus decorative art, 112–14
folk/historic revivalism, 305 n. 15

Forest, Lockwood de, 23
Frackelton, Susan Stuart, 30, 33, 69, 73, 145, 147, 252 n. 83, 304 n. 8
Frans Hals Museum, 272 n. 23
Frederick Loeser Co., The, 233
Freer, Charles Lang, 125, 183, 184
Freer Gallery, 183
French Academy, 20
French Impressionism,, 125, 280 n. 112
French Royal Porcelain factory, 278 n. 95
Frick, Henry Clay, 180, 183, 184
Friedlander, Max J., 122
Fry, Henry, 36–37
Fry, Laura A., 47, 81
Fry, Marshal, 136, 138, 143
Fry, William, 36–37
Fulper Potteries, 305 n. 19

Gamble House, 180, 294 n. 3
Gannett, William, 194
gardens, 218
Gates Potteries, 75, 89, 263 n. 58
Gazette des Beaux-Arts, 131, 43
George Shreve and Co., 205
Germaine, Betty (Lady), 183
Gérôme, Jean-Léon, 113
Gest, Joseph Henry, 78, 96, 221, 236
Gilded Age, 25–26
Gilder, Richard Watson, 53, 190
Gilman, Charlotte Perkins, 17
Glasgow International Exhibition, 15
Godey's, 18
Godkin, E. L., 53, 123
Goodall, Frederick, 104
Gorham Manufacturing Company, 136; silver overlay, 282 n. 29
Goshorn, Alfred T., 3, 183, 254 n. 104
Gothic architecture, 55
Grueby Pottery Company, 75, 89, 140, 263 n. 58; criticisms of, 299 n. 72; decorator training, 269–70 n. 122
Guerrier, Edith, 73
guilds, 83
Guimard, Hector, 212

Hamilton Road Pottery, 41, 43
Handicraft journal, 57
Harper's Monthly, 180, 188, 210
Harrison, Birge, 279–80 n. 107
Harrison, Constance Cary, 187
Havemeyer, H. O., 122
Haviland, David, 255 n. 110
Haviland, Theodore, 281 n. 10
Haviland and Company, 40, 150, 255 n. 110

wood-block prints, 286 n. 90

"Working Women in New York," 27

World's Columbian Exposition (1893), 86, 96, 132–34, 136, 151; architectural examples át, 263 n. 51; chromolithographs at, 123; Rookwood's Native American display at, 161

World's Fair (Paris, 1889), 191

World's Fair (Paris, 1900), 136, 138, 151; Native American displays at, 169–73, 177–78; Rookwood's Native American display at, 161

World's Fairs, 129; and Native American displays, 161

Wright, Frank Lloyd, 59, 268 n. 104

Wright, Tyndale and Van Roden, 205, 207

Wyant, Alexander, 124, 273 n. 37

Yelland, Henry, 268 n. 100

Yellow Wallpaper, The (Gilman), 17

Young, Grace, 98, 100, 165, 290 n. 145

Young, Jennie, 147, 149